Marketing Fine Art Photography

Alain Briot

Marketing Fine Art Photography

rockynook

Alain Briot (www.beautiful-landscape.com)

Editor: Joan Dixon
Copyeditor: Julie Simpson
Layout and type: Petra Strauch
Cover design: Helmut Kraus, www.exclam.de
Printer: Tara TPS Co., Ltd. through Four Colour Print Group
Printed in Korea

ISBN 978-1-933952-55-0

1st Edition 2011 (1st reprint, November 2011)
© 2011 Alain Briot

Rocky Nook, Inc.
802 East Cota Street, 3rd Floor
Santa Barbara, CA 93103

www.rockynook.com

Library of Congress Cataloging-in-Publication Data

Briot, Alain.
 Marketing fine art photography / Alain Briot. -- 1st ed.
 p. cm.
 ISBN 978-1-933952-55-0 (soft cover : alk. paper)
 1. Photography--Business methods. 2. Photographs--Marketing. 3. Selling--Photographs.
 4. Photography, Artistic. I. Title.
 TR581.B75 2011
 770.68'8--dc22
 2010028855

Distributed by O'Reilly Media
1005 Gravenstein Highway North
Sebastopol, CA 95472

Table of Contents

DOWNLOADABLE RESOURCES

The forms and documents that are pictured throughout this book can be downloaded from Alain Briot's website: **www.beautiful-landscape.com/Briot_Marketing.html**

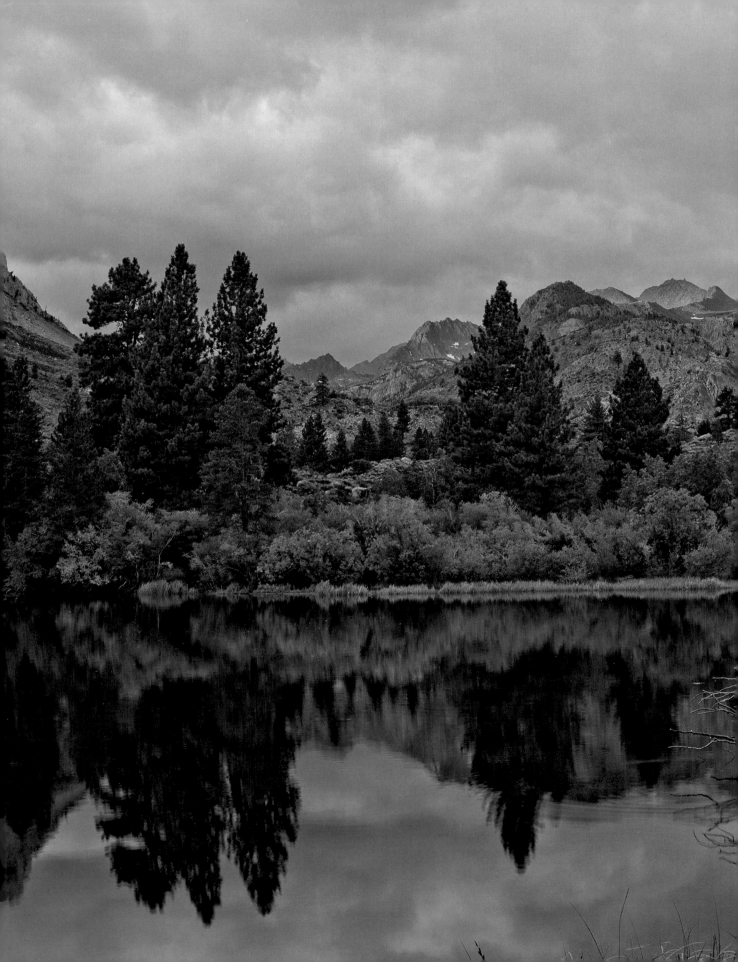

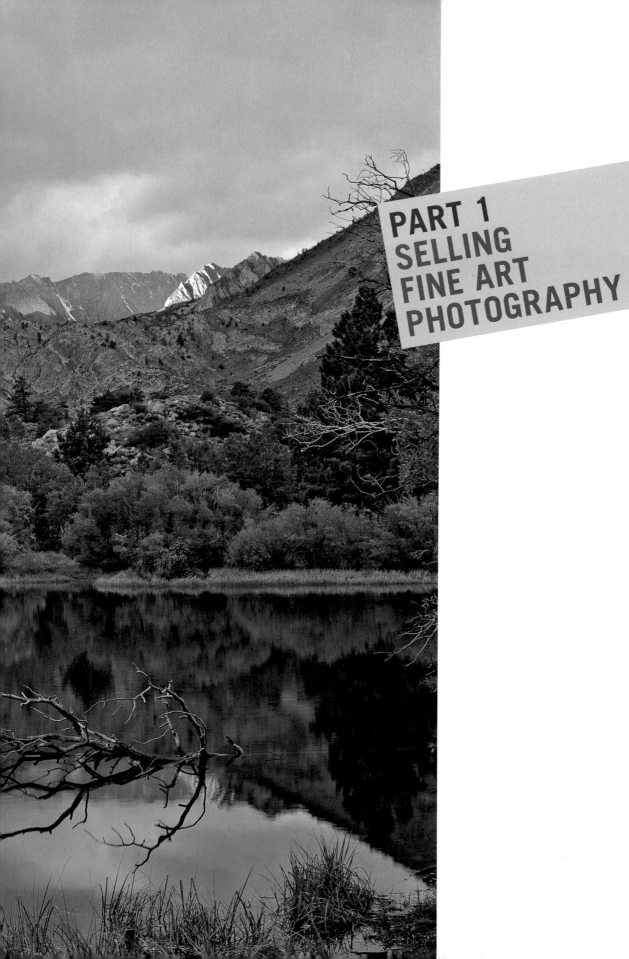

PART 1
SELLING
FINE ART
PHOTOGRAPHY

Successful people do the things
that unsuccessful people are unwilling to do.
 JOHN MAXWELL

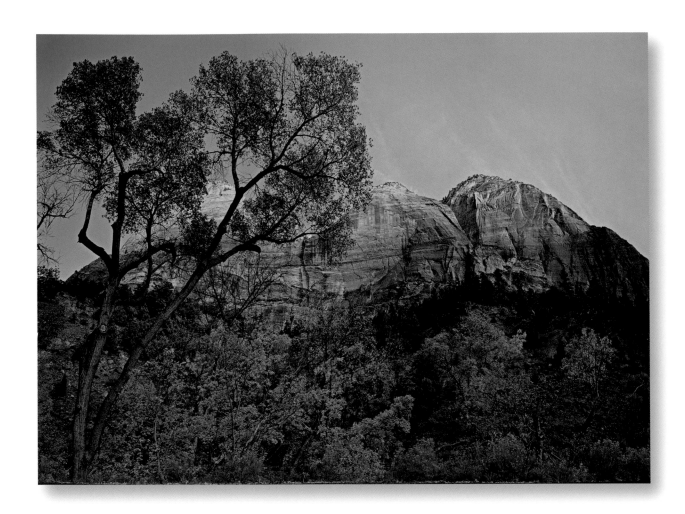

Chapter 1
Taking Control of Your Destiny

We are successful when we take control of our lives instead of waiting for success to come to us. Marketing your work is taking control of your financial destiny instead of hoping that luck will bring you money and fame. By taking control we ensure that specific things will happen because of our actions, our decisions, and our personal abilities, not because of some unknown outside force that may or may not come our way. By deciding today that you will make things happen, instead of waiting for things to happen "someday," you take control of your life. It is taking control that, eventually, will bring you success.

Making dreams happen carries both costs and sacrifices. In order to be successful running your photography business, you will need to sacrifice some of the time that you would have otherwise spent creating photographs. This time will instead be spent on marketing your work and selling your photographs at shows or in other venues. It will also be spent doing accounting, ordering supplies, and completing the multitude of tasks that are part of running a successful photography business.

If you follow the advice I offer in this book, you can build a successful business. However, you will no longer be able to spend all your time doing photography. This can be seen as a sacrifice. However it can also be seen as success because you will no longer need to have a job that just "pays the bills" and allows you to do photography on the side.

This is all about choices, about knowing what you really want to do and about doing what is required to make your dreams come true. If you really want something—if you want it enough to work as hard as is necessary to get what you want—you can achieve it. This has proven true for me, and I am sure it will prove just as true for you.

The Best-Kept Secret

A poor photograph well marketed will always outsell a great photograph poorly marketed.

Therefore, the goal is to create great photographs and marketing them effectively.

Photographs do not sell simply because they are pretty. Like any product, photographs sell because they are properly marketed. Better cameras and equipment do not lead to better sales. Better marketing leads to better sales.

Most photographers who sell their work spend far too much time and money on equipment and far too little on marketing. In fact, many photographers do not spend *any* time or money marketing their work. Instead, they wait for people to come and buy from them: they wait to be discovered. Needless to say, they are quickly disappointed because artwork is not sold by waiting for customers to knock on your door. Artwork is sold by knocking on the customer's door, either physically or metaphorically.

Why is that? It is because most people have a very difficult time deciding what is good art and what is bad art. This being the case, people rely on information made available to them regarding the artwork they are looking at. They need to know more about the work presented to them before they can decide to buy it. They need to know who the artist is and why they should buy this artwork. Without this information they will rarely buy, and if they do, they will mostly purchase only low-priced pieces.

This information can be provided to them by the artist's representative. If no one is representing you, then you must provide your audience with this information yourself.

You may say, "But I have had articles written about me, I have done interviews, I have a website, and so on. Why can't my customers learn about me that way?" They certainly will learn about you that way, provided they find these articles, interviews, and websites. The problem is, how do you know they will find this information? And how do you know the right people—those who are considering purchasing your work—will find it? The fact is that you don't. And the fact is that most likely they will not find this information.

This being the case, it is your job, as an artist who is marketing your work, to provide prospective customers with this information. You simply cannot expect your customers to find it on their own.

For example, one of the best marketing pieces you will ever have in your hands is your Artist Statement. The Artist Statement is a crucial piece of information about yourself which, if designed and used properly, will help you generate more sales than you ever thought possible. I will address the Artist Statement in more detail in Chapter 20.

What is Marketing?

Marketing encompasses a wide variety of promotional activities. There is really no limit to the marketing venues and approaches that can be used. The secret (if there is one) is to develop a marketing system that works for you and that you will fine-tune over time. The next step is to apply this system systematically.

The Goal of Marketing

The goal of marketing is to generate sales that would otherwise not be generated—to convince that part of the audience that is not yet ready to buy, or is not aware of your product's existence or advantage, to buy your product.

Therefore, the purpose of marketing is persuasion. How this is achieved is the focus of this book.

Successful marketing is persuasive marketing. A successful marketing campaign is one that persuades a large segment of the audience to buy the product being marketed. An unsuccessful marketing campaign is one that does not persuade a significant segment of the audience to buy the product.

No effort should be spared in persuading customers to buy your product except, of course, illegal or unethical practices. When considering all the marketing venues available, none should be rejected a-priori. Instead each should be carefully considered and then evaluated for its effectiveness.

Effectiveness is the key element in marketing. Fear or insecurity are often reasons people reject a potential marketing approach. Therefore, it is important to eliminate fear from the marketing planning stage.

During the planning stage one must consider not only the positive aspects of a particular approach, but also the negative aspects. For example, a negative outcome is the potential damage to the image and the public perception of a business as a result of a marketing campaign. A marketing campaign must not only be persuasive, it must also keep intact and, preferably, reinforce the image that the business wants to project to its audience. Therefore, an important goal of marketing is the reinforcement of a business image. This is best achieved by the creation of an image that is constantly refined through new marketing campaigns. The goal of each new campaign is to reinforce this business image and to remind the audience why they should buy the advertised products.

Why Marketing is Indispensable to Success in Photography

What you never want to forget is that marketing is absolutely necessary in order to sell your work. This is true regardless of the type of marketing you decide to do and regardless of the product you decide to sell.

Your marketing can be as simple as talking to your co-workers or as complex as a national campaign orchestrated over a long period of time. The type of marketing you choose to do is not what is important. What is important is that your marketing is aimed at meeting your financial goals and that it reaches your target audience.

When all the expenses are tallied up, creating photographs costs a lot of money. Furthermore, as your level of involvement increases, these costs

Nobody hangs a $100 photograph over the mantle in their million-dollar home.

increase proportionally and, sometimes, unfortunately, exponentially.

For example, if you open a gallery you will have to pay rent for office space, pay for utilities, buy insurance, pay salaries to your employees, and more. All of a sudden you find out that you either need to make additional sales, or you must raise your prices to cover these new expenses. You also find out that your previous marketing approach no longer works because it either does not attract enough customers, or it does not attract customers who are willing to pay your higher prices, or both. As a result, you need to set new financial goals and prepare a marketing campaign designed to reach these goals.

The need for marketing does not make itself known until running your business requires a specific level of income. Until then, marketing is an option. When the time I just described arrives, things take a 180 degree turn and marketing becomes a requirement. At that time marketing is no longer something you *could* do. Instead, marketing becomes something you *must* do. Income from photography is no longer a desire; it is now a necessity and in some instances a dire necessity.

Crucial Questions

I have seen too many photographers start a business and hope to make a good income without doing much, if any, marketing. Launching a website without doing any marketing is like waiting for a miracle to happen. Opening a gallery without doing any marketing is akin to committing suicide.

Whether you launch a website or open a gallery, if you do not market your work and your location, how are people going to find you? And if people do find you, how do you control who visits your site or walks into your gallery? For you to sell your work, you need to attract people who are interested in your product or services.

At such time, important questions surface such as:

- How will you find the correct marketplace for your work?
- Is there a market for this work in the first place?
- Do you have to compromise and make your work fit a specific marketplace?
- Can you offer a new style or do you have to conform to an existing, sales-proven style?
- Are you going to sell quantity or quality?

These questions are rarely asked by photographers because photographers prefer to focus on getting new camera gear, new software, or new photographic knowledge.

Instead, these questions focus on how to make money by selling your work, something that many artists like to think will happen if they simply do great work. The problem is that great work does not sell itself. Great work, or

any work for that matter, needs marketing in order to sell. You can have the most beautiful photographs in the world, or the best product ever, but it is not going to do you much good if you do not explain to those who are qualified to buy your product *why* they should buy it.

There are countless ways that your work can be marketed, and we will look at many of them in this book. What is important to remember is that marketing has to be done in order to generate the business income you desire.

Photography Must be Your Career in Order to Succeed

In order to sell your work successfully you need to approach this activity as a career, and not as a hobby. This is because while a hobby is usually done on the side, a career plays a primary importance in your working life. This decision is significant because it will shape how you approach your photography business as a whole.

You can make your photography business a part-time career or a full-time career. Many start doing this part-time and later move on to doing it full-time. For example, you may look at it as having a "day job" and a "night job," or a full-time job and a part-time job. Others start right off doing it full-time, often by retiring from a previous career and beginning a new career in photography.

Whichever way you look at all this, keep in mind that it is going to be a lot of work and that it will not be easy. I do not want to hide this fact from you. If this were easy, everyone would do it and everyone would be successful at it.

Market, Market, and Market Again

An old maxim goes like this: If you do not market your work one thing will happen—nothing.

The saying is true. I verified it for myself when I first tried to sell my work. Let me explain.

When I started selling my photographs I thought that having stunning, high-quality work was the secret to selling it. I believed that my work would speak for itself and that its beauty alone would be enough to generate sales. Therefore, my efforts were focused on constantly improving the quality of my work by acquiring better cameras, better equipment and, overall, by learning how to create better photographs.

The way I "marketed" my work was by displaying my work in galleries. Although I did not realize it then, I was relying on the galleries to market my work. But the fact is, the gallery owners marketed their galleries, not my photography. They promoted the name of their gallery, and when doing so, they included all the artists they represented. My name was featured in their marketing materials along with all the other artists they represented. Because

these galleries represented many artists, the name of each individual artist received little attention. This did not work very well for me. Although I did make a few sales, they were at low prices and irregular intervals. I could not rely on this income to make a living from my photography.

Because I believed that the beauty and the quality of my photography would make people want to buy them, when they did not sell I concluded that my photographs were not good enough and that I had to make them better. Consequently, I spent a lot of time and money doing so. Unfortunately, while the quality of my work did improve, my sales did not increase.

Because I had no idea how to market my work myself I decided to place ads in magazines. Since I did not know which magazines to advertise in, I chose to maximize my chances by advertising in magazines that had a national distribution. These ads were very costly.

Although I did not know how to design an effective ad, I could not afford to hire a professional graphic designer. Therefore, I designed my own ads, making beginners' mistakes. As a result my ads generated only marginal income. At the end of the day I barely covered my costs. I certainly did not make a profit.

The Breakthrough

All these mistakes cost me a lot of time and money. Eventually, I realized that I needed to generate a sufficient income through the sale of my work or quit trying altogether. I could not sustain these expenses if I was not making a profit.

This is when I realized that I needed to study marketing. Because there were no books explaining how to sell fine art photographs, I studied marketing techniques used to sell a variety of other products and devised ways of applying these techniques to the marketing of fine art photographs.

Completing this research took me years. Testing my findings also took a long time because I could only do it through trial and error. The whole process was very time consuming. However, it led me to the formulation of a successful fine art marketing system that can be used to sell photographs and other fine arts, such as paintings, sculptures, etc. Furthermore, this system can be adapted to sell other products as long as these products are sold on the basis of quality rather than quantity.

I now know that the reason my work wasn't selling well was not because of low quality. My work was not selling because it was not marketed properly. What I needed to improve was the quality of my marketing, not the quality of my work. It took me a long time to understand that, and it took me even longer to devise a successful marketing strategy. The outcome of my efforts is the marketing system that I present in this book.

Skill Enhancement Exercises

In this book, as in my previous books, at the end of most chapters you will find what I call *Skill Enhancement Exercises*. These exercises are designed to help you get the most out of the information provided in each chapter by applying it to your personal situation.

The first Skill Enhancement Exercise in this book focuses on taking care of your own destiny. It consists of two questions. Answer each question in writing as accurately and as honestly as you can. I recommend you keep all your answers to the various Skill Enhancement Exercises in this book in a single notebook, or a single text file on your computer, so that you can refer to your answers easily and monitor your progress.

Taking Control of Your Destiny

1. What are you doing right now to take control of your own destiny?
2. What else can you do to take better control of your destiny?

Art implies control of reality, for reality itself possesses no sense of the aesthetic.
Photography becomes an art when certain controls are applied.
 ANSEL ADAMS

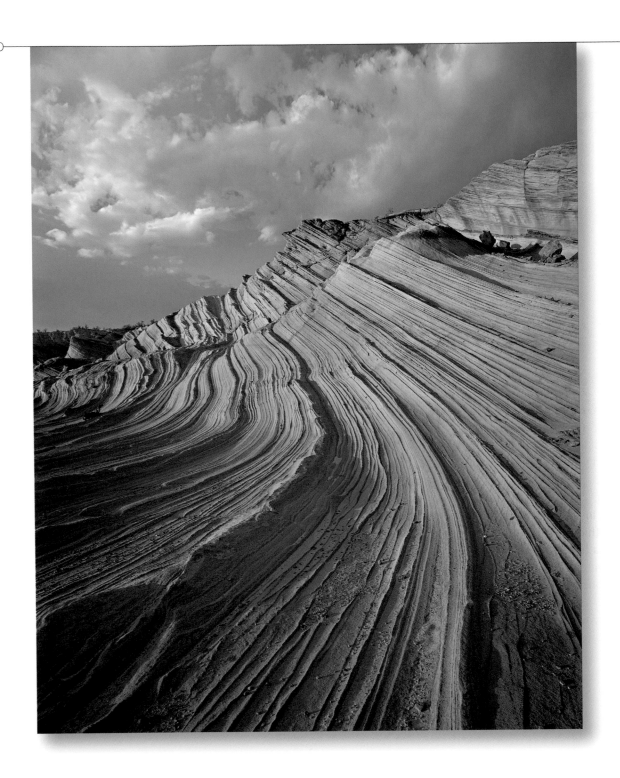

Chapter 2
What is Fine Art Photography?

Because the goal of this book is to teach you how to sell fine art photographs, it is important first to discuss what fine art photography is. However, this is challenging for several reasons. First, fine art photography is not all that common, which means there are not many practitioners to talk to, and most are more interested in doing fine art photography than in explaining what it is.

Second, photography has many purposes, only one of them being the creation of fine art photographs. Photography can be used to record and document events, for scientific or forensic research, to capture personal memories, and much more. All of these uses result in the creation of photographs, yet none are intended to be fine art photography.

Third, there is a tendency on the part of some photographers to lower the criteria for fine art photography for commercial reasons. Creating fine art photography can be expensive, however, these expenses can be recouped, and then some, through the higher prices a photographer can charge for fine art photographs. Unfortunately, some photographers claim that their work is fine art when in fact it does not meet the quality standards for fine art. This has led to a general misunderstanding of what fine art photography really is.

Fourth and last, the distinctions between photography and art can be blurry. Does art include photography? Before we can consider what fine art photography is, we must first determine whether or not photography is an art.

In this chapter I will give answers to the questions above. However, I want to point out that the primary purpose of this chapter is not to answer the question "what is art?" but rather "what is fine art photography?"

In the context of the above remarks it is worth pointing out a couple of things. First, asking "what is art?" means questioning the nature of art as a human endeavor regardless of the medium being used. On the other hand, asking "what is fine art photography?" means questioning the nature of photography practiced as a fine art. The purpose of this chapter is to discuss the nature of fine art photography, not the nature of art as a whole. While it is inevitable that I discuss "what is art" in this chapter, those who want to read a full-fledged discussion focusing only on the nature of art will have to wait until I write a book devoted solely to that subject.

I also want to point out that because of the subjective nature of art, not all readers will agree with my views on the subject. I will discuss some of the reasons for this situation, and I also talk about how to handle disagreements and criticisms, later in this chapter.

Finally, I want to point out that I carefully pondered this issue before I started writing this chapter and I concluded that, to use a common expression, "I agreed to disagree." In my view, the only way to write about art is to take it for granted that not everyone will agree and that many will consider what follows to be opinions rather than facts. Therefore, I decided to not let this hinder me, or worse stop me, from addressing this subject.

Defining Fine Art Photography: A Checklist

I present the answers to the question of "what is fine art photography?" as a checklist. This checklist will be useful in helping you find out if your work, or that of other photographers, qualifies as fine art. There are three aspects to fine art photography and so I have divided this checklist into three parts: A) artistic, B) technical, and C) marketing.

(A) **The Artistic Aspects of Fine Art Photography**

(1) **Fine art photography is first about the artist** — Fine art photography is first about the artist, second about the subject, and third about technique. The artist is the most important element in the creation of art. The same artist may, and often does, work with various subjects during his career, using a number of different techniques and possibly a variety of mediums. The goal is to create a work of art; subjects and techniques are both vehicles used in the process of reaching this goal.

(2) **The photographer must consider himself an artist** — The photographer must consider himself an artist in order to create art. Imagine how difficult it would be to create fine art photographs if you did not think of yourself as an artist. Further, although you might be able to create art, imagine how difficult it would be to write an artist statement if you did not believe you were an artist. The artist statement is an essential document to have when pursuing a career as an artist. It directly addresses how the artist views himself, his experience, approach, goals, and work. Not being able to write an artist statement would have a negative impact on your artistic career.

(3) **The artist must demonstrate control of the creative process and of the final outcome** — This statement directly informs the place that luck, happenstance, and other "happy events" have in the creation of art. While there is no doubt that all these factors come into play, their value comes in only when the artist has done his best to control the outcome of the work. At that time, luck usually works in favor of the art rather than against it. But while luck may be a component of the process, it is not responsible for an

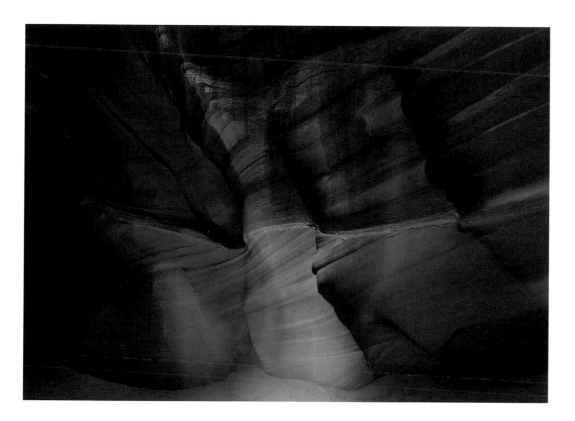

artist's success over an entire career, or for demonstrating the highest level of craftsmanship in the completion of complex projects. It is the artist's control of the process that is responsible for these achievements.

Furthermore, because art is first about the artist, it is essential that the artist control the work. Only through this control can the artist's personality, inspiration, passion, and vision become part of the work. Only through this control can the artist share his vision through his work. Ultimately, what the audience wants is to see how a specific artist views the world, and this can only take place if the artist assumes full control of the creation of a work of art.

Beginning artists often argue against the necessity of controlling their creations. Experienced artists rarely hold this type of discourse. Beginning artists feel more comfortable having the work exist by itself, disconnected from their responsibility toward it. They can be reluctant to take responsibility for the nature and the facture of their work. This is often because of a certain level of shyness regarding their creation that they cope with by presenting their work as being due to something outside of their control rather than as being the outcome of their personal vision. As artists become more experienced, as they find an audience for their work, and as their work becomes more accepted, taking responsibility for the outcome of their efforts starts to replace the disconnection with their work that they originally displayed.

Sandstone Waves, Antelope Canyon – This photograph is actually not one that I have taken with my camera alone. Instead, it is a collage of eight photographs, stitched together in Adobe Photoshop CS4 using Photomerge. The stitching setup I chose distorted the image to the point that blank areas appeared in the corners. Since I did not have additional photographs to fill-in these blank areas, and since I liked the image and wanted to finish it, I decided to clone substantial areas of the image. In doing so I truly "invented" part of the photograph using as guidelines the areas that I had photographed. The result is an image of something that does not quite exist as it is shown here. It is the work of my imagination as much as that of my camera. As such I believe it represents a work of art, as well as a combination of art and science.

As artists start to accept more responsibility for their output, they begin to exert more control over their creations. As a result, the necessity for a higher level of craftsmanship begins to surface, and in turn a higher level of mastery begins to take shape.

These developments are motivated by the realization that being responsible for the outcome of the work also means being responsible for the level of craftsmanship demonstrated in the work. A sense of pride starts to build in the artist and the desire to demonstrate one's abilities surfaces. In due time, the artist becomes concerned with demonstrating mastery of his art to his audience. At this point, the transition from refusing responsibility for the work to taking full control over the outcome of the work is complete.

(4) A fine art photograph is done with the goal of creating a work of art – This further reinforces the necessity for the photographer to consider himself an artist and to take control of the creative process. Both of these are necessary if one is to create a work of art and not simply a documentary photograph. We will discuss this in greater detail later in this book.

Creating a fine art photograph means creating an image that goes beyond the literal aspect of the scene or the subject photographed. It means creating an image that shares a personal vision, a message, or a metaphorical aspect. It means *creating* a photograph, not just *taking* a photograph.

(5) A fine art photograph is not just documentary – Documentation is favored in certain types of photography, such as scientific and forensic recording. In these fields the purpose of taking a photograph is to record the scene or the subject in the most literal and factual manner possible so that what the photograph shows is as close as can be to what the witnesses, researchers, and investigators saw. The goal is to prevent the personality and the opinions of the photographer from becoming part of the photograph. The person who took the photograph must be totally absent from it. Their personal beliefs, views, and opinions should in no way be present or expressed in the photograph, either implicitly or expressively. It is as if this person never existed; as if the camera took the photograph by itself.

Fine art photography is the exact opposite. In fact, we can take each of the statements above, write exactly opposite statements, and have excellent guidelines for the creation of fine art photographs. Let's give it a try. First, what a fine art photograph shows must be different from what was seen by observers present when it was taken. Second, the purpose of a fine art photograph is to share the photographer's personal vision of the scene or subject. Finally, the person who took the photograph must be present in the image, metaphorically speaking. When looking at a fine art photograph we must know that the photograph was created by an artist and not just by a camera.

This is because art is the opposite of documentation. Art is the expression of the artist's personality, vision, and inspiration. As such, a fine art photo-

graph is a vehicle through which the artist shares his vision with his audience. Therefore, to be considered art a photograph cannot be purely documentary. Instead, it must primarily be expressive. This expression must reflect the artist's personality, inspiration, vision, personal style, and, most importantly, emotional response to the subject. The photograph cannot just show what was in front of the camera; it must also show what the photographer felt.

6 **The image represents an interpretation of the subject** – As we just saw, a fine art photograph is always an interpretation of the data captured in the photograph. In fine art landscape photography this interpretation starts in the field when the photograph is taken and continues in the studio when the photograph is converted and optimized. (More on this in Section B—Technical Aspects, below.)

7 **A fine art photograph has an emotional content** – As we saw previously, the image must express the artist's emotional response to the subject. For this to happen there must be an emotional content in the photograph. Because photographs are purely visual, this emotional content must be expressed visually. This is done through various means: the composition of the image; the choice of image format; the cropping of the original photograph; the choice of color palette; color saturation (or the use of black-and-white or color monochrome instead of color); contrast and lightness; the use of curves, lines, and other visual elements; and more.

The choices of these elements define one's personal style. To be used effectively, this approach requires extensive study, training, and practice. To minimize the amount of time required to learn it, it is best to study under the guidance of an experienced photographer.

8 **The composition of the photograph is complex and sophisticated** – By complex and sophisticated, I do not mean that the composition must be complicated. I simply mean that it needs to have multiple layers of meaning. A composition can be very simple—minimalist even—and still have multiple layers of meaning. These layers each represent a different level of understanding and appreciation of the work. There needs to be more to the composition of a fine art piece than meets the eye at first glance. The meaning of the image must reveal itself over time, not all at once. As the viewer spends time admiring, studying, and reflecting on the piece his efforts are rewarded by a deeper understanding of the work.

9 **A metaphorical level of meaning is present in the image** – A metaphor is something that stands for something else. Metaphors can be expressed through a variety of mediums: writing, visual arts, music, architecture, etc. Metaphors are not necessarily self-evident. Because metaphors are arbitrary, they are by nature cultural and will therefore vary from one culture to another.

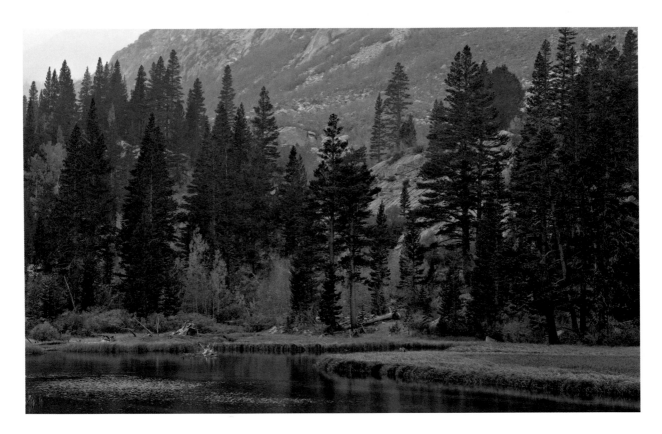

North Lake, Eastern Sierra Nevada —
A fine art photograph does not have
to be one that conceals the location
where it was taken. It can be an image
of a scene all of us can recognize and
relate to. However, all the aspects of the
work discussed in this chapter must be
there to testify that the photograph is
a representation of the photographer's
emotional response to the scene and not
just a documentary record of this scene.

An object that stands for something in a given culture may stand for something entirely different in another culture. For example, in American culture red roses are a symbol of love, yet in Europe they are a symbol of socialism. Although the origin of the rose as a symbol of love originated in Europe in the middle ages, the origin of the rose as a symbol of socialism originated in France in May 1968, when red roses were used as badges during street protests in Paris. One must therefore know the cultural context in which a metaphor exists in order to understand its meaning.

In fine art photography metaphors must be expressed visually by using elements that are either already present in the scene or placed there by the photographer. These elements are used to express a metaphorical level of meaning that extends beyond the visual contents of the image.

For example, in a fine art landscape photograph a young tree located next to a mature tree may be used to represent the contrast or the transition between youth and old age. In this instance, the trees have a metaphorical meaning that extends beyond their visual presence. The young tree stands for youth while the mature tree stands for old age. Similarly, a pool of dark water may stand for mystery, reflections of clouds in water may stand for infinity and introspection, and so on. The possibilities are infinite and limited only by the artist's imagination.

10 **The emphasis is on quality rather than quantity** – When creating fine art photographs the artist's emphasis must be placed on quality rather than quantity. This approach must permeate every aspect of the photographer's endeavors, because the process of creating fine art is characterized by deep thinking, deliberate actions, and attention to detail in every aspect of the work. As such, the process of creating fine art naturally results in a small number of individually made, high-quality pieces. The artist's emphasis is on the creation of a small number of individual pieces rather than on the mass production of identical objects.

Only by limiting the number of pieces can one control the quality throughout the entire process. Because we all have the same amount of hours available in a day, increasing quantity means having to create more pieces in the same amount of time. This means spending less time working on each piece, which in turn means that less time is available to pay attention to details and to ensure that every aspect of the work is completed to the highest standards.

11 **Cost considerations are secondary** – In the creation of fine art photographs, the primary concern is for quality. Costs, be it that of your equipment (cameras, lenses, computers, etc.) or your supplies (film, paper, inks, mat board, frames, etc.) are secondary.

Creating fine art photographs is not about trying to save money by buying lower-priced equipment or supplies. It is about creating the finest piece possible regardless of cost. While we all have a limit to how much we can spend on our art, concerns for costs need to come second, not first.

12 **The artist wrote an artist statement** – The contents of an artist statement are described in Chapter 20. It is an important document because it describes who the artist is, what he does, what his training and experience are, and how he is positioned in the art field. As such, it legitimizes the artist, his vision, and his goals.

13 **Individual pieces are part of a larger body of work** – A body of work says more about an artist's abilities than a single photograph. This is because a body of work, such as a portfolio, demonstrates the artist's abilities over time instead of in a single instance. A single, high-quality photograph can be seen as a fluke by a suspicious audience. However, a portfolio of quality images lays these suspicions to rest by positively answering the question, "Can the artist create images of this quality regularly, or was this just a happy accident?" It is much easier to see if the artist can regularly produce quality work and sustain his vision over time when looking at a portfolio than when looking at a single image.

14 **The work is discussed in relationship to other works of art** – The work is discussed in relationship to other works of art and comparisons are made. In this discussion, foundational aspects of art are addressed, such as pedigree, provenance of the work, facture (meaning execution), history, palette, etc.

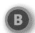 The Technical Aspects of Fine Art Photography

1 **Post-processing is a requirement in order to express the artist's vision** – The camera sees and records images differently than the human eye. Furthermore, the camera is a machine, not a thinking, feeling human being. Therefore, in order to express an emotional response to the scene or the subject through our photographs, we must step in, so to speak, and modify what the camera "saw" and recorded. We cannot pretend to create art by simply pressing the shutter-release button and letting hardware and software alone produce the final image and the print.

This "stepping in" means that we must apply post-processing to the photograph. The term post-processing is somewhat antiquated and can be misleading. A remnant of the film days, it refers to what was done to a photograph after the film had been developed—i.e., processed—in the lab. What was done back then was done optically and chemically, during the development of the film, the exposure of the photographic paper in the enlarger, and the processing of the exposed paper in the developer, fixer, and toner.

Today post-processing continues to be done even though there is no longer any processing involved. Instead, the RAW file is converted into an RGB photograph in the RAW converter, then it is optimized, enhanced, and adjusted in the computer using what has become the fundamental photographic processing software, Adobe Photoshop, or some other image editing software.

To those who are unfamiliar with fine art photography, Photoshop processes are often grouped under a single term: manipulation. This term is sometimes used in a derogatory fashion to indicate that an artist went beyond the boundaries of what should be done to a photograph. My purpose here is not to argue against the use of this term or its implications. I did so in other essays I wrote on this subject and at this point I consider the matter closed and unworthy of further attention. What I want to point out here is the absolute necessity of applying some amount of post-processing to every photograph in order for the image to express the artist's emotional response to the subject.

The reason for this is simple: there is no other way to express your emotional response to the scene or the subject that you photographed. If you leave the image as it came out of the camera, what you have is how the camera "saw" and recorded the scene. In order to add what you experienced emotionally to what the camera captured technically, you must post-process the image, meaning you must use image conversion and image processing tools to express your vision.

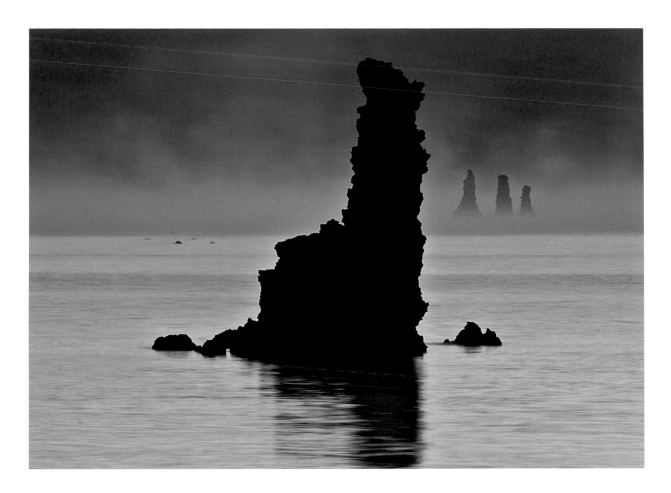

② **A fine art photograph demonstrates technical mastery** – In order to perform post-processing so that the result is a fine art image, the finest techniques must be used. Because fine art photography emphasizes quality rather than quantity, the emphasis on quality must be present not only in the post-processing of the image but also in all aspects of the creation of the piece. These include image capture, processing, printing, matting, framing, and all the other technical steps involved in the creation and completion of the work.

Because digital photography is changing constantly, and because new equipment and new techniques are introduced all the time, the artist must continually seek to refine his technical skills and keep up with new techniques and equipment through regular study and research.

③ **Technical mastery is placed at the service of artistic inspiration** – In fine art photography technique is not an end in itself, therefore the goal is not to develop technical mastery for its own sake. Mastering technique without mastering art results in the creation of technically perfect images in

Four Tufas at Dawn, Mono Lake, California – The tonality, contrast, color palette, and image format of this photograph were modified from what they were when it was recorded by the camera. The motivation for these modifications was to express what I saw and felt when I experienced this scene. As an artist I see what the camera captures as a point of departure, not as an end in itself. The image is complete only after I have modified what the camera captured so that it shows what I experienced.

which inspiration, vision, and personal style are lacking. Technical mastery results in making technically excellent photographs, but not necessarily artistic photographs. This is because art is not just about technique. Good art implies good technique, but using good technique alone does not result in the creation of art. To be considered art a photograph must be both technically excellent and artistically inspired and inspiring.

Of course, technical mastery has to be considered within the context of the artistic movement that a specific artist is working in. What that mastery entails will therefore vary. For example, with reportage-type images, blur or movement is often part of the work and not considered a flaw. On the other hand, with photographs that follow the tenets set forth by the f-64 art movement, sharpness throughout the entire scene is expected and any blurring is seen as a flaw. Each type of image, each art movement, calls for a specific technical approach. What is considered to be a mistake for one movement may be purely intentional for another movement. Therefore, the technical quality of a fine art photograph can only be assessed in the context of the technical tenets of the art movement that a given artist belongs to. The topic of art movements is addressed more thoroughly later in this chapter.

(4) **A fine art photograph is printed and signed by the artist** – The work must be printed by the artist, or by a master printer under close supervision of the artist. Machine prints done by high-volume labs offering low prices and quick turnaround times cannot be considered fine art.

A fine art print must be done on high quality paper and the paper must be chosen specifically for the type of print desired by the artist. The print needs to be mounted, matted, and framed to archival museum standards. As discussed previously, only the finest materials must be used.

The photograph may be numbered, though releasing photographs in a numbered edition is not a requirement for fine art categorization. However, if the artist numbers his prints he must demonstrate impeccable integrity and record-keeping in his practice of the numbering process.

Finally, the print needs to be signed by the artist. The presence of the artist's signature indicates that the artist personally inspected the print and approved it. It shows both provenance and pride on the artist's part.

(5) **The photographer retains the right to print the image differently over time** – Each new print from a specific photograph reflects the vision of the artist at a specific time in his or her life. As such, the same photograph may be interpreted and printed in different ways throughout the artist's career. As a result, prints of the same image made by the artist during different periods of his career may reflect different visions for the image and may therefore look quite different from one another.

6 **The print warrants an extended analysis, enjoyment, and display** – The final goal of the fine art photography process is the creation of a print, which is meant to be enjoyed for many years without the image losing its ability to hold the viewer's interest. A fine art photograph is a piece that can sustain extended attention and enjoyment.

A fine art print must "sing." This means that the print must have a lyrical quality, a quality that makes the image come to life and metaphorically sing, or speak, to the viewer. The print needs to transport the viewer to a different place: to open a window on the world that the artist is inviting the audience into. A fine art print must be capable of being a vehicle through which the viewer can access another level of understanding of the subject represented in the photograph.

7 **The print quality is complex and sophisticated** – Just like the composition of a fine art photograph, the print quality of the piece must be both complex and sophisticated, revealing levels of meaning over time.

8 **The original photograph is captured in RAW format*** – This insures that the maximum amount of data a specific camera is capable of producing is saved.

9 **A non-destructive workflow is used during image conversion and processing*** – To this end the RAW files are saved and the converted photograph is optimized in Photoshop using adjustment layers.

10 **A large color space is used*** – The image is converted and saved in a large color space, such as ProPhoto RGB. This color space is embedded and saved with the file.

11 **The master file is archived as a layered file*** – The master file from which the print was made is archived as a layered file in TIFF or Photoshop (PSD) format. This insures that the image can be reprinted later on with the same quality by adjusting the optimization if necessary and by reproofing the file to match new printers, inks and papers.

12 **The master files and all related files are migrated to new media periodically*** – This is done to prevent loss due to media failure as well as to increase access speed.

* Sections 8–12 above follow the guidelines recommended by the American Society of Media Photographers (ASMP) in the white paper titled *Digital Processing Best-flow Quick Reference*. This white paper outlines the ASMP-recommended "digital photography best practices and workflow." These guidelines and white paper are available at www.dpbestflow.org.

**Tilted Abandoned House,
Thompson Junction, Utah**

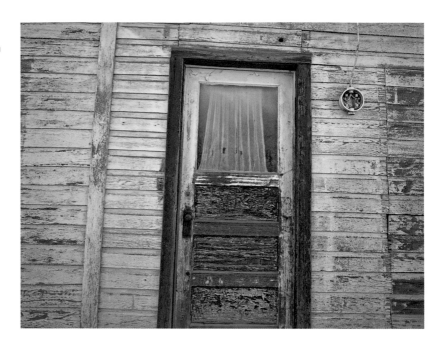

C The Marketing Aspects of Fine Art Photography

1 **Marketing considerations must come after the final image is completed** – The selling potential of an image should not be considered while the image is created. During each phase of the image creation the focus needs to be the expression of the artist's vision and his or her emotional response to the scene and the subject.

Inevitably, you will be asked if you considered the salability of specific images while you were creating them. And, if one of your images becomes a known bestseller, part of your audience will be convinced that you created a bestseller on purpose. Do not let that bother you. Keep in mind that not considering the selling potential of an image as you are creating it does not mean that this image will not be salable. Because the focus of fine art is upon the artist first and the work second, expressing your personality, vision, personal style, and emotions through your work is the best guarantee that your work will become financially successful.

In fact, focusing on marketing considerations alone can be detrimental to creating fine art photographs. This is because one of the main changes that a photographer needs to make in order to start creating fine art photographs is that of moving from selling images on the basis of the location or the subject featured, to selling photographs on the basis of the artist's name and personal style. Marketing considerations often involve focusing on specific locations or subjects because they are popular, but such an approach forfeits focusing

on one's personal style. Doing so causes the artist to move away from the creation of fine art and to focus on the creation of commercially oriented art.

Although creating fine art photographs without focusing on subjects that rank high in salability might mean that your work will take longer to generate a profitable income, the outcome of this approach is the development of a personal style free from the influence of commercial considerations. What this means is that your style is developed on the basis of your vision and your personality rather than on the basis of what the buying public likes. This approach is far more likely to result in the creation of fine art pieces that reflect a true personal style. In turn, this style will allow you to command higher prices for your work than you would have been able to if your work had been commercially oriented.

2 **Fine art marketing focuses on a quality-based marketing model** — Fine art marketing needs to follow a quality-based marketing model. In a quality-based marketing model, business income is realized through the sale of a small number of high-priced items. This model is in opposition to a quantity-based marketing model in which business income is realized through volume sales of low-priced items.

This quality-based model is difficult to implement if you do not have extensive marketing knowledge. This is because sales are based on leverage and reputation rather than on price. For this reason many photographers follow a quantity-based marketing model because it is easier to implement, requires fewer marketing efforts, and is accessible to beginning photographers who have not yet gained leverage.

3 **Fine art is not priced on a cost-of-goods basis** — Fine Art is not priced on the basis of what it costs to make it. If it were, a Picasso would cost only a couple hundred dollars because paint, canvas, and stretcher bars are relatively inexpensive. A Monet, painted decades earlier, would cost even less, because prices for these supplies rose over the years between Monet's and Picasso's times.

Each year, as you file your taxes, you have to calculate your "cost of goods" for the IRS. The cost of goods is what it costs you, in supplies and materials, to create a specific piece. Your time is not included because it is not a tangible good; neither is your reputation because leverage is also not a tangible good.

After calculating your cost of goods, you know exactly how much each piece cost you to create. The first time I did this I was surprised at how low this figure was. I was also surprised at how much I was selling my work for in comparison to my cost of goods.

What I did not know then was that my marketing approach was correct. I was not multiplying the cost of goods by two, or four, or even ten. I was not taking the cost of goods into consideration at all when pricing my work. Instead, I was pricing my work based on how much time it took me to create it.

Later, to this factor I added the leverage and reputation I had gained over the span of my career. In doing this no multiplying factor was applied.

(4) **A professional artist charges for his or her time** – Your time is valuable. No matter who we are, rich or poor, famous or unknown, we all have 24 hours in a day and not a minute more. Since you cannot make more time, you have to charge for your time when it is used to serve somebody else's needs.

So you need to figure out how much you want to charge for your time. To do this, set an hourly rate and apply this rate to the number of hours you spend working on specific projects.

(5) **An artist increases income by increasing prices, not by increasing output** – In the business of selling art, increasing your income is achieved by increasing your prices. As we saw earlier, you cannot increase your output without lowering quality or creating an "art factory." While creating a factory is certainly an option, and while a number of artists have done so successfully, it is not everyone's cup of tea (it certainly is not mine). So in order to increase your income without becoming a factory, you have to increase your prices.

Art Movements and Personal Styles

As I mentioned in the introduction to this chapter, artistic preferences are by nature personal. Different people will like or dislike different types of art, will prefer different artists, or will be attracted to different art movements.

Therefore, it is logical that not everyone agrees if a specific work of art is good or bad, or if it is art at all. Because art is such a personal endeavor, and because personal beliefs play such an important role in defining one's artistic approach, it is inevitable that not only critics but also artists themselves differ in their opinions regarding what art consists of.

This has been the case since the advent of art and this is what has brought about different art movements. An art movement is simply a group of artists who share similar beliefs regarding what they think art should be and who proceed to implement these beliefs in their art.

Throughout the history of art, movements have included cubism, impressionism, realism and modernism, among many others. Although all artists live in the same world and, arguably, experience the same reality, a cubist represents the world very differently than an impressionist. While the former represents the world as geometric shapes, the latter represents the world as the interplay of light and color.

Artists who belong to one movement rarely see eye to eye with artists who belong to a different movement. If they did, they would all belong to the same movement. In fact, arguments between artists belonging to different

art movements take place regularly, because these artists attempt to make their view of the world stand out as being more valid. As with most things in art, passion rather than reason drives these arguments.

As discussed above, personal style must be expressed visually in fine art photography. This is achieved through the use of various technical elements, such as composition, format, cropping, choices of palette(s), the use of curves and lines, etc. Taken individually, each of these elements represents a stepping-stone toward the definition of a personal style. Taken together, and provided that their use departs significantly from the approach followed by other groups of photographers, the combination of these elements can become the tenet for a new movement in fine art photography.

To complete this brief look at art movements it is important to point out the differences between an art movement and a personal style because the two can be easily confused. An art movement defines the specific direction, purpose, and vision followed by a group of artists. A personal style is the manner in which individual artists working *within* a specific art movement each create their personal work. In painting, personal style is often referred to as *facture*. A French term difficult to translate literally, *facture* refers to the "signature," metaphorically speaking, characteristic of a specific artist. By signature we refer to the way brushstrokes are laid out on the canvas, or the color palette favored by a specific artist, or the type of compositions, subject matter, choice of lighting—and a myriad of other details that characterize the work of this artist and that contribute to making it unique.

Many different personal styles can exist within the same artistic movement. In fact, when talking about accomplished artists who are members of the same movement, it is expected that each of them will have a different and unique personal style. Monet, Cezanne, and Degas were all members of the impressionist movement. However, each of them had a unique personal style. This means that a trained art enthusiast can easily identify a specific painting as being a Monet, a Cezanne, or a Degas by looking for the artistic elements that characterize their work. This is possible because while all three of them were working within the same movement, each developed a uniquely recognizable personal style.

In the paragraph above I used the term "trained art enthusiast." I could have said "viewer" instead. However, I wanted to be clear about what it takes to recognize the personal style of a specific artist. This is because it is easier for the beginning art enthusiast or "non-expert" to recognize an art movement than to recognize a personal style. For example, it is easier to recognize the differences between a cubist and an impressionist painting than it is to recognize the differences between the styles of Picasso and Braque, two artists who worked within the cubist movement. The same remark can be made about other artists who were members of the same movements.

It is worth noting that when an art enthusiast mentions that an artist has a specific style, they are often really talking about this artist being part

of a specific movement. What they recognize are the characteristics of the movement rather than the specific approach that an artist uses to implement the tenets of the movement.

Similarly, when a casual observer mentions that an artist does not have a personal style, they often mean to say that this artist has not "invented" a new artistic movement. This comment is often heard in fine art landscape photography because few movements have emerged in this field. As a result, most fine art landscape photographers work within the same movement. Because of this, their work is fairly similar in its approach and the differences between the styles of particular fine art landscape photographers are difficult for a casual observer to identify.

Volcanic Tablelands and White Mountains, Bishop, California

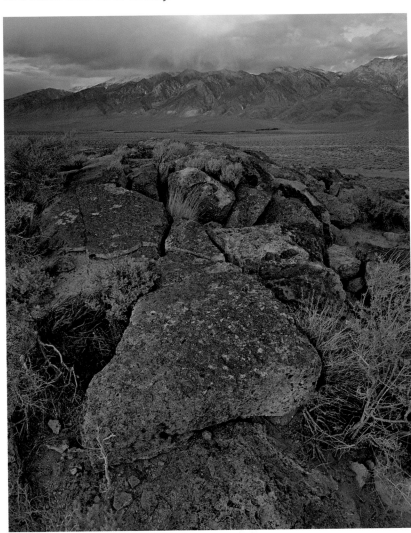

Handling Criticism

A fine art photographer must be able to handle criticism well. Just as not everyone agrees on what is art, not everyone will agree that your photography is art. In other words, you will have fans and you will also have critics. You will have aficionados sold on your work and you will encounter those who see no value in it.

There are two important things to remember about this: First, this situation is inevitable. Not everyone will like what you do. Even if you create fine art landscape photographs, like I do, you will have people upset about what you do. They may be upset about the colors you use, the saturation levels in your work, the removal of certain elements by cloning, the warping of the photograph, the cropping, or any number of things that you probably would never have guessed would upset anyone, much less motivate them to take it up with you personally.

Such is the nature of art. Art creates passionate reactions and if your work creates such reactions it is proof that it is art. Most of the time these reactions are positive. However, occasionally they are negative and one must be able to know how to handle them and how to react. The best reaction is to listen and let it be. Do not take issue with it. Instead, simply point out that art is a matter of personal opinion and that the world would be a boring place if we all agreed on what is beautiful and artistic. After this is said, move on. If your interlocutor persists, I suggest that you politely let them know that they really need to spend their energy looking for art that they like rather than waste their time and yours.

Second, you must remember that it will be those who are discontent, displeased, or upset by what you do who are the most verbal. I have found that those who love what I do are far less expressive and tend to enjoy the work quietly and peacefully instead of manifesting their enjoyment in a loud public display of admiration. This situation may be a reflection of our society. It may indicate that we are far less expressive when we are happy than when we are unhappy. I don't know for sure. All I know is that this is a reality.

What matters is that you keep this in mind when you are confronted by someone who vehemently expresses their discontent with your work. Remember that unless your work is highly controversial, this person is part of a very small, although verbal, minority. Also remember that you do not have to try and change this person's mind. Even if you tried you could not do it. Their mind is made up and they do not want to be bothered by the facts. In fact, they would love nothing else more than to capture your attention and force you to spend your valuable time trying to make them happy. Don't do it. Instead, spend your energy helping those who love your work love it even more! Focus on the positive, not the negative. Focus your energy on those who love your work, not on those who dislike it and find issues with it. Give your time to your fans, not to your detractors.

Counterintuition and Irony

There are some counterintuitive aspects in fine art photography. There is also some irony present when we compare what we do to what our goals actually are.

You may wonder why I am pointing this out in the context of a discussion about the nature of fine art photography. My motivation is simple: a large number of art enthusiasts, as well as a number of beginning photographers, are not familiar with this aspect of fine art photography. As such, they find it difficult to understand why we do what we do and why doing these things is important. As a result of this questioning, they fail to realize the importance of capitalizing upon the counterintuitive aspects of our art. They also fail to understand that this capitalizing is one of the essential aspects of fine art photography.

To clarify this aspect of our practice, and to help others understand it better, I've assembled the most common counterintuitive aspects of fine art photography into a short list. Again, to emphasize the dual aspect I place upon fine art photography, I divided this list into two parts: technical and artistic.

Technical:
- Smaller f-stop numbers give you greater depth of field
- We see with two eyes but our cameras only have one eye (we must therefore recreate the appearance of depth)
- Shade is more colorful than direct light
- Bad weather equals good photographs
- The best exposure rarely looks good without post-processing

Artistic:
- The light is more important than the subject (great subjects in bad light do not look good)
- We start to photograph sunrise before sunrise and finish photographing sunset after sunset
- We use a camera to take the photograph but we want to express ourselves
- Even though photography is highly technical, vision is more important than technique
- While it is the distant scenery that draws our attention, we need to pay close attention to the foreground if we include it in the photograph

I personally practice all of these things. Depending on where you are in your study of photography, you may already be doing some or all of these, or they may be new to you. Depending on your personal approach and style, you may agree or disagree with some or all of these things. This is perfectly fine.

What If You Cannot Do All of This?

Don't despair. I could not do what I describe in this chapter when I began making photographs. I simply did not have the income or the knowledge required to do so. Most importantly, I needed to generate income right away. I did not have the luxury of learning and saving money until I had it all figured out.

What you can do, and what I did, is get started doing the best that you can even though it may be less than the full fine art requirements. Just keep your eye on the prize. The prize in this case is being able to create and sell fine art photographs. Why? Because doing so will raise your self-esteem (because you will be creating world-class pieces) and will also raise your net worth (because you will be able to obtain higher prices for your work).

Terminology

It is important to note that fine art photography practitioners rarely refer to what they do as "fine art photography." They simply refer to it as "photography." This approach to terminology is typical of what I call "expert groups." Expert groups are groups of individuals brought together because of a specific interest and focus. These groups often refer to their particular use of the medium by the global name of the medium. I believe that this practice originates in the group's desire to present their specific use of the medium as the most important use, and to some extent, the only use to be considered seriously.

In this approach the global name of a medium is used to describe a specific use of this medium. The artist, who is essentially a specialist, sees himself as the one who defines what the medium is and what the medium can do. This may be due to art being used to push the envelope of the medium, to reveal new uses for the medium and to extend the boundaries of what can be done with the medium.

It is important to note that the use of this terminology is not limited to the artists themselves. It also extends to professionals working in the same field, such as gallery owners, critics, curators, etc., as well as to audience members who closely follow artists working in this medium, who go to openings and shows regularly, who read magazines focused on specific mediums and so on. The use of this terminology as well as of other terms commonly used in these relatively closed circles, permeates the language of all those who become part of these circles. Language becomes evidence that one is a member of these circles, that one is an insider or a participant at one level or another and not just an onlooker. Language and the use of the terms used in these circles are evidence that one belongs to these circles and is "in the know."

This is the case in photography when fine art photographers refer to their medium as being "photography," thereby ignoring the fact that photography has many other uses besides the creation of art. It is also the case in fine art

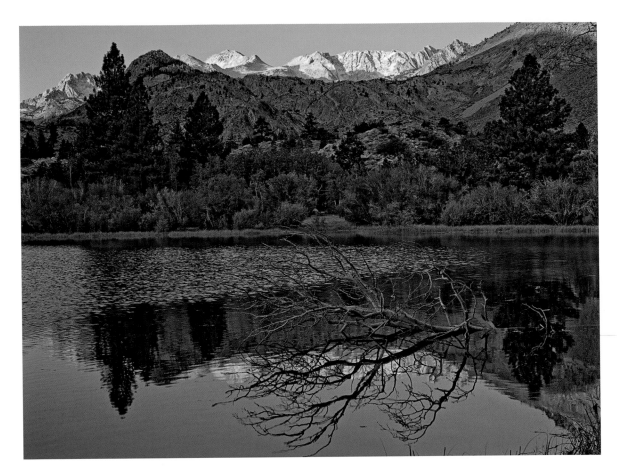

Sabrina Lake,
Eastern Sierra Nevada,
California

painting when painters refer to their medium as "painting," and ignore the many other uses of painting besides the creation of art.

Similarly, it is the case in sculpture, dance, music, cinema and any other mediums when these mediums are being used for the purpose of creating art and when other uses of these mediums are ignored even though they are just as important and legitimate. Without going into an explanation about why that is, it is worth pointing out that it may be due to an elitist approach in which art is perceived by practitioners as being above all other uses of a specific medium, making the artistic approach worthy of being named after the medium as a whole.

Conclusion

A fine art photograph expresses the artist's vision and emotional response to the scene and the subject photographed. In this quest to express vision and emotions, fine art photography is first about the artist, second about the subject, and last about the technique.

It is not the technical quality of a fine art photograph that needs to stand out. It is its artistic content and the vision behind it. Ideally, the artist's work should demonstrate mastery of both technique and vision. If the artist expresses his vision in a powerful manner and if the photograph is compelling enough, the audience is usually willing to excuse technical flaws. But if the photograph has no artistic content, technical flaws become impossible to ignore and the image is judged on technical aspects alone.

I recently visited Galen Rowell's gallery, *Mountain Light Photography*, in Bishop, California. What I found stunning during my visit was how grainy and relatively unsharp many of his photographs were. They did get better as films improved over the years, the most recent images being the sharpest and least grainy, but they were all pretty "rough." Yet, the power of the images was intact, this power being rooted in the artistic vision of the photographer rather than in the technical quality of the images.

The message expressed in the photographs, which to me is about experiencing the beauty and awesome power of nature through a physical relationship with the landscape, was in tune with the technique used to create these images. These are images created with 35mm cameras, most of the time handheld and often during extreme hiking or climbing conditions. It is therefore expected that the technical quality of these images could not be fully controlled and that sacrifices and compromises had to be made.

For Rowell, capturing the scene and the subject was more important than achieving impeccable technique. When looking at his work, one does not expect the resolution, clarity, and impeccable facture that a large format camera mounted on a sturdy tripod and loaded with high resolution and low speed film would deliver. Instead, one expects to see images of locations and events that are beautiful and uncommon. They are rarely photographed in ideal conditions because of the difficulty of doing so. In the end, what stays with the viewer is the experience of sharing the photographer's vision and adventures through his work. The technical aspects of the work, while being noticeable, do not hinder this experience in any way.

Skill Enhancement Exercise

Examine your approach to fine art photography by doing the following:
- Make a list of the items in this chapter that are already part of your approach to creating fine art photography. Do this for all three areas: artistic, technical, and marketing.
- With this list completed, find out which items are missing and add them to your list.
- Finally, include these new items in your work.

A market is never saturated with a good product,
but it is very quickly saturated with a bad one.
 HENRY FORD

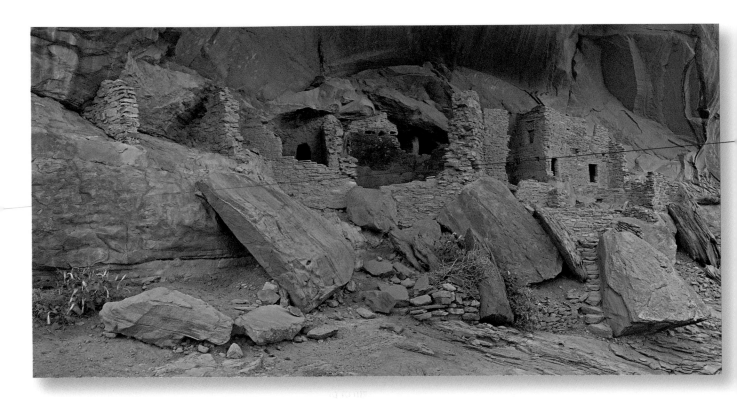

Chapter 3
Wholesale, Consignment, or Retail?

To sell or not to sell, that is the question. Although the implications may not be as far-reaching as those faced by Hamlet, they still have the potential of keeping you awake at night.

Making the decision to sell your work is difficult. However, once you have decided that you want to sell your work, you need to decide *how* you want to sell it. In other words, you have to decide which type of business model you are going to use and who you are going to sell your work to.

In this chapter I will describe the various ways you can sell your work and the marketing approaches or business models that are available to you.

There are basically three business models offered to you. You can sell your work wholesale, on consignment, or retail. We will look at these three options and see how they differ from each other. In Chapter 6: *Where to Sell Fine Art Photography,* we will continue this study by looking at specific wholesale, consignment, and retail venues.

Selling Wholesale

When selling wholesale you sell your products to retail stores and they take care of displaying it and selling it to customers. Traditionally the wholesale price is 50% of the retail price, which means that for any given product you are paid half of what the store will sell the item for. Thus, your margin of profit on each item is smaller than when selling at retail prices. However, if you manage to get wholesale accounts in large stores, these stores should be able to sell far more than you would on your own. If this happens, then you will make up for the lower per-item profit through the volume of items sold.

The main advantage of wholesale is that you do not have to wait for customers to purchase your work piece by piece. Instead, you make the product and then sell this product in volume to stores. Your job ends, so to speak, when the stores purchase your work. After that you can devote the rest of your time to other activities.

Wholesale sales are not subject to sales tax, so you do not have to worry about collecting and reporting sales tax. This also saves you time.

Small, moderately priced items work best for wholesale. Traditionally, notecards, postcards, posters, calendars, and 8×10 matted photographs (and larger) have been the items of choice in the photography wholesale business.

One drawback of wholesale is that you may have to provide stores with displays to present your work. While some stores have their own displays, others expect you to provide them with displays, often for free. This is an added expense and takes time and effort, but with certain stores there is no way around it. If you do not provide displays to the stores they will either not purchase your work or they will purchase it and not display it properly. Because the quality and type of display used is very important, not having the proper display will significantly reduce your sales.

Gift stores and bookstores are typical wholesale outlets. It is difficult to sell fine art in a wholesale location because people expect to purchase fine art in galleries or directly from the artist. As we will see in the next chapter, this issue is related to selling quantity rather than quality.

Selling on Consignment

If you want to sell expensive pieces, wholesale is not the way to go. Instead, you need to consider selling your work through galleries or directly on your own.

Most art galleries operate by selling works on consignment: the gallery will display and sell your work but will not pay you until your work sells. There is good news and bad news regarding the consignment approach. The good news is that since the gallery does not have to buy your work they will usually agree to carry and display larger and more expensive pieces. The bad news is that if your work does not sell, you do not get any money. Finally, as with wholesale outlets, galleries take care of collecting and reporting sales tax.

Selling Retail

Selling retail means selling your work yourself directly to customers. The most popular retail locations for selling fine art are fine art shows at which you are personally present. Another retail venue for fine art can be your own gallery or store.

Selling retail involves having direct contact with the public and spending long hours at a show or other retail location. It also involves a lot of hard work setting up your show, your store, or your gallery.

I personally enjoy this approach but I realize that this is not for everyone. First, it is difficult to have a second job when you sell retail because you must be at your retail location for long periods of time. Second, you have to enjoy working with the public and answering many questions. Third, you have to handle the sales tax: charging sales tax when customers make a purchase, keeping track of how much tax you collect, reporting it, and paying it back to your state. Fourth, you need to carry a relatively large inventory consisting

of both framed and unframed photographs in a variety of sizes from 8×10 to 20×30 or larger.

I highly recommend selling your work retail at art shows, even if you decide not to do this "forever" or full time. I believe it is one of the very best ways to learn how to sell your work. The contact with the public will allow you not only to practice your salemanship skills, it will also allow you to find out which of your pieces people prefer and which ones do not sell well. Finally, while selling retail is a lot of work, you do keep 100 % of the income you make, which means you only need to sell half the pieces you would need to sell wholesale or through a gallery to earn the same amount of income.

White Rose – Roses have a universal appeal. They work well as home décor and they can be sold in a wide variety of locations, even locations where roses do not grow. For these reasons flowers are an excellent subject for store sales in a wholesale situation.

Retail and Wholesale Comparisons

In the following few pages, I will address the merits and drawbacks of selling your work wholesale versus retail.

Wholesale of Volume Products *(Quantity-Based Business Model)*

Profit per piece is low. Wholesale profit is generated through selling a high volume of low-priced items.

You need to produce a large quantity of pieces. You must produce a high number of similar pieces to make wholesale profitable.

Stores expect a low per-item price and the only way to do this is by producing a large quantity of items at once.

Recouping your initial investment is slow. Because you must produce a large quantity of the same items in order to get a low cost per item, you must invest a significant amount of money initially. Since the profit per item is low, you must wait until a large number of items have been sold to recoup your investment.

Let's say that you invested $2,000 to produce 2,000 posters. This means that each poster costs you $1. Stores sell these posters for $6 after purchasing them from you for $3 (wholesale is normally half of retail). Therefore, to recoup your investment, you must sell 677 posters to the stores (677 × $3 = $2,000).

This means that your profit per poster is $2 ($3 wholesale price minus $1 cost). The maximum profit you can expect if you sell all 2,000 posters wholesale is $4,000 (2,000 × $3 = $6,000 minus your $2,000 initial investment = $4,000).

The outcome of this business approach, in this example, is a profit of $4,000 after 2,000 posters have been sold to 2,000 in-store customers.

Production and fulfillment are a challenge. Producing and fulfilling wholesale orders is a significant challenge for a small or single-person business since this is how most artists get started. This is particularly true when a wholesale business becomes successful. Because wholesale is a volume-based business, success means a large number of sales. As a wholesale business becomes more successful, the volume of sales increases. Artists who expect only a few sales here and there often see this as success. However, success is having a profitable business, not just a business that sells large quantities of products. While profitability can be attained by selling large quantities of inexpensive products, profitability can also be attained by selling small quantities of expensive products, as we will see in Chapter 4: *Quantity or Quality*.

Selling wholesale requires a large commitment of space and time. The necessity to produce and stock a large quantity of items means that a significant amount of space must be devoted to storage. These products represent your investment and must be stored carefully and kept in perfect condition.

The necessity to fulfill large numbers of orders means that a significant amount of your time must be spent filling, delivering, or shipping orders— time that cannot be spent creating new products or doing other things.

You risk damaging your health. Volume-based businesses create stress, both mentally and physically. In turn, this stress creates a significant risk to your health. Not only do you run the risk of being physically exhausted during "crunch-time" (which can become a constant time if you are successful), you also run the risk of neglecting your mental and physical health due to the constant necessity of taking care of business, orders, fulfillment, re-supplying, stocking, etc.

You may be faced with customer problems. Customer problems related to sales can be expected to be a percentage of your total number of sales. While this could be a very small percentage, the higher the number of sales you make, the higher the number of problems you will have.

Solving problems takes time away from running your business efficiently. Plus, it can cost you money if you have to replace orders that were improperly packed and became damaged in shipping, or orders that were improperly filled and have to be returned, re-filled, and shipped again. For this reason, most wholesale and volume-based businesses lose a significant amount of money solving problems generated by their volume of sales.

You will need to hire employees. Hiring employees can quickly become a requirement when running a wholesale business. This is because wholesale requires so much of your time that you simply cannot do it by yourself and you must hire others to help you. If your business does well, these employees will be working for you on a permanent basis. This means that you will be required to manage them, which means you will have another job on your hands, unless you hire a manager to manage your employees.

Of course you will need to pay your employees, which in turn means less profit in your pocket. Since profits are already low in wholesale, this means having to sell more products to pay your employees' salaries. You may find yourself on the path of diminishing return—a path where the more you sell, the more your expenses go up without seeing an increase in profit.

You will need to increase your volume of sales to increase your income. Increasing your income in a wholesale and volume-based business is achieved by increasing the volume of sales. You need to sell more products to make more money.

PART 1 SELLING FINE ART PHOTOGRAPHY
CHAPTER 3 WHOLESALE, CONSIGNMENT, OR RETAIL?

40

You cannot make more money by increasing your prices because your prices are controlled directly by your competition. There is little or no leverage in a wholesale business approach. All postcards, regardless of who makes them, are sold for the same price. Certainly, large postcards sell for more than small postcards, but all postcards of the same size sell for the same price. The same pretty much applies to all other wholesale products. Price is a very sensitive aspect of any wholesale product since the consumer makes the decision of whether or not to buy based primarily on price.

Wholesale items represent a low investment value for buyers. Buyers of wholesale products do not perceive their purchase as being an investment that might increase in value over time. Therefore, increasing your prices does not help sales because it does not reflect an increase in the value of the product. All that you will see by increasing your wholesale prices beyond a standard inflation markup is a reduction in your volume of sales. Fewer people will buy, because your product will be less attractive price-wise.

In fact, if you increase your prices too much your product may no longer be competitive with other similar products offered by your competitors. Your customers will see your price increase as negative and will almost always turn to your competitors' products instead of buying yours. If the only difference between your product and your competitor's product is price, customers will purchase the lower-priced product. Raising your prices beyond inflation adjustments will result in pricing yourself out of the market. You will lose previous customers while new potential customers will fail to understand why your product is more expensive.

You will have a lot of competition. In quantity sales, you are competing on the basis of price. For this reason, obtaining the lowest production cost is crucial because this will allow you to offer a lower retail or wholesale price. The problem is that getting a lower price usually means producing or ordering a large quantity of items at once. In turn, this means carrying a large inventory and tying up your investment until it is sold out.

Because wholesale competition is mainly based on price, the lowest price wins, which means that companies able to produce and offer the lowest priced product are at the top of the pyramid. Competition is fierce in this marketing model and profits are often small because you must cut your profit margin in order to lower your prices.

You will need to maintain a large inventory. A large inventory is a fact of life because the only way to lower your cost per item is to produce a large quantity of similar pieces at once.

You risk your self-esteem. Selling wholesale often means selling work that is not fully, or not at all, of fine art quality. Often it means selling what amounts

to souvenirs in the mind of the customers. This fact can cause you to lower your self-esteem. It may also cause you to not think of yourself as an artist. Those are considerations worth pondering if you only sell your work through wholesale outlets.

What happens if your wholesale business fails? Failure in wholesale is costly. Wholesale retail prices are low but wholesale production costs are high. If you fail, if your work does not sell, you are left with an unsold inventory consisting of thousands of pieces that you will have to store (at an additional cost if you have to pay for storage) or discard, a significant loss. Plus, you may not have made a profit yet. In fact you may not have even recouped the cost of production.

Eiffel Tower – Iconic images, such as this photograph of the Eiffel Tower in Paris, will always sell, regardless of audience or location. This is because these locations are world famous and their appeal is universal.

Retail Sales of Fine Art Products *(Quality-Based Business Model)*

Profit per piece is high. Fine art profit is generated through low-volume sales of high-priced items. When the number of sales is lowered, the costs of production are lowered as well because fewer supplies are necessary to generate the same level of income. This means that both the profit per piece and the profitability of the business are higher.

You only need to produce a small number of pieces. Your customers expect fine art to be limited in availability. Therefore, you only need to produce a small number of pieces to make fine art retail sales profitable. You also need to produce a quality product and the only way to do this by yourself is to limit how many pieces you create.

Recouping your initial investment is quick. Because you only need to produce a small number of fine art pieces, often only one of each image, and because the costs of production are low, your initial investment is low. Since the profit per item is high, you can generate a profit after selling only a few pieces, or even after selling only a single piece.

For example, let's say that you invested $500 in supplies to produce twenty 16×20 matted pieces at a cost of $20 each. If you price these 16×20 pieces at $250 each, which is a good starting price for 16×20 fine art matted photographs, you will recoup your total investment after only two sales. If you sell all twenty 16×20s at $250 each you will make a $4,500 profit ($5,000 in sales minus $500 in supplies).

If you price your 16×20s above $250, say $500 each—which is a reasonable price for an artist who is starting to gain leverage—you will recoup your investment after a single sale. If you sell all twenty 16×20s at $500 each you will make a $9,500 profit ($10,000 in sales minus $500 in supplies).

Production and fulfillment are not a challenge. Producing fine art products and fulfilling orders is not a challenge for the fine art photographer selling retail because most of your sales are products that are immediately available and that customers can take with them. If you have to ship items, because they are too large to be carried by the customer or because you are out of stock, the smaller quantity of sales means that little time needs to be spent on packing and shipping orders.

Because fine art is a quality-based business, your customers expect to pay more to receive a fine quality product. If your sales increase beyond a volume level that you can handle comfortably, all you need to do to reduce the volume of sales is increase your prices. This approach is based on the fact that in any business the volume of sales is controlled by the price. Low prices = high volume while high prices = low volume.

Because fine art customers value quality over price, moderately increasing your prices on a periodic basis will not affect your overall income. It will certainly reduce your volume of sales slightly (which is the goal) but since you will be making more money per sale after raising your prices, your income will either remain the same or it will increase.

A low number of sales is often seen as a failure by artists who expect to make many sales and who associate success with having many people buy their work. However, as stated above, success in business means having a profitable business, not having a business that sells large quantities of products. In fact, for a one-person business, profitability is more easily achieved by selling a small number of products at high prices than by selling a large number of products at low prices. This is because finding customers is one of the key challenges for a small business. It is easier to find a few customers than to find hundreds or thousands of customers. When your income is based on a small number of sales, it is logical to offer higher priced items of high quality. If you do not, you will not make enough money to stay in business.

Success in business means having a profitable business, not having a business that sells large quantities of products.

Selling retail frees up space and time. Since you do not need to store a large quantity of products, you can use available space to create art rather than to store products. And, since you do not need to spend large amounts of time filling orders, you can use your time to create new works instead of printing, packing, and shipping.

There are fewer risks to your health. A quality-based business does not create a lot of stress, either mentally or physically. You enjoy free time; time for your hobbies, and time for your friends and family. You are able to relax and think about other things besides your business.

This means that you have time to give both your body and your mind a rest. In turn, this saves you from becoming physically exhausted. "Crunch-time" becomes limited to specific times of the year, if it happens at all. It is certainly not constant. Because you enjoy some free time, you can take care of your body and your mind, free of the constant necessity of taking care of business, orders, fulfillment, re-supplying, stocking, etc., that volume-based businesses are plagued with.

You can expect few customer problems. As we saw before, customer problems are inevitable with a small percentage of your total number of sales. Since a fine art business only needs a small number of sales, you can expect a very small number of problems. Your time can be spent doing productive things instead of constantly having to fix customer problems. This creates not only a more profitable business, but also a more enjoyable one—a business that allows you to keep your sanity, have some free time, and engage in hobbies and activities unrelated to your business.

You do not need to hire employees. Hiring employees is rarely a requirement when running a fine art business because creating fine art and fulfilling fine art orders do not require much of your time.

You may only need to hire employees during the busiest times of the year, such as during an important show, or during the holiday season. At these times it is often easier to have a family member, spouse, or friend help you rather than hire someone from outside your personal circle. At any rate, this is a temporary situation and you will rarely need full-time employees, which means that you do not have to manage employees or hire a manager. All this frees up time to do other things.

Finally, you do not have to use part of your profits to pay employee salaries, therefore more profits stay in *your* pocket instead of going into someone else's. When you combine this with a low overhead, low costs of production, and a high profit margin, it means that your business has the potential of operating at a peak profitability level.

You can increase your income without increasing your volume of sales. Increasing your income in a fine art, quality-based business is achieved by increasing your prices. You do not need to sell more products to make more money; all you need to do is raise the prices of your current products.

Doing so is possible because a quality fine art product is not primarily sold based on price. Instead, it is sold on the basis of the artist and prices are determined by that artist's leverage. Price is not a very sensitive aspect of a fine art purchase because customers make their decision based on quality and provenance first and on price second. As your work gains higher levels of recognition and starts to attract a larger number of potential buyers, your prices can go up accordingly. This is because artists are not expected to produce more work when they become more famous. Rather, they are expected to increase their prices proportionally to their level of notoriety and leverage.

Artists have a high level of flexibility when pricing their work. As a result, the same size and style of painting by two different artists, one well known and the other just starting out, can sell for very different prices. They will definitely not both sell for the same price (unlike postcards) because fine art pricing is artist-based instead of product-based.

Fine art pricing is artist-based instead of product-based.

As prices increase the volume of sales decreases. Often artists see a decrease in the number of sales as being negative, but looking at it that way is a mistake because what is important is the *profitability* of the business, not the number of sales. At the end of the year, the most important number is not the number of sales made but the amount of profit generated by the business.

Direct sales by the artist represent a solid investment value for collectors. Buyers of fine art see their purchase in part as an investment, and they expect their investment to increase in value over time. Your regular increases

in price, aimed at reducing the volume of sales, also has the positive effect of increasing the value of the fine art pieces your customers purchased in the past. In other words, the value on the investment made by previous customers goes up each time you raise your prices.

While some previous buyers may see your price increases as negative because your prices exceed their buying capabilities and they are no longer able to buy your work, others see it as positive because their previous investment just went up in value. For new and potential customers, your regular price increases means that your work represents an investment that regularly goes up in value and that can be expected to continue going up in the future.

If you develop a unique personal style, you will not have much competition. In fine art, you are competing on the basis of your artistic vision, notoriety, and personal leverage. Your competition is yourself, in the sense that your personal style, your vision, and the uniqueness and quality of your work are what set you apart from your competition.

Your desire and ability to create the finest quality work at any cost, to express your vision, and to communicate effectively with your audience, gives you an edge over your competition. This is because fine art customers purchase the artist first and the artwork second. Therefore it is paramount that you carefully position yourself in the art world, in terms of your approach, your style, your credentials, your achievements, and so on. Centering your marketing on yourself by explaining your approach and your vision to your audience through a carefully crafted artist statement, gives you a definitive advantage over artists who expect their audience to purchase their work blind.

Your personal style, your vision, and the uniqueness and quality of your work are what set you apart from your competition.

You only need to maintain a small inventory size. Because you only need to sell a relatively low volume of work, and because you produce the product yourself, there is no need to maintain a large inventory. Unlike wholesale, you don't have to create a large number of pieces at once to lower the cost-per-piece. Your cost is the same whether you produce one piece or many. You are in control of how much work you produce. If you produce your work carefully, you are also unlikely to get stuck with a large number of unpopular photographs.

Your self-esteem is enhanced. Selling a high-quality, high-priced product that expresses your vision and your personality generates a high level of self-esteem. Your product looks good, expresses something meaningful, is worth a significant amount of money, and reflects well upon you. Successful artists usually have a high level of self-esteem. In return, having a high level of self-esteem definitely generates customer confidence in your product and helps you sell your work.

What happens if your fine art business fails? Failure in fine art is not costly. Retail prices are high but fine art production costs are relatively low even though high-quality supplies are used. This is because you only need to make a few pieces, often as little as one piece of each image. Since you calculate your costs based on the cost of goods, a 16×20 mat size often costs less than $20 to produce, depending on where and how you purchase your supplies. (Buying supplies in quantity lowers your costs significantly, for example.)

Although your selling prices are high, if you fail and have to quit doing business, you will have a small number of unsold items left and little money tied up in inventory. Plus, you can give unsold items as gifts or display them on your walls.

Skill Enhancement Exercises

Exercise 1: Volume or quality? Based on the information provided in this chapter, decide whether you want to create a volume-based or a quality-based business. Support your decision by listing the reasons that make the most sense to you.

Exercise 2: Reflect on the contents of this chapter. Take some time to write down your initial reactions to the contents of this chapter. Write about what you do and do not agree with. Write about what you think you should do in your own business, based upon your personal situation.

Which of the many points you have just read make the most sense to you? Which ones did you know before reading this book and which ones are new to you? Which ones jump out at you because they appear to be the most important at this time?

Excellence is not a skill.
It is an attitude.
 RALPH MARSTON

Chapter 4
Quantity or Quality

There are two main directions you can focus on when setting up your business, and you need to choose one or the other. You can create either a quantity-focused business or a quality-focused business.

I can hear your questions already. Can't I do both? Can't I focus on both quality and quantity? Can't I create a quality product in large quantities? Well, if we think in abstract terms, this certainly is conceivable. However, when we think in realistic terms, in the context of a small business, the answer is no. You see, most photography businesses are family businesses owned and operated by members of a single family. These businesses are often one-person corporations; that is, they have only one "employee" who is the boss and the owner of the business. Furthermore, this person is almost always the photographer. When there is more than one person, the business usually consists of a husband-and-wife team. Finally, when there are more than two employees (which is rare), these other employees are usually other family members.

What this means is that you have to do everything required to run a business by yourself. You must be the artist, the business owner, the account-ant, the receptionist, the person who orders supplies, the one who answers customer calls, etc. And of course, you must both make the product and sell the product, plus you have to market the product, which actually means three different jobs:

1. You make the product (take the photographs, print them, mat them, frame them, package them, and price them).
2. You market the product (find customers who are interested in purchasing what you make and willing to pay the price you are asking).
3. You sell the product (be physically present to sell your work in a store or at shows).

That is a lot of work! In fact, it is more work than most business owners ever have to do because most other businesses have more employees than photography businesses have. In this situation, to think that you can do qual-ity work in large quantity is simply not realistic.

Quantity or Quality

As I said at the beginning of this chapter, you need to decide whether you want to do quantity or quality. Quantity means selling a lot of pieces for a relatively low price per piece. Another way to think of quantity marketing is to think of selling a commodity. Home décor stores, for example, sell art as a commodity.

Quality means selling few pieces for a high price. Another way to think of quality marketing is to think of it as selling something that is the expression of the artist. Galleries sell art as the expression of individual artists.

So let's go back to our question: can't I do both quality and quantity? I wish I could create countless pieces at the finest quality level. Unfortunately, this does not work. For quantity marketing to work, the price must be low. This means that the time one can devote to each piece must be minimized (time is money). As time is minimized, the attention to detail and the level of craftsmanship are also minimized. The cost of the materials must be minimized as well, which in practice means that lower quality materials are used (quality materials are expensive).

The reduction in the time available to create each piece, together with the reduction in the quality of the materials used, results in a significant drop in quality. High quality materials and high quality workmanship do not come cheap. You can, of course, sell high quality workmanship and high quality materials for a low price, meaning with a minor markup. However, if you do that you will not be in business for long.

My approach to marketing art is to focus solely on quality. I have tried a quantity approach and it nearly killed me. I made a lot of money doing quantity, but I make more money today doing quality. Plus, I am in better health. Maintaining a high-quantity production rate over many years is very hard on you physically. Eventually, you become unable to do it all by yourself. At that time you have to hire employees to do part of the work (and say goodbye to work made entirely by yourself). You also need to buy or rent a large work facility, such as a warehouse, which further adds to your business expenses.

Finally, and most importantly, it makes me feel a lot better to be selling work of the highest quality I can possibly create. Doing so fosters my creativity and my artistic abilities because I do not have to be constantly printing, matting, and framing. I am also faithful to my belief that the value of art lies in its quality and limited availability. High quality work is by nature limited in its availability because it is difficult to create for the aforementioned reasons. For me there is no such thing as high quantity art. It is either art or it is produced in quantity, but not both. *Quantity art* is an oxymoron. This is a deeply entrenched belief among art collectors.

Look carefully not just at the price other artists sell their work for but also at the quality of their work. Look not only at the print quality, look also at the

Quantity art is an oxymoron. The value of art lies in its quality and limited availability.

matting, the framing, the materials used, the warranties they offer (if any), the equipment they own, and so on. What you will see is that high quality work features quality materials and comes with strong warranties. Therefore, it is not surprising that quality work sells for much higher prices than quantity work. As with most things, you get what you pay for.

Paris Street Scene – There is a market for early work from a specific artist or for work that departs strongly from the type of images an artist is known for. This is a street scene taken in Paris long before I started to create the land-scapes I am known for today. I occasionally make these prints available to collectors because even though they strongly differ from what I do now, they are of interest to those who want to add diversity to their collection of my work. I am from Paris so my audience finds it logical that I have photographed my hometown and that I offer these photographs for sale. Paris is one of the most beautiful cities in the world and photographs from the *City of Lights* are in high demand for home and office décor.

A Comparison of Quantity-Based and Quality-Based Marketing

Quantity-based marketing (QTBM)

Quantity-based marketing (QTBM) is characterized by selling a large number of products for a relatively low price per product. This model favors wide distribution and affordability. In many ways, it is the number one marketing approach in Western culture, both in being embraced by the majority of marketers and in being popular with the majority of customers.

This marketing model addresses an audience that has moderate to low buying power. This audience desires to own products that are affordable even

if that means owning the same things that are owned by many other people. This model does not foster exclusivity and uniqueness. Instead, it favors wide availability and commonality.

The wide range of products available in this marketing category, together with the constant improvements made to the products and the many different versions available for any particular product, means that it is easy to find products at a price point that meets the audience's needs. Cost is the primary concern for customers who favor this marketing model. The fact that friends, family, and acquaintances may own the same or a similar product is a secondary concern, if it is a concern at all.

Quantity–based production and marketing are omnipresent today. This is the means by which most of what we consume and use is produced. Our food, our cars, our furniture, our clothing—in fact nearly all the goods we use on a daily basis are produced and sold according to a quantity-based manufacturing and marketing model.

Quantity production is required for many products because of the ever-increasing size of the world population. This model allows for the production of large quantities of goods at an affordable price. It allows us to continue growing in population size without increasing the cost of living beyond inflation levels. Sociologically, this is certainly a good thing. No one complains that the food and products we consume on a daily basis are provided to us at an affordable price. However, there are problems when this model is applied to the production and marketing of fine art.

First, a quantity production model requires more than one person to set up and operate. In fact, it requires many people to work. If you look at businesses that operate according to a quantity-based model, you will see that they employ a sizable number of people. Even small businesses, such as photography businesses, generally have at least four people working full-time. If you have fewer employees than that, a quantity-based model is not for you.

Because many photographers work alone, or have a single helper (often their spouse or other family member), implementing a quantity-based marketing model means that their time is now fully devoted to production. As a result, there is no time left for the creation of new products, for the marketing of these products, or for other business tasks. This also means that there is no time available for family life, leisure, hobbies and other non-business related activities. As a result the quality of life is significantly decreased for these individuals.

Second, a quantity production model requires you not only to produce a large number of similar products, but also to inventory, pack, ship, track, invoice, and provide customer service for this large quantity of products. The amount of work that you have to do in the areas I just mentioned is multiplied by your volume of sales.

Third, a quantity-based model relies on low selling prices as its number one attraction, which means that the cost of production becomes the primary

concern. Low production costs are a must in order to keep the selling price low.

Fourth, a quantity production model requires you to constantly look for new customers. Since customers are buying your product primarily on the basis of price, they will constantly be shopping around for products similar to yours offered at a lower price. This means that the minute your customers find a similar product from one of your competitors at a lower price, they will stop buying from you and start buying from your competition. There is little or no customer loyalty in a quantity-based production model.

Fifth, it is difficult to create uniqueness in a production-based model. This is because the most effective way to create uniqueness is by limiting quantity, and limiting quantity is exactly what a production-based model is designed to avoid.

Quality-based marketing (QLBM)

Quality-based marketing (QLBM) is characterized by selling small numbers of products for a high cost per product. These products are available to a small number of people at a relatively high cost.

This model favors exclusivity and uniqueness. It is a relatively little-used model in contemporary Western culture, because it is embraced by relatively few marketers and because it is unpopular with the majority of customers.

However, this model addresses an audience that has a strong buying power. This audience desires owning products that are exclusive, unique, and hard to find, even if that means paying a premium to own these products. This audience does not want to see other consumers use or own the same products. The small number of products available, the high level of customization available for each product, and the high cost of these products mean that the chance of meeting someone who owns the same exact product is virtually nil.

Product exclusivity and uniqueness are the primary concerns in this marketing model. Cost is a secondary concern, if it is a concern at all.

Skill Enhancement Exercise

Quantity or quality? Which of these two approaches did you decide to follow?
- If you chose quantity, explain why this approach will fit in with your current lifestyle and with your goals for your work, your income, and the audience you want to reach.
- If you chose quality, explain why this approach will fit in with your current lifestyle and with your goals for your work, your income, and the audience you want to reach.

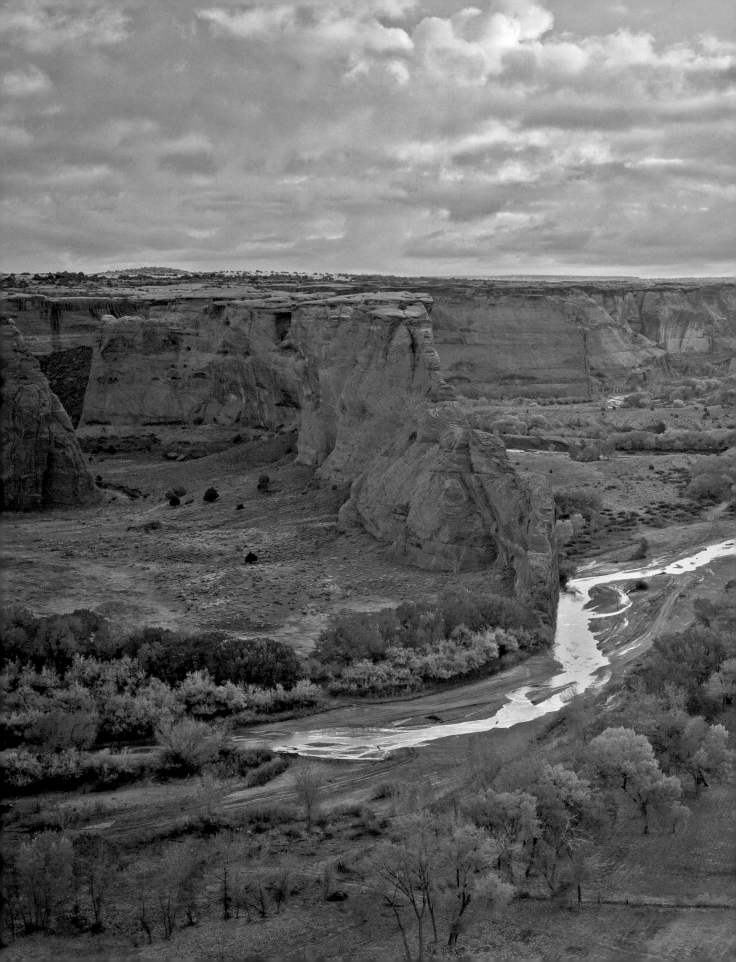

**PART 2
WHAT TO SELL
AND
WHERE TO SELL IT**

What really decides consumers to buy or not to buy
is the content of your advertising, not its form.
 DAVID OGILVY

Chapter 5
What to Sell

Now that you have made the decision to sell your work and have chosen a marketing model, the next big step is deciding *what* to sell. When asked what they are going to sell, most photographers say, "Prints!" Well, certainly, since we are photographers we are going to sell photographic prints. However, there is a problem with thinking that you can sell a print "hot off the printer" or straight out of the darkroom. The problem is that while you will certainly have a photograph on paper, you do not have a product.

The Difference Between Prints and Products

An unmatted, unmounted, loose print is not a product. It is a print, period. It cannot be sold as such, especially when your focus is selling quality products. Before you can sell this print you need to mat it, mount it, package it, and price it. The way in which you mat, mount, and package your print defines what type of product you have. The pricing you decide to sell this product for defines whom your audience will be, meaning who will be able to afford your work.

Most photographic prints are mounted and matted in a white mat using archival materials. Mounting is done either with mounting corners that hold the print loosely to the backing board, or by permanently adhering the print to the backing board with hot or cold adhesive. The mat is hinged to the backing board and placed over the print, either covering a very small area of the print all around, or revealing ¼" of printing paper around the print. The mat is signed in the lower right-hand corner, in pencil below the image so that if the print is re-matted your signature is still present on the print. The print is also signed.

Transparent bags are the simplest form of packaging. The most widely used are those sold by ClearBags.com. They come in just about every size imaginable and offer a clean and professional presentation.

Product Variety

Matted prints are not the only product you can offer, by far. As an artist in business it is important that you expand your product line beyond prints. Therefore, in this chapter I will present the following types of products:

- Matted Prints
- Framed Prints with Glass
- Framed Prints without Glass
- Portfolios
- Folios
- Self-Published Books
- DVDs Showcasing Your Work
- Music CDs
- Calendars
- Posters
- Screen Savers
- Postcards

For each product I will give a description of the product, some examples, and a recommendation level. This recommendation level is either based on my personal experience or having seen this product sold by artists that I know personally. These recommendations are made in the context of selling quality products, not quantity products. Quality is the approach that is behind all my marketing efforts. It is also the approach that I consider the most successful when selling fine art.

Matted Prints

Characteristics: The photographs are matted and mounted. The most popular mat color is white or off-white; however, colored mats may also be used— beige, black, or any color of your choice. Single or double matting can be used. Single matting means that a single sheet of matboard is used over the print; double matting means that two sheets of matboard are used.

The matboard can be 4-ply or 8-ply. The ply number refers to the thickness of the matboard. 4-ply matboard is about ⅛" thick while 8-ply matboard is about ¼" thick. Of course, the thickest matting is achieved by using a double 8-ply mat which makes the matting about ½" thick. This matting presentation looks stunning and works very well for large pieces.

Recommendation level: Absolutely necessary and therefore very highly recommended

Examples: A matted print of *Playa Reflections* next to the same print non-matted and lying on a table. The matted print has a professional presentation that gives it elegance and class. The unmatted print looks unfinished and rough. Because of its fine appearance the matted print can command a higher price. It is also more desirable because it is ready to frame and because the matting protects the print from potential damage while handling the print.

Which one do you think your customers would prefer to buy as a fine art print?

⬤ Framed Prints with Glass

Characteristics: The photographs are matted and framed. The frame can be made of wood or metal and can be very thin or very wide, anywhere from ½" to 6" in width, or more. Metal frames tend to be relatively thin while wood frames can be extremely wide.

Framed prints are delivered to customers with a hanging wire attached to the back of the frame. The thickness of the wire is proportional to the weight of the framed photograph. Heavy pieces require thick wire able to support the weight of the piece. For extremely heavy pieces, solid metal hanging brackets can be used.

Glass or plexiglass can be used as glazing. It is best to use plexiglass for very large pieces because it weighs less than glass and because large sheets of glass can break easily. Plexiglass is also preferred when shipping large pieces or when shipping pieces of any size overseas. Doing so reduces the weight of the piece and prevents damage caused by broken glass.

Recommendation level: Absolutely necessary and therefore very highly recommended

Antelope Canyon Arch – This photograph is framed in an inlayed wood frame and double-matted in a beige mat with a dark brown under-mat. While this presentation strongly departs from the traditional white matting and black frame often associated with fine art photography, it is pleasing to customers looking for a piece for home décor because the fine woodwork and the warm mat tones complement fine wood furniture very well.

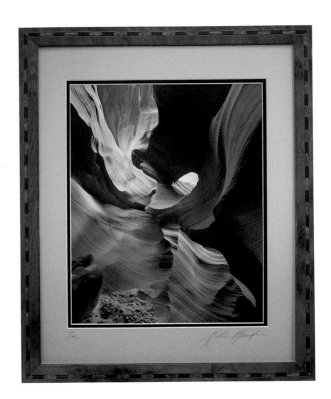

Framed Prints without Glass

Characteristics: The photographs are mounted on a backing board. No glass or plexiglass is used. Any photographic mounting technique that does not use glass for protection can be used. This presentation gives a contemporary look to the work.

Mounting techniques:

- **Rigid support mounting** – Mounting on a rigid support such as Gatorboard, metal, or wood. Either heat-activated or cold mounting adhesive tissue can be used. The front of the photograph is protected with a transparent, UV resistant and waterproof, overlay.
- **Stretched canvas** – The photograph is printed on canvas and stretched on a wooden frame. The photograph can extend over the edges of the canvas frame (this is called *gallery wrap*). Or the edges of the canvas frame can be painted black for a painting-like look. Or wood trim can be attached to the edge of the canvas frame for a more finished look.
- **Photographs adhered behind plexiglass** – The photograph is mounted on the back of a sheet of plexiglass. This process gives an extremely glossy appearance to the print that increases color, contrast, and saturation. It also gives a glossy look to the piece without having the paper exposed to the

air. Once the print is adhered to the plexiglass, the piece and the plexiglass become one and have to be framed together.

Note: Be aware of potential problems with photographs adhered to plexiglass, including the following:

» The print cannot be separated from the plexiglass without destroying the print.

» If the plexiglass is damaged both the print and the plexiglass must be replaced.

» Some customers and photographers do not consider this process to be archival.

Recommendation level: Highly recommended if you like these mounting styles

Wooden support – A photograph of *The Desecrated Panel,* along the San Juan River, mounted on a wooden support

Wooden support mounting style – The wooden support is 1" thick, painted black and beveled on all four front edges. The photograph is hung on the wall with a wire, just like a regular framed piece.

Wood-mounted photograph protected with a UV and waterproof film — Because it is waterproof and UV protected, a presentation such as my *Barrio Doorway* can be used outside without fear of damage. However, the print does need to be displayed in a shaded area. Although it is UV-proofed, constant exposure to direct sunlight will eventually damage the piece.

A 40×50 stretched-canvas — This version of *Antelope Light Dance* is displayed in a home environment. This presentation is both elegant and traditional because artists have used canvas for hundreds of years. This presentation offers several important benefits: first, it results in a piece that is lightweight, which means that the piece is easier to handle, less prone to damage if it falls, and less expensive to ship, an important consideration since most pieces of this size will need to be shipped. Second, you can do the mounting yourself with relatively simple tools. You do not need a mounting press and you do not have to worry about dust or other particles getting trapped under or over the print during mounting. Third, there are no reflections on the photograph because the canvas has a mat finish and because no reflective surfaces are used over the photograph.

Tips on Selling Framed and Unframed Prints

- You need to offer each print in several sizes, however, do not offer too many sizes as too many choices make it difficult for customers to make decisions!
- When talking about sizes, we always refer to the mat or frame size, not the print size.
 - The mat size is the outside measurement of the mat.
 - The frame size is the size of the area where the print goes into the frame, not the outside measurement of the molding. For example, a 16×20 frame may be made with a narrow molding or with a molding several inches wide. In both instances it is still a 16×20 frame.
 - The print size is usually one size smaller than the mat or frame size. For example, an 11×14 print is matted in a 16×20 mat. A 16×20 print is matted in a 20×30 mat and so on.
 - Offering each piece in three sizes is an excellent approach. This approach follows the Great American Marketing Breakthrough (GAMB), which consists of offering products in three sizes: small, medium and large. For example you can offer photographs in these three standard sizes (all sizes are in US inches): 11×14, 16×20, and 20×30.
 - Customers have a difficult time seeing a difference between sizes that are less than twice the previous or next size, therefore do not offer sizes that are too close to one another as customers will question the difference in price between sizes they believe to be identical. Therefore, offer sizes that are roughly twice, or half, the size of the previous or next size:
 - 16×20 is roughly twice the size of 11×14
 - 20×30 is roughly twice the size of 16×20
 - 30×40 is roughly twice the size of 20×30
 - Make sure you offer only standard frame sizes. When customers buy your work unframed they often want to be able to get an inexpensive ready-made frame. Offering non-standard frame sizes means that your customers will need to get custom framing, and they will often refuse to buy a matted photograph that is not standard size due to the high cost of custom framing.
 - Make sure you offer the same piece unframed and framed. If a customer wants a framed piece, you want them to buy it from you, not from a custom framer because you make more profit when you sell a framed piece. So be sure to price your work so that the cost of buying a framed piece directly from you is less than what the customer would pay to have the same piece custom framed by a framer. However, do not try to compete with inexpensive ready-made store frames. First, you cannot compete with the prices offered by large retail stores. Second, it is not worth it because there is very little money to be made. Instead, just let customers who want to buy the least expensive frame

get it themselves from a large retail store. In that instance, focus on selling them the photograph matted. Use the standard size as a selling point by pointing out that they can get a low cost, standard frame anywhere.

» Carefully consider how many frame types you are going to offer. Frame types are called moldings. Do not offer too many different molding types. Again, too many choices lead to indecision on the part of the customer. It also increases your overhead and your inventory. I recommend carrying two different frame types, three at the most. You can be very successful carrying only one frame type. In that case customers focus on your photographs, not on the variety of frames. The framing becomes "standard" and customers no longer need to make decisions about the molding type. They only need to decide between purchasing the print framed or unframed.

» Do not offer non-matted photographs. If people ask for them, simply point out that you only offer photographs matted. You can also explain to customers that they are paying for the photograph, not the mat. Therefore not including the mat would not reduce the price. In other words, the mat is "free" with purchase.

Items You Can Sell Besides Framed and Unframed Prints

⬤ Portfolios | The Navajoland Portfolio*

- Portfolios are projects
- They can be sold by themselves
- They also open the door to satellite products such as:
 - » DVDs
 - » Music
 - » Single prints
 - » Etc.

Contents of The *Navajoland* Portfolio:
- 25 photographs: 5 matted and 20 unmatted prints
- The unmatted prints are the same format as the matted ones and therefore can be interchanged using the five mats included in the portfolio
- Interleaving tissue used to separate and protect the 20 unmatted prints
- Handmade tray to hold the 20 unmatted prints

* See my book, *Mastering Landscape Photography,* to learn how to create a Portfolio of your work.

Navajoland Portfolio and contents. Portfolio case size: 16" × 20"

- Bound 20-page artist statement that features thumbnails and descriptions of all 25 photographs
- Letter to portfolio collectors
- Music CD by Travis Terry
- Handmade tray to hold artist statement, letter, and music CD
- A pair of white cotton gloves
- 16×20 handmade portfolio case
- *Note:* this is a Limited Edition of 50 portfolios

Recommendation level: Highly recommended

Folios | The White Sands Folio

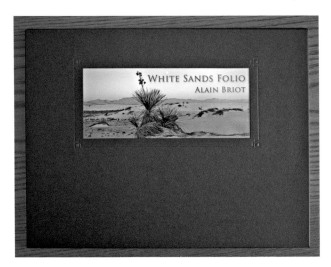

The White Sands Folio enclosure. The case size is 8.5×11.

White Sands Folio and contents

- A folio is a project that is easier to manage than a portfolio
- A folio can be completed in less time than a portfolio
- A folio is smaller in size than a portfolio
- A folio has fewer prints than a portfolio
- Folio prints are not matted, which saves time and supplies
- Both the folio artist statement and project description are shorter
- A folio has a lower cost of production than a portfolio
 - The selling price is lower than a portfolio which means that a folio addresses a larger audience
 - A folio can be numbered just like a portfolio
 - A folio is collectible
 - A folio is a nice addition to a collector's artwork collection
 - A folio does not take as much storage space as a portfolio

Recommendation level: Highly recommended

The 18 pages of the White Sands Folio — The seven pages of text consist of the title page, list of photographs, artist statement, biography, quote, colophon, and logo page. The 12 print pages each feature a different image, with the title of the photograph, the name of the folio, and my name underneath each photograph.

🔵 Self-Published Books | Death Valley book

Characteristics: There are a large number of websites where you can self publish a book. One of the better known is Blurb.com. Apple also offers this option, as do many other sites. You prepare the book layout on your computer then upload your files to their server. You can have them print just one book or a number of books. You can create a limited edition by printing, for example, 50 books, and numbering each of them.

Recommendation level: Highly recommended

🔵 DVDs Showcasing Your Work | The Navajoland DVD

This DVD showcases 29 of my photographs. The photographs are accompanied by music created for them. Each song is titled after a photograph on the DVD. This brings coherence to the project because the photographs and the music relate to each other.

Recommendation level: Highly recommended if budget allows

❯ Because this has to be commercially produced, a minimum of 1,000 to 2,000 copies must be made at one time in order to keep the cost per copy reasonable.

The Navajoland DVD – A satellite project of the Navajoland portfolio, this DVD was created a year after the Navajoland portfolio had been offered for sale.

The Navajoland DVD – Features a double-sided insert. On the front are the 29 photographs featured on the DVD (the front side is visible in the open DVD case above). The reverse side of the insert features a special offer. DVD owners can order any of the 29 photographs featured on the DVD at a special price. Because of this insert, the DVD also acts as a marketing piece through which my fine art prints are sold.

Navajoland Fine Art Photographs
by Alain Briot

Each of the 29 photographs featured on the DVD is available as a fine art photograph hand printed and signed by Alain Briot. Mat size is 16x20 and print size is indicated after each photograph in inches (1 inch = 2.5 cm). All photographs are color except number 10 which is black and white. Only the finest, museum-quality archival materials are used to create this artwork.

To Place your order simply call, email, fax or mail the order form (or a copy of it). Use the numbers under each image (on the other side of this page) to reference the photographs. Here is the list of the 29 images available:

1-Chinle Moonset - 10x15
2-Horseshoe Bend and Flowers - 10x15
3-Antelope Light Dance - 10x15
4-Sunset at Spiderock - 10x15
5-Slot Canyon - 10x15
6-Round Rock Clouds - 10x16
7-Snowstorm at Spiderock - 10x15
8-Sunrise, Canyon de Chelly - 10x15
9-Eye of the Wind Lower Antelope - 10x15
10-Upper Antelope Black & White - 10x15
11-The Dancing Rocks - 10x15
12-Sunrise, Greg's Arch - 10x15
13-Tear Drop Arch - 10x15
14-Dawn, Greg's Arch - 10x15
15-White House, Canyon de Chelly - 10x10
16- Anasazi Handprints - 10x16
17-Wutpaki - 10x15
18-Sand Dunes - 10x15
19-Yei Bei Chei Masks - 10x15
20-Navajo Mustangs - 10x15
21-Navajo Pictographs - 10x15
22-Alain photographing on horseback - 10x14
23-Alain photographing with Linhof 4x5 - 10x15
24-Hogan in Fall, Canyon de Chelly - 10x10
25-Travis playing at sunrise in Canyon de Chelly - 10x15
26-Monument Valley Shadows - 8x16
27-The Chuska Mountains - 6x16
28-Sunrise after Snowstorm, Canyon de Chelly - 6x16
29 -Spring Storm, Canyon de Chelly - 6x16

All photographs are presented in a white museum mat and signed on mat & print (original in color).

Fine Art Photographs and Navajoland CD Order Form

These Fine Art Photographs are printed on Hahnemuhle 308gr Photo Rag Paper and matted in Bainbridge Artcare Cotton Rag Museum Mat. Each photograph is personally printed and hand-signed by Alain Briot. These are collector prints suitable for framing. They will forever remind you of your journey through Navajoland and will become a family heirloom.

The real Fine-Art Prints look much better than the reproductions you see here. The colors are richer and the images have a luminous quality that can only be experienced when admiring the fine art prints. Each hand-matted and signed Fine Art Photograph is only $175 including worldwide shipping. You do not pay extra to have your order delivered to your home, no matter where you live.

Yes, I want to order Alain's beautiful photographs!
Please ship my order right away:

I want photograph(s) number:_____

I also want to have _____ (indicate quantity) Navajoland Music CD(s)

Name:_____ City_____ ZIP _____

Address_____

Email:_____Phone_____

Credit card # (Visa, MC, Amex)_____

Expiration date_____ Total enclosed_____

Return this form by Fax to: 207-226-6168
by email to: alain@beautiful-landscape.com
by mail to: Alain Briot, Beaux Arts Photography, PO Box 12343
 Glendale, AZ 85318 - USA (you can send a check if you like)
or call 800-949-7983 (US) or 623-561-1841 (Intl.) to order over the phone.

You can order the Navajoland Music CD (the companion to this DVD) for only $19.95 including worldwide shipping. With the CD you will be able to listen to Travis' music anywhere! Here is the list of the songs on the CD. These are the same songs, in the same order, as on the DVD:

1-Navajoland 4:54
2-The Dancing Rocks 3:10
3-Canyon de Chelly Sunrise 3:06
4-Storms at Tsegi Overlook 3:25
5-Touching the Past 3:13
6-Monument Valley Shadows 4:02
7-Seasons of Spiderock 3:21
8-Antelope Light Dance 3:08
9-Navajoland Reprise 4:47

Alain and Travis after recording the Navajoland CD. The full story of how this project came to be is included in the CD.

🔵 Music CDs | The Navajoland Music CD

If you have music made for you, you can offer the CDs for sale as well. In my case, I was the music producer for this project and I own the copyright to the music. I designed the CD cover, back cover, and insert. I used my photography in the design and I wrote the text for the insert. I included a panoramic photograph in the insert that unfolds to 5×15 inches, a size which makes the image exciting to look at.

The CD is sold as both a physical and a digital product. The physical CD is sold in brick-and-mortar stores. The digital version is sold online through iTunes, CD Baby, and other digital music stores.

Recommendation level: Recommended if you produced the music for a project

Navajoland and Grand Canyon Music CDs

Music CD – Also sold through a number of other online music stores, including CD Baby, Amazon.com, and many others.

🔵 Posters | Grand Canyon National Park Posters

Characteristics: Posters are not huge sellers in terms of income, and you can easily fall into quantity sales if you offer them.

If you do offer a poster, be sure to not print the posters on your inkjet printer because doing so means that the print quality will be the same as your fine art prints and smart buyers will buy the poster instead of buying your fine art prints. Therefore, be sure to have your posters printed on a printing press. This means doing offset printing. You need to point out to customers that this printing type is not archival because it will start fading within just a few years. Offset printing is of lower quality than fine art prints.

I believe that offering posters is not a good idea. You certainly will sell more of them than if you offer only fine art prints, but because you need to make a large print run (2,000 minimum and up to 5,000 to get a good price per poster) you will have to invest a lot of money up front. You will also need lots of space to store your poster inventory. Finally, you will need more than one poster image to make a serious income from poster sales. This is true not only for posters but also for postcards, calendars and any other item that you have mass-produced by a commercial printer.

Recommendation level: Not recommended because of the low profit margin and the risk of getting stuck with a large, unsold inventory.

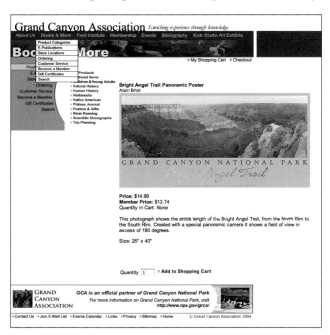

Bright Angel Trail poster – Sold on the GCA website in addition to being sold in the GCA brick-and-mortar gift store at Grand Canyon National Park. Posters can be sold in various venues by vendors.

Poster Sales – You will need to have several different posters to make a serious income from poster sales. You will also need to provide a poster display to the stores because most stores will not have their own displays. Finally, you may also need to roll and place your posters in transparent sleeves yourself because stores will not want to do that either. This is a lot of work for relatively little money when compared to selling fine art prints.

Poster Storage – Unsold posters stored in garage cabinet. This poster stack is 22" high and contains about 4500 posters.

Focus on a Theme – The salability of a poster can be increased by focusing on a theme specific to an area, or even specific to a single park or monument. This poster was designed specifically for Canyon de Chelly National Monument. While focusing on this specific location limits where this poster can be sold, it is desirable because it is specific to this one National Monument. To some extent the same can be said about both Grand Canyon posters. However, the Grand Canyon has a very wide appeal and products designed for the Grand Canyon can be sold in locations other than at Grand Canyon National Park.

Gift Certificates

Characteristics: Gift certificates are nice to have for people who want to make a gift. Customers do not have to decide what to get. They only need to decide how much they want to spend on the certificate. (Be sure to learn the laws in your state that govern gift certificates, including expiration dates, fees, cash redemptions, etc.)

Recommendation level: Recommended

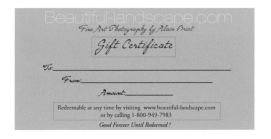

The Beaux Arts Photography Gift Certificate

Calendars

Characteristics: Calendars must be sold within a short period of time: a year or less as they are not sellable afterwards. You must produce a large quantity of calendars to keep the cost low. You must therefore have access to a large buying audience to make this product profitable.

Recommendation level: Not recommended until you have acquired a strong following that enables you to sell the entire print run quickly.

Screen Savers

Characteristics: Screen savers showcase your work. While they were attractive when they first came out, today they are no longer a novelty. They also compete with free screensavers on the Internet. You cannot charge much for this type of item so you must rely on volume, which is always challenging.

You risk having your images stolen because you are making digital copies available. (You do not have this problem when you offer a DVD because the photographs are in movie format, not in jpeg, tiff, or other photographic format). If you do offer a screen saver, keep the images to the minimum file size (low resolution) to prevent unauthorized use. Also, be sure to have your name on each photograph. It is important that you have your name and copyright both in the image metadata and on the image itself.

Recommendation level: Not recommended because of low profit margin and risk of image theft

Postcards

Characteristics: This product offers an extremely low profit margin per sale. Therefore it requires an extremely high volume of sales, equating to a high level of production and fulfillment. Carrying this product will hurt print sales because people will be tempted to buy a postcard instead of a fine art print.

Recommendation level: Absolutely not recommended

Part of the collection of postcards offered by George Mancuso

Packaging, Protecting, and Presenting Your Products

The easiest way to package your photographs is to mat them, sign them, and place them in a clear bag. I also use a backing board to make the package more rigid and give a clean look to the back of the matted photograph. If you use price tags, use small tags so they are not distracting.

We use Crystal Clear Bags (sold on www.clearbags.com). There are two models: one with the adhesive strip on the flap and one with the adhesive strip on the back of the bag. You want to use the bags with the adhesive strip on the back of the bag.

Otherwise, if the adhesive strip is on the flap it will stick to the print when the photograph is pulled out of the bag.

Here are the ClearBag sizes and part numbers for the most common print sizes (PC stands for protective closure.): 8×10: B108 PC, 11×14: B11 PC, 16×20: B16 PC, and 18×24: B18 PC.

Other Important Considerations

What type of prints should I sell?

You may wonder what type of photographic prints you should sell. The truth is that any type of photographic print that meets your quality standards can be sold. These may be traditional prints done on light-sensitive materials, or digital prints done on inkjet printers. In my opinion, using an inkjet printer to print your work will give you more control and will lower your costs.

I personally print all of my work because for me printing is part of the creative process. Doing my own printing also allows me to print the photographs on demand, which means I do not have to stock a large inventory. There is also no delay waiting for the lab to complete my order and no time spent finding the originals, packaging them, sending them to the lab, etc.

Should I mat my work?

Yes, I recommend you mat your work. I cut all my own mats. However, if you cannot or do not want to cut your own mats there are numerous places that sell ready-cut mats in standard sizes.

Should I sign my work?

I personally hand-sign each photograph and I recommend that you do so as well. Signing your work enhances its fine-art quality and makes it more

attractive to your customers by setting it apart from mass-produced items. I recommend you sign in pencil on the mat and on the print. However, if you print on glossy paper you will need to use a non-smudging, archival, pigmented-ink pen because pencil will not work on glossy paper. Pencil signatures look clearly hand-signed while signatures done in ink sometimes look like they were reproduced.

A customer admiring my work at a show — Art shows provide an excellent venue for selling your work. (In Section D, *Selling Your Work at Art Shows*, you will find detailed coverage of this topic.)

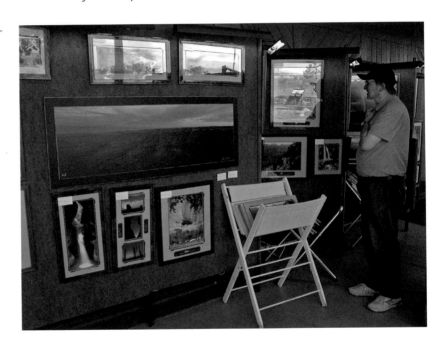

Conclusion

In this chapter I described specific products that you can sell in your photography business. I also made recommendations about which products can be expected to be profitable or not. These recommendations are based on my experience running a fine art photography business and doing low-volume, high-quality work for a limited audience.

As they say, "your mileage may vary." In other words, you may want to make choices different from mine, which is not a problem. Just keep in mind that what I am recommending here has proven successful not only for me but also for many photographers who run fine art photography businesses. Therefore, before making any final decision, consider the pros and the cons of each decision carefully. It is easier to prevent making a mistake than to try to remedy a problem caused by the wrong decision. Once things are done it is difficult to undo them.

What matters most is that you are enthusiastic about your work because your passion and excitement will show in your final product.

Finally, keep in mind that it is important for you to have fun doing what you love. What matters most is that you are enthusiastic about your work

because your passion and excitement will show in your final product. Your goal should be to offer exciting and beautiful photographs to your customers, regardless of the actual products that you decide to sell.

Skill Enhancement Exercise

Defining your products.

- Describe the products that you are going to sell.
- Write out a description of each product and include as many details as possible.
- Explain in writing why you decided to sell these products.

In the end, the customer doesn't know, or care,
if you are small or large as an organization...
she or he only focuses on the garment hanging
on the rail in the store.
 GIORGIO ARMANI

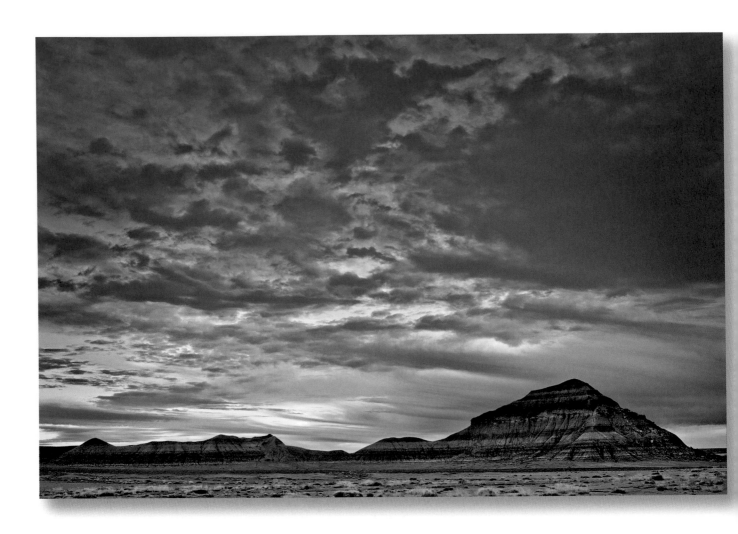

Chapter 6
Where to Sell Fine Art Photographs

In this chapter we will look at a variety of approaches that can be used to access the different venues through which you can sell your work. These approaches include wholesale, consignment, and retail. Chapter 3 contained an overview of these three approaches and a comparison between wholesale and retail. This chapter takes a closer look at these approaches and provides you with detailed descriptions of what selling through the following venues entails:

- Selling to Stores *(Wholesale)*
- Selling through Galleries *(Consignment)*
- Selling through a Representative *(Consignment)*
- Selling on the Internet *(Retail)*
- Selling in Your Home Gallery *(Retail)*
- Selling in Your Own Brick-and-Mortar Gallery *(Retail)*
- Selling at Art Shows *(Retail)*
- Selling Stock Photography *(Retail)*
- Selling to Books and Magazines *(Retail)*
- Selling by Advertising in Magazines *(Retail)*

Selling to Stores *(Wholesale)*

Selling your work to a store means selling your work at a wholesale price to a place where it will be resold to customers. The stores most likely to purchase photographs and photographic products are gift stores and bookstores. Stores located in touristic areas can be very profitable since tourists like to purchase photographs and other products featuring photographs as souvenirs.

I have sold my work through the Grand Canyon Association (GCA) Bookstore at Grand Canyon National Park and through other National Park bookstores. Before you can sell your work in a National Park bookstore, it first has to be accepted by a review panel that will determine if your work meets the requirements set by both the National Park Service and the specific Park Association that will be purchasing your work. This panel consists of Association members and National Park Rangers. The requirements are centered on interpretation and education. Each product sold in a National Park bookstore must, in some way, provide educational or interpretative content to help visitors learn more about the park.

The requirements of most National Park bookstores are fairly demanding. Stores located outside of the National Parks will have far less stringent criteria. However, all stores to some extent will evaluate your product to determine if it is suitable for a specific location. Stores want to make sure that each product they purchase will be well received by their clientele, has a good chance of selling well, and does not duplicate a product they already carry.

Stores can be a profitable source of income if you are able to sell a lot of work. The name of the game here is quantity. Most items sold in bookstores and gift stores are low- to medium-priced. Because you are only paid half of the retail price, you need to sell a lot of products to make a profit. On the other hand, you do not have to be physically present to sell each item, since this is the stores' responsibility. This allows you to sell your work at other venues, such as shows, where you have to be physically present.

The Grand Canyon Association (GCA) – Store on the South Rim of Grand Canyon National Park. The area circled in red shows the poster I sell through the GCA. I circled it to show one of the main problems with selling through a store: your product may become visually lost among the hundreds, if not thousands, of other products sold in that store. In this instance my poster not only has to compete for attention against other posters, it also has to compete with books, DVDs, postcards, maps, calendars, tee-shirts, and just about every other Grand Canyon-related product imaginable.

Selling through Galleries *(Consignment)*

When you sell through a gallery, you sell on consignment. You begin by finding a gallery interested in carrying your work and you sign a contract with this gallery. You then provide your work to the gallery on a consignment basis; meaning that the gallery shows your work but pays you only after your work sells. The gallery usually keeps 50 % of the selling price and gives you the other 50 %. This percentage varies from gallery to gallery, but in my experience 50 % is the most common arrangement. This percentage can be higher, up to 60 % or greater, in favor of the gallery, meaning the artist receives only 40 % or less of the selling price.

Consignment is really a variation of the wholesale approach. You sell your work at half the retail price (occasionally lower) to a store that takes care of showing and selling your work retail to their customers. The main difference is that you do not get paid unless your work sells, while with traditional wholesale you get paid when you deliver the product to the store.

Working with a gallery provides opportunities for shows, openings, announcements, and newspaper or magazine articles. Over time this may allow you to develop name recognition, and incidentally leverage, in the geographical area covered by the gallery.

Showing in a gallery can bring you fame as well. However, be aware that fame and fortune do not necessarily go hand in hand. It is easy to be famous and poor at the same time. I know many artists whose names are quite well known but who do not make enough money to live on. Fame alone does not help pay the bills. Fame is only an asset when you leverage your name recognition through an appropriate marketing campaign.

If you decide to work with galleries, my recommendation is to start with small galleries and proceed slowly until you find out if the gallery approach works for you.

Be aware that fame and fortune do not necessarily go hand in hand. It is easy to be famous and poor at the same time.

I also recommend looking for galleries in cities that are known for the arts. In the American Southwest this means Santa Fe, New Mexico and Scottsdale, Arizona, among other locations. Your local, "small town" gallery may be a good place to start in regard to gaining experience, but it may not be enough in the long run to generate a regular income.

The first gallery is the most difficult one to find. Simply getting over the fear of walking into the gallery with your work "under your arm" can be tough to overcome. If you are in this situation, keep in mind that gallery owners depend on you, and on other artists, for their inventory. If artists did not walk in and provide them with artwork, they would not have anything to sell!

Once you are represented by a gallery you can use this representation as leverage to get representation from other galleries. To begin, you can create a promotional marketing brochure, with the gallery name on it and the pieces sold there, to show to other galleries.

Try your best to meet with gallery owners during the week. Do not meet with them during the weekend because that is when galleries are busiest and they will not have time to talk to you.

Once you have been accepted by a gallery you need to keep in regular contact with the gallery owner. Working with a gallery is not very different from any important relationship. Both you and the owner must put work into it. If one or the other, or both, of you do not work at this relationship, nothing good will come out of it. Never forget that artwork does not sell itself. It needs to be sold. This is true for any selling venue, and a gallery is no exception. The gallery owner needs to be motivated to sell your work. For that to happen you must keep in touch and provide them with new work on a regular basis.

That said, however, it is important that you do not give too much work to the galleries that represent you. Four large pieces and ten medium-sized pieces is a good amount to start with. Do not give small pieces to your galleries unless you can sell them for a high price. Unlike wholesale, where you can expect to sell large quantities of products, galleries will only sell a few pieces. In this low-volume environment, where you will receive only half of the selling price at best, your prices must be high. Yet, you do not want to be the highest priced artist in the gallery either. Customers do not buy the highest priced piece because this is the "masterpiece." A masterpiece is a piece that is so large and so expensive only people out of their mind would buy it. It is only meant to impress people who then will buy something more reasonably priced. (I discuss the concept of the masterpiece in more detail in Chapter 7.)

The masterpiece approach works differently in a gallery where there are several artists than it does in a show booth or dedicated gallery exhibit displaying only your work. When only your photographs are on display, after seeing your masterpiece customers can choose one of your lower-priced pieces. However, in a gallery that sells the work of several artists, if one of your pieces is the masterpiece, there is a good chance that patrons will choose a lower-priced piece by another artist because they will be under the impression that your entire body of work is "the masterpiece," meaning that your work is the most expensive in the gallery. Therefore, it is important that you let another artist be the highest-priced artist with the masterpiece.

The best way to get in a gallery is by proving to the owner that your work will sell. A gallery is a business, not just a place to display your work in a beautiful setting. The owner must carry products that sell well in order to make a profit and stay in business. To prove that your work sells well, bring a sales track record with you on your first visit to the gallery (if you have one). This can be a list of your sales records for the previous year, or for a specific show, or for any other venue. Also bring best sellers. Finally, bring pieces that you know sell fast. Gallery owners are in the business of selling art, not just showing art. If they know that your art sells they will want to carry it.

Keep in mind that when selling through a gallery you are selling quality not quantity. Therefore you want to be represented by galleries that follow the same approach. This means galleries that cater to an affluent audience and where quality art—meaning expensive art—is sold. It also means galleries that are located in attractive areas where people go looking for art and where other galleries are located. Galleries are often located in touristic areas because many people purchase art while on vacation.

When applied to galleries, the 80/20 law stipulates that 80 % of your income will come from 20 % of the galleries you are in.

You will need to be represented by several galleries in order to make a regular and sufficient income from gallery sales. Once several galleries represent you, you will need to apply the 80/20 law. When applied to galleries, the 80/20 law stipulates that 80 % of your income will come from 20 % of the galleries you are in. There is no point working hard for a gallery that does not bring a sufficient income. You need to apply this law so that you make the best

use of your time and efforts. To do so, find out which galleries are bringing you the most income. Look at the sales records for each gallery. Then, keep your work in the galleries that bring the most income and pull your work out of the galleries that are not bringing you enough money. Once you have done this, look for new galleries in order to replace the low-income galleries with higher-income ones.

Michael Stoyanov's Gallery in Scottsdale, Arizona

Being represented by a gallery does not mean you have "arrived" and that you can lay back and wait for wealth to come your way. In fact, it means that you now have to work harder than before: you must now provide your best work to your galleries, help them sell your art by developing a good relationship with the owners, and apply the 80/20 law regularly.

When working with a gallery, never forget that your sales will only be as good as your relationship with the gallery. A poor relationship with your gallery means poor sales. A good relationship means good sales.

You also need to know that signing a contract with a gallery does not guarantee that things will work in your favor if there is a problem. And, as with anything in life, problems do show up. For example, your work may become damaged, or the gallery might close and take your work with them, or your work may even "disappear." Even though you have a contract, it is often too costly to litigate and you may find it best to take a loss and move on.

Furthermore, if you go to court and win (which is far from being a certainty), you will most likely receive as financial compensation only what it cost you to produce the artwork. This is because in a court of law, a piece that may have been selling for thousands of dollars in the gallery is only valued

for what it cost you to produce it. This is why litigation is often not worth the trouble. Your best bet is to develop a good relationship with your galleries so that if such problems arise you can work things out personally and amicably.

Selling through a Representative *(Consignment)*

Many artists believe that having a representative—a *rep*—sell their work will be the answer to all their marketing problems. However, finding a good rep willing to sell your work is a very difficult thing to do, especially when you are just starting your business. This is because a rep makes money only when they sell your work. Therefore, reps want to represent artists who have a proven track record. The ideal artist for a rep is an artist whose work is already selling very well and who is looking for someone to handle the sales because they can no longer handle all the business themselves. It is rare that a rep will take on a brand new artist with no sales track record because the rep will have to spend a lot of time marketing the work, showing it to their clients, and explaining who the artist is—all without knowing for sure whether or not the work will sell.

In many ways a rep operates in a manner very similar to a gallery. The main difference is that a gallery has a physical retail location while a rep operates out of an office by calling clients and visiting retail locations. In practice, many reps operate out of their car because they need to be constantly on the road going from store to store.

When working with a rep, you give them an inventory of your work for consignment and you usually get paid half of the price the rep gets from the stores—after your work has sold. This arrangement is very similar to working with a gallery, but with one main financial difference. When working with galleries there is only the gallery between you and the customer. However, when working with a rep there is the rep plus the gallery between you and the customer. This means there is one more person in the loop who needs to make money from the sale of your work. In effect, this usually means that you get 25% of the final retail price.

For example, if your work sells for $200 retail, your rep will sell it to the store for $100. Out of this $100 you will get $50 and your rep will get $50. This means you are only getting 25% of the retail price. Therefore, when selling through a rep you need to sell even more work than when selling your work wholesale or through a gallery to make the same amount of profit. Think about this carefully before hiring a rep and be absolutely certain that this financial arrangement will work for you because there will be no way around it once you start working with a rep.

Personally, working with a rep has not worked for me. I much prefer representing myself and selling my own work directly. I make more money this way by cutting out what amounts to the middleman, or the second middleman.

If you are still interested in working with a rep, keep in mind that a rep wants to make money, not help you become famous. If your goal is to become famous, this is your responsibility. Finally, reps are not interested in teaching you the business of photography or how to sell your work. Again, learning how to do this is your responsibility.

Selling on the Internet *(Retail)*

An attractive venue to sell your work is on the Internet, through your own website.

However, while setting up a website is fairly easy, selling your work on the Internet is not any easier than selling your work in any other venue. In fact, in some ways it can be more difficult due to the ever-increasing number of websites. Because setting up a website is relatively simple, just about everyone with access to the Internet does it. As a result, just about every photographer has a website in one form or another, thereby increasing the number of locations where one can see—and buy—photographic prints.

The Web also has one interesting particularity when compared to a store or other physical, brick-and-mortar, locations. While you can accidentally find a store or a gallery by simply passing in front of it and walking in, you cannot go to a Website accidentally. You have to have a link to get to any site. This means that all visitors to your site will find you because they did a search and that search returned your Web address, or because you gave them your Web address, or because they found a link to your site somewhere on the Web.

What this means is that marketing is just as important on the Web as it is in any other venue. In fact, marketing is more important on the Web because of the extreme level of competition and the constant appearance of new websites all fighting for the attention of the same audience.

If you decide to create a website to sell your work, you need to know that there are three main types of websites when it comes to photography as follows:

- ❯ There are sites whose purpose is to display photographs.
- ❯ There are sites whose purpose is to sell photographs.
- ❯ There are sites whose purpose is a combination of displaying and selling photographs.

My site, beautiful-landscape.com, belongs to the third category. I showcase photographs for the viewer's enjoyment in one area of my site and I sell photographs in another area. These two areas are clearly separated, and only the pages in the selling area have purchase buttons.

My experience selling on the Web taught me that selling artwork on the Internet is difficult. It takes a lot of work and it takes a lot of time to get your

web presence established enough to generate regular sales from visitors. While I now sell my work regularly on the Internet, it took me years of work to get to this point.

If you are just starting, you must expect a similar experience. It is unrealistic to expect making a full income from Web sales immediately after opening a website, no matter how well designed your site might be. It takes years of constant marketing efforts to reach a significant level of income from Internet sales of fine art photographs.

However, a website is an excellent venue to add to your other marketing venues. It is excellent for displaying your biography, your artist statement, a portfolio of your work, news about your photography, and any other information about yourself. The great thing about the Web is that once your site is built there is no cost associated with running it besides paying an annual fee for web hosting and domain name registration. These fees are much lower than the cost of printing brochures featuring your work for example. Plus, your site is available 24 hours a day, 365 days a year, and it is accessible from anywhere in the world.

These are significant advantages. Therefore, all artists today should have a website. You simply need to be realistic about the income potential of a new site. In my opinion your website is best used as just one of the elements of your marketing system and not as the only component of your marketing.

Screenshot of my website store

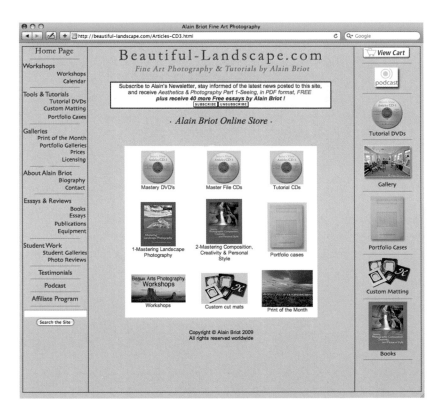

Selling in Your Own Home Gallery *(Retail)*

Selling in a home gallery is a very good option provided you have the space. A home gallery makes a lot of sense financially because you do not need to purchase or rent something new. If you already have a home with the necessary space, you are all set. There is no extra cost involved in having a home gallery besides the possible cost of furniture and lighting.

If you have a guest bedroom, or a room left empty when a child grew up and left home, these are good options for creating a home gallery. Or, if you are planning to purchase a new home, you can look for one that has a room that will work well as a home gallery. This is what we did with our current home. My wife Natalie and I selected our home in large part because one of the rooms is perfectly set up for use as a home gallery.

Natalie holding a print in our home gallery

Our home gallery in Vistancia, Arizona

Besides being a place to sell your work, another important aspect of a home gallery is as a place to display your work. All artists need to show their work. You simply cannot create work forever without displaying it. Plus, the minute your work is displayed, all the visitors to your home—or to your home gallery—become potential customers. Art is sold for emotional reasons and the first thing needed to sell your work is to show it. By having your work nicely displayed in a permanent location in your home you accomplish these two things automatically.

In our home gallery, in addition to the furniture, we use wood and metal display easels and wooden print bins to display framed and matted photographs. Some of the work is stored in portfolio cases and presented to customers when they request it, as Natalie is doing in the photograph.

Lighting is very important when displaying artwork. In our gallery the many windows provide excellent lighting during the day, especially since it is

Art is sold for emotional reasons and the first thing needed to sell your work is to show it.

sunny most of the time in central Arizona. At night we use the track lighting that we installed on the ceiling. The light bulbs are tungsten and balanced to daylight colors, insuring faithful color on the prints. Each light fixture on the track can be pointed to just the right area of the gallery to illuminate each print perfectly.

We paid a lot of attention to the furniture when furnishing the gallery. We wanted furniture that was elegant and of high quality, but would not take attention away from the artwork. After all, the artwork is the most important aspect of the gallery, not the furniture. We were also surprised at how much furniture was necessary for what is, after all, a place where artwork should stand alone. In addition to places to display your work you also need a comfortable place to sit with your customers and a place to store artwork and supplies. The room should also look as if it is lived in, because after all this is your home.

Selling in Your Own Brick-and-Mortar Gallery *(Retail)*

Having their own brick-and-mortar gallery is the dream of many artists. A gallery of your own can be a reliable source of income, if operated properly. It also carries a certain level of prestige with it.

As with any type of real estate, location is everything. If you decide to open your own gallery be sure to select an area that is propitious for art sales. This can be the art district, if there is one in the town you select for your gallery, or it can be a location where people go out for dinner or for relaxation, or it can be an area popular with tourists, such as a shopping area near a National Park or near other tourist attractions.

While your own gallery is certainly an excellent venue, it does present significant costs and constraints. First, you have to rent or purchase commercial real estate space to set up your gallery. The price can be high. Plus you have to factor in the cost of utilities such as electricity, water, phone, Internet, etc. You also have to purchase property insurance for your gallery and liability insurance for your customers. You will also need to invest in producing enough work to fill the gallery, something that can be very costly, especially if you rent a large gallery space. Finally, you may need furniture and lighting for the gallery, and you may even need to budget for renovation unless the space you rent is brand new or has been recently renovated.

Once all this is done and you are settled in the gallery, you need to staff it and operate it on a daily basis. This means being physically present during business hours every day of the week. This can become a serious burden because while you are at the gallery you are not able to take care of other business in your studio or elsewhere. You are also unable to go out photographing.

Sooner or later you will have to delegate running the gallery, at least part of the time, to someone else. This means either hiring an employee to operate

the gallery, or having a family member present in the gallery instead of you. If you hire an employee you will need to train this person in salesmanship and other aspects of the business so that they do as good of a job as you would do yourself. However, one thing they cannot do is *be* you. Since an important aspect of purchasing artwork is personally meeting the artist, not being there full-time may cost you some sales.

These are important things to consider when thinking of opening your own gallery. This is not a proposition to take lightly given the costs involved and the demands placed on your time. Running a gallery is not something you can do in your spare time! It is something you can consider only if you are doing photography full-time.

Selling at Art Shows *(Retail)*

Art shows are excellent venues to sell your work. I devote Chapter 12 entirely to art shows, therefore I refer you to that chapter for a detailed description of what selling at art shows is all about.

Selling Stock Photography *(Retail)*

Selling stock photography means selling photographs through a stock agency for use in books, magazines, advertising, and other publications. Stock agencies maintain a large inventory of images—a stock—among which customers can search for the images they are looking for.

Personally, I do not sell through a stock agency because fine art photography does not lend itself well to stock sales. At one time I was represented by a stock photography agency that focused on fine art—Swanstock—but it did not work well for me. This is not to say that selling fine art photographs as stock cannot be done. It can. But to do well in the stock photography business one has to shoot specifically for stock and doing so is not my focus.

If you decide to work with a stock agency, keep in mind that stock photography sales is a numbers game. You have to sell a lot of images to make a living and you have to have a very large inventory of images from which potential customers can choose. You also have to constantly refresh your stock collection in order to keep it current and to have something new to offer to regular customers.

There are a number of books that focus solely on how to sell stock photography. For this reason I decided to only mention this type of venue in this book and not go into further details. If selling stock photography is something you are interested in, I recommend looking at books that specialize in teaching this type of photography sales.

Selling to Books and Magazines *(Retail)*

You can also directly sell your photographs for use in publications such as books and magazines. In a way, this means that you are your own stock agency. However, there is a difference. While a stock agency requires you to provide them with thousands of images, you can limit yourself to selling your fine art images for stock use whenever someone contacts you. You do not need to shoot specifically for stock. You only need to respond to queries when someone contacts you with a request to use one of your photographs in a specific publication.

Publishers of books and magazines regularly need photographs to illustrate their publications. If they contact you and you have the images they are looking for, making a deal involves negotiating a price that is fair to both parties, then uploading the images to their FTP server. Such sales happen for me occasionally. While I do not prospect for these sales, I do respond favorably to requests when a publisher contacts me. However, this is not a regular source of income for me because I do not actively market to book and magazine publishers. All I do is indicate on my website that my work is available for stock use.

If you want to make book and magazine publishing into a regular source of income, you will need to market and sell your work to book and magazine publishers regularly. This is because books and magazines pay only a few hundred dollars for a cover image and less than that for an article illustration. Unless you can develop a regular publishing relationship with a magazine, or find a stock agency to represent you and carry your work, it is difficult to make a living from book or magazine publishing alone.

World Rock Art, **a 275-page book.**

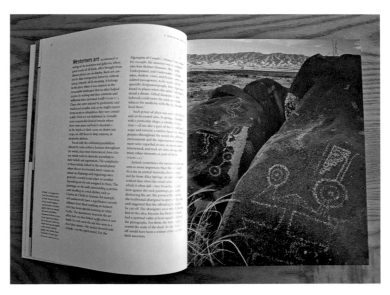

The book *World Rock Art* features seven of my photographs, most of them as two-page spreads or as full-page illustrations. I was contacted by the Getty Museum in Los Angeles regarding the use of my images in this book. They knew exactly which photographs they wanted to use and we negotiated a use fee that was satisfying to both of us. In this case the fact that I am well known for my rock art photographs was a key factor in being contacted for this publication (I received the American Rock Art Association Oliver Award for excellence in Rock Art Photography in 1999). Often, you will find that being known for a specific subject matter, or type of photographs, will be helpful in getting your foot in the door of the stock photography business.

I was contacted by a business that sells horse stalls. They knew which photograph they wanted to use and we agreed upon a use fee. Such a use fee typically limits how long the photograph can be used as well as where it can be used. For example, this photograph was used in a small brochure with a specific size and printing quantity. If the company wanted to use the same image on a poster, or a billboard, the use fee would have to be renegotiated.

Image used for Ad – An advertisement for high-end horse stalls that features my photograph *Navajo Mustangs* as a background.

Selling by Advertising in Magazines *(Retail)*

You can sell your photographs by advertising in magazines. I have used this approach on several occasions, as shown in the examples.

In this marketing approach the design and content of the ads is crucial. First, the cost of the ad is based on its size. Therefore, purchasing a relatively small ad is recommended until you find out what works best for you. Because you do not have much space to write, every word counts. And, because you may only be able to show a single image, it is extremely important that you choose the right image.

As with most advertising, having something unique to offer will generate more sales. Both of the images featured in the ads shown here were best sellers and catered specifically to the audience where these magazines were being distributed.

Alain Paul Briot
Experience the beauty of Isle Royale National Park

Image size:10x16 Isle Royale National Park 1000 S/N
Paper size: 12x18 50 AP

Indigo print on Rives BFK 170lb watercolor paper. UV and water protective coatings
$95 ($4.50 shipping)

Alain Briot was 1994 Artist-In-Residence at Isle Royale National Park in Michigan. He creates his majestic images on a Macintosh computer from photographs captured during his residency. His work celebrates the beauty of America's National Parks.

Alain Briot Studios
214 Scallon Avenue, Hancock, MI 49930 (906) 482-3343

Dealer inquiries welcome

This ad was used in *Fine Art Magazine*, which is distributed in the US Southwest

Beautiful Photographs by Alain Briot
Matted, signed & ready to frame

Special Grand Circle readers price
11x14: $95
16x20: $145
price includes shipping worldwide

To order:
www.beautiful-landscape.com
alain@beautiful-landscape.com
800-949-7983 (USA)
623-561-1641 (international)

This ad was used in *Grand Circle Magazine*, which is sold in the Upper Peninsula of Michigan

Conclusion

In this chapter we looked at the main venues through which you can sell your work. The venue you decide to use is a matter of personal preference. Keep in mind that you do not have to make a final decision right now. Instead, I recommend that you take your time to consider the pros and the cons offered by each venue.

I also recommend that you read the chapter devoted specifically to art shows before making a final decision. Art shows are an excellent venue, one used by many artists as their starting venue. The chapter on art shows will tell you everything you need to know in order to make an informed decision about whether you want to do shows.

Skill Enhancement Exercises

Exercise 1: Venues. List four different venues where you feel your work will do well. Develop a plan of action to begin selling your work in these venues within 30 days.

Exercise 2: Retail and wholesale outlets. Look for potential retail or wholesale outlets in your area. Do not just look at whether the owners will be interested in your work; also consider how well each different outlet might work for you. Ultimately, what matters most is how much money each outlet can generate over a specific period of time.

Knowing is not enough; we must apply.
Willing is not enough; we must do.
 JOHANN WOLFGANG VON GOETHE

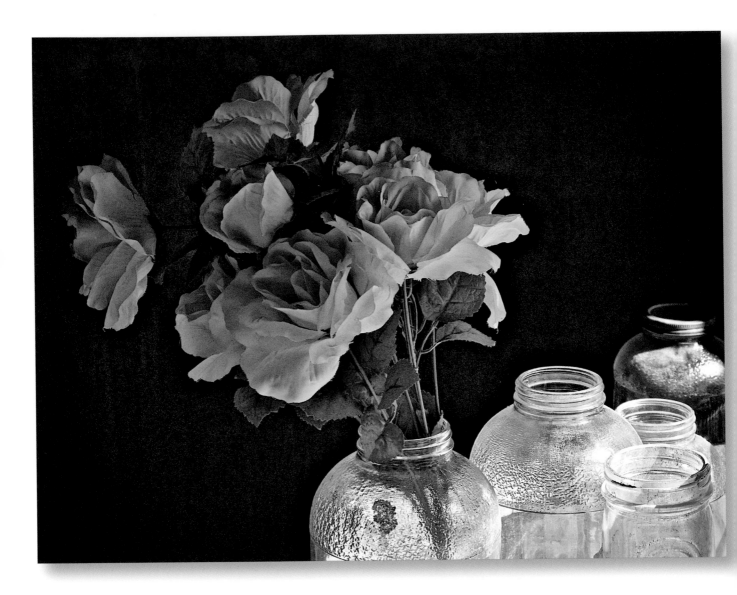

How to Price Fine Art Photography

Pricing your work is a very important aspect of selling your work because the prices you set for your work will define and affect many different things.

First, your prices will define your audience. There is an audience for everything, and when it comes to prices there is an audience for all price points. There is an audience that looks for low-priced items, an audience that looks for medium-priced items, and an audience that looks for high-priced items.

This is the simple version. In practice, it is more complex than that. Price is definitely the factor that most people look at before they consider buying from a specific store or vendor. Notice that I did not say, "before they buy" but "before they *consider* buying." What this means is that most people will not even look at the work you have for sale until they see what prices you are asking for it. Certainly this takes place in the blink of an eye, and to both merchant and customer it is most often unnoticeable. However it is there.

This fact is known to most business owners. However, most business owners believe that unless their prices are affordable no one will buy from them. This is not accurate. Certainly, you have to be priced fairly; however, you only need to be priced fairly in relationship to products similar to yours. In other words, if you sell a fine art photograph created with the finest supplies and released in a limited edition of 10 in 40×50 inch size, it would make no sense to compare the price of this piece to a similar-sized piece that is mass-produced and created with low-quality materials. Although these two pieces may look similar from a distance, careful observation will reveal that significant differences exist. As a result, the price of the high-quality, limited edition piece is expected to be higher than the price of the low-quality, mass-produced piece.

A discerning audience, meaning people knowledgeable about fine art photography, will see these differences and expect to see a price difference as well. If they wonder why your work is high priced, you can explain the reason to them. This is called *educating your audience*. Just describe what the differences are and then ask the potential buyer what type of artwork they are looking for. Are they looking for mass-produced work created with low-quality supplies, or are they looking for limited edition work created with high-quality materials? Do not shy away from addressing price. Price is very important and your audience does expect to pay more for high-quality work. Name your price and name the price of your competitors. Then ask again what type of

work they are looking for: mass-produced and inexpensive or collectible and high-priced?

You will not hurt your sales by doing this because there is an audience for everything. There is an audience for mass-produced, low priced art and there is an audience for limited-editions, high quality and high priced art. It is also important to know who you are talking to so that you do not waste time trying to sell to the wrong audience. What is also important to know is that even though you may have the right audience, there may still be negotiation required down the road, after your customers find a piece they are interested in taking home with them. Just because customers agree with your pricing in principle does not mean they will not try to negotiate on your prices! Just be sure to tell them, if such is the case, that you cannot drop your price to the level of a mass-produced, low-quality artwork. Once your customers know this, you both know the negotiation parameters you can work with. The rest is salesmanship and skillful negotiation. The goal, as with any successful negotiation, is to reach a win-win agreement.

Your prices will also affect the volume of work you sell. Low prices will generate a high volume of sales while high prices will generate a lower number of sales. Basically, as your prices increase, fewer people can afford to buy your work. This is normal and expected. Therefore, it would be a mistake to set high prices and then wonder why you only make a small number of sales.

Red Beavertail Cactus Flowers, Arizona — Flowers are always popular subjects. They are by nature decorative and because of their many colors it is easy to find one to fit just about any kind of décor. Flowers will often become best selling images (see Chapter 8 for detailed information on how to create best sellers).

Pricing Based on Expected Sales Volume

As we just saw, the question of how much to charge for your photographs is directly related to the quality and the volume of your work. There are two possible approaches to pricing: you can decide that you want to sell a lot of inexpensive pieces or you can decide that you prefer to sell only a few very expensive pieces.

Suppose that your goal is to make $20,000 this year selling your photographs. To reach this goal you have several options as far as pricing your work is concerned:

You can sell a single, monumentally large and incredibly stunning photograph for $20,000, or you can sell:

- 2 for $10,000 each,
- 4 for $5000 each,
- 8 for $2500 each,
- 16 for $1250 each,
- 32 for $750 each,
- 64 for $313 each,
- 128 for $157 each,
- 256 for $78 each,
- 512 for $40 each,
- 1,000 for $20 each or
- 2,000 for $10 each

In this example the amount you want to charge and the number of photographs you want to sell (or can create) in one year define where you fall on the scale above. You may think that this example is oversimplified. It is not. Just read it again and you will see that the whole issue of pricing your work is embedded in it. If you desire to reach a higher income just start with a single photograph at this higher income level and work your way down using the same scale of increased quantity and decreased price.

There are basically three questions embedded in the above example:

- How much are you comfortable selling your work for?
- How many pieces can you realistically expect to sell in one year?
- How large is the audience that you are addressing?

Your answers to these questions are the basis on which you can start pricing your work.

Pricing Based on Actual Costs

There are various methods you can use to price your work. The first one is the one we just discussed, which is based on the expected volume of sales. However, while this approach is useful in giving you a general idea about the number of sales that you can reasonably expect to make, it does not allow you to calculate a precise cost of production for individual pieces.

The second pricing approach is based on your production costs. When pricing your work according to this approach there are five basic steps involved. First, add the cost of all the supplies you used to create your photographs: the cost of the print (paper, plus inks or chemicals), the mat board and the mounting tape, and the plastic bag. If it is framed, add the cost of the frame plus glass and backing, the framing supplies (wire, screws, framing staples), and so on. Add up the costs of all the materials you used to create the piece. You need to count every single item you paid for because the cost of each item is part of the final cost of creating your product. Remember that you paid for all these things and that you need to account for them in order to recoup your expenses.

Second, you also need to take into consideration the total cost of operating your studio (rent, mortgage, utilities, insurance) and the cost of doing business (fees, licenses, business insurance, etc.). If you do art shows you need to add show fees and travel expenses—such as gas, food, and lodging—to this total. Because operating costs are spread over the creation of multiple photographs, you will need to divide your total operating costs by the number of photographs you create so that you have a per-item amount that you can add to the cost of supplies.

Third, decide how much you want to make per hour. Then estimate how many hours it took you to create each specific photograph and multiply this figure by how much you want to make an hour. This total is your cost for the time you spent working on this piece.

Fourth, calculate the grand total by adding the cost of supplies, the costs of production, and the cost of your time. The sum represents your total cost for creating the piece that you are pricing.

The fifth step is to do the following: Multiply your total cost by two to arrive at your **wholesale** price. Multiply your wholesale price by two to arrive at your **retail** price.

Once you have reached the above wholesale and retail prices, compare them to the prices photographers in your area are charging for work of similar size and quality. If your prices are much higher, you may want to look into your costs and reduce them. If your prices are much lower you may want to raise your prices because people will most likely expect to pay what your competitors are asking. You can under-price your competitors but there is no need to offer the same item at half the price your competitors are asking.

CALCULATING COSTS FOR WHOLESALE AND RETAIL PRICING
Costs of Supplies
+ *Operating Costs*
+ *Cost of your time*
= *Total Cost of Production*
Total cost of production × 2 = Wholesale price
Wholesale price × 2 = Retail price

Note: This is only a starting point. In practice, I recommend multiplying your costs by a factor higher than two. However, the multiplying factor you choose to use is up to you. The only hard and fast rule is that a factor of two is the absolute minimum to use.

Pricing Based on Leverage and Reputation

The third type of pricing uses your leverage and reputation as the main elements of your pricing. This approach to pricing starts with the calculation of your total costs, as we just saw. However, instead of applying a multiplying factor and leaving it at that, you continue by adding a leverage and reputation factor.

This leverage and reputation factor is not an actual number but rather a price point that you arrive at over the course of your career. Therefore, this pricing approach is not one you can use when you are just starting to sell your work. Instead, it is one you can use only after you have built both leverage and reputation. At that time, you can start to increase your prices regularly to reflect your increasing worth.

You may think there is a conflict between these two pricing approaches, but there is no conflict. There is a progression from one approach to the other. You must start by calculating your costs of production and applying a multiplying factor to get a starting price. Once this starting price is set, you need to increase this price proportionally to your level of leverage and reputation.

Understandably, when you are just starting you will not yet have a reputation and you will not have any leverage. You must work on developing these while you are selling your work. You do so by doing shows, by enlarging your audience, by increasing the number of collectors who own your work, by submitting your work for publication, by doing interviews, by receiving awards, and more. As your leverage and reputation grow, you continue increasing your prices. Over time, your costs of production become a smaller and smaller

percentage of your prices until they are virtually irrelevant. At that time the switch from a cost-based to a leverage-based pricing approach is complete.

What is Leverage?

Let's look at leverage in the context of pricing your work. Leverage is simply an advantage that you have built over the course of your career, through exhibiting and publishing your work, and through peer recognition of your accomplishments in your field. Leverage is also represented in the value of your work when it is seen as an investment. For example, an artist with strong leverage will see his work go up in price in the secondary market, meaning that when sold by one collector to another his work will sell for more than what the first collector paid for it when they purchased it directly from him.

Leverage is also based on reputation. For that reason it is very important that you protect your reputation. This means having integrity, offering work that is only of the highest standard, and offering warranties when appropriate. Offering low-quality work, not having warranties, not being concerned with customer satisfaction, not having integrity, and trying to cut corners wherever possible will definitely result in damaging your reputation in the long run.

If you attend to your career properly, your leverage and reputation will increase regularly; and because your prices reflect your leverage and reputation, your prices must also increase regularly. I recommend that you increase your prices 10% to 20% once or twice a year. The percentage and frequency you use will be based on your level of confidence, the speed at which your reputation is growing, and the ongoing market conditions that you are experiencing.

Pricing based on leverage is ultimately the way in which fine art is priced. A Picasso does not cost millions of dollars because the auction house wants to make their yearly income from just a couple of sales, or because a multiplying factor was applied to the total cost of production. A Picasso does not follow volume-based pricing or pricing based on cost of goods.

Pricing based on leverage is ultimately the way in which fine art is priced.

Instead, a Picasso, a Monet—or any fine art work recognized for its quality and for the achievement of the artist—is priced on the basis of the leverage and reputation of that artist. This is why prices for work by internationally known artists reach such heights. That these works are rare is a factor, but rarity is not the main determining factor. The fact is, well known artists—including Monet, Picasso, and many others—were much more prolific than is often believed. If their work were priced in regard to production, prices would undoubtedly be lower. It is the reputation and the leverage that they command that makes their work so costly.

Should You Offer Limited Editions?

This is an important question to consider when pricing your work. The first thing to say about this is that deciding to offer limited editions is a marketing decision rather than an artistic decision. It is a marketing decision because with today's digital technology we can make 1,000 prints of the same image and keep the same quality from the first print to the 1,000th print.

In the past, with printing technologies such as lithography, copper plate printing, photogravure, and others, quality declined as more prints were made. This is why the editions were numbered. The first prints were understood to offer the highest quality because this is when the copper plate had its highest relief or when the lithography stone had the finest colors. As more impressions were made, the engraving on the plate became flattened, the colors on the stone started fading away, and consequently the print quality declined. Unless the collector was present during printing and was able to pull aside the first prints, the only way to know which prints were first and which were last was by looking at the number on the print. This is why prints were not only signed but also numbered by the artist.

Today, numbering no longer indicates a specific level of quality because, as I explained previously, all prints in a digitally printed photographic edition will look the same.

Some customers are clearly aware of this fact and consider limited editions to be marketing schemes. Other customers like limited editions regardless of these considerations because, after all, they do limit how many prints are being made, even though all prints are of equal quality. Finally, some customers like specific numbers, for private reasons, and limited editions offer the opportunity to own artwork that is both pleasing and personalized, if one can find the print number that is meaningful to them.

The question of whether or not to create limited editions is also related to the issue of purposely creating scarcity. While it can be said that artists create false scarcity through the use of limited editions, it can also be said that they are using quantity as a way to control what they spend their time doing, either printing the same piece over and over again or creating new pieces and moving forward with their art. Eventually all artists face this dilemma and there is value in creating new work versus spending your time repeatedly printing old work. Printing 10 images takes a certain amount of time. Printing 100 images takes 10 times more time, and so on. Since we only have 24 hours in a day, no matter who we are, the number of prints we make per image basically affects how many new images we can create.

If you do offer limited editions you need to carefully keep track of the number of prints released. You also have to include a certificate of authenticity with each piece. This certificate must, at the very least, feature the title of the artwork, the print number, the total number of prints in the edition and your signature. In other words, you must do it right. Do not just put a number on

the print. Instead, provide credible proof that the edition is truly limited and that you are carefully keeping track of how many copies are being printed and sold.

Finally, end the edition when the last copy is sold and avoid creating a new piece that is too similar to the one you just sold out. There is nothing more irritating for a customer than to find out that the edition of the piece they purchased is sold out, but that you just released a new piece that is virtually identical, save for a few minor details. If you limit, you must truly limit, not just pretend that you do.

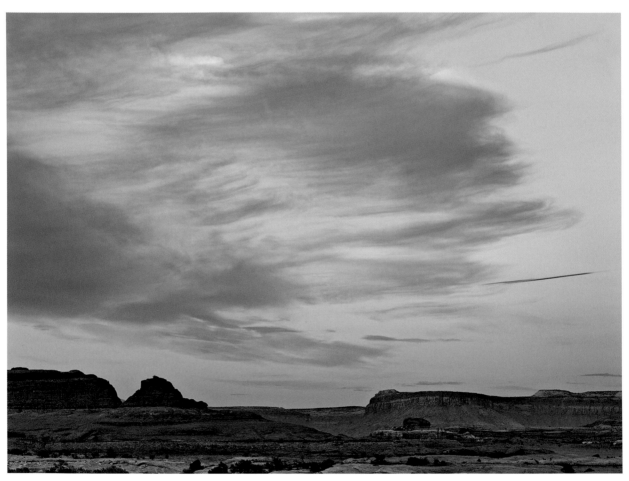

Sunset, Canyonlands National Park, Utah — Landscapes are popular because, just like flowers, they offer a pleasant and restful subject to look at. As such they fit well in a home environment and are frequently used as home décor.

Summary of Things to Consider When Pricing Your Work

1 – Want versus need: Art is a "want" item, not a "need" item. You therefore have to make people want to purchase your art. You cannot expect them to come and buy it without you doing anything. You have to sell it actively.

2 – Price matters: The quality of your work must be in tune with the prices you set. In the eyes of your audience, high prices reflect high quality and low prices reflect low quality. When you sell your work on the basis of quality, for your customers to agree to the prices you ask, you must strive to achieve only the finest quality and demonstrate excellence in every area of your work.

3 – Price complaints: If nobody complains about the price of your work, your prices are too low. If you price your work adequately, you must expect a certain number of pricing complaints. This is not a bad thing. In fact, it is a good thing because it means that your work is priced correctly.

If nobody complains about the price of your work, your prices are too low.

4 – You control the volume of work by the price: The higher the price, the lower the volume of sales. The lower the price, the higher the volume of sales. In turn, the volume of sales dictates the size of the inventory you need to carry. Therefore, the lower your prices are, the larger your inventory needs to be and the higher your prices are, the smaller your inventory needs to be.

5 – You need to carefully consider the relationship between pricing and salability: I advise against selling your work on the basis of price. Getting more business with lower prices is relatively easy, but keeping business obtained purely because of price is difficult. Here is the rule that applies to this approach: If customers come to you because of price, they will leave you because of price.

If customers come to you because of price, they will leave you because of price.

Because of this I recommend that you sell your work on the basis of your images being the unique expression of your vision and personality, your talent, your artistic skills, and your desire to share all this with an audience who appreciates your work. Here is the rule that applies to this approach: If people buy from you because of the uniqueness and the quality of your work, they will come back for the uniqueness and the quality of your work.

For this reason I recommend you price your work on the basis of your leverage and reputation, as we saw earlier. Do all you can to build your leverage and your reputation by seeking publication of your work, doing shows, and participating in other activities conducive to increasing your leverage.

6 – You must decide how much you want to make per hour: What do you think your skills are worth? What hourly wage do you want to pay yourself for your hard work? Personally, I charge $330 per hour (at the time this book is written) plus materials and expenses. This fee is the same whether I sell a product or

a service. For products, I multiply the total by two for wholesale and four for retail. For services, the fee is simply $330 per hour plus any expenses incurred.

7 – You need to raise your prices by 10% to 20% once or twice a year: Everything you buy increases in price with regularity. This is a fact of life and it affects all of us, whether or not we are in business for ourselves. We have come to expect it. Therefore, your customers expect you to raise your prices. What is surprising to your customers is not that your prices go up but that your prices stay the same year after year!

Prices increase because costs go up: the cost of living, the cost of supplies, of labor, gas, etc go up. Your prices need to go up in the same proportion. If not, your income may stay the same but you will make less and less money. Furthermore, as we saw earlier, your prices also need to increase as your leverage increases.

8 – You need a masterpiece: A "masterpiece" is a piece that is so large, so impressive, and so outrageously priced that nobody who thinks clearly would buy it. If someone does buy it then you need to immediately raise the price of the next masterpiece because this is not supposed to happen. When compared to your masterpiece, all your other pieces will seem "inexpensive".

When asked the price of your masterpiece, simply quote the price in a soft, unconcerned voice. Say, for example, "This piece is my largest. It is only $8,000." Most of your customers will yell, scream, and otherwise complain about the price. You can then mention that you have a slightly smaller piece for, say, only $5,000. If this is still too much, you can continue going down in size and therefore in price. Each time you do so, make sure to spend a lot of time explaining the advantages that each size offers. Do not move to the next smaller size too fast. Take your time.

9 – You must understand the 80/20 law: The 80/20 law stipulates that 80% of your profits come from 20% of your efforts. Once you find out what those 20% are you can maximize your efforts in that one area.

To find what your 20% are you simply look at your sales receipts:
- Find out what brings you the most income for the least amount of work.
- Look at the income versus work ratio.
- Make a ratio for all the different products you sell.
- The product for which this ratio is the lowest is the one you need to focus on.

10 – Know what your average sale is: You calculate your average sale by taking your total income from sales and dividing it by the number of sales you made. The number of sales you made is the number of invoices you wrote. If an invoice has several items on it, it is still considered a single sale.

It is best to make this calculation over a one-year period because a relatively long time-span will give you a more accurate result. However, you may want to know what your average sale is for a specific show, or a specific time frame. If such is the case it is perfectly OK to do so. The goal is to increase your average sale as much as possible.

11 – You need to find out where you fit in: Where does your product fit price-wise among other similar products your customers are buying? Is it more expensive, less expensive? Is it on the low end or the high end of the scale?

You do not exist in a vacuum. People who buy from you also buy from other businesses. People who buy your product (photographs are a product) buy other products as well. Which of these other products fit in the same category of purchases as yours? Finding this out will enable you to price your work more accurately.

12 – You must educate your audience as follows:
- Most people cannot tell average photography from good photography, or good photography from very good photography
- Most people do not understand how art is priced
- Your audience relies on your marketing to help them decide whether or not to buy your work
- Your marketing must focus on, among other things, educating your audience about your work. Therefore, your marketing must explain:
 - What makes your work unique
 - Why your work is priced the way it is (quality, leverage, reputation, etc.)
 - All other important aspects of your work

13 – The price of your work is only one of many selling points: When buying art, for many people the deciding factor is not price. Instead, it is one or more of the following considerations:

- Whether or not you can ship
- If your work will fit in their chosen location of their home
- If it is the right size
- If it is a landscape, whether they have been at the location depicted in the photograph
- If they are in love with the piece
- If the piece is available immediately or later
- The quality of the work
- The subject matter
- The colors
- The location
- The presentation (matting, framing, mounting)
- The personal style of the artist

- The uniqueness of the artist's style and of the subject matter
- The marketing approach used by the artist
- More ...

Product Cost Calculation Forms

As we saw earlier, knowing exactly how much it costs you to produce a product is essential. To determine this, you must account for each and every item that you used in creating your product.

This information will be very useful when it comes to calculating the cost of your inventory at the end of the year. Your inventory cost is the money you have tied up in items stocked for resale. If you stock ten framed pieces, then you are stocking ten times the cost associated with all the parts that go into making this framed piece.

Shown below are three forms used to calculate your cost of goods. These are the same forms that Natalie and I use to calculate the cost of goods of my fine art pieces.

Conclusion

Thinking about all the issues related to pricing your work takes us very far from creating photographs and enjoying the results in the privacy of our home. Certainly, if you decide to sell your work, you will have to wear two hats: that of a photographer and that of a businessperson. You will also have to schedule your activities so that you have time to market and sell your work as well as time to photograph and create new images.

So why should we bother with all this? In my case the underlying reason is two-fold. First, I want to make a living doing what I like. Second, I want to be in charge of my own destiny. Marketing and selling my work is the key to reaching these two goals, and I find doing this just as exciting as taking photographs.

Skill Enhancement Exercises

Exercise 1: The cost of doing business. Being in business costs money. List all the things you have to buy or pay for as an artist in business; things that you would not have to buy or pay for if you were not in business. These include the supplies necessary to create your work (paper, ink, matboard, etc.). It also includes things that are in excess of the cost of supplies, such as rent, utilities, insurance, fees, etc.

Exercise 2: Pricing. Decide on a price for each of the products you decided you were going to sell after completing the Skill Enhancement Exercises at the end of Chapter 5: *What to Sell*.

Calculate these prices based on the information featured in this chapter. Finally, calculate both a retail and a wholesale price.

Alain Briot – Beaux Arts Photography

Product name: Framed Photograph

Part Description	Cost each	Quantity x	Total cost for item
1 – Costs of your materials:			
Paper			
Ink			
Mat board			
Mounting Tape			
Dry mounting supplies			
Frame			
Glass			
Screws			
Wire			
Paper Backing			
ATG Tape			
Framing staples			
Print Label			
Other materials and supplies			
2 – Cost of your time:			
Number of hours spent creating product:			
3 – Wholesale and Retail factors:			
2× Factor = minimum wholesale price			
4× Factor = minimum retail price			
4 – Leverage factor			
→ Can be applied to retail & wholesale			
5 – Final wholesale price			
6 – Final retail price			

PO Box 12343, Glendale AZ 85318 · 800-949-7983 or 928-252-2466
alain@beautiful-landscape.com · www.beautiful-landscape.com

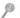 Full-sized downloadable forms and documents may be found at
www.beautiful-landscape.com/Briot_Marketing.html

Alain Briot – Beaux Arts Photography

Product name: Poster (also applies to DVD)

Part Description	Cost each	Quantity x	Total cost for item
1 – Design costs			
Layout/design (if done by hired designer)			
Layout/design (if done by you)			
=Number of hours spent creating product:			
2 – Poster costs			
Total cost for print run			
3 – Shipping costs			
For shipping files from you to printer			
For shipping posters from printer to you			
4 – Other supplies or expenses			
(if applicable)			
5 – Total all costs above			
6 – Divide this total by the # of posters			
7 – Wholesale and Retail factors:			
2× Factor = minimum wholesale price			
4× Factor = minimum retail price			
8 – Leverage factor			
→ Can be applied to retail & wholesale			
9 – Final wholesale price:			
10 – Final Retail price:			

PO Box 12343, Glendale AZ 85318 • 800-949-7983 or 928-252-2466

alain@beautiful-landscape.com • www.beautiful-landscape.com

Alain Briot – Beaux Arts Photography

Product name:

Part Description	Cost each	Quantity x	Total cost for item
1 – Cost of your materials:			
2 – Cost of your time:			
Number of hours spent creating product:			
3 – Wholesale and Retail factors:			
2× Factor = minimum wholesale price			
4× Factor = minimum retail price			
4 – Leverage factor			
→ Can be applied to retail & wholesale			
5 – Final wholesale price:			
6 – Final Retail price:			

PO Box 12343, Glendale AZ 85318 • 800-949-7983 or 928-252-2466
alain@beautiful-landscape.com • www.beautiful-landscape.com

The greatest education in the world
is watching the masters at work.
 MICHAEL JACKSON

Chapter 8
Best Sellers

Having a best seller is a goal for many photographers who are selling their work. In a way, a best seller is a guarantee that a specific image will bring a regular income over a long period of time. Having a best seller is therefore an important business asset.

Creating a best seller is a somewhat mysterious process with no hard and fast rule regarding how to do this. Often, it is somewhat of a surprise when a specific image turns out to be a best seller. And, just as often, images that we expect to become best sellers turn out not to be very popular with buyers.

However, there are a number of things that can be said about creating best-selling images. For example, there are specific types of images, locations, colors, print types, and more, that are known to sell particularly well. There is also a specific approach that you can follow to increase your chances of creating best-selling images.

In this chapter I will go through all of these points, starting with a description of the process I recommend to create best sellers and continuing with a list of best-selling subjects, print types, colors, etc.

Two Main Approaches to Creating Best Sellers

Creating a best seller does not have to be a conscious goal. You have, in this matter, two possible options open to you.

First, you can set out to create a best seller by following the advice in this chapter. If you do, chances are high that you will indeed create one best-selling image, or an entire collection. However, you will also create work that, to some extent, is somewhat cliché because you are following a recipe. There is no way around this.

Second, you can set out to create work that pleases you, regardless of what anyone else says or thinks, and not take into consideration any of the recommendations in this chapter. In this case you will be creating work that is uniquely yours—work that is personal and is motivated by your inner desire to express yourself and share with the world what you see in your mind's eye. The result, if you follow this approach to its full potential, will be work that has not been seen before, work that is new and that may not fall into the lists of best-selling techniques and subjects provided here.

Which of these two approaches you decide to follow is up to you. Personally, I have followed both. I started with the first option, creating best sellers purposefully, and I have been very successful with it. It did take me a number of years of trial and error, but I eventually created an image that sold extremely well at Grand Canyon National Park. Sales from that image alone, in a number of different sizes and presentations, over a period of several years, amounted to enough money to allow me to buy my first house with cash. I chose this image, titled *Yavapai Dusk,* as the cover image of this book because of its relevance to the topic of marketing fine art photography. It played an important role in my career and it is safe to say that without this one image I would not be where I am today. To this day this image is displayed prominently in my house, and is enjoyed by friends and visitors.

If you do decide to follow the second approach—that is, to follow your heart and create images that are meaningful to you regardless of their selling potential—I recommend you study my two previous books, in particular *Mastering Photographic Composition, Creativity and Personal Style,* which focuses on the development of a personal style and gives you all the information necessary to do so.

The Best Seller Creation Process

Let us now look at the process of creating a best seller on purpose. Let's say I photographed the Grand Canyon for a week with the definite goal of bringing back a best-selling photograph of it.

Setting such a goal is the key to success because once this goal is defined everything I do will be aimed at reaching it. If I did not set this specific goal, chances are I would get sidetracked into photographing things that are interesting, pretty, or unique but that have no chance of becoming best sellers.

Think of creating a best seller as being an assignment. You may not be working for an editor who is giving you this assignment, however, you can give this assignment to yourself. Doing so will immediately focus your efforts and give you a clear understanding of what you are looking for when photographing and, later, when editing your work and deciding which images you are going to keep.

Setting a specific assignment for yourself will also give meaning to your endeavor and provide you with a benchmark against which you can compare your results. There is nothing as effective as setting a goal beforehand to let you know whether or not you reached this goal when you look at the results!

In this example my self-assigned task is to create a best-selling image of the Grand Canyon. When my photography trip is completed and I return to my studio the first thing I do is edit my photographs by searching for those that come closest to the goal. Of course, there is some guesswork involved; but having this goal in mind definitely enables me to make a selection right

There is nothing as effective as setting a goal beforehand to let you know whether or not you reached this goal when you look at the results!

away. As in many things in life, starting with a goal in mind guarantees better results in the future.

When editing photographs with the goal of finding a best seller, I select the images that I believe will be popular with my audience. Being involved in photography as a business the way I am has given me the experience of knowing, to a certain extent, which images will be popular with my buying audience. This is certainly a big help when looking for best sellers.

A Gradual, Multi-stage Process

Of course, finding images that I think will become popular is not my only objective. I also look for images that are free of technical problems, have a strong composition, and have a unique light quality, among other things.

The selection process is a multi-stage process. In my case, I no longer rely only on my own judgment, as I know that I am too emotionally involved with my work to be objective about its selling potential. I know that I like certain images for reasons that have nothing to do with the visual content of these images.

Let me give you two examples using images that have become worldwide best sellers. The first of these two images is *Yavapai Dusk,* the photograph that I mentioned previously and which I often describe as having "paid for my house." If it had been my call, this photograph would never have been printed. Let me explain.

When I created *Yavapai Dusk* my goal was to create a best-selling photograph of the Grand Canyon. Armed with this goal in mind I scouted a suitable location for several days. I finally decided on Yavapai Point because it provides some of the most stunning views of the Grand Canyon from the South Rim. It also shows the Grand Canyon the way the majority of visitors see it.

The composition I selected involved using a small pinion pine whose appearance had been shaped by living on the canyon edge, exposed to brutal winds, merciless freezing conditions in winter and dire heat in summer. This, added to the nearly total lack of topsoil from which to derive nourishment, created a shape that only a bonsai master could improve on.

I had worked out a composition, lens selection, and camera position over an entire day. The main problem was getting both the pinion pine, which stood only a few feet away from the camera, and the canyon itself perfectly sharp while using a short telephoto lens to emphasize the size of the tree and the distant formations in the Grand Canyon. Once this was done I had to wait for the perfect light, which in this specific instance happened just prior to sunset and only lasted a few minutes. I also had to be there at a specific time of the year when the position of the sun is such that the mesas behind the pinion pine are in direct light while the tree itself is in the shade. My carefully designed plan of action for this image worked perfectly. Reassured that I had

the image on film, I relaxed and considered the possibility of creating a second image. However, the sun was minutes away from setting and if I were to do a second composition, I had to work very quickly.

In front of me the canyon turned orange, then red, then crimson—a color that I had never seen before. I set up my camera right along the canyon's rim to capture as much of this color as possible. I had no choice but to include part of a large pinion pine on the right side of the image. I did not change the lens, for lack of time, and focused the photograph almost intuitively. I adjusted the exposure to account for the fading light level, closed the lens, inserted the film holder, and released the shutter. I turned the film holder around and took a second photograph as the sun started to fade. As it would turn out, only the first exposure showed the crimson color. By the time I took the second exposure it was already too late and the color was gone.

When I received my film back from the lab I had all but forgotten about this second image. I reviewed the film to see if I had captured the one I worked so hard at creating and I saw that I succeeded. I had not only a vertical version of this image but also a horizontal, both perfectly sharp and well exposed. I took only a passing glance at the second image I created that day and focused instead on creating a 40×50 print of *Yavapai Tree*.

An intended best seller is only a best seller if people buy it. In the case of *Yavapai Tree* the public's response was not what I expected. It's not that people didn't like it. They did. They just didn't like it as much as I liked it. It sold well, but it was not a runaway success. Why? It's hard to say. If I knew, I would be creating best sellers everyday! I think it was essentially because customers saw the tree, which to me was an artistic element, as obscuring part of the canyon, so that the Grand Canyon was not shown as much as it could have been. People wanted to see the Grand Canyon, not a tree in front of the Grand Canyon. The fact that the tree had a uniquely artistic shape was not doing it for them.

In my quest to find the best seller I was seeking, I went back to my film file and took a second look at the images I had taken that fateful day at the Grand Canyon. I had only created three images: a horizontal and a vertical composition of *Yavapai Tree* and the horizontal image that I now call *Yavapai Dusk*. I had tried to sell both the vertical and the horizontal versions of *Yavapai Tree* with limited success. If there was a best seller in this shoot, what I had to do was quite simple: I needed to print, mat, and frame the third image and see what would happen in regard to sales.

I honestly expected that this third image would suffer a worse fate in terms of sales than the two others. I was little prepared for what was to take place. We sold out of every size, both matted and framed, of *Yavapai Dusk* on the first day of a seven-day show. We were left to contemplate how much better we could have done if we had brought an inventory sufficient to last the whole show. At the next show we brought a much larger inventory of *Yavapai Dusk,* one that we believed would carry us through, yet we found our stock depleted, in all sizes framed and unframed, after only three days.

It took us four shows until we brought a stock of *Yavapai Dusk* large enough to last us a week. Even then, we would run out of certain sizes, as well as of matted and framed versions, no matter how many we brought. Until we stopped selling at this particular show, we were unable to carry enough inventory of this specific image to see us through an entire one-week show. We were facing a production as well as a carrying-capability problem. We could only make so many in the time we had available between two shows and we could only carry so many in the space we had available in our vehicles. I know it is hard to believe and I know that it is a good problem to have. However it was a serious problem and we needed to find a solution.

The only viable solution was to offer certain sizes on a "ship only" basis to make sure we had a display piece available for the entire show. "Ship only" pieces are pieces that are displayed and sold but that customers cannot carry away with them. Instead, these pieces are shipped to customers. We did this to make sure that we had these pieces on display for the entire show. Once back home we would print, mat, frame, and ship however many pieces of that framed size we had sold. We would then prepare for the next show and do it all over again.

Involve Other People in the Selection Process

The above example shows how difficult it can be to select the best images from a shoot. Eventually, once you have reduced the images to those that are technically perfect, it all boils down to a matter of taste. Therefore, unless your goal is to please yourself and nobody else, it makes complete sense to have other people help you make the final selection, or at least give you their advice.

In my case I often ask Natalie, my wife, for her opinion. While she is often present when I photograph, she does not look at the photographs from the same perspective. She looks at them from a more audience-based perspective. Without her advice I would not have printed several images that have become best sellers. For this reason I strongly recommend that you have your spouse, significant other, friends, or relatives, look at your work and give you their opinion. The goal is not to have them critique your work. The goal is to find out which images they like and which images have the potential of becoming best sellers.

What Makes a Best Seller?

Is there any way to actually tell if an image will become a best seller? With over 20 years of experience behind me, and with tens of thousands of images sold, I have enough knowledge of what makes a photograph popular to make

an educated guess about which ones have a chance of becoming best sellers. However, both good and bad surprises are common. Often, what I think will sell well doesn't and what I think will not sell becomes popular. The variables are many and include not only what your photograph depicts, its technical qualities, and the way it is presented but also, and sometimes mostly, what your customers are looking for at a given time.

A variety of factors contribute to the creation of best-selling images. Often, as we will see, it is not a single factor that makes a photograph a best seller. Instead, it is the sum of several different factors that, when combined in a single image, add up to make the image irresistible and something that people feel they have to have.

Print Types that Sell Best

- High contrast photographs
- Highly saturated photographs
- High contrast and highly saturated photographs
 - People love the combination of high contrast and high saturation!
 - This explains why Velvia photographs printed on Cibachrome sold so well in film days.
 - Today this look can be easily created in Photoshop.

Colors that Sell Best

- Reds in cold climates and just about everywhere else
 - Red is the least common color in nature.
 - Red is the color people are most attracted to.

- Blues in warm and in dry climates such as deserts
 - Blues make the viewer think of water and metaphorically give a feeling of coolness.
 - Photographs with blue waters are very popular (see waterfalls, below).

- Fashionable or "trendy" colors
 - Your photographs may sell because their colors match the proverbial couch, in other words the color scheme of the buyer's home décor.

Subjects that Sell Best

- Popular and famous locations
 - Photographs of popular locations in the area where you are selling sell well.
 - Find out what the most popular areas are, photograph them, and have these photographs available during shows or in stores in that area.
 - Your "locations collection" can be adapted to the different areas where you do shows, or sell in stores, by changing which collections you show at the different shows or stores, and by always focusing on local scenery.
 - What sells well in one location may not sell well, or at all, in another location. For example, Paris photographs did not do well at all at the Grand Canyon because people wanted photographs of the Grand Canyon, not photographs of other locations.
 - Understandably, people want to purchase images of the location they are visiting. How well your photograph depicts this location is the key to its success. People often want a photograph that shows the location the way they saw it. For this reason "creative" or "artistic" photographs do not always sell well.

- Flowers
 - Flowers sell very well and never fall out of fashion.
 - Irises are particularly popular. You cannot go wrong with irises!
 - Photograph just the flowers and nothing else.
 - Working in a studio makes things easier. You have no wind, you control the lighting, and you control all the other variables.
 - Use a plain background, such as a black cloth or other solid color, to simplify the image.
 - Think of this process as creating "flowerscapes."

- Photographs related to a specific activity
 - The activity must be practiced by the audience you are targeting. For example, a golf audience will be interested in golf courses from all over the world. Having such a collection and making sure it features the most popular and challenging courses and holes is guaranteed to be successful. You just need to find shows that golfers attend and sell your work there. The Pro Shops on the golf courses may also be interested in carrying your work.
 - In such a case, be sure to get permission before taking photographs because you will be photographing private property. You will also need the owner's permission to sell the photographs.

- The same approach can be used with just about any activity.
 - Skiing
 - Car racing
 - Snowboarding
 - Mountain biking
 - Mountain climbing
 - You name it!

- Slot canyons
 - The polished and flowing shapes found in slot canyons fascinate people.
 - The color saturation and the unique light quality also fascinates people.
 - It is a semi-abstract type of scenery and it works very well as wall décor.
 - The endless possible interpretations of slot canyon images leave room for the viewer's imagination and makes the image a subject of conversation.

- Horses
 - Horses running, herds galloping, etc.
 - Horses portraits.
 - There are many people who love horses and/or who have a horse.
 - Because horses are difficult to photograph, people who like horses look for professional images to display in their home or office.

- Photographs featuring water scenes (waterfalls, seascapes, lakes, ponds, etc.).
 - These are popular to decorate washrooms, bathrooms, laundry rooms, etc.
 - Because water scenes are soothing, they also sell well to decorate other locations in homes and offices (see the section on blue colors above).
 - Water is also the source of life and it is beautiful to look at.

- Subjects that are uncommon or difficult to photograph
 - Night photography.
 - Night photographs with artificial light added.
 - Star trails and star fields.
 - Horses, as we saw previously.
 - Underwater scenes.
 - Any subject that people love but have been unable to capture themselves in photographs.

- Exotic destinations
 - The specific destinations are subject to trends, fashion, and news.
 - In Europe, the most popular countries are:
 - France
 - Greece
 - Italy (Tuscany, primarily)
 - England
 - Typical village scenes are particularly popular.
 - They create a nostalgic and exotic feeling.
 - They complement home décor trends, such as Italian or French.
 - They show things and places like they were in the past.
 - The most successful images are those that have a romantic feel to them.
 - Images need to be devoid of modern devices (cars, modern appliances, etc.).
 - Images sell best when they show pre-industrial age scenes, which means farming scenes, fields, farming village, farmer's markets, etc.

- Reflections
 - Reflections are beautiful and have an intriguing quality.
 - People do not know how to photograph reflections.
 - People also do not notice reflections in the real world.
 - Photographs showing only reflections are popular. These are images in which no other part of the landscape is shown.
 - Photographs showing both the subject and its reflections also work great.

- Single trees shown alone and centered in the landscape
 - You cannot go wrong with photographs of single trees!
 - They sell well just about every time.
 - They have a metaphorical quality that talks about loneliness and strength.
 - They touch something deep within us and have a lot of meaning to many people.
 - Always photograph single trees when you see them!

Photographic Formats that Sell Best

- Horizontal panoramic photographs
 - These were uncommon and hard to find until recently.
 - They fit conveniently over a couch, a bed, or over any furniture where the wall space is wider than it is tall.

- Vertical panoramic photographs
 - They fit in tall narrow places such as at the end of a hallway, on pillars between rooms, in stairways, and in entryways.

- Very large photographs
 - These were uncommon and hard to find until the advent of large format inkjet printers.
 - Many people still think that only top-of the-line photographers can make huge size prints.
 - Large photographs are necessary to decorate very large spaces and walls.
 - Contemporary homes often have large wall spaces.

- Small photographs
 - There is also a need for smaller size photographs to decorate intimate areas.

Framing and Mounting Styles that Sell Best

- Photographs printed on canvas and stretched on stretcher bars
 - When printed on canvas photographs look like paintings. This increases the perceived value of the photograph. It also places the photograph at a price point comparable to paintings. This means you can sell the photograph for a higher price. Limiting the edition through numbering further increases the perceived value. The photograph does not need to be framed because people love the simple look of an unframed stretched canvas.
 - A gallery wrap presentation can be used. This means printing the image larger so it is extended to the edges of the canvas. This presentation can make a canvas print an even better best seller.

- Photographs framed in very wide frames
 - A wide frame is a frame anywhere from 5" wide and up. This presentation gives a powerful and gutsy presence to the piece. Most people are not used to seeing photographs framed with very large frames.

- The frames are almost always wood. The wood can be left natural or painted black or some other color.
- This presentation dramatically increases the perceived value of the photograph.

- Photographs framed without glass
 - The photograph can be dry mounted on various supports, such as aluminum, wood, Gatorboard, plexiglass, etc. When no glass is used the photograph needs to be laminated to prevent damage to the print surface.
 - Or the photograph can be adhered under optical-quality plexiglass. This adds shine to the image and increases contrast. This is a relatively new process, and customers are often not familiar with it and are not sure how it is done. There is a sort of "mystery" regarding how the print is mounted. The process is seen as being "exotic" and this increases both interest and demand.
 - The lack of frame gives a very contemporary look to the piece and focuses the viewer's attention on the photograph rather than on the frame.

- Photographs matted in canvas-covered mats
 - This presentation is not seen often by customers and has an uncommon yet classical and refined quality.

- Photographs matted in black, canvas-covered mats
 - This presentation also has an uncommon quality. The interest is the dramatic presentation created by using a wide black canvas mat. A white mats offer a quiet presentation while a black mat creates a dramatic presentation by drawing the viewer's attention to the image.
 - Black also increases the perceived color saturation of photograph. This creates a powerful presentation guaranteed to generate maximum impact.
 - A black mat makes the photograph look brighter than a white mat and also isolates the image from its surrounding in a dramatic manner. Therefore, the image stands out more than when matted in white.

- Photographs matted in decorated mats
 - These are popular with an audience looking for decorative rather than fine art pieces. They can be customized for different geographical areas. Simply use décor items related to the cultural and natural items found in that area.
 - See example at the end of this chapter.

- Triptychs and other multi-image presentation
 - Several images matted, framed, or mounted together sell very well. Tripychs—three photographs matted or framed together—are the most popular presentation.
 - An excellent approach is to select photographs with a similar theme, such as three photographs of rainbows. Or three photographs of horses, flowers, slot canyons, moonrises, lightning, etc.
 - See example below.

Where Photographs for Décor Can Sell

- Home décor
 - Keep in mind that all rooms in a house can be decorated with photographs, not just the main living areas. People will buy photographs for a hallway, a laundry room, etc. Even walk-in closets can be decorated with photographs.
 - Do not forget the garage! Car photographs sell well for garages.

- Workplace and corporate decor
 - Boardrooms, hallways, bathrooms, waiting rooms, and private offices all need wall décor. You can create specific photographs with a "corporate feel" for these locations.

- You can sell photographs to decorate a wide variety of locations
 - Do not rule out any location. I have even sold photographs to decorate RVs!

Best Seller Examples

The next best seller? – In photography, as in other marketing endeavors, one always tries to secure a best seller. What makes people tick, or in this case reach for their wallets, is always elusive. To continue photographing in hope of capturing the one that will make it all worthwhile generates motivation.

Condor, Grand Canyon National Park, South Rim — In the search for best sellers, rare, uncommon, or newsworthy subjects can be valuable additions to your photographic collection. Condors were recently re-introduced to Grand Canyon National Park and this event has generated a lot of media coverage. Visitors want to bring back photographs of this elusive raptor, and if you have the goods you may be in business.

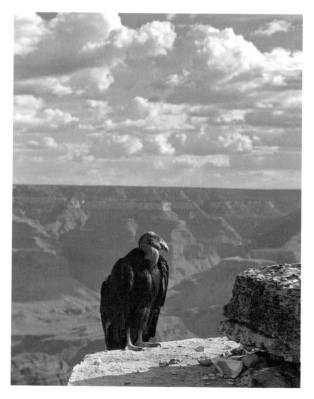

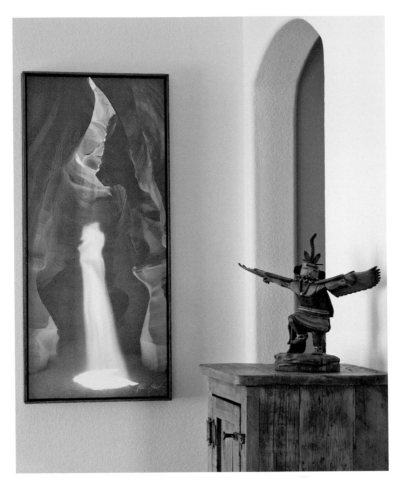

Vertical panorama of Antelope Light Dance – Vertical panoramas have become popular items because they fit in areas where no other format will fit. Here, a vertical panoramic version of *Antelope Light Dance* is exactly what is needed to fill the space between the window and the filing cabinet.

While this piece is not as impressive as the original 4×5 ratio version of this popular photograph, it does look very nice, especially when the larger version is not there to offer a direct comparison.

Yavapai Dusk displayed in a home setting – Sales from this image alone brought in enough money to allow me to pay for my first house in cash. I chose it as the cover image for this book because of its importance in the context of the book. It is safe to say that without this one image I would not be where I am today.

Navajo Mustangs in a home environment — This photograph of running horses—a popular subject, as I explain in this chapter—is 75" wide. Yet, it barely covers the space over this sofa, which means it could be quite a bit larger and still not be too large. In today's homes, wall space is plentiful and large pieces are often required to fill large spaces.

If you cannot make the piece any larger, because of image resolution, printing capabilities, or some other constraint, you can always use a wide molding to make the piece bigger while keeping the print size the same. If this photograph WERE framed in a 6" wide molding, this piece would become 87" wide—a foot wider than it is now—and may work better as a wall display in this location.

Three Natural Phenomena triptych – Sometimes a best seller is the result of a combination of elements. In this instance the framing, the matting, and the selection of photographs all combined to create a piece that literally "flew off the walls" when we sold our work at Grand Canyon National Park.

Capturing a lightning strike, a moonrise, and a rainbow is something challenging for many tourists. Framing them together as a triptych increases the excitement by displaying all three together. The best-selling format of the triptych itself adds another level of excitement to this piece. Finally, the Italian, burl-inlayed frame is a best-selling frame and the Southwestern mat decorations are also very popular.

With all these best-selling factors brought together in a single piece, it is no surprise that we could hardly keep these in stock! In fact, we ran out of these at just about every show.

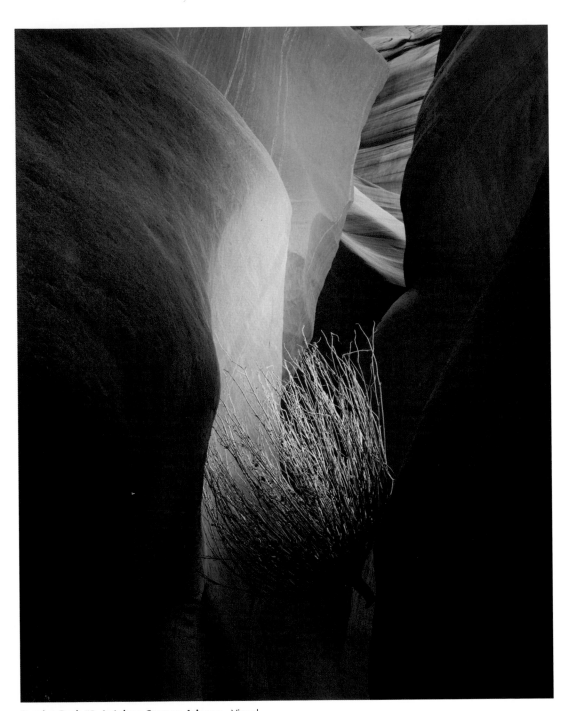

Burning Bush #3, Antelope Canyon, Arizona — Visual metaphors can be very powerful. Relatively few people in the world have been to Antelope Canyon, where this image was created. However, the title points to a story known to many.

Conclusion

Creating a best seller can be challenging, but once you succeed the rewards are certainly worth it. One of the main decisions you will have to make is whether to proceed by using the list above, or whether you prefer to follow your own inspiration and create a best seller that is truly representative of your vision and inspiration.

While the second approach is more difficult and will take more time to complete, it is, in my opinion, the better of the two. Not only will you prevent being blamed for "selling your soul," you will also, potentially, be able to create a best seller that will outdo the salability of any "manufactured" best seller. Why? Because you will be the only one to have this image. Others will have to copy you and that is always difficult to do. In the arts, as in sports, it is easier to lead than to try to catch up.

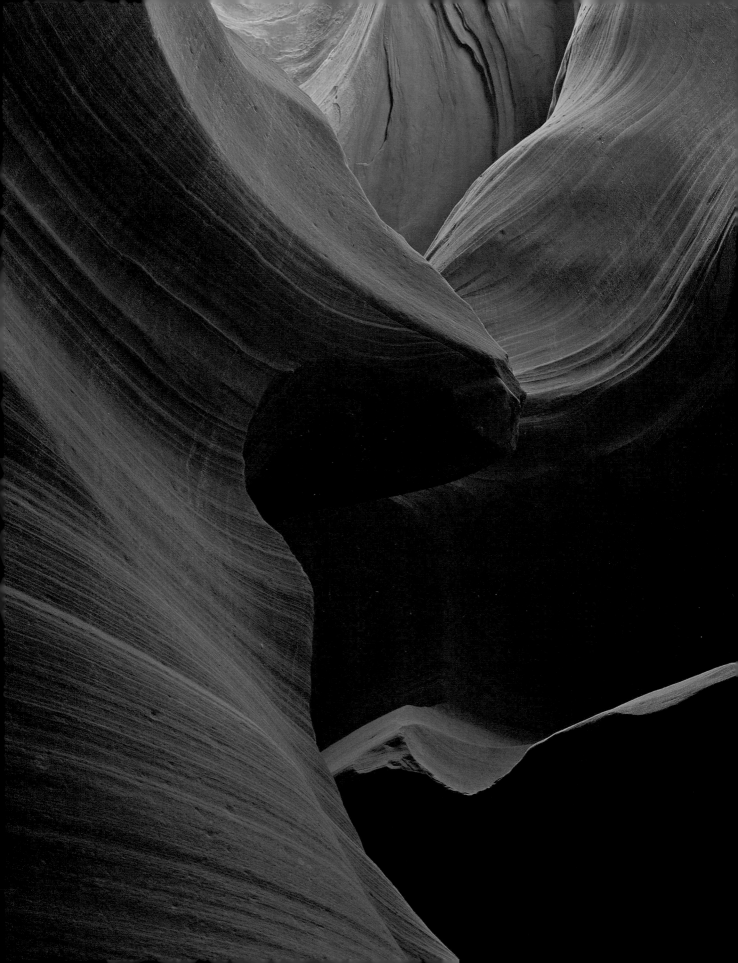

THE FUNDAMENTAL ASPECTS OF MARKETING, SALESMAN-SHIP, AND BUSINESS

For a business not to advertise is like winking at a girl in the dark.
You know what you are doing but no one else does.
 STUART H. BRITT

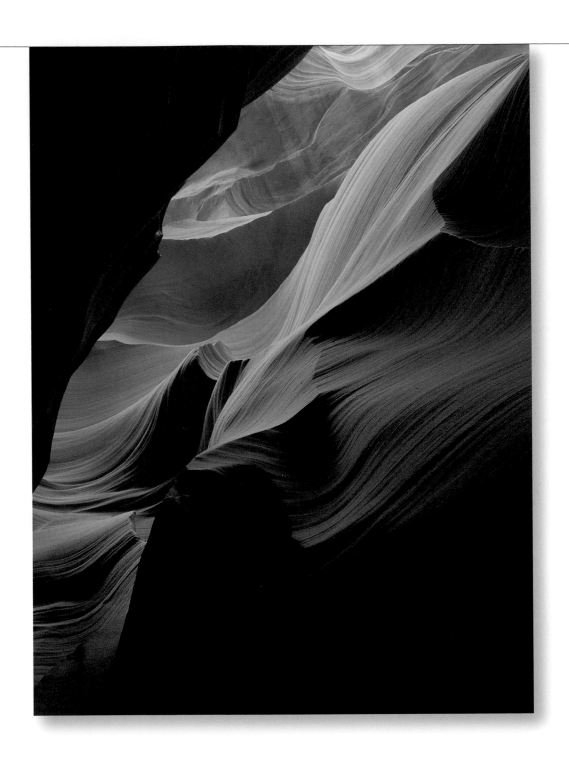

Chapter 9
The 26 Fundamental Principles of Successful Marketing

In the following three chapters we will focus on some of the fundamental aspects of doing marketing, of being a salesperson, and of running your business. These are the principles that are at the very foundation of doing business and of selling your work.

These fundamentals are not affected by technological progress. They do not change when technology changes. We live in a world in which new marketing vehicles and new channels of communication are constantly offered to us: print on demand, self-publishing, email, the Internet, Facebook, and Twitter—and much more—have all surfaced within the last 15 years. Yet people were doing business successfully long before all these new technologies and forms of communication appeared. Furthermore, the same people continue to do business successfully today using these new technologies. Why do these people continue to be successful? They are successful because they have adapted the fundamental principles of marketing, salesmanship, and business to these new communication venues. Successful marketers know that regardless of what new marketing venues may come up next, the fundamental principles of marketing will continue to apply. They know that to be successful you do not need to reinvent the wheel—all you need to do is use it.

In this instance the wheel metaphorically stands for the fundamental principles of business, marketing, and salesmanship, all of which were invented a long time ago. All we need to do is adapt them to the new marketing venues that are available to us today and to the new marketing venues that will be offered to us tomorrow.

The contents of the three fully packed chapters in this section are based on my years of experience in selling art and photographs. I strongly recommend that you refer to them when you are preparing new marketing materials, when you are doing shows, and anytime you are marketing and selling your work. Keep a copy handy and study these fundamentals when you have free time or when sales are not up to the level you would like them to be.

The Difference Between Marketing and Salesmanship

Though marketing and salesmanship are closely related, in practice the two do not take place simultaneously. Marketing is the process of presenting your product to your buying audience. Marketing is concerned with presentation, market placement, image, packaging, and advertising. Salesmanship is the process of actually selling your product to your customers, usually in person. Salesmanship is concerned with what you say to your customers, how you respond to their questions, and how you address their concerns.

As an artist in business, you may be the only person running your business. If so, you are responsible for both marketing and selling your work. You therefore have to learn and master both marketing and salesmanship to become financially successful. Chapter 9 covers the 26 fundamental principles of successful marketing. Chapter 10 features what I consider to be the 26 fundamentals of successful salesmanship.

Chapter 11 features the seven fundamental principles of a successful business. You will no doubt notice that there are some crossovers between marketing, salesmanship, and building your business. Many things are similar, no matter what the endeavor is, be it designing a business plan, creating a marketing campaign, or using salesmanship to sell your work. This is good news because what you learn in one area will be applicable to other areas of your business.

Principle #1 – Hard Work Alone is Not Enough—You Must Have a Plan

Hard work and long hours alone will not generate success.
You must have an organized plan.
Dale Carnegie

The most important action you will ever take toward success in your photography business is to devise a plan of action complete with specific goals and deadlines. This plan will guide you each step of the way as you build your business.

Hard work alone is not enough. Working hard without a plan of action does not lead to success. I often compare this to driving fast without a map. Driving fast in the wrong direction will not get you where you want to be. You must have a clear destination in mind and your route must be carefully laid out. The same thing applies in business. You can work very hard yet not reach your goals if the work you are doing does not follow an organized plan. Hard work only needs to come after the plan has been put together, so your hard work will then be placed at the service of your objectives. The outcome will be a productive effort aimed at reaching your personal goals.

I suggest that you do not make concessions when you first outline your goals. Stick with what you really want to do. If you make concessions at the beginning, you will never stop making them. Later on down the road, depending on what happens, you may find it necessary to make changes and

concessions. Remember, you are doing this because you want to. Keep it fun. Keep it the way you want to do it. After all, you are the boss!

Principle #2 – Do What Others Are Not Willing to Do

Success is uncommon. For each successful individual there are hundreds who fail. In sports, regardless of how many enter a competition, there is only one winner. If 20 participants enter a race, 19 will lose and one will win. Failure is more common than success. Most of those who fail do not fail because their work is not good enough: they fail because they are not willing to do what it takes to succeed.

If you are successful, many will think you were lucky, or that you were at the right place at the right time, or that you were an opportunist. While some or all of these assumptions may be true, none of these alone are enough to generate success. To be successful you must have a plan, be willing to work hard, and be willing to do what others do not want to do.

Principle #3 – Decide Between High and Low Volume

As soon as possible you should decide between low or high volume. As we saw in Chapter 4, you cannot do a "medium volume" business. If you decide to do medium volume you will soon veer toward either high volume or low volume. You will also lose valuable time deciding which way to go and in turn you will lose a lot of money.

In the fine art business, high volume translates into selling a large number of low quality pieces at a low price. Low volume translates into selling a small number of high quality pieces at a high price. As we all know, we get what we pay for. Since you are now the manufacturer, it is your customers who will get what they will pay for. What do you want them to get? Personally, both as a customer and a businessperson, I favor the low volume approach. It is up to you to decide which approach you will implement.

Principle #4 – Generate a Large Demand for Your Limited Product

For a low volume selling approach to work, you must generate a large demand for your limited product, and you must control the volume of sales with the price. If you do not generate a large demand, the low volume approach will not work. You must create a large pool of potential customers because a lot of people will find that your prices are too high and will not buy from you.

If you only have a small audience, you will turn away just about all of them. However, if you have a large audience, there will always be some who are willing and able to purchase your product at the price you are asking.

Principle #5 – Control the Volume of Sales by the Price

Once you have a large audience considering whether or not to buy your product, you control the volume of sales by the price. If your prices are low you will generate a large number of sales. If your prices are high you will generate a smaller number of sales.

Knowing this, you can adjust the number of sales by adjusting your prices. Raising your prices will reduce your number of sales while lowering your prices will increase your number of sales.

Principle #6 – Spend at Least 50% of Your Time on Marketing

It is essential that you create a marketing campaign, test it, implement it, and fine-tune it. And that all takes time. If you are just starting your business and you have not marketed your work before, you will need to spend from a minimum of 50 percent up to 75 percent of your time on marketing.

If you are doing high volume, you will most likely be unable to find enough spare time to market your work as much as you should be. This is another reason I strongly recommend focusing your business on low volume sales. Only a low volume selling approach will give you enough time to market your work effectively.

Principle #7 – Develop an Interactive Marketing Plan

To be successful you must implement an interactive marketing system with parts that are designed to work together. You cannot depend on a single source of income as that one source could dry up at any time and leave you without any income. Therefore, you have to generate your total income through various types of sales.

Your various sources of income must also be related to each other. Only then can your marketing be integrated into a system in which all the parts work toward a single goal. For example, if you generate some income with non-photography-related products, you will not be able to market these products in the context of your photography marketing program but will have to market them separately. This will generate extra work for you and eventually something will have to give because you can only do so much.

Therefore, it is important that your various products are all related to each other so that they can be marketed together.

Principle #8 – Implement the Four Legs Approach

When you have not one but several sources of income, each of these sources of income becomes one of the legs of a four-legged table. If you cut off one of the legs, the table will tip over but will not fall completely to the ground. You would have to cut all four legs for the table to fall completely flat.

Having several different sources of income prevents your business from going under if you lose one or more of your sources.

You must have at least four different sources of income from your photography business. There is no maximum number for your different sources of income; you can have as many as you want as long as you do not overwork yourself. These different sources of income can include:

- Print sales at shows
- Print sales via your website
- Print sales through galleries
- Wholesale sales to stores
- Stock image sales
- More...

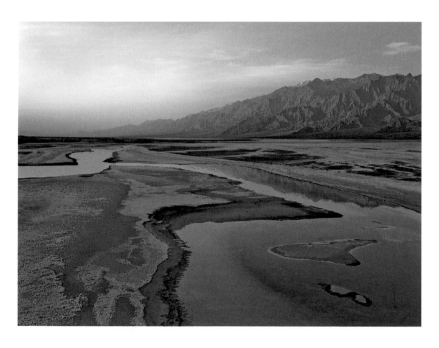

Death Valley Playa Lake – Sometimes unique weather conditions allow you to create photographs that are not only uncommon but are also very rare. This lake at Badwater in Death Valley appears very rarely. Its presence is dependent upon heavy rainstorms, something that happens extremely rarely in Death Valley.

The possibilities are endless. What matters is that you have at least four sources of income. If one source does not provide income, or provides insufficient income, you still have the others to keep you in business. Your "table"—your business—will not collapse!

Principle #9 – Market or Nothing Will Happen

You must market your work. It is not a matter of *if* or *when,* it is a matter of whether you want to be successful or not. You cannot say that your work does not sell or that people do not want to buy your work unless you make a fair attempt at marketing it. If you do not market your work you can only expect one thing to happen: nothing.

A fair attempt to market your work should be expected to take one to two years at minimum. Only after this period of time will you be able to make an educated conclusion about the quality of your marketing campaign.

Principle #10 – Market in Both Good and Bad Times

Your marketing budget should be a percentage of your gross income. I suggest you start by setting your marketing budget at around 10% of your gross income. As your income increases, your marketing budget will increase as well. The more successful you are, the more marketing you can do and the more exposure you can give to your work. You are not marketing because you are *not* doing well. You are marketing because you *are* doing well!

This is the best way to ward off the competition. You will reach a point where your competition will simply not be able to afford the marketing that you can afford.

Since marketing defines success, by following this approach you guarantee continued and ever-increasing success.

Principle #11 – Know Why You Are Successful

It is very important that you know why you are successful. If you do not know why you are successful you will not be able to achieve continued success and you will not be able to go beyond a certain level of success. In Chapter 15: *Personal Skills* we will examine the many rules that define success. Refer to this chapter for more information on knowing what makes people successful.

Principle #12 – Do Not Try to Please Everyone

Decide what you want to do, as well as what you do not want to do—and adhere to it. Once your marketing system is in place, stick with it. If you decided not to do "x" and someone calls you and asks if you can do "x," stick to your decision. Remember, you cannot be all things to all people. You cannot do everything and you only have so much time to devote to your photography business. Spending your time on things that are not part of your goals means having less time to spend on achieving those very goals.

You must be in charge of your business; do not let your customers run your business. Never forget that you are the boss! You are the one who decides what you are and are not willing to do.

Principle #13 – Final Profit, Not Income, Is What Matters

You need to calculate your costs precisely (see Chapter 7: *Pricing Your Work*). Make sure you take into account *all* your expenses. It is easy to forget some of your costs or think that certain things are not actual expenses.

Once you know your exact costs you will be able to calculate your actual profits. Doing so is easy: simply deduct your costs from your total income and what is left is your gross profit. From this gross profit you must remember to deduct the amount of tax you will pay to the IRS. For example, if your tax rate is 30% of your adjusted income (adjusted income being what you earned minus your expenses and deductions), then your final profit is 70% of your adjusted income. Your final (net) profit is the amount of money that is yours free and clear.

These calculations might seem tedious, and in a way they are. However, doing this will prevent you from spending money that is not part of your final profit. You certainly do not want to confuse income with profit because doing so may cause you to spend money that is owed to the IRS, or money that you need to pay to your suppliers or other bills. You can quickly get in trouble if you spend this money. However, you can just as easily stay out of trouble by saving this money in a separate bank account until it is owed. By not considering this money yours you will always have it available when it comes time to pay your bills.

Principle #14 – Know and Apply the 80/20 Rule

The 80/20 rule dictates that 80% of your profits (not your gross income) come from 20% of your efforts. To word it differently: 80% of the money you keep comes from 20% of the work you have done.

The sooner you find out what that 20 % of your work is, the sooner you are on your way to making a fantastic income as a photographer. Find out where 80 % of your profits come from and you are on your way to running a very successful business.

Principle #15 – Know your Average Sale

You need to calculate your average sale and bring it to the level you want. As we have seen, the number of prints you sell is not necessarily a measure of success. This is because you can sell a lot of prints but generate only a small profit. A more reliable measure of success is to calculate your average sale. Simply divide your total income for a show, or a year, or any span of time you are interested in evaluating by the total number of sales you had in that same amount of time. For example, if you made $10,000 and had 100 sales, your average sale would be $100.

When selling fine art I recommend that you work toward bringing your average sale price as high as possible. The only way to raise your average sale is to sell fewer pieces at a higher price. How high should you go? This depends on the market you are in. You certainly do not want to price yourself out of your market (meaning that no one is able to afford your work), but you do want to price your work high enough that you do not need to make a huge number of sales to make the income you desire.

Principle #16 – It's a Free Country!

If other people criticize your marketing or your pricing, let it be. The amount you charge and how much you market your work is entirely up to you. You are the boss and you are free to run your business the way you want to, as long as you are honest and you are not breaking any laws. What is tremendously important is that your customers *understand* why your prices are what they are. This can only be achieved through marketing—by explaining to your customers how they *benefit* from doing business with you and purchasing your work.

Principle #17 – Raise Your Prices Regularly

You need to raise your prices by 10 % to 20 % once or twice a year. This is very important. Everything goes up in price over time; therefore, your work needs to go up in price as well. Most artists price their work way too low and rarely raise their prices. In fact, many artists price their work at wholesale prices in a retail situation, which means they could double their prices overnight and be

priced just right. The same artists keep their prices the same year after year, even though their own expenses increase regularly. As a result, their income decreases further and further. When they finally realize that they need to increase their prices it is often too late to implement just a small increase. Instead, they have to double their prices (or more) overnight, and the result is that most of their customers can no longer afford their work. This is a situation that you want to avoid. Therefore, I recommend that you raise your prices slightly, by 10 % to 20 % once or twice a year, depending on the economy and on how comfortable you feel regarding your sales.

By using this approach your prices will increase regularly without this increase being noticeable. Nobody will object to a 10 % to 20 % increase. In fact, most people will not even notice. But everyone will notice if you double your prices overnight.

Using a discrete approach to price increases will also allow you to take your work to an adequate price point over time. Regardless of which price you start with, by raising your prices regularly, year after year, you will eventually price your work high enough to generate a solid income from a small number of sales.

Never forget that people who love your work will buy from you despite price increases. This is because people expect products to increase in price regularly. People will also not mind your price increases because, if you follow my advice, you are not selling on the basis of price. Instead, you are selling on the basis of your personal style and on the investment value of your work. When an investment goes up in price, this is good news. This is why it is important that you create quality work in small quantities and that you sell this work on the basis of your personal style. All these factors play an important role in helping your customers perceive your work as an investment and not just as a commodity.

Principle #18 – Build a Contact List

You must build a contact list of your past and potential customers and you must contact them regularly. Collect the email address, physical address, and phone number of people interested in receiving information from you. You can do so every time you have contact with the public and everywhere you are showing your work. Assure your clients that this information will not be used for any other purpose. Locations favorable to building your mailing list include your website, art shows, other places where you are showing your work physically, when speaking with people that you meet during presentations of your work, and more.

Once you start building your mailing list, you can mail, email, or phone your customers to share such things as news about your work, ongoing special offers, and upcoming events.

Principle #19 – Take Advice Only from Those Who Are Where You Want to Be

Do not listen to the advice of those who are not where you want to be. Do not listen to those who have not tried to do what you are doing yet tell you it cannot be done. Since they have not been where you want to go, their advice will be dead wrong for you. Take advice only from photographers or business-people who are where you want to be.

Also, be very careful of the company you keep. Stay away from people who have a negative attitude and people who keep telling you that you cannot do this or you cannot do that. Instead, spend time with positive people who believe in you, listen to your ideas, and help you reach your goals. If you cannot find such people, stay by yourself and work on your marketing, which is better than listening to negative feedback that denigrates what you are trying to accomplish.

Winged Car and Concrete Teepees, Route 66, Arizona – There is a market for specialized imagery, such as this photograph of a scene right out of the 1950s. This type of image belongs to the "nostalgia" category.

Principle #20 – Do Not Reinvent the Wheel

Remember, the wheel has already been invented. All you need to do is use it. Marketing experts and successful photographers have developed highly successful marketing systems. Instead of spending years reinventing what they have already discovered, learn from them! Take classes, read their books, and attend their seminars and conferences.

You will have to spend money to acquire the knowledge needed to market your work. If you do not spend this money the only way you will learn is by attending "the school of hard knocks." I have been there, and believe me, I do not wish anyone to be accepted at this school! I thought I would never graduate and I was certainly glad when the beating I was experiencing while trying to learn everything on my own stopped. The beating ended the day I hired someone with the proper experience to help me. I would not be where I am now and I would not have moved forward as fast as I did had I not hired experts to help me along the way. There is no glory in doing everything by yourself. All you get by doing so are hard knocks and wasted time and money.

Principle #21 – Shows and Other Direct Selling Venues Are a Great Way to Start

Shows will allow you to:
- Test the market and see the response to your work
- Start with a low minimum investment
- Do only as many shows as you feel comfortable doing
- Do more shows as your business grows
- Learn from other artists
- Have direct contact with your buying audience
- Get feedback from customers
- Make sales
- Find out which images are your *best sellers;* that is, which images your customers prefer
- Get exposure
- Start getting name recognition
- Try your marketing strategy
- Build your customer contact list
- Promote and advertise your website

Principle #22 – Pricing Determines Everything You Do

Price determines:
- How much respect you get from your customers
- How much profit you make
- How hard and how much you work
- If you go on vacation
- Where you go on vacation
- Where you live
- What car you drive
- Which school your children go to
- What you sell
- Who your customers are
- Who you work with
- Much more... Add your own examples to this list

Principle #23 – People Buy Art for Emotional Reasons

This is very important and usually overlooked by photographers who spend most of their time telling their customers about the cameras, lenses and other equipment they use to create their artwork. You see, while equipment is important to you, equipment does not mean much to non-photographers because they are not familiar with photographic equipment, they cannot relate to it, and what equipment you used is unemotional to them.

People do not buy photographs based on the equipment you used. People buy photographs because they have an emotional attachment to your work. Therefore, you are better off talking about the emotions you felt when you took each photograph, as well as the feelings you want to share in your work. Tell your customers stories about how you created each photograph, and tell them emotional stories. This is something your customers can relate to because everyone can relate to emotional stories. This is something that they will remember. And because of your stories, they will buy your photographs.

Principle #24 – Display a List of Unique Factors

Your unique factors tell customers the benefits of investing in your work. If you do not explain what makes your work unique, then customers will use price to compare your work to your competitor's work. Your work most likely already has many unique factors, so you may not need to invent or do anything new! All you have to do is consider what is unique about your work and make a list for your customers.

You may already be doing these things but, and this is very important, you may not be *telling* your customers that you are doing these things. Therefore, you are not using these things to generate sales.

You are also losing business to competitors who may not be working as hard as you are and may not be giving as much as you to their customers. But they are advertising the few unique aspects of their business to their customers!

Do not make the mistake of thinking that mentioning what is unique to your business is akin to bragging! Explaining what is unique to you is one of the most powerful and important marketing tools you will ever have.

Principle #25 – Your Customers Must Know How They Will Benefit from Their Purchase

Your marketing must point to the benefits your customers will experience when they invest in your work. This expands on an emotional approach. People buy because their purchase will benefit them. They do not buy because it will benefit you. In order to sell, you need to tell your customers how their purchase will benefit them.

This is the reason behind writing a list of unique factors (see above). These unique factors each represent a *benefit* that your customer can get. Your fundamental benefit, the one that needs to be mentioned first each and every time, is your warranty. Read the section on warranties in Chapter 21 to learn more about this extremely important aspect of marketing.

Principle #26 – Study the Fundamental Salesmanship Principles

If you sell your work yourself, you must study salesmanship in order to reach the success you deserve. Study the fundamental salesmanship principles featured in the next chapter.

Skill Enhancement Exercises

Exercise 1: The many aspects of marketing
1. List every aspect of marketing you knew prior to reading this book.
2. Then list every new aspect you need to study and become familiar with.

Exercise 2: How much time do you spend marketing?
1. Calculate precisely how much time you spend marketing right now.
2. How much more marketing do you need to do to make it at least 50% of your time?

*For every sale you miss because you're too enthusiastic,
you will miss a hundred because you're not enthusiastic enough.*
 ZIG ZIGLAR

The 26 Fundamental Principles of Salesmanship

Marketing is often described as "salesmanship in print." What this means is that salesmanship is the basis of marketing. Therefore, good marketers are first and foremost good salespeople. In other words, if a selling technique works in a salesmanship situation it will also work in a marketing situation. All you need to do is write it down instead of saying it to a customer.

Salesmanship can be described as being the art of making the sale or the art of closing the deal. The purpose of all actions taken in a salesmanship situation is to close the sale. Closing the sale means making the sale. It means getting the customer to agree to buy the product according to specific terms. These terms are usually the price that you agree upon with your customer. However, these terms can also include things such as shipping, delivery, quantity discounts, free items, etc.

Before we go into the fundamental principles of salesmanship, it is important to understand that each and every sale you close is the result of a successful negotiation between you and your customer. This negotiation can be quick; the customer can agree to your terms either immediately or within a very short time. Or it can be long; you may have to discuss the price with your customer over a period of time, negotiate a price lower than the one you were asking, consider shipping options, offer a package price for the purchase of several pieces at once, and more. The number of possible variations during a negotiation is infinite. What remains the same with every sale is that it is a negotiation, even if it does not present itself as a negotiation to the customer. Therefore, you have to be prepared to negotiate successfully with customers. You also have to learn not to lose your patience or your cool, because becoming animated during a negotiation usually causes the deal to fall apart.

In order to not lose your cool you must be diplomatic. This means being focused on being helpful, not on being right. Your number one goal should always be to be helpful to your customer. If the customer is wrong, you do not need to prove that to them. You can simply explain what you offer and what you are willing to do to help them purchase your work.

You do not have to agree to every customer request or you would put yourself out of business in no time! However, it is important that you are always helpful, even when you are saying to your customer that you cannot do what they ask. When you must say this, always give a good reason or offer an alternative. You can also use humor as you say this because humor helps people relax. Explain, for example, that your dog would be very upset at you

if you did what they ask. Be creative, be funny, but be helpful. This focus on helpfulness will allow you to close many sales.

The goal of this chapter is to help you make the most of every selling opportunity. While your goal is to close 100 % of the sales, the reality is that you will not close all the sales opportunities that are presented to you. You have to expect that some of them will get away and you have to be OK with that. This is part of being a salesperson. Do your best, try to close them all, but do not be depressed when someone walks away. That is just the way things are. If you follow the advice in this chapter and people walk away, just remember that you did your best. The customer was simply not ready to buy.

Here are the 26 fundamental principles of salesmanship:

1 **Respect** — People buy from people they like, respect, and who care about them.

2 **Keep your customers in your store** — The longer a customer stays in your store, the more this customer will buy.

3 **Create trust** — You must create trust between you and your customers. Trust is the most important aspect of doing business successfully.

4 **Be willing to walk away from the sale** — When negotiating, the person who is willing to walk has the strongest position. Sometimes taking this position is necessary in order to close the sale.

5 **Handle objections** — As a salesperson you must know how to handle stalls and objections. Stalls and objections are hurdles that customers bring up to stop the buying process. You must know how to get past these hurdles so that the buying process can continue and you can close the sale.

6 **Ask questions** — The person who asks questions is in control. As a salesperson you must learn to ask questions. Know which questions to ask, and when.

7 **Price presentation** — It is not the price that matters it is how you present the price. Use the appropriate language when presenting your price (see #26 in this chapter). Do not make price the most important aspect of the sale.

8 **Give reasons for making a purchase** — There must be some very good reasons for customers to give you their money in exchange for your services or product. You must give these very good reasons to the customer *before* they ask for them. And they must be presented in terms of *benefits* to your customers.

9 **Warranty** — You must have a rock-solid, better-than-everyone-else, money-back guarantee. You must display this warranty prominently. I recommend you offer this warranty for one full year.

Bugatti, Scottsdale Automobile Museum – Photographs of rare, collectible, or uncommon cars appeal to collectors and aficionados, both because these cars are difficult to find and because even if you can find them, photographing them well is not easy. While this is certainly a niche market, it is one worth exploring. Events such as the Barrett-Jackson car auction that takes place in Scottsdale, Arizona each winter are excellent venues for this type of image.

10 **Show your uniqueness –** You must have a list of what is unique about your work, which must be displayed prominently in your store.

11 **Explain who you are –** You must have an artist statement and a biography of yourself. This artist statement and biography must be displayed in your nicest frame to show how proud you are of both your work and your achievements. You must also display a photograph of yourself "at work," meaning a photograph of you photographing in the field.

12 **Present testimonials –** You must have testimonials from satisfied customers posted in a visible location. If you are the only one saying something good about your work no one will take you seriously. Everyone expects you to say good things about your work! Why would you say bad things? However, if others say good things about their experience buying from you, prospective customers will realize that they can expect the same. Testimonials are a way for previous customers to share their experience with prospective customers and help you sell your work.

Be sure to ask the person first if you have their permission to use their testimonial. Include the name, city, and state of the person in each testimonial.

(13) **Offer packages.** – You must have packages and not just *à la carte* items. *A la carte* means items sold by themselves, while *packages* are items sold as a group. Packages will always outsell *à la carte*. Packages save your customers money, allow you to make larger sales, and raise the amount of your average sale.

(14) **Framing** – Your work must be available both framed and unframed in different sizes. Framed pieces must be displayed in large sizes.

(15) **Show what you sell** – You sell what you show. Hence, show what you want to sell!

(16) **Your "best seller"** – When asked by a customer which photograph is my favorite, I answer by showing them my best-selling piece. I do this because I have come to learn that when a customer asks which photograph is my favorite, what they really want to know is which one is the most popular. Often, they are thinking of offering this piece as a gift for someone else. Or, if they are looking for something to decorate their home, they want to find something that will be pleasing not only to them but also to their guests, friends, and family.

Of course, I do not come out and say that this piece is my best seller. It took me years to find out which photographs are my best sellers and I don't want to give this information away.

(17) **Location** – In landscape photography, location is everything as far as which subject will sell best. Therefore, make sure you carry framed, large-sized scenes of local attractions. Your "masterpiece" (see No. 22) should be a local scene unless you know for sure that another image will work better based on previous experience.

(18) **Special offers** – You must have special, limited-time offers. Special offers motivate customers to make a purchase now in order to take advantage of a lower price before the offer is over. You must have a deadline for your special offers, usually 15 days after the start of the offer.

(19) **The *special* special offer** – Have a special offer on top of your special offer for the first few customers who are placing an order. This is usually the first 5 or 10 customers, although this number depends on your personal strategy. This special offer usually consists of a free gift—but not your artwork, it must be something else!

(20) **Never give your work away** – You must never, ever, give your artwork away for free! You can give other things away such as informational brochures, advertising items, etc., but never your work. Giving your work away cheapens

it. If people see you give your work away for free, they will not want to pay the price you are asking for it.

(21) **Enthusiasm** – You must create enthusiasm and excitement for your work and your services. Enthusiasm translates into positive energy surrounding your work and your person. Without enthusiasm you will not reach success. Therefore, you must be enthusiastic about your work before your customers will be enthusiastic about it.

(22) **The masterpiece** – You must have a *masterpiece* in each of your exhibits. A masterpiece is a photograph so big, so expensive that nobody in his or her right mind would consider buying it. It must be priced higher than any other piece you are selling. Remember that you are not supposed to sell it. If you do sell it, immediately raise the price so that this does not happen again! The goal of displaying your masterpiece is to sell your smaller pieces, which will seem inexpensive by comparison.

(23) **The smallest piece** – You must decide what is the smallest size print you want to offer. This decision will determine everything else.

Your smallest size will be your lowest priced piece and thereby your best selling size. Since in photography prices are related to image size, your smallest print size will be your lowest-priced piece as well. Since the majority of people will want to invest in the lowest amount, it will be your best-selling size right away.

This means that you need to set your lowest price where it makes a difference income-wise. Since you can expect a lot of sales for your smallest piece, you do not want to price it too low or you will end up losing money. On the other hand, you do not want to price it so high that it discourages everyone from buying from you.

(24) **Your contact list** – You do not need to carry business cards but you should be ready to collect customers' addresses, emails, and other contact information if they are interested in purchasing from you in the future. Plan to contact them on a regular basis.

(25) **Presenting yourself** – You must look your best and be on your best behavior at all times while selling.

Some artists want to look like "starving artists" in the hope that people will feel sorry for them and that this will generate "mercy sales." Do not do this. Mercy sales will not make you successful. Instead, this approach will make you feel sorry for yourself and will make others view you as an unsuccessful businessperson.

Instead, look your best all the time. You need to appear successful in order to be successful. Dress nicely. If you wear jewelry be sure to wear nice jewelry.

You do not need to overdo it, but you do not want to look cheap, either. Be casual but be professional and elegant.

Remember that you are selling fine art and that fine art is a luxury product. Therefore, you must look the part. What you wear and how you look must represent the qualities of the product you are selling. Keep in mind that elegance is timeless and expresses quality and refinement.

As an artist you are also expected to have a wild side and be non-conformist. Therefore, adding a touch of "creativity" to your attire is a good idea. It is not absolutely necessary, but if you want to do so it is an option that most people will appreciate. Just keep it in good taste—you can be creative and elegant at the same time.

Your behavior must be pleasant and courteous at all times. If something upsets you, do not stay in front of the public. Instead, leave your selling location, collect yourself, and return to your selling location after you feel better.

You cannot be angry, frustrated or otherwise have a negative attitude while selling. None of these will result in successful sales. Instead, these attitudes will result in lost sales because you will come across as being unfriendly, pushy, and not helpful to your customers.

The best frame of mind to adopt is this: you are a very successful artist and if someone purchases something from you things will be even better. However, if they do not purchase anything, you are still very successful!

26 **The translation principle** – You must be intimately familiar with the *translation principle,* i.e., the language you need to use each time you talk to your customers. Below is a short list of "translated" terms. These will help establish your reputation as a fine art artist, which in turn translates into the ability to sell your work at higher prices. The term on the left is the one you do not want to use; the "translated" term on the right is the one you should use.

- large = substantial
- price, cost = investment
- shot, taken = created
- photograph = artwork
- size (in numbers) = names for each size (*studio size, artist size,* etc.).
 For example:
 - 8×10 = Companion Print
 - 16×20 = Artist
 - 20×24 = Studio
 - 30×40 = Gallery
 - 40×50 = Master

Skill Enhancement Exercises

Exercise 1: Giving your work away

Did you give your work away in the past?

If yes, list four reasons why you need to stop now.

Exercise 2: Finding what to give away

If you want to give something for free as part of a special offer, make a list of items to give away. This list cannot include fine art prints or photographs!

Exercise 3: Familiar and unfamiliar principles of marketing

Which principles of salesmanship were familiar and unfamiliar to you when you read this chapter?

Make a personal list of the items that were unfamiliar to you.

Practice doing the items on this personal list each time you are selling your work.

*This may seem simple, but you need to give customers
what they want, not what you think they want.
And, if you do this, people will keep coming back.*
 JOHN ILHAN

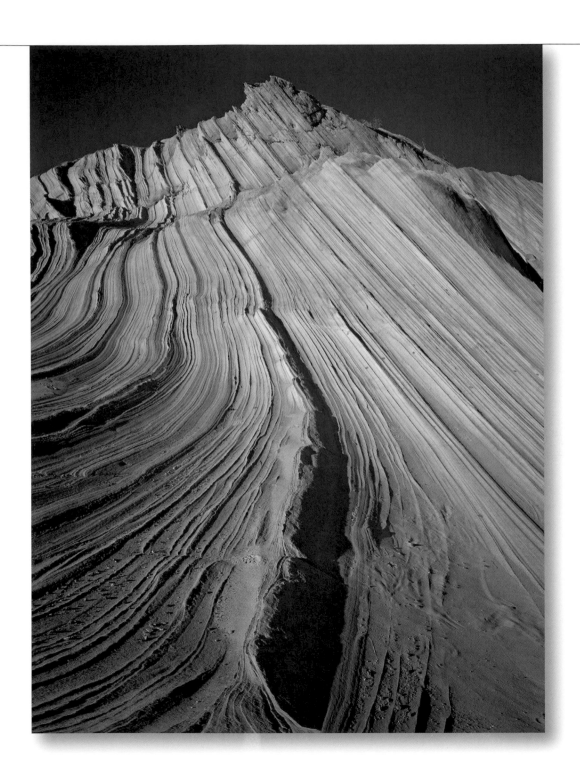

The Seven Fundamental Principles
of a Successful Business

In order to become a successful artist in business you need to understand how other photographers became successful. Find out what they did to get where they are and which goals they set for themselves. You need a road map, a blueprint, a guidebook. If you don't know where you are going, it is unlikely that you will get there. In order to get where you want to go, you first have to decide on the destination. Ask yourself, "Where do I want to go?" The answer to this question will guide you every step of the way.

To make money with your photography you must learn how to turn your hobby into a business. If you already have a photography business and this business is not generating enough income, you need to learn how to turn your existing business into a *better* business, a business geared toward generating the income, and the lifestyle, that you desire. This is a major step and it has to be done in the proper manner.

To get where you want to go you must follow simple, progressive steps. Success does not happen overnight and success will not be continuous if you do not work on your system diligently and logically.

Here are seven vital steps to help you in this endeavor:

1 **Have a goal** — As Dale Carnegie explained: "Hard work and long hours will not generate success. You must have an organized plan." You must therefore develop your organized plan and you must put it in writing. You also need to have a timeframe for each specific goal.

2 **Have a product for sale** — You may not have thought of your work as a *product* until now. However, in order to generate an income from the sale of your work you need to think of it as a product positioned in a specific section of the marketplace and competing with other comparable products.

3 **Have a unique product** — You need to know what makes your product unique. To do that, make a list of the unique aspects that characterize you and your product. This list of unique features is what separates you from your competition. If you do not have unique features then the only difference between you and your competition is the price. This means you will compete solely on the basis of price, which is a tough, cutthroat proposition. This may be what you want, however you need to make sure you are aware of this important fact before taking your business in this direction.

Ferrari Testarossa. Wheels of Wellness 2010 event, Scottsdale, Arizona — Sports car photographs have their own audience. Some collectors focus on a single automobile model, such as Ferrari, Porsche, or Lotus. Other collectors focus on a specific event, such as the 24 hours of le Mans, Nascar, or Formula 1. Yet others focus on a specific time period, or even a specific driver. This is a market in which having the exact image that collectors are looking for makes the sale. The key is having a diversity of images while not letting volume take over, something that can be challenging. However, never forget that you are selling fine art and that your vision of the car matters just as much as the car. In this image I focused on only a section of the car because I felt it described the car visually in an effective manner. The result is a personal portrait of this vehicle rather than a catalog image that would show all the features of the car.

4 **Your product must offer serious benefits to your customers** — In order to have a successful product you must point out the benefits of owning your product to your customers. People buy things because owning these things benefits them. Ask yourself "How will buying my work benefit my customers? How will they get more benefits out of buying my work instead of buying the work of another artist?" These benefits must be clearly explained to your customers. Again, make a list of the benefits you offer to your customers, just like you made a list of the unique aspects of your work.

5 **Market your work** — You *must* market your work if you want to be successful selling your photography. Marketing is what will take you where you want to go. It is part of your organized plan (but it is not the entire plan). Marketing needs to be done on a constant basis. You need to market your work if you are not selling well, and you need to market your work if you *are* selling well.

 You also need to spend at least 50 percent of the time you can devote to photography working on your marketing. If you are just starting your business, and if you want results fast, you may have to spend 80 to 100 percent of your "photography time" on your marketing.

6 **Understand that art and marketing are entirely different** — If your work is not selling as well as you would like, it is rarely because your work is not good enough. Certainly, you want to sell work that you are proud of and you want to sell work that your customers will be proud to own and display in their homes. However, if you have good work and it is not selling, it is usually because it is not marketed properly, not marketed *enough,* or not marketed to the right audience. To be more successful you need to change your marketing, not your work.

7 **You must have integrity** — You must operate your business with the utmost level of integrity. This means being honest and straightforward in every aspect of your business. This includes declaring all your income, not making empty promises, answering questions truthfully, and treating everyone fairly, equally, and with respect.

Operating on the basis of integrity will attract customers and business owners who also value integrity. As a result, you will have far fewer problems and far more enjoyable business relationships. I have followed this approach since I started my business and I am glad I did. I would not consider doing things any other way.

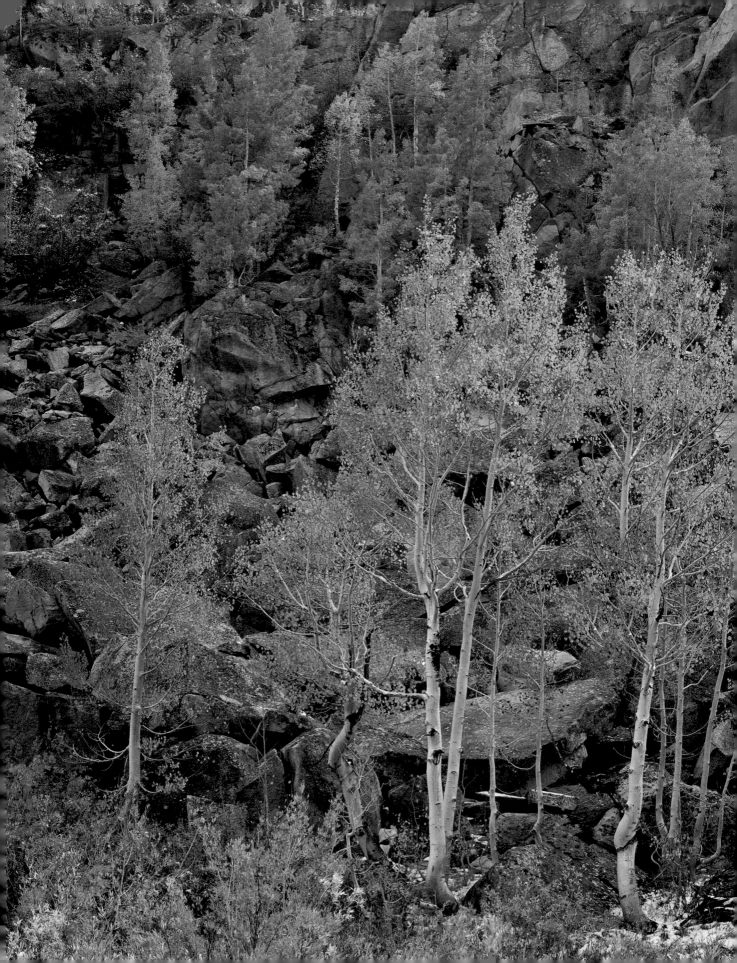

The point to remember about selling things is that, as well as creating atmosphere and excitement around your products, you've got to know what you're selling.
 STUART WILDE

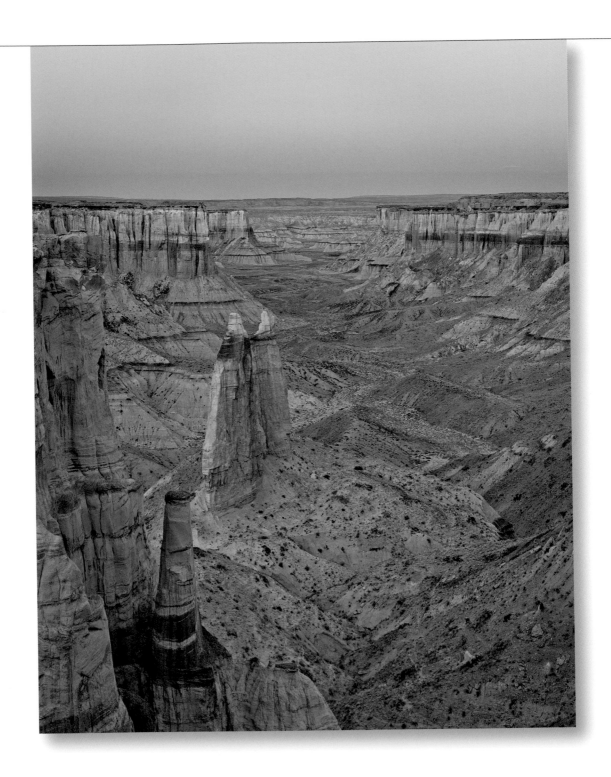

Finding an Audience

In order to sell your work you need to find an audience interested in buying it. This is true for any product, not only for art and photography. All businesses need an audience interested in purchasing their products. However, art has different requirements in regard to audience, because when selling art we sell the artist just as much as we sell the art. Finding an audience means finding people who like you and the work that you create.

Why do you need an audience? Because you can only sell your work to people who like what you do. This is why finding an audience is the key to selling your work.

When selling art we sell the artist just as much as we sell the art.

Finding an audience can be difficult. In the process of looking for an audience we all start pretty much the same way. We begin by showing our work to our friends and family. We then continue by showing our work to co-workers and other acquaintances. If we are fortunate, we sell some of our work along the way.

This is just a starting point. If you want to do better than occasional sales, you need to expand your audience beyond friends, family, co-workers, and acquaintances. This is where things get tough. Who else can you show your work to? And how are you going to find people who want to buy your work?

Certainly, you can rely on a gallery or a representative to find a buying audience for you. (See Chapter 6: *Where to Sell Your Work*.) But the problem is that neither reps nor galleries are interested in representing unknown artists who do not have a proven track record. Plus, if you work with a third party (such as galleries and reps), not only will you need to give them half of your income (galleries and reps take around 50% of the selling price as commission), the rep or the gallery will also not share the customers' information with you. As a result you will not be able to market directly to the customers who are buying your work through a rep or in a gallery.

This means that there are serious problems with selling through a third party. In short, you will lose half of your potential income and you will not be able to build a mailing list of people who purchased your work because all the buyers' contact information will be in the hands of the rep or the gallery. Reps and galleries will not share this information with you for fear that you would bypass them by selling to their customers directly.

Why Art Shows?

I have found that the most effective way to find a buying audience and build your customer base is to exhibit and sell your work at shows. The simplest way to do this is to participate in shows that are open to artists. The more complicated way is to organize your own shows. This entails renting the space, putting together the events, and advertising them.

While the second option is certainly viable, I recommend that you start with the first option. Not only is it easier, it is also guaranteed to bring you an audience that enjoys attending art shows and buying directly from artists.

Showing your work yourself is important. Why? Because, on the one hand, people need to meet you and see your work in order to find out who you are and what you do. On the other hand, for people who already know you, shows are an opportunity to discover your new work and talk to you in person.

By doing shows regularly you stay in contact with your audience, you generate excitement for your work, and you open the door to new marketing opportunities. Showing your work becomes the foundation of your marketing system.

In this chapter I am going to explain how to sell your work at art shows using a specific show as an example. This show is the El Tovar Hotel Show that I participated in on the North Porch of the El Tovar Hotel at Grand Canyon National Park for over five years.

I will also show the tools and equipment necessary to do art shows. Finally, I will explain how to find art shows that meet your needs, and I will provide a list of resources you can use to locate specific shows, as well as a list of suppliers from whom you can purchase the necessary tools and supplies. You will find the contact information for suppliers and show listings in Chapter 23: *Resources and Materials*.

Doing Art Shows

As realtors say, there are three things that matter: location, location, and location. In art shows, as in real estate, location is everything. Of course, when doing a show, other things matter, such as the work you have for sale, the prices you ask, and the quality of your display. However, if you do all this correctly in the wrong location it will be difficult to be successful.

In art shows, as in real estate, location is everything.

So where is the right location? Basically, the right location is where customers looking to purchase artwork comparable to yours are going to be. Remember that it is easier to go to where the customers are than to have the customers come to you. One of the best locations I found was the El Tovar Hotel at Grand Canyon National Park.

Before we go any further, let's think about why the El Tovar Hotel is such a great location. First, it is in a National Park and arguably in one of the most

famous National Parks: the Grand Canyon. This is a park that people come from all over the world to visit; five million of them a year. That's a lot of potential customers and nearly all of them will be walking in front of the El Tovar Hotel.

Second, the El Tovar is a hotel, which means that you can count on hotel guests to look at your work and invest in it. In this sense any hotel in a touristic location will work reasonably well because it will ensure a steady flow of visitors who are there because they are staying at the hotel.

Third, the El Tovar is 60 feet from the rim of the Grand Canyon, thereby guaranteeing that people who came to see the Grand Canyon will see your work while they walk in front of the hotel to the canyon's edge.

Fourth, the El Tovar is in Grand Canyon Village and right along the Rim Trail that leads to and from the Bright Angel Trail, one of the two most heavily used trails in the Grand Canyon. This means that hikers will see your work either on their way down into the canyon or while hiking out of the canyon. Because hiking the Grand Canyon is a major endeavor, often a once-in-a-lifetime adventure, many of these hikers will want to bring back a professional photograph showing where they have been. If you have the goods, you will be in business. I did extremely well with photographs of the Bright Angel Trail.

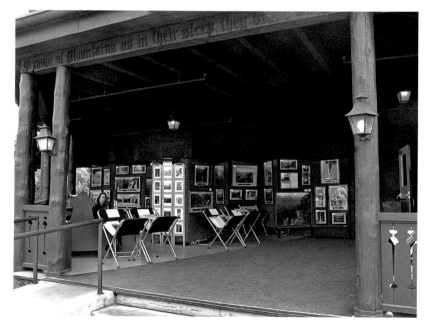

Art show at the El Tovar Hotel,
Grand Canyon National Park.

Fifth, the El Tovar is up the hill from the Grand Canyon Railroad Station. This means that people exiting or returning to the train walked right past my display. The Grand Canyon Railroad starts in Williams, Arizona, 60 miles away, and ends at Grand Canyon National Park, right near the canyon rim. Hundreds, if not thousands, of people take the train each day to the Grand Canyon

instead of driving. Train passengers only get to stay three hours at the Grand Canyon. After that, the train returns to Williams. This means that they have only a short time to photograph the canyon, usually in less than ideal lighting conditions because they are there in the afternoon when the sun is directly overhead. As a result of these factors, most train passengers want to bring a professional photograph home as a souvenir of their visit.

Displaying Your Work at a Show

So there you are, in the best place on earth, with your work ready to sell. To put all the chances on your side you need to have the nicest-looking display you can possibly have and you need to think carefully about which photographs you want to display. For your show to work as well as possible you need to remember one of the basic rules of marketing: *you sell what you show*.

The photographs in this chapter give you a very good idea of the way I display my work, the sizes I show, and the framing and matting styles that are the most popular with my customers. My approach is based on years of experience and it works very well for me. It may or may not work for you, but the best way to find out is to try it and make changes if it does not work for you.

Display panels – Carpet-covered displays are both attractive and practical. Their only drawback is their weight. But, if you don't have to move them every day they are the perfect solution. In my case, they stay put for the whole season, from March to November, so weight is not a problem.

Display panel hook – The best way to hang artwork on carpet-covered displays is with simple curtain hooks.

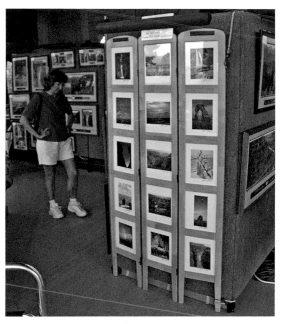

Floor-stand print display – How to display 15 photographs in the least amount of space: use a room-separation print display! This is one of my most useful displays.

Print bins – Folding print bins are an excellent way to display and sell unframed prints. Plus, they do not take much space when folded, which makes them easy to transport. Because the framed pieces help sell the unframed pieces, you should expect to sell more unframed than framed pieces. Your choice of frame and matting is very important and should fit the type of home décor that is popular with your buying audience. You should have the same photographs displayed both framed and unframed. If a customer sees a photograph framed and wants it unframed, you can find an unframed version in your inventory, or unframe it if the framed version is the last one you have. The same goes for unframed pieces: if a customer finds an unframed piece and wants it framed, you can either look for a framed one in your inventory, or frame it for them at the show.

Booth lighting – Lighting is important and should be both elegant and powerful. The lights shown here are elegant but not powerful enough for an outdoor show. However, they were mandated by the National Park Service and we had to use them regardless of how inefficient they were.

Booth during daytime and nighttime – Your show must look great day and night, hence the importance of good lighting.

Framed Artist Statement – One of the most important framed pieces in the show is not for sale. This piece is your artist statement. It needs to be well written and nicely presented. It explains a lot more to the customer than you could in an hour and takes no effort on your part once you have it done. Mine includes my biography and artist statement, a photograph of me "in the office" and several testimonials from past customers. It is one of the most important pieces in my show because it helps customers learn about who I am and what I do.

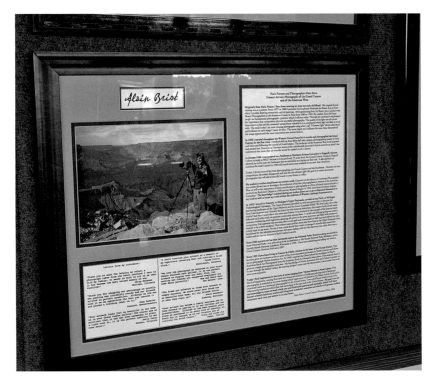

Price tags – All your work needs to be priced in a visible manner. Signs stating your policies, such as this "Do not touch" sign, also need to be prominently displayed. This way if a dispute arises there can be no question about your attempt to inform the public. While it is better to have typed signs, sometimes hand writing them is unavoidable. In such instances, having a hand-written sign or price tag is better than not having a sign or a price tag at all!

A good price tag is priceless – The photographs here show the price tags that I used in 2002. I have since moved to typed price tags. (See Chapter 18: *Marketing Tools*.)

Packing and Transporting Your Work

Selling your work at shows means setting up and taking down your frames and your prints every day, or at least at the beginning and end of the show if you can leave your work up for the whole show. At any rate, if you do a lot of shows this means a tremendous amount of packing, unpacking, and transportation to and from the shows. The photographs below show my approach to protecting my work. This approach works well for me and I have had little damage since I started using it.

Plastic Containers – Protecting frames during transportation is essential. To this end we wrap each frame in bubble wrap and store them in plastic containers. The lids help keep dust out while protecting the top of the frames.

Bubble wrap – Natalie shown wrapping a framed piece in bubble wrap.

Setting Up an Outdoor Office and Frame Shop

Selling at shows also means setting up a temporary, and sometimes *impromptu,* office in a setting that may at times be challenging to say the least. The way in which you set up your "office" at a show is largely a matter of personal preference. Here is my time-tested approach, one that I feel comfortable with.

Keep in mind that you will have to do a lot of transactions and that some of these transactions may be significant both in price and in size. You also will need to keep track of orders that are to be shipped so that you don't make any mistakes when the time comes to ship these orders. Finally, you will need to keep an accurate record of each sale for accounting purposes.

Plastic filing drawers – Protecting unframed prints is just as important as protecting framed photographs. These plastic drawers stack on top of each other and double as an "office." The two smaller drawers on the top right side are used to store office supplies.

The mobile office – Essential business tools include: calculator, pen and receipt book, rubber stamps for invoices and checks, clock, stapler, shipping chart, price list, etc. In the evening everything goes into the first drawer underneath. The second drawer is used to store copies of my artist statement. My contact information and web address are on my artist statement. We give a copy of my artist statement to each customer. Notice I do not use a cash drawer since I prefer to keep the cash on me to prevent theft. Coins, however, go into a small box on this "desk" because they are too heavy to carry.

Credit card machine – You will doubtless need one of these as well as a wireless model (see the upcoming section on credit card processing). The fees charged by card-processing companies are greatly offset by the larger purchases your customers will make when they can charge them.

Standard 9×12 envelopes – A simple, inexpensive, and attractive way to package prints after the sale. In boxes of 100, they cost less than 20 cents each.

Show Chair – This show chair is a necessary convenience. It allows you to rest your legs and to sit at "conversation height" with standing customers. Notice that it matches my print bins.

Alain at the show – Once the show is set up all you have to do is kick back and wait for the customers.

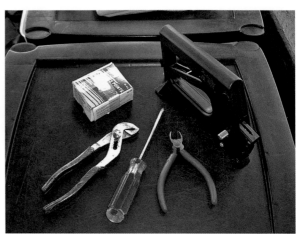

An impromptu outdoor frame shop – We routinely re-frame and re-mat artwork to fit customers' tastes. Notice the roll of tape on the left used to tape photographs to mats. The boxes contain unmatted photographs. Also notice the tape gun to package sold items and the roll of white plastic bags to bag large purchases.

Framing tools – Essential framing tools include a Fletcher framing staple gun, extra staples, pliers, wire cutter, and screwdriver. With those, I can take a photograph out of a frame and re-frame it in a different frame in a matter of minutes. Being able to change frames, and mats, is a service that is very much appreciated by customers.

Finding Art Shows

The two best art show references I know of are *Sunshine Artist* and *The Art Fair Sourcebook.*

Sunshine Artist Magazine

Sunshine Artist not only lists shows across the United States but also ranks them according to their popularity, how well they are organized, and how much attendance they receive. The other great thing about this magazine is the resources page on their website, which lists many resources needed to do shows, such as equipment, supplies, and more. Find them at www.sunshineartist.com.

The Art Fair SourceBook

The *Art Fair SourceBook* is published by Greg Lawler. I met Greg personally during a show in Arizona; he simply walked the show telling each exhibitor about his *SourceBook,* an approach that I found personable and that required more work than simply including a brochure about the book in the Show Packet given to each exhibitor. Find them at www.artfairsourcebook.com.

Chamber of Commerce

Another good source of information is your local Chamber of Commerce. They know the names of the show organizers in your area and you can get that information by visiting their office, calling them, or emailing them.

Accepting Credit Cards

PayPal with Your Cell Phone or iPad

PayPal is widely used to make payments on the Internet. What is less known is that PayPal is also a web-based credit card processing company. Processing credit cards via PayPal is possible for anyone with a PayPal account. All you need to do is apply online and go through the acceptance and verification process.

Once your credit card processing account has been approved by PayPal you can process credit cards not only on your desktop or laptop computer, but also on any wireless device able to access the Internet and accept text and numerical input. The most popular wireless devices at the time this book is written are cellular devices such as the iPhone and more recently the iPad. An important aspect of the iPad is that you do not need the 3G version. All you need is wireless access, which all iPads have, therefore, using an iPad saves money on cell phone connection fees. Of course, you can also use a laptop with a wireless connection, but laptops are larger than the iPad and therefore more cumbersome to carry around. All you need to access PayPal with these devices is a wireless connection, something which is becoming more and more commonplace.

The only shortcoming of this approach is that you cannot print a receipt. However, you *can* email the receipt to your customer! The advantage of this

PayPal – Wireless PayPal processing on Apple iPad

approach is that you capture their email address and you can later email them news and announcements about your work, as well as special offers. Just be sure to ask for your customer's permission before doing so. Also keep in mind that as these devices are improved, printing will eventually be possible.

Wireless Credit Card Machines

There is a wide diversity of wireless credit card processing terminals available. Make sure you get one that can print receipts. You will need to print a receipt both for yourself and for your customers.

Verifone-vx-610 **Nurit 8020**

Imprint Credit Card and Process Later

There will be times when there will be no cellular or wireless Internet connection. At those times you will need to take an imprint of the credit card, or write down the card number, expiration date and code, plus the customer's information, and process the order later on.

This is not as risky as it seems. I have done it frequently without problems. Just make sure that you get the customer's address, home phone, cell phone, and work phone numbers. The biggest risk is that the card is cancelled, or maxed out, before you process the charge—something that happens if the customer over-uses their card, loses their card, or has their card stolen. When that happens you need their phone numbers so you can call your customer and get the number of their new card.

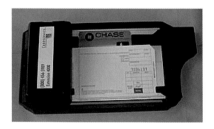

Old style credit card imprint machine.

Where to Get Your Show Equipment

A detailed list of where to get show equipment, information on where to purchase supplies such as framing, matting, and marketing tools, various website hosting providers, and much more is provided in Chapter 23: *Resources and Materials*.

To keep things as simple as possible, I decided to group all resources under the heading of a single chapter rather than list specific resources at the end of each chapter. This way, when you need to look up a specific resource, you don't need to browse through multiple chapters until you find what you're looking for.

Conclusion

Doing shows can be a great way to sell your work. You can also make a handsome income doing so. However, it can also be a frustrating activity if you do not approach this endeavor in the correct manner. Planning your show, your booth, and your setup carefully is essential in order to reach the success you deserve. This chapter shows you the approach that I used successfully at the El Tovar Hotel at Grand Canyon National Park. The next chapter will show you the setup I used at other shows. It will also show you a variety of booth setups that you can use for your own shows.

Skill Enhancement Exercises

Find shows that you want to participate in using these resources:
- *Sunshine Artist* magazine
- *The Art Fair SourceBook*
- Other resources listed in Chapter 23: *Resources and Materials*
- Other resources specific to your area, such as the Chamber of Commerce, local newspapers, magazines, and the Internet

The only thing that separates successful people from the ones who aren't
is the willingness to work very, very hard.
 HELEN GURLEY BROWN

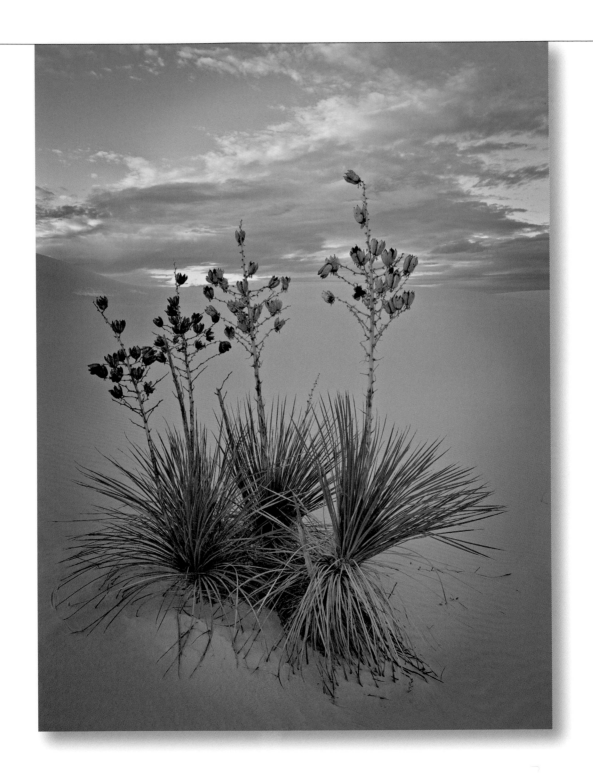

Chapter 13
Show Booth Examples and Layouts

The purpose of this chapter of photographs is to provide you with examples of "Marketing in Action," so to speak, and to illustrate how actual show displays look in a variety of venues, small and large. I did not include a lot of text, preferring to let the photographs speak for themselves.

Examples from Actual Show Setups

El Tovar Show

I described this show in detail in Chapter 12. In my opinion, this was one of the best locations in the world to sell landscape photography. Unfortunately, because of changes in Grand Canyon National Park policies, this show is no longer open to artists. However, you may be able to sell your work under a comparable arrangement in a different National Park.

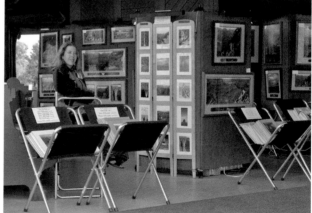

Biltmore Fashion Mall Show

This show took place at the Biltmore Fashion Mall, in Phoenix, Arizona. The Biltmore Fashion Mall is an upscale mall with an inner courtyard and a weekly art market, of which the art show was a part. I was set up between Christofle, a high-end French tableware store, and the Apple Store—a perfect combination of technology and Art de Vivre. This was an excellent show. Unfortunately, because of changes in the Mall management this show is no longer open to artists.

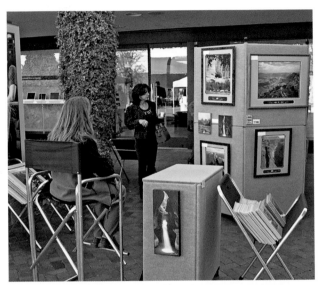

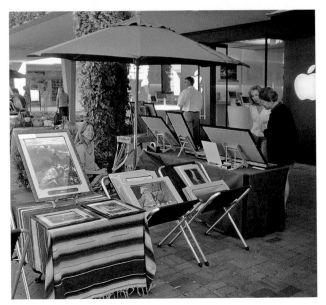

Anthem Mall

This show took place at the Anthem Outlet Mall north of Phoenix. We did a few shows there and business was good, even though the environment was not as upscale as the Biltmore Fashion Mall.

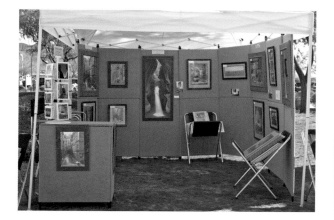

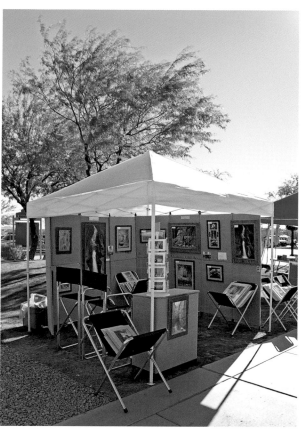

WestWorld Show

This show was an indoor fine art show in Scottsdale, Arizona. We had a 10' × 20' corner booth. The normal booth size is 10' × 10', and 10' × 20' is just about as large as you would want to have in a show.

Corner booths are desirable because your booth is open on two sides rather than only one side.

10' × 20' booths are twice the price of 10' × 10' because they give you twice as much space. Corner booths are more expensive because they offer a prime location and expose you to foot traffic on two sides of your booth.

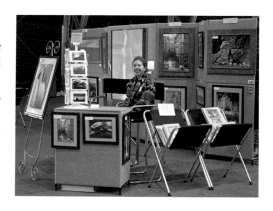

Barrett-Jackson Show

This show takes place during the annual world famous Barrett-Jackson Collector Car Auction in Scottsdale, Arizona. This is an indoor show located within the vendor area of the car auction tent. The show lasts for the entire duration of the auction, which is about a week.

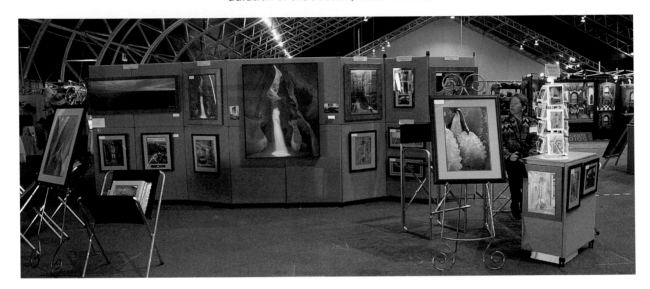

MAMA Show

This is a large street show organized by the Mill Avenue Merchant Association (MAMA) in Tempe, Arizona. Although the number of photographers selling at this show is very high, we did well there.

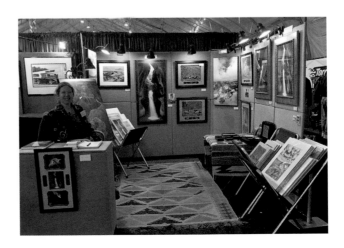

Scottsdale Thunderbird Show

The setup we used at this show is interesting because it is open on two sides, allowing customers to walk in and out easily. This was possible because we had a valuable corner booth location.

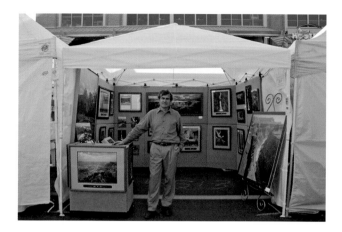

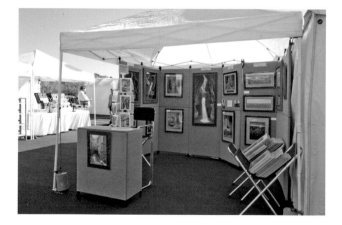

Show Booth Layouts

Many different booth designs can be used within the space allotted to you by show organizers. In this section I cover some of the most common designs and point out what you need to watch out for when choosing a specific booth design.

Because a 10' × 10' area is by far the most common booth size provided to artists by show organizers, I will use this size in each of my examples. However, both my comments and the designs that follow can be adapted to a booth size of 10' × 20', or larger.

There are things to watch out for when planning your booth design. The most important thing to consider is how your customers feel and move when they are in your booth. You want to avoid making your customers feel cramped or trapped. To achieve this, you must leave enough space for them to walk around and look at your work. You also want to have a wide area to enter and exit the booth, which often means having fewer display panels or print bins. However, in this instance less is more.

Just Say No to the Fly-Trap Booth

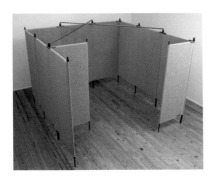

Flytrap booth not advised.

You want to make sure that your booth is not a fly-trap type booth. A fly-trap booth is one in which you enter the booth through a narrow opening. Many customers are reluctant to walk through a small opening because they are afraid to be "trapped" once inside the booth. In addition, artists using this booth design often stand in the middle of the opening as soon as a customer walks in, effectively closing the trap!

When customers feel trapped they become uncomfortable and they immediately want to leave. Of course, they lose all desire to make a purchase, and any effort to motivate them to buy something is perceived as an attempt to hold them hostage. This creates an uncomfortable situation both for artist and customers, a situation in which no sale can be made.

Using a fly-trap booth design is one of the most common mistakes made by show artists. The booth set up images on page 180 show us some solutions. It is desirable to either have a wide opening at the front of your booth, such as in setup A, or provide two entrances to your booth, one in the front and one on the side, as in setup C or D. Setup C is only possible if you have a corner booth, an option that is very desirable even though it will usually cost you more. Setup D is possible only if foot traffic is allowed behind your booth, something that varies from show to show. In some shows, booths are located back to back with only minimum space or no space at all between the back of the booths, and this effectively prevents foot traffic behind the booths. In other shows, booths are placed in front of open areas and foot traffic is possible both in front and behind the booths. In that case a design such as D is a recommended option.

Storage Area

Having a storage area for your work is also something to consider. If your vehicle is parked within a short distance of your booth it is possible to keep your extra inventory in your vehicle. However, if walking back and forth to your vehicle is not convenient, your extra inventory must be kept in your booth. At such times a booth design such as B (below) is a good option. The

recess created by moving the display panels away from the left corner creates a storage area that you access by moving one of the panels. Artwork not on display is kept in that corner, out of sight of your customers.

Desk Space

You need a place where you can write receipts and keep your credit card machine, receipt book, business cards, artist statements, and other tools and supplies. This desk area can be located either at the front or at the back of your booth. I strongly recommend placing it in the front because customers can see you when they get close to your booth. It is important for customers to see you because you must greet every customer who enters your booth, whether you believe they will make a purchase or not.

If you place your desk area at the back of your booth, you will be effectively hidden away from customers walking in front of your booth each time you write a receipt, or process a credit card, or do anything on your desk. This is not a good practice because customers will think that you are not in your booth or that you are not available to talk to them.

The most practical desk type is the one made by Pro Panels. It is made of the same material as their display panels and it folds flat, thereby taking a minimum amount of space when you travel. Choose a color that matches the color of your panels so that your display is color-coordinated. The height of the desk is designed to accommodate a tall director's chair. Such a chair allows you to sit high enough to be at eye level with customers. Sitting high enables you to talk to customers without having to look up at them. It also makes you look like you are working even though you are seated. You cannot stay on your feet for 8 or 12 hours a day and you certainly do not want to look like you are lounging around while you are in your booth!

Selecting Your Display Panels

Purchasing display panels requires an investment; therefore you want to select them wisely.

The panels shown in the following photos are all single-section panels that are 77" tall. Two-section panels that have a bottom section and a top section are also available. The bottom section is 45" tall and the top section is 38.5" tall. The total height, with the two sections assembled, is 83.5".

The advantages offered by two-section panels are significant. First, they are much lighter to carry individually because the sections are smaller. Second, they do not need as much space to store and transport. For example, you can carry two-section panels in the bed of a regular-length pickup truck. Single-section panels on the other hand will require a long-bed pickup or other larger

Booth Setup A

(9) 6' Pro Panels

(6) Stiffeners

(2) L-Stiffeners

(2) Support Bars – Long

Booth Setup B

(9) 6' Pro Panels

(5) Stiffeners

(1) Support Bar – Long

(1) Support Bar – Short

Booth Setup C

(9) 6' Pro Panels

(4) Stiffeners

(1) L-Stiffener

(1) T-Stiffener

(2) Support Bars

Booth Setup D

(9) 6' Pro Panels

(4) Stiffeners

(1) Support Bar – Long

(1) Support Bar – Short

Booth Setup E

(11) 6' Pro Panels

(5) Stiffeners

(3) L-Stiffeners

(1) T-Stiffener

(2) Support Bars – Long

Photos © Pro Panels

vehicle. Before buying display panels, ask yourself if the panels you want will fit into the vehicle you have. That way you will not need to buy another vehicle just to carry your display panels!

The booth layout you choose must also take into consideration structural integrity. This means that the panels must be solidly attached together and that stiffener bars are used when required. (The photos below show where stiffener bars are required.)

The color of your panels also matters. Panels are available in a variety of colors, from discrete to quite noticeable. I recommend choosing a discrete color that does not distract from your artwork. Your want your clientele to look at your work, not at your panels! Light grey is an excellent color because it is neutral. Black is also a good option because your work will stand out against the dark background. Black works particularly well with saturated colors. Other colors can be used providing they make sense in the context of the overall color scheme of your booth.

Success is not the key to happiness.
Happiness is the key to success.
If you love what you are doing,
you will be successful.
 HERMAN CAIN

Chapter 14
Packing and Shipping Your Photographs

Selling your work is an important and challenging step. However, shipping your work once the sale is completed is just as important. It can also be just as challenging.

If you sell over the web, or by mail order, all purchases will have to be shipped. If you sell at shows, or in other venues where you meet customers physically, most of your customers will carry their purchases with them, however, not all your customers will be able to do so. This is because their car may not be big enough to fit your artwork, or they may not want to take heavy and fragile artwork with them. Also, when people are traveling, they are often unable to take artwork with them, which is particularly true when people travel by plane.

In any case, shipping your work is an ineluctable aspect of doing business. It is therefore important that you know how to package your work quickly, efficiently, and in a reliable manner. You do not want the packing to take too much of your time, but you do not want the photographs to be damaged on the way to their destination either. How to reach these goals is the purpose of this chapter.

Being a photographer, this chapter is based on my experience shipping framed and unframed photographs. However, my advice should apply equally well to other types of artwork, although you may have to make adjustments for your specific needs.

Shipping your work is also called "fulfillment." This is because when you ship your work to your customers you are fulfilling your business responsibility by providing to your customers the goods they purchased from you. When you sell at shows and customers carry their purchases with them, fulfillment takes place immediately after payment is received. When customers request that their order be shipped, or when orders are placed by mail or over the web, fulfillment is delayed until orders are packed and shipped.

Shipping Companies

There are several shipping companies and which one you do business with is both a matter of personal preference and practicality. In my case, I ship almost everything with the US Postal Service via Priority Mail. I have found the Postal Service to be quite careful in handling artwork. When artwork is too large to

be shipped with the USPS, I ship via Federal Express (FedEx) or by UPS. In the case of extremely large artwork that needs to be crated, I ship with a trucking company.

Calculating Shipping Costs

A NOTE ON PRIORITY MAIL

There is only a minimal cost difference between Priority Mail and Parcel Post (about 50 cents to a dollar on a 22" × 28" package containing a framed piece, for example). However, Priority Mail gets there fast while Parcel Post can take one week or more. To give you an idea of the cost, a 22" × 28" package from Arizona to California via Priority Mail, packed with foam peanuts which are very light, costs only around $35 to ship and will be in the customer's hands in two days. The same package sent via Parcel Post from Arizona to Connecticut costs about $45 and will get to its destination in three days. I charge $10 extra when I ship to Canada since packages have to go via international airmail.

I keep a detailed, typed shipping costs chart with me at art shows. When I am asked how much shipping is going to cost for a specific piece, I show this chart to my customers. This builds trust because customers can see that I am not figuring shipping costs from the "top of my head," so to speak.

My costs include what I pay at the post office, the cost of all necessary supplies (boxes, bubble wrap, tape, foam peanuts, etc.) plus a fixed amount for the time spent packing (it usually takes me and Natalie three days to prepare 20 to 30 packages—our current shipping load after a show). What I charge for shipping covers all of the above expenses.

Another good thing about the post office is that they provide free shipping supplies such as tape and boxes. I personally use a lot of USPS priority tape. USPS boxes are good for small, unframed prints. However, the post office does not offer boxes large enough to ship framed pieces. The USPS tubes (triangles, actually) are to be avoided at all costs because they bend during shipping. I used them for only one package and had to replace the print because it was destroyed during transit. I now use only thick round tubes which are much sturdier.

If you want to order US Postal supplies all you need to do is call 1–800-THE-USPS. There is also a special order form available at your local post office. Supplies can also be ordered on the USPS website: www.USPS.com.

Tools

Packing tools

A tape gun is a must. Without one, there is only so long you can spend trying to figure out where the end of the tape is on the roll before you go crazy. If you do a lot of shipping, you will need at least one tape gun and preferably two: one for USPS priority tape and one for clear tape. I use the USPS priority tape to tape the packages together (close the flaps, hold the sides, reinforce corners, etc.) and I use the clear tape to tape the address label and the warning labels.

You will also need a utility knife to cut down boxes and pieces of cardboard.

I also use my wall board cutter to cut large sheets of cardboard to the sizes I need. If you do not have a wall board cutter you can also use a mat cutter. In that case be sure to use the straight blade and not the beveled blade on your mat cutter.

Confirmation of Delivery

We place a delivery confirmation label on each package. This costs only 75 cents extra and you can give the tracking number to your customers over the phone or by email. Having a tracking number is reassuring for customers. It also allows you to confirm if and when each package was delivered.

Insurance

In over 12 years of regularly shipping packages containing framed pieces via the USPS, most of them with glass, I only had two of them break. (I ship about 20 to 30 pieces with glass a month on average.) Both of the damaged packages showed evidence of very rough handling. Both packages also took longer than normal to be delivered.

When something like this happens and the artwork gets damaged I ask my customer to return the damaged piece and I ship them a free replacement right away. In other words, I cover the insurance myself and I absorb the loss. I use this approach because very few of my packages get damaged. This practice is therefore more cost effective than insuring every single package through the post office or purchasing other types of insurance.

Foam peanuts

Fill

Fill is basically what you fill the empty space in the packages with. Traditionally, foam "peanuts" have been used for this purpose because they are both extremely light and crushable, meaning they absorb shocks very well. However, if you do a lot of shipping and have large packages, you will need a lot of foam peanuts. This is not a problem if you can find a free source of supply by either recycling foam peanuts from packages you receive or if you can get peanuts from other people or companies who receive a lot of packages themselves.

Of course, you can buy new foam peanuts. However, there is another solution which is to make filling material yourself with a paper-shredder. There are two types of shredders, crosscut shredders and strip shredders. You need a strip shredder to make fill. Get one that captures the strips in its own container. Then, just shred all of the paperwork, newspaper, and junk mail available and soon you will have more than enough fill for your packages! I tried this approach last year after running out of foam peanuts and it worked great. Plus, if you are careful not to stuff the shredding too firmly into the box it should be only slightly heavier than peanuts.

Strip shredder

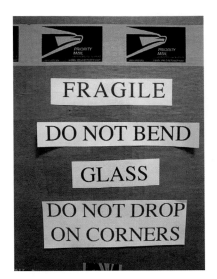

Homemade warning labels

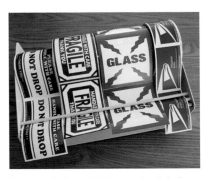

Commercially available warning labels

Labels

I use a variety of labels to indicate that the contents are fragile, that the package should not be bent, that there is glass inside, and so on. I avoid using labels saying "Photographs" because in my opinion this makes the packages more noticeable and subject to theft.

You can make your own warning labels on your computer with a layout or writing program using large red and black type for maximum visibility. This saves a little money because it prevents you from having to order commercial labels. It also allows you to print only the quantity of labels that you need.

Commercially produced labels are widely available from companies that sell shipping supplies. Using ready-made labels will save you time when compared to making your own labels, they will look more professional, and they will meet specific postal and shipping regulations. These are the labels we use on most of our packages.

The roll dispenser is very practical because it keeps the labels organized and makes them easy to pick up. The labels have an adhesive backing and the dispenser is designed to automatically peel off the backing, giving you labels that are ready to apply to packages. Every little thing you can do to save time and make your life easier makes a difference. It all adds up to saving a lot of time and effort in the long run!

Packaging Artwork for Shipping

Now that we have looked at the materials and tools required for packing, it is time to look at how we are going to pack specific types of photographic products. Because packing needs to be adapted to the artwork, different types of artwork will require different types of packing. In the instructions below I will proceed from simple to more complex packages.

Packing Unmatted and Unframed Photographs

The easiest piece to package is an unframed and unmatted photograph. Such an image is shipped rolled, in a sturdy 2" or 3" diameter tube.

First, inspect the artwork to make sure it is perfect in every respect. You don't want to ship a piece which is damaged, dirty, or has bent corners.

Second, roll the photograph in an oversize piece of interleaving paper to protect it from scratching during shipping.

Third, take an oversize tube (4 inches or so longer than your rolled photograph), cap one end with a plastic cap, and place some crumpled paper at the bottom of it so that the photograph is not in direct contact with the plastic cap. Place your photograph in the tube, add more cumpled paper at the top and close the tube with a second plastic cap.

Fourth, secure the two plastic end caps to the tube with tape and attach the address label. Make sure the label has both the destination address and your return address. I use custom-made shipping labels with my return address preprinted on them so that all I have to do is write the destination address and tape the label to the package. I also add a "Fragile" label on the tube.

Packing a Matted but Unframed Photograph

The second easiest type of package is an unframed matted photograph. Because it is matted it has to be shipped flat, but since there is no frame it can be shipped between multiple layers of cardboard rather than in a box, thus reducing shipping weight. (Remember that shipping costs are calculated by weight.)

First, inspect the piece to make sure it is perfect in every respect.

Second, take the matted photograph, make sure it is inside a crystal clear bag (see suppliers list) and that it has a thick backing board.

Third, cut two oversize pieces of stiff cardboard. These pieces of cardboard have to be about 2" larger than the mat size. You can cut these pieces of cardboard with a utility knife, on a mat cutter or on a wall cutter.

Fourth, take one of the two pieces of cardboard you just cut, put it under the bagged photograph, and tape each corner of the bagged photograph to it so it will not shift during shipping.

Fifth, take the second piece of cardboard, place it on top of the bagged photograph and tape the four sides of the two pieces of cardboard together. Make sure to close each side with tape so that no humidity can get in. You are in effect constructing a box inside which the photograph is protected.

Sixth, add cardboard corners in all four corners as extra protection and tape those to the package as well. I use the corners that come as protection on ready-made frames and which I recycle for packaging. However, you can also purchase these corners in bulk for a minimal cost from framing supply stores (see suppliers list) or make your own from pieces of scrap cardboard.

Seventh, place the address label and the warning labels on the front of the package. I use labels saying "Fragile" and "Do Not Bend" on this type of package.

Packing a Framed Photograph

The third type of package consists of framed photographs. These packages can be divided in two categories: photographs framed with glass and photographs framed with Plexiglas or other brand of acrylic sheeting. Such products as Plexiglass are actually better than glass because they add an extra layer of

UV protection, they do not scratch, and they will not send glass shards flying toward your artwork in the event the piece is dropped. Plexiglas products are widely used by museums and galleries. We use plexiglas products designed specifically for framing, and produced by various manufacturers, such as TruVue, etc. (*Note:* For ease of explanation, and to not favor one manufacturer over another, I use the generic term "plexiglas" in this book.)

Plexiglas is lighter than glass and therefore less expensive to ship. Plexiglas will not break during shipping, which will alleviate your worries a great deal. However, framing-quality Plexiglas is more expensive than glass and this cost has to be taken into account when pricing pieces framed with Plexiglas. Finally, if you buy ready-made frames, these frames will come with glass, which makes shipping them with glass easier and more cost efficient.

If you ship pieces framed with glass you have to add much more protection than if you ship pieces framed with Plexiglas. I normally ship pieces framed with glass in sizes up to 22" × 28" framed size. When shipping pieces larger than that I use Plexiglas, knowing that glass is likely to break during shipping or that crating will be required in order to protect the glass. Finally, any framed piece shipped outside of the continental United States is framed with Plexiglas. This is because the cost of shipping pieces framed with glass overseas is prohibitive due to their weight.

Packing a Photograph Framed with Glass

First, inspect the piece for any defects and clean the glass. The piece must look perfect in every respect. This is true for any piece that you ship, not just one that is framed. However, it is particularly important to inspect a framed piece carefully because if dust is trapped under the glass or Plexiglas, the customer will not be able to remove it.

Second, wrap the piece in bubble wrap and tape the bubble wrap securely all around.

Third, completely wrap the bubble-wrapped piece in an oversize piece of cardboard. Create crushable structures on all four corners and fill these structures with foam peanuts.

Fourth, place this package into an oversize box and place packing material all around the piece. I like to have *at least* two inches of space all around the piece. (The boxes I use are all five inches thick.) Make sure to place a layer of packing material at the bottom of the box prior to placing the piece in it, then,

holding the piece in the center of the box, add fill to the sides and the top of the piece until it is totally surrounded.

Fifth, tape the box shut with packing tape and place shipping and warning labels on the box. I use labels saying "Fragile," "Glass," and "Do Not Drop On Corners" on this type of package.

Note: We routinely place up to two 16" × 20" or 22" × 28" frames in one 5" thick box. We place the two framed pieces face-to-face, meaning that the glass sides are facing each other. That way, it is virtually impossible to break the glass since only the back of the frame is exposed to lateral shocks.

Packing a Photograph Framed with Plexiglas

To ship a piece framed with plexiglas, I follow the same approach as above except that no packing material is used. First, inspect the piece to make sure that it is perfect in every way.

Second wrap the piece in bubble wrap and securely tape the bubble wrap.

Third, cut two pieces of cardboard to the size of the frame and tape one sheet on the front and one on the back of the frame. This step is very similar to packing a matted photograph as described above.

Fourth, place the piece in a box of same thickness as the packed frame (you do not need a 5" wide box). I normally use mat board boxes for shipping pieces framed with Plexiglas. They are the perfect size for up to a 32 × 40 piece, are very sturdy, and have crushable structures at the top and bottom. I place the frame in the middle of the box and I add fill to the sides to form two additional crushing areas. I do not add fill to the front and back of the box. The front and back are protected with the sheets of cardboard as described in the previous step.

Fifth, tape the box together and add shipping and warning labels. I add the same labels as for pieces framed in glass except for the "Glass" label.

Conclusion

Packing your work so that it is protected during shipping is a crucial aspect of selling fine art. The sale is not complete until your work is in the hands of your customers and has arrived in perfect condition.

No one wants to receive a damaged or a broken work of art. If you do not pack your work well and it arrives damaged, you will have to deal with returns and complaints. This will increase both your workload and your stress level. It is much better to prevent having to fix these problems by taking the necessary time to pack your work carefully.

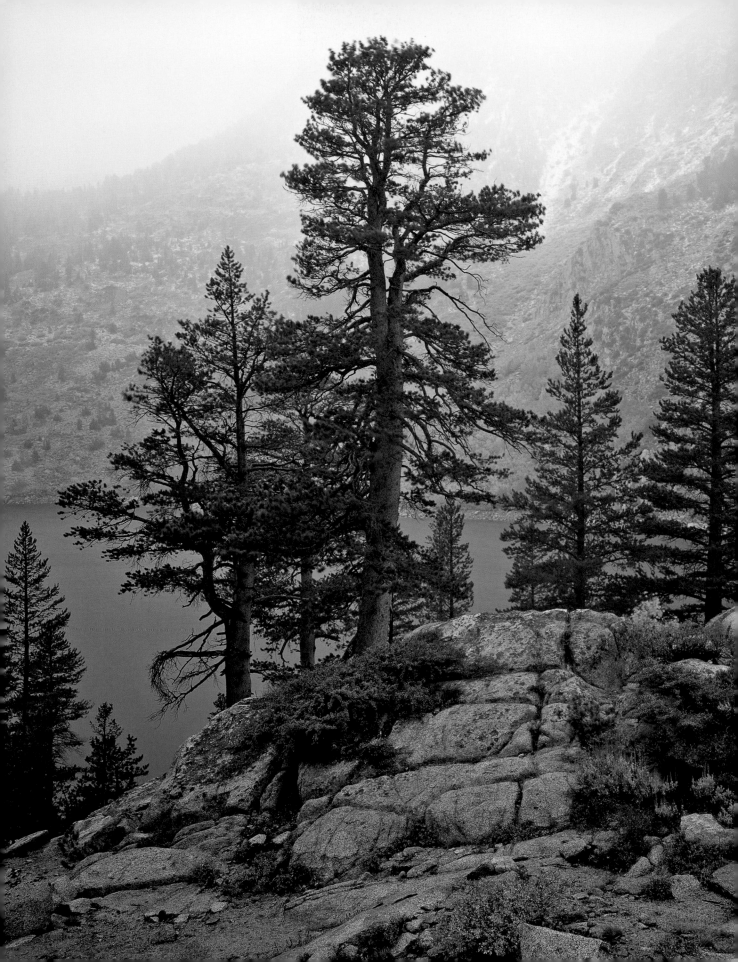

Success doesn't "happen."
It is organized, preempted, captured, consecrated common sense.
 F.E. WILLARD

Chapter 15
Fine Art Photography Skills

Four categories of skills are required to successfully sell fine art photography:

- Technical Skills
- Artistic Skills
- Marketing Skills
- Personal Skills

In this chapter I will go over what each of these categories of skills consists of. I will cover artistic and technical skills only briefly because I address them at length in two other books: *Mastering Landscape Photography* and *Mastering Photographic Composition, Inspiration and Personal Style*. Similarly, I will cover marketing skills only briefly since marketing is the focus of this book. Therefore, the emphasis of this chapter is on the personal skills necessary to operate a successful fine art photography business.

Technical Skills

Technical skills are required in order to use cameras, computers, printers, software, and just about all the other tools necessary to create photographic images. Technical skills are also necessary to calculate exposure, process and optimize photographs, evaluate print quality, and complete all other technical aspects of creating fine art photographs.

The scientific knowledge required to do fine art photography at a professional level includes:

- Knowing which equipment is right for you (camera, tripod, lenses, accessories)
- Knowing how to operate your equipment (camera, tripod, etc.)
- Knowing how to expose, focus, and set the ISO correctly for each specific situation
- Knowing the differences between how we see and how the camera sees
- Knowing how to shoot RAW and read a histogram
- Knowing how to process and optimize (post-process) your images
- Knowing how to print your images
- Knowing how to curate, mat, and frame your images

Artistic Skills

Artistic skills are just as important as technical skills in the creation of fine art photographs. Without artistic skills, your photographs will lack the personal touch that art adds to an image. Artistic skills are what will enable you to develop a personal style and take your work beyond a literal reproduction of the subjects that you photograph and toward a personal interpretation of these subjects.

The artistic skills necessary in fine art photography include:

- Knowing the different types of light and how to use them
- Knowing the different types of compositions and how to use them
- Knowing the three variables of color and the one variable of black-and-white
- Knowing what a color palette is
- Knowing how to use a viewfinder to compose your photographs
- Understanding why post-processing is indispensable to express your personal vision
- Knowing how to express emotions in photographs
- Knowing how to develop a personal style
- Knowing the foundational characteristics of art
- Knowing the language of art
- Knowing which artists you like and do not like
- Knowing how to write an artist statement
- Studying the photographs and writings of other photographers and artists
- Collecting original work by other photographers and artists

Marketing Skills

Marketing skills are necessary to run a photography business and to sell fine art photographs profitably. The marketing skills necessary to sell fine art photography successfully include:

- Knowing the differences between wholesale, retail, and consignment (Chapter 3)
- Understanding the differences between quality and quantity (Chapter 4)
- Knowing which photographs sell best (Chapter 8)
- Knowing how to price your time (Chapter 7)
- Knowing how to price your work (Chapter 7)
- Mastering salesmanship (Chapter 10)
- Knowing how to operate a business profitably (Chapter 11)
- Knowing how to avoid common marketing errors (Chapter 16)
- Knowing what your USP is (Chapter 21)
- Having warranties (Chapter 21)

Personal Skills

The fourth category of skills is what I call *Personal Skills*. If one wants to succeed in a business endeavor, one must have the personal skills to do so. And so the remainder of this chapter is devoted to these important skills.

I realized the importance of personal skills by looking back at my own life. When I first came to the United States as a foreign student in 1986, my personal belongings consisted of a suitcase and a camera bag. At first my father was supporting me and paying for my studies since I did not have a work visa. By the time I became a graduate student and started working on my master's degree, I was supporting myself by working as a graduate teaching assistant (GTA) at my university. I continued doing so while working on my PhD. The pay was very low and by the time I completed my studies and started my photography business in 1997, I was broke. On top of that I was also seriously in debt, drove a beater of a car, and had few valuable belongings except for my cameras.

In the thirteen years that followed starting our photography business, Natalie and I were able to turn our situation around 360 degrees. By 2010 we owned three houses, 200 acres of land, three new cars, a fully equipped photography studio, a home gallery, an art collection, and more. Most importantly, everything we owned was fully paid for.

Looking at the turnaround that we were able to accomplish, I couldn't help but ask myself why more people don't do what we did. My question was motivated by the fact that what we accomplished was achieved entirely by ourselves. We did not win the lottery, we did not play the stock market, we did not get help from wealthy family members, we did not find a bag full of cash forgotten by someone in a rental car, and we did not play roulette in Las Vegas. In short, we did not benefit from any lucky financial break. All the money we made was earned through our efforts. Furthermore, all our income was reported and taxed, none of it was illegally acquired or protected from taxation in any way.

Not being originally from the United States, I also started with a handicap. I was not a native speaker, I was not intimately familiar with American culture, and I had to face the various drawbacks that all immigrants face. Yet, I succeeded beyond what many native speakers achieve and I did so in only 12 years while it takes most people 30 years to get where we are now.

So what played in our favor, so to speak? What made all the difference? I quickly ruled out talent or innate abilities. Whether or not talent exists is something that is very difficult to define. It was clear that the amount of work we put in over the twelve years during which we turned our lives around was a major factor. Hard work, more than talent, was responsible for this massive change.

Yet other factors were also at work, and as my life gave me more time to reflect on what we had accomplished, I started jotting down notes to try and

Our doubts are traitors, and make us lose the good we oft might win, by fearing to attempt.
William Shakespeare

list all the things that I consider to have played an important role in achieving the changes that I just described. Over time, I organized my notes into named categories.

What follows is a list of the most important of these categories, followed by a description of the most important aspects of each. It is my hope that the knowledge that follows will allow you to achieve what we achieved and go even further than we did. I truly believe that there are no limits to what we can conceive of and achieve if we approach the task in the proper frame of mind, equipped with the necessary skills.

Let us now look at what these skills and this state of mind consist of. For the sake of convenience and simplicity, and to emphasize the fact that they are all equally important, I decided to present these skills in alphabetical order. Therefore, the order in which these skills are presented does not reflect a ranking of importance.

Indian Gardens, South Rim of Grand Canyon National Park – This is another view of the Bright Angel Trail, but this time taken from the viewpoint in front of the El Tovar Hotel. This image shows not only the trail but also the rim plus Indian Gardens and Plateau Point, both located below the rim, which are popular destinations for day hikes. This photograph was extremely popular with El Tovar guests because it is the view that they could see from their room, if they had a room with a view on the canyon, or from the North Porch of the hotel (where my art show was located), or from the rim since the El Tovar overlook is only 50 feet from the hotel itself. In other words, this was the view that all hotel guests saw during their stay. It was taken during the day, at around 9 a.m. Since most visitors see the Grand Canyon during the day, this image closely matched their visual experience of the Grand Canyon. As with the previous image, more consideration was given to the audience than to my artistic impulses and vision. I personally preferred other images of this scene taken at sunrise or at sunset but those other images did not sell as well.

I also decided to use single words as titles. Some of these words are nouns and others are verbs. I like the single word approach because it goes straight to the point. It also makes an immediate impression when you read the title of each section in this chapter. Finally, single words have retention power. They are easy to remember and that is important because remembering the information below is what this chapter is all about.

ADVICE: I realized early on that I needed to take advice only from people who were where I wanted to be. When I started selling my work, a number of other artists gave me advice on how to run my business. However, I could see

that these artists were not where I wanted to be. Some were not declaring their income. Others had been selling photographs for years and were still unable to make ends meet. Yet others favored working just enough to get by financially. None of these were things I wanted to do. These were not my goals and listening to advice explaining how to get to where they were was just dead wrong for me.

I decided to seek my own answers. For example, it was clear from early on that doing everything I was asked to do by customers would force me to dilute my efforts and would prevent me from focusing on what mattered most. It was also clear that pricing my work at wholesale prices in a retail situation would not allow me to generate a sufficient profit to stay in business.

I also realized that I had questions that required specialized knowledge to answer. Questions related to marketing and salesmanship, for example, defeated my attempts at finding correct answers. I learned that I needed the help of experts with these questions and by my second year in business (1998) I was working one-on-one with a marketing expert on a monthly basis.

ANGER: "Anger: Don't feel it." I remember seeing a sign with this statement in a used car dealership in Los Angeles, where I went to resell my car. I was angry at the low price the dealer offered me for the car and when I saw the sign I understood why it was there. Probably a lot of customers felt the way I did. The sign did not make me feel better. But it stood out in my memory of the event, which occured over 20 years ago.

What is meant by "don't feel it"? Here is how I have come to understand the meaning of that phrase. Regardless of whether you are selling a car and getting next to nothing for it, or whether a customer is trying to buy your work for less than you consider acceptable, you can always say no. You do not have to accept a deal that is insulting to you. In short, you do not have to feel insulted. You can simply refuse to accept what you consider unacceptable. If you do, you will not feel angry.

In the two examples above, anger comes from believing you do not have control over a situation that is not working for you. The fact is, while you do not have control over what other people are doing or asking you to do, you do have control over your reaction to their demands. You do not have to agree with them and you do not have to give them what they ask for. If anger is part of the deal, it is better not to make a deal.

Often, when selling our work we become angry when a negotiation is not going the way we want. When this happens, agreeing to conditions that are unfavorable to you will make you angry. However, not agreeing to these conditions will stop your anger. If you feel that you are getting angry over an offer, just say no. You do not need to get angry. All you need to do is turn down the offer.

Being angry is not helpful when working with customers. Always remember that the goal is to be helpful, not to be right. Therefore, instead

of getting angry, present conditions that are more pleasing to you. When negotiating, the best approach is to look for a win-win situation—a deal that is favorable to both the buyer and the seller. In such a deal both parties are willing to give up part of their initial demands in order to make the deal work. Nobody loses and everybody wins. Most importantly, nobody gets angry.

APPROACH: Spend the necessary time to develop a successful marketing approach. Decide to put as much effort into the marketing, pricing, and selling aspects of your photography business as you put into your photography itself. Good selling and marketing does not mean pressure or manipulation. It is finding out what people want and helping them get it. You achieve this by asking questions to potential customers, first to qualify them and second to find out what they need and what you can help them with.

ATTITUDE: Having a positive attitude is one of the most important things you can do in regard to generating success in your business and in your personal life. Positive thoughts bring positive results and negative thoughts bring negative results. In short, believing that you can do something is a large part of actually being able to do it. Conversely, believing that you cannot do something is largely responsible for you not being able to do it. This is because we unconsciously attract what we think about. If we think positively we attract success and if we think negatively we attract failure. By thinking positively we look for ways to reach our goals. By thinking negatively we look for ways to prove that these goals cannot be achieved.

When you close the door of your mind to negative thoughts, the door of opportunity opens to you.
Napoleon Hill

Basically, over time we become what we think about. If we think negatively, regardless of what form this negative thinking takes, we achieve negative results and become unsuccessful. If we think positively we achieve positive results and over time become successful. It is that simple. Nobody succeeds because they think and act negatively! Successful people are positive thinkers who are enthusiastic about what they do and who believe that success is possible.

This may seem like an overstatement, but it is not. I used to think that I could not make a living doing what I really wanted to do until, one day, I asked myself how much harder it would be to do what I like instead of doing what I did not like. My answer was that it could not be any harder because doing what I did not like was a living hell. At that time I stopped thinking negatively and I started thinking positively. I stopped thinking that it could not be done and I started thinking that it could be done.

I attribute the success I encountered afterwards to this change in thinking. Certainly, I had to work very hard and it took a number of years to be successful. However, without changing from thinking negatively to thinking positively I would never have been successful doing what I wanted to do.

Thinking positively is the key to success. If you have been thinking negatively, in order to succeed you need to stop thinking about the reasons why

you cannot be successful and start thinking about the reasons why you can be successful. Doing so will change your life.

COMFORT: Make it a habit to get out of your comfort zone and to stay out. This is because everything we have achieved so far is part of our comfort zone. Or, to put it differently, our comfort zone encompasses all the things that we have done successfully so far. We are comfortable doing all these things and we are comfortable living the way we do now.

If we want to go beyond what we have done and acquired so far, we must get out of our comfort zone. This is because everything that we want but do not yet have is outside of our comfort zone.

COMMON SENSE: Most business decisions are based on common sense. While studying business does help, not everything taught in business school is useful and not everything you need to know is taught in business school. I personally never took a business course. Instead, I focused my studies in the humanities. I received a bachelor of arts degree in English and a master's in Rhetoric. Finally, before deciding I did not want to be an academic, I started work on a PhD in Rhetoric. Despite my lack of formal education in business, I was able to operate a profitable business successfully and figure out how to make important decisions by using common sense as my guiding light.

As I said in the introduction, this book is designed to help you avoid making the many mistakes that I made along the way. However, if you need to make a decision for which this book does not have an answer, use common sense to help you find the proper course of action.

Business is not rocket science. Business is about making sound decisions by making the best use of your resources at a given time. Those resources are time, money, leverage, knowledge, etc. When faced with a situation you have not encountered before, a situation for which you have no ready-made solution, bring common sense to the rescue. Ask yourself how you could best handle this situation while making the best use of the resources you have at your disposal. I am confident that if you do so, you will find a satisfying answer to most problems.

COMPETITION: Love your competition; it makes you better and it makes you work harder. Without it you would not be where you are now. Do not run your business by focusing on your competition. To do so is similar to driving your car by looking in the rear view mirror. You need to look forward, not backwards or sideways. Do not worry how well, or how poorly, your competition is doing. It has no direct bearing on how well *you* are doing. What matters at the end of the day is how much money you have in your pocket, not how much money your competition has in their pockets.

CONCESSIONS: When you start working on a new project it is better to aim high than to aim low. You can always lower your expectations, your goals, and your standards. However, it is almost impossible to raise them if you find out that they are too low. For this reason I recommend that you do not make concessions at the start of a project. You can always make concessions later on if it becomes clear that you will not be able to get everything that you want.

CONFIDENCE: A large part of being able to do something is believing that you can do it. I found that out very early by realizing that if I did not believe I could complete a project, most of the time I did not even get started on that project.

Believing you can do something is half the battle. People often wonder how I can do what I do. One of the main reasons is because I believe I can do these things before I get started. Even though most of the time I do not know exactly how things will turn out, I have confidence in my skills and abilities. In other words, what is most important to me is believing that I can complete a project. I do not have to have everything I will need before I get started or know the answer to every question regarding the project.

What I need most is a precise goal, a realistic deadline, and a project that I know I can complete. I can get the required supplies and knowledge as the project moves forward. What I cannot get later on is the confidence that I can complete this project. This confidence has to be there at the start of the project. If you do not have confidence that you can complete your project, the first difficulties you encounter will stop you dead in your tracks.

CONTROL: First, to be successful you have to take control of the things that influence the outcome of your endeavors. Success is based on controlling the variables that affect your performance and that influence your life.

Second, you need to focus on what you can control, not on what you cannot control. For this you need to separate the things that you can control from the things that you cannot control. To know which is which, I recommend making two lists: on the first list, write all the things that you can control. On the second list, write all the things that you cannot control. Once those two lists are completed, keep the list of things you can control and throw away the list of things you cannot control. Finally, focus the rest of your life upon changing the things that you can control.

Putting energy into things that are out of your control means wasting your time, your money, and your energy. However, a lot of people spend their entire life doing just that. The outcome is anger, frustration and a negative attitude.

Third, you need to take control of your destiny now. Do not wait for luck to strike. Do not wait to be "discovered." While it is tempting to wait for fate to bring you what you want, you must understand that it is not something you can control. It is on the list of things you cannot control, the list you just threw away.

Ask yourself "what if luck doesn't strike?" and "what if I am not discovered?" If luck does not happen—and believe me, most people do not become famous or rich because of luck—then you will be left with nothing. You will have wasted your time and when you realize that, it may be too late to take control of your destiny.

By taking control right now you take away this risk. You let go of relying on luck to make you successful. But, what if luck does strike, you may ask? What if I am discovered? Well, if that happens, great. More power to you! Personally, I welcome luck. However, I also know that lucky events are out of my control. Therefore, I work toward making my own "lucky breaks." Why? Because working hard toward reaching specific goals is within my control. If luck strikes, fantastic! In the meantime I am doing everything I can do so that I get what I want in case luck does not strike.

CRITICISM: First, do not accept criticism blindly. Always ask yourself why someone criticizes your work. Criticism falls into different categories and criticism is made for various motives. Some of these motives are valid and you need to pay attention to them. Others are invalid and should be of no concern to you.

The most important is to know in which category the criticism you receive falls into and what motivated the critic to make this criticism in the first place.

For example, some of my photographs have been criticized for being "manipulated" in Photoshop, meaning that I had modified the original image, either by changing the colors, modifying the contrast, cropping, changing the format of the photograph by stretching the image vertically or horizontally, or changing the shape of elements in the image through warping or distortion. However, doing all this was intentional. It was not an error on my part. What some called "manipulation" was simply the reflection of my personal style, of my approach to photography. I do not consider the image finished when it comes out of the camera. Instead, I consider it finished when the image expresses what I saw and felt, not just what the camera captured. And in order for the image to express my feelings, I have to modify a number of things in the original capture. This is done deliberately and purposefully. I am aware of it and despite such criticisms, I have no intent to stop doing it.

Reflect on the nature of the criticism you receive and on the motives that people have for critiquing your work. Take valid criticism into account and make the necessary changes to correct what was pointed out to you. However, let invalid criticism fall by the wayside and pay no further attention to it. As the saying goes, let the dogs bark and drive on by. Only let criticism improve what you do. Do not let criticism change who you are.

It is also important to remember that those who are critical of your work tend to speak louder than those who enjoy your work. In other words, people who have issues with what you do are more verbal than people who are satisfied with what you do. This means that you may hear more critical comments

Success is nothing more than the progressive realization of a worthy ideal. Most people do not know what success is and therefore they do not know how to look for it.
Earl Nightingale

GRAND CANYON NATIONAL PARK

Bright Angel Trail

Bright Angel Trail Panorama Poster, South Rim of Grand Canyon National Park – I created this poster for sale in Grand Canyon National Park after I realized that it was one of my best selling images. It shows the Bright Angel Trail, the most heavily traveled trail in Grand Canyon, in its entirety, from the El Tovar on the South Rim (at left in the photograph) to the Bright Angel Lodge on the North Rim (at extreme right in the photograph).

This poster had to be approved by Park Rangers prior to being sold in the park. Approval was granted on the basis that the image was not manipulated in any way. Since over 180 degrees of view are shown in this image, a single photograph cannot capture the entire scene. I therefore used a Seiss rotating panoramic camera to create the original photograph. Stitched digital captures would not have been accepted because they would have been seen as manipulation.

The image was taken at mid morning, not because this is the best time of the day for color or light quality, but because this is when the trail could be seen in its entirety. Too early and it would be in deep shade, too late in the day and it would be washed out by direct sunlight. Clouds also helped soften the deep shadows that usually fill the inner canyon.

Finally, this image was taken in March, because spring and fall are the time of year when most people hike the Bright Angel Trail, when the temperature is still low. Most hikers start early in the morning and find themselves in the middle of the trail by mid morning. They do this to avoid hiking in direct sun (the majority of the trail is in the shade in this photograph). Similarly, cloudy days are a blessing since there is less or no direct sun. Because the Grand Canyon is a mile deep, temperatures at the bottom are often 30 to 40 degrees higher than on the rim, hence the importance of hiking in cool conditions.

As you can see, decisions were made not so much from an artistic point but mainly from the perspective of pleasing the audience. As an artist I would have preferred to show this scene in a very different way. I may also have decided not to take this photograph at all.

than comments praising your work. However, this does not necessarily mean that the majority of your audience is unhappy with what you do. It simply means that some are unhappy, and that they voice their opinion vehemently. When people like what you do, they rarely "jump for joy" and start yelling how wonderful you are. However, when people are dissatisfied with something they tend to make a public display of their displeasure. This is human nature. There is nothing we can do to change it. All we can do is keep in mind that people who dislike what we do are by nature more verbal than people who appreciate what we do.

If you want to check whether the majority of people are happy or unhappy with your work, simply ask everyone in your audience, through a public announcement, how they feel about what you do. Once you have tallied the answers, bring up the critical comments you receive and ask who else feels that way. You may be surprised to find out that only a minority does. What happens is that this unsatisfied minority expresses their issues publicly, while the satisfied majority often remains silent and keeps their opinions to themselves.

Second, do not be the critic of your own work. Your personal judgment for your work is based on considerations that are different than those of your audience. Instead, let people decide which of your photographs they like or dislike. Let them "vote with their money." It works great and the answer is accurate.

We all have opinions and as artists we have to remind ourselves that negative reviews are just that, opinions, and that we cannot please everyone out there. We cannot lose our creativity over it, or stop doing what we love doing. Art is by nature polarized. Some will love your work while others will dislike it. We just need to keep in mind that our audience consists of those who enjoy what we do.

Finally, you need to learn how to respond to difficult questions and to criticism. I provide answers to a number of difficult questions in my previous two books, in essays such as *Being an Artist, Being an Artist in Business, Just Say Yes, The Eye and the Camera, The Numbering Affair* and more. I therefore refer you to my two previous books for a longer discussion of this important topic.

CUSTOMERS: When selling my work and talking to customers, I am mainly concerned with being helpful. For me, being helpful is more important than being right. Sometimes customers will ask me to do something that I do not offer. For example, I may be asked to provide a service that I do not offer, or provide a frame style that I do not carry. When that is the case I do not try to argue with customers or prove them wrong. I simply explain that this is not something that I do. If they persist, I provide them with locations where they might find this service or type of framing.

I simply cannot please 100% of the people 100% of the time. I can only please some of the people some of the time. By not trying to be right all the

time, and by not trying to be all things to all people, I focus on being helpful to my customers rather than on being right. I also save myself a lot of stress and time.

It is also important to remember that not everyone who walks through the door, or contacts you in one way or another, is a good prospect for your photography business. You need to find out what potential customers are looking for. This process is called *qualifying the customer*.

You qualify customers by asking them questions about what they are looking for. Doing so allows you to find out who is likely to enjoy your work and make a purchase and who is not likely to do so. When you qualify customers you will find out that a number of people who seem interested in your work are simply not qualified. Their interest is superficial and they are not interested in making a purchase. They are "just looking," as they will often say.

Do not feel badly that you can't make a sale to these customers. Instead, keep in mind that in order to be successful in business you must be willing to send some people away. This is a perfectly normal approach. In fact, doing so is an important aspect of becoming a successful businessperson.

You also have to expect some level of dissatisfaction. This is because some people cannot be pleased no matter what you do. They simply do not like you, or your work, or the way you do things. Don't let their negativity stop your progress. The best thing to do is to let them be and not worry about it.

DEADLINES: Deadlines are one of the most important aspects of completing a project successfully. When we do not have a deadline, we feel that we can push things back "just a little" because there is no specific date by which something has to be done. The problem is that by pushing things back "a little" over and over again, nothing gets done. Eventually, the lack of results causes us to become unmotivated. We progressively lose interest in the tasks we have to perform. Finally, we quit and the project remains unfinished.

Most of the time things get pushed back because we encounter difficulties along the way. If we have a deadline, we are forced to find a solution to these difficulties right away in order to meet the deadline. But when you do not have a deadline, you are not under pressure of completing the project by a specific date. Instead, you can take your time and wait until "a solution is found." The problem is that no solution will be found until you put your mind to it and actively look for that solution. Waiting does not solve problems; it only postpones having to find a solution.

Most projects are stalled because of unexpected difficulties. Projects fail to be completed because people working on these projects are not willing to find solutions and overcome difficulties. To be successful you simply cannot be vague about completion dates. Having a deadline and enforcing this deadline is the best guarantee that your project will be completed.

DECISIONS: Successful people are decisive. Being successful means being able to make decisions quickly. When I started my business it took me forever to make decisions. As a result I missed out on several opportunities because by the time I had made a decision these opportunities were gone. I learned that the faster I made a decision the more successful I became. However, I also learned not to make decisions blindly. It's important to gather all the information necessary to make an informed decision, to talk things over, and to consider all potential outcomes.

What you do not want is to be paralyzed by the inability to make a decision. It is better to walk away from an opportunity than to waste time agonizing about whether you should take advantage of it or not. Eventually, time is your most valuable asset.

Finally, many decisions can be changed later on. In other words, few decisions are irreversible. If you find out you were dead wrong, it's OK to change your mind and correct your course of action.

DELEGATING: Don't try to do everything yourself. To be successful running the many different aspects of your business you need to become a great delegator. You cannot possibly do everything that needs to be done by yourself.

When I started my business I thought I could do everything by myself. In fact, I found a source of pride in trying to prove I could do it all. However, I quickly found that there were too many things for me to do and that I had to delegate some of them to others. In other words, I realized that I needed help. I also realized that delegating tasks to others did not mean I was unable to complete these tasks myself. Instead, it meant that I was smart enough to realize that my time was better spent running my business rather than tending to every aspect of it.

There are many things that can be done very well by others. On the other hand, there are things that I need to do myself. Knowing what I need to do myself and what I can delegate to someone else is the key to success.

When you delegate tasks and responsibilities, it is important to have people you can count on to do these things for you. If you cannot count on them you will have problems. It is also important that you follow up on everything to make sure that things get done. By checking that tasks have been successfully completed, you make people accountable for the tasks you delegated to them.

DEFENSIVENESS: Being defensive is perceived as a sign of weakness, and many people believe that someone who needs to defend their position or beliefs is a person who has problems. It may be suspected that this person is not strong enough to stand on their own, or they have something to hide, or they have an ulterior motive that has not been revealed.

Solid positions are transparent. They are what they are. While certain things may need to be explained, these explanations take the form of teaching

not of defending specific choices. This is particularly important when selling because when arguments are being put forward to defend a product, customers often feel that it is because there is something wrong with it.

It is better to teach than to defend. Teaching means explaining why you do things the way you do and revealing the techniques and the philosophy behind your approach. Teaching is about facts. Facts can be checked and proven scientifically. They do not change from one person to the next.

Defensiveness is about closure and darkness; about obscuring facts by presenting opinions. Opinions cannot be checked. They cannot be proven scientifically and they vary from one person to the next.

DISCOVERED: Do not wait to be discovered. Take control of your destiny today. If you are discovered later on: great! If not, you will have taken care of your destiny and your career anyway and you will not need to be discovered.

DOING: Do what you love. Doing what you love is the only activity that will allow you to use all your energy and abilities. Success is being able to do what you love. It is having the time and the resources to do what you really want to do, not what you think you have to do. This is because everything that you want to do well is difficult. It is also because you will have competition no matter if you do what you love or not.

Ask yourself how much harder it would be to do what you love than to do what you do not love? Most likely it would not be any harder.

Doing what you love is important. It is important because it matters to you. Whether it is important to others or not is beside the point. However, if you think it should be important to others then you need to explain why to them.

Doing what you really want to do is important because you have waited long enough. It is important because you are good at it. We are all good at doing what we love. It is important because you need to share your gifts with others. It is important because you deserve it. It is important because it is your turn to do what you want.

The best time to get started is right here, right now. There will never be a better time.

It is never too late to do what you love. Regardless of age, circumstances, timing, or any other difficulties, you can still do what you really want to do. All it takes is getting started, and the best time to get started is right here, right now. There will never be a better time.

ENTHUSIASM: Enthusiasm is contagious. Be enthusiastic about what you do and others will be enthusiastic about it as well. Enthusiasm ends in I.A.S.M. which can be seen to stand for I Am Sold Myself. If you sell a product that you personally believe in, you will make others believe in it as well.

EXCUSES: Excuses prevent you from doing what you love and from getting what you want. To stop making excuses, first find out which excuses you have

been making so far. Second, find out what the opposite statements to these excuses are.

For example, if you have been using the excuse "I am not selling my artwork because my work is not good enough," replace this excuse by saying "I can sell my work because I am going to learn how to create artwork that is good enough." In other words, replace the excuses you have been making with opposite statements. By doing so you will discover that excuses are really smokescreens preventing you from reaching your full potential. These excuses are keeping you from doing what you love and from unleashing the abilities that are within you.

Often, excuses are used to avoid making the changes you need to make. By refusing to make excuses for what you have not been able to accomplish so far, you will start to see what changes you need to make in your life in order to make things possible. For instance, in the example above, the change that needs to take place is learning how to produce artwork that is good enough to sell. Doing so is possible because it is a matter of learning how to do something well. Once you set this as a goal you can start learning how to create high quality artwork.

What has prevented this learning is the excuse that was put forth so far, because this excuse focuses on your abilities: "My work is not good enough." When this statement is changed to: "I am going to learn how to create artwork that is good enough," the emphasis is on learning and on the possibilities that this learning opens up. In this example, switching from an excuse based on a lack of confidence in one's abilities to the decision to learn new skills is what will make selling the artwork possible.

FAME: Fame or fortune? Make a choice! Decide which one you need the most. This is because you will not get both, at least not right away. I had to make this decision when I started my photography business. At that time I was in debt, drove an old car, and lived in a dilapidated mobile home. Considering my situation it was clear that I could not afford to work toward becoming famous. I needed money more than I needed fame! Today, twelve years later, I have hit the sweet spot of photographing what I want while enjoying notoriety with an audience that likes my work. In many ways this is the ultimate result where my audience and I both gain something from my artistic and business efforts.

If you are just starting to sell your work I recommend that you follow the same approach. Seek first to make a solid income from your work and second to become famous. While making a name for yourself is important in order to gain leverage, it is even more important to make an income. Without income your hands are tied and you will not be able to move forward. Once you have succeeded at generating a regular income from the sale of your work, you can start working on developing name recognition for yourself.

Success requires no explanations.
Failure must be doctored with alibis.
Napoleon Hill

Courage is resistance to fear,
mastery of fear, not absence of fear.
Mark Twain

FEAR: I learned to not let fear paralyze me, because when fear paralyzes you it prevents you from making rational decisions. I also learned to understand fear. As I reflected upon my fears, I realized the importance of understanding exactly what I was afraid of. I realized the importance of becoming an expert in fear, especially in my own fears.

When I am afraid of something I ask myself what is the worst that can happen if I do that thing. I then answer the question as accurately as possible and I quantify this answer. I put a number on this answer, either dollars lost, hours wasted, or any other loss or risk. In other words, I answer this question with facts, not with opinions. I identify the worst that can happen accurately and factually, not emotionally. Then I ask myself: "Can I live with this if it happens? Will I be OK?" Very often, I find that the worst is not to be feared. It is no big deal. Other times however, the worst should be avoided at all costs. Knowing the worst thing that can happen if you take a specific course of action means knowing the future as far as this course of action is concerned.

Learn to control fear or fear will control you. Those who do difficult things do not do them because they are not afraid. They do them despite their fears, because they are able to keep their fears under control.

Engage in risk management. The worst risks are the risks we ignore. Risk management is preparing for all possibilities. By being prepared we learn what to do if a specific thing happens. We do not have to react on the spot, and we are less likely to react in the wrong manner or in a way that will make things worse.

Remember that fear is normal and instinctive, and is not a shameful reaction. We are afraid because we perceive danger in a specific situation or course of action. There is nothing wrong with being afraid. Being afraid is not being a wimp. Being afraid is normal. The problem arises when reacting to fear through panic. Panic is wrong. Fear is not wrong. There is, however, something wrong with not being afraid. Not being afraid when facing a dangerous situation means lacking the necessary awareness to gauge danger.

Panic is reacting to a dangerous situation by freaking out. Panic usually results in a higher level of risk, or in the situation escalating to a higher level of danger. Panic is jumping out of the window when there is a fire without asking yourself how long you can safely stay in the room. Panicing is doing something without thinking. If you are afraid, yet remain able to think through the situation clearly, then fear is helpful because it allows you to understand that you are in a dangerous situation. Keeping your cool is what enables you to find the best way to get out of this dangerous situation.

Only a small percentage of what we fear will actually happen. The fears that will never concretize only exist in our minds. Their only consequence is preventing us from doing things we want to do. If we decide to do what we want to do by first analyzing and then ignoring these fears, we will most likely succeed and nothing bad will happen.

FOCUS: Success lies in consistency. You do not have to get everything done in a day. You only need to do a little bit every day to be successful. Do what you can each day, even if it is small things. Some days you will do more than others. What matters is that you get something done.

Regularity is more important than speed. Remember the fable about the Tortoise and the Hare? Even though the Hare is faster, the slow Tortoise wins in the end because its pace is constant and it does not stop. The Hare on the other hand speeds up then takes a nap and while it is sleeping the Tortoise wins the race.

Zen masters point to the same phenomena in their teachings: *Nature does not hurry yet everything is accomplished.*

In business as in life, regularity is more important than speed. Going fast is nice, but going steady is better. It is more important to work slowly but constantly than fast but sporadically.

FRIENDS: Choose your friends carefully and socialize with positive-thinking people. Friendships are great but the wrong friendships are wasteful of your time and of your positive energy.

FUTURE: The future is an extension of the present. If today you are not shaping your life the way you want it to be, the future will not turn out the way you want it to either.

GOALS: Set specific goals and deadlines. Without goals and deadlines nothing gets done. Set both short-term and long-term goals. Set goals you can reach within one to three months and set goals that will take several years to reach.

You finish a marathon by focusing on reaching the next block, not on reaching the finish line. Keeping your objectives within sight keeps your interest and your focus at a high level. Setting short-term goals insures regular rewards and therefore a constant desire to push forward.

Set new goals once you have reached the ones you set previously. Success is dependent upon working toward a goal. Your next goals must be more challenging than your previous goals. You must set goals that are more difficult to reach than before, goals that you may have put aside in the past because you did not think they could be reached.

Plan your life, not your weekend, though planning your next weekend may seem like more fun. However, ten years from now you will not remember what you did that weekend. The life you will live then will be a direct consequence of the goals you are setting now. It is therefore important to set goals for your life now. Plus, doing so does not prevent you from planning your next weekend afterwards. What it does is set priorities. To be successful you need to be more interested in living a successful life than in immediate gratification.

Success is uncommon. It is neither easy nor accidental. It is not due to happy accidents, luck, or other twists of fate. It is the result of taking carefully

Success is the sum of small efforts, repeated over and over, again and again. The masters of success are the ones who have the power to add a second, a third, and perhaps a fourth step in a continuous line. Many can take the first baby step and go no further. Yet, with each additional step, you enhance greatly the importance of your first step.
Unknown

planned steps over a long period of time, and these steps must be planned well in order to lead to success. Goals are the roadmap of your trip to success.

HAPPINESS: Seek happiness first and financial success second. True success is happiness. Wealth is just icing on the cake. Real success is rarely, if ever, purely financial. Success is being happy doing what you really love.

Setting a goal that is important to you and reaching it brings more happiness than having all the money in the world. To find happiness, focus on what matters to you and make it a goal to go and get it. Making an income from doing what you love is important. However, it is not the size of this income that brings happiness. What brings happiness is the fact that you are making your income doing something that is meaningful to you.

HOBBIES: When a hobby becomes your profession you need to find new hobbies. Otherwise you will be working all the time. Having hobbies is one way to know if you are successful or not in your profession. You are not totally successful if you work all the time. Success is having time to enjoy things other than work, even if your work allows you to do what you love.

HUMOR: Do not take yourself too seriously. Doing so creates stress and eventually leads to being permanently worried about how you come across to others. Instead, be yourself and use humor to relax things. Humor works great to move out of a tense situation, or to answer questions that you do not want to go into seriously. Humor is a quality. In Navajo culture, a person is not complete if he or she does not have a sense of humor and cannot joke around.

INSPIRATION: Do not lose your inspiration. Do not stop being an artist.

INTEGRITY: Operate your business with honesty and integrity. Lying, or cheating, in any aspect of life eventually catches up with you. Attempts at hiding lies consume enormous amounts of time and energy and you will forever worry that your lies will be exposed. You are better off putting this energy into succeeding honestly. Eventually, by being honest you will succeed for real.

LIFESTYLE: Eventually we do what we love to achieve a specific lifestyle. Make sure this goal is not lost in the process of becoming successful.

GROWTH: Growth is the key to success in business. You must therefore focus on growing your business over time.

MARKETING: If you do not market your work one thing will happen: nothing. Marketing is not a four-letter word. Marketing is not the eleventh capital

sin that some photographers, and some art collectors, make it out to be. Marketing is not something to be ashamed of.

Marketing is a legitimate endeavor whose purpose is two-fold. For the vendor (the photographer in this instance) marketing is the way to guarantee an income. I personally believe that if you do not market your work you will not be successful in selling your work. When looked at from this perspective, you really do not have much of a choice. You either market your work and give yourself an opportunity to be successful, or you roll on your back and wait for death to strike you and put you out of your misery. Since I am not a big fan of self-pity, the first option is the one I choose.

For your clientele, marketing is the vehicle—the medium, if you will—that explains what characterizes and is unique about your work. Marketing is not hype or manipulation. Marketing is information about your work. Clearly, this depends on how your marketing is done. However, if you market your work honestly, which you should do, by explaining what you do and what the benefits are to your customers, you are truly helping your customers appreciate your efforts and understand what you are doing. Marketing is the honest way to increase your income.

MONEY: There is no direct relationship between money and happiness. After our basic needs are met, earning more money does not result in generating more happiness.

How much you make does not necessarily reflect how good you are as an artist. Being an artist does not mean making an income from your work. This means that once you decide to go into business, how much you make is not related to how good your art is. Your art and the money you make from it are two separate things. (See the chapter titled "Being an Artist" in my first book, *Mastering Landscape Photography,* for more on this subject.)

Don't get me wrong. There are some great artists out there who make a fortune selling world-class art. But, there are also some world-class artists out there who make only a pittance because their work sells very poorly even though it is excellent. Finally, there are artists out there who make a fortune with art that is really second-rate at best.

Good artists who make a lot of money are individuals who understand marketing very well, who are able to create a quality product, and who know how to use their leverage to price their work at a price point that their audience is willing to pay. However, only a very small number of artists fall into this category. These are artists who have it all, so to speak.

There is no specific reason why artists cannot make a good income from the sale of their work. The key is keeping art and business separate. If this is not possible, the artist must focus on creating art and hire a business manager to sell his work.

The real challenge for an artist is not to succeed financially, but rather to become financially successful *while continuing to be an artist*. This is because

the desire to continuously increase one's income stands in the way of continued artistic growth and creativity.

NEGATIVITY: Renounce negativity. Negative thoughts bring negative actions. If you say that something cannot be done, you will not be able to do it even if it actually can be done. Instead, think positively and seek the companionship of positive people. Positive thoughts bring positive actions. It is by thinking positively that we are able to achieve positive results.

OPINIONS: Opinions are not facts, however, many people present opinions as if they were facts. This leads to making decisions on the basis of inaccurate information. Being able to differentiate between opinions and facts is therefore important to guarantee success in any given endeavor.

Opinions are personal beliefs that one subscribes to. They vary from one person to the next. Not everyone shares the same opinion on a given subject. Opinions cannot be proven. They can only be stated. If you disagree with someone's opinion, you can counter it by presenting a counter-opinion. Neither opinions nor counter-opinions are provable or true for everyone. However, neither can they be absolutely disproved or refuted.

Facts are the opposite of opinions. Facts are external to the people who mention them. They are not a matter of personal belief but a matter of measurable quantity. Facts can be tested, proven, and checked simply by verifying their source or testing them for accuracy.

ORGANIZATION: Organized people are more successful than disorganized people. This is because when you are organized nothing "falls through the cracks." Nothing is lost, misplaced, or forgotten. Disorganized people lose things. Consequently they cannot find the information they need when they need it. They get frustrated and waste time trying to find now what should have been organized a long time ago. Eventually, they are unable to get things done, not because they do not have the ability to do these things but because they are overwhelmed by their own disorganization. Success at that point becomes getting organized, not getting something constructive done. Instead of moving forward and reaching meaningful goals, disorganized people focus on getting through the day and putting out fires lit by their disorganization.

PERFECTION: Perfection is not the goal. Getting your product in the hands of your customers is the goal. Setting perfection as the goal will cause you to delay putting your product in front of customers. In fact, it will delay doing just about anything. Perfection is best set as a long-term goal. If you create something that is perfect, great. If you do not, you still have accomplished something by completing the job and putting your product on the market. You can always improve it later if it turns out that changes are necessary.

PERSEVERANCE: Perseverance is one of the main keys to success. As we saw previously, taking control of our destiny is one of the most important aspects of success. Perseverance is something that we can control because it is we who decide that we will persevere until we reach our goals.

Therefore, the decision of not giving up gives us control over our destiny. Eventually, if we have a plan and if we set specific goals and deadlines, perseverance—not giving up—will make us successful.

Creating fine art photography is not instantaneous. It takes time, work, and commitment. When I started doing photography my results were far from being what they are today. I had great expectations for them—until I had the film developed, that is. It was then, when looking at my first negatives, that I realized I had a very long way to go. Only through regular study and constant practice was I able to achieve results that were satisfying to me. However, my satisfaction lasted only until I opened a coffee table book by some of my favorite photographers and saw how much further I really had to go. For a long time, doing photography was a humbling experience, one that constantly reminded me that I had to continue working hard to achieve results comparable to those of the photographers I admired.

While I am now able to create images that I am proud of, I continue to work extremely hard at what I do and I study regularly with other photographers. Over the past few years I have studied with Joseph Holmes, Michael Reichmann, Charles Cramer, Tony Sweet, Mac Holbert, and other photographers and artists. Even though today I am able to create images that satisfy me, I do not assume that I know everything or that my way is the only way. Study, practice, and perseverance are the keys to success.

Don't give up no matter how difficult the challenge might seem. You are most likely much closer to succeeding than you think. Often, it is the last, final push that is the hardest. But if you do give this final push, you will find that the rewards greatly exceed the hardships you had to go through.

PRESS ON: Pressing on is directly related to perseverance, to not giving up. I realized early on how important it is to continue working regardless of adversity, problems, distractions, or other impediments. I call this being able to "press on regardless."

As a professional I am in for the long haul. I have made a commitment to doing my best and to being successful. I cannot let small things stop me. I have to press on, regardless of what happens.

PROCRASTINATION: Do not procrastinate. Do not wait for everything to be perfect to get started. Things will never be perfect, and if you wait you will never get started. The perfect time to get started is now. It is already later than you think. By waiting you are wasting time. You need to get started now because time is your most valuable commodity.

PRODUCTIVITY: Do not confuse activity and productivity. Being constantly active is not the same as being productive. Eliminate everything that gets in the way of productivity, including unnecessary activity. Your productivity is at its highest when you are working toward a specific goal that you must reach within a predetermined time frame.

REWARDS: Reward yourself. You cannot achieve things constantly. You need to take time to enjoy your success, take stock of what you achieved so far and celebrate your achievements.

Seek fulfillment. Fulfillment is achieved by obtaining things whose value to you exceeds their monetary cost.

Live successfully. Spend money to live at the level of your income. Be a representative of your own success. In other words, enjoy your success. It may or may not last, but when you are successful it is definitely real.

SELF-ESTEEM: High self-esteem leads to happiness and confidence. It also leads to accepting your own weaknesses. On the other hand, low self-esteem leads to instability and doubt. It leads to a need for constant validation about your self-worth. People with low self-esteem are also more verbally defensive and more likely to react negatively to criticism. People with high self-esteem accept the good and the bad about themselves and their work and are less defensive about criticism.

SERVICE: Be of service to others. Your success will always be measured by the quality and the quantity of service you render. Think of marketing and selling your work as being a service that you render to your customers. Be helpful, make it a point to serve your customers to the best of your abilities and success will follow.

TALENT: Talent and success are not related. One can be talented and unsuccessful. One can also be successful and not talented. In fact, talented people are not always successful. This is because they expect talent to do everything for them. As a result, they do not always work hard enough at what they do.

On the other hand, people who do not consider themselves talented know that the only way they will be successful is through hard work. Consequently they develop a hard-work ethic in which success is the result of one's efforts instead of one's talent. They do not wait for talent to open doors for them. Instead, they rely on their work to open these doors.

As we saw previously, taking control of our destiny is one of the most important aspects of success. Therefore, to be successful we must engage in activities that we can control. Talent is not something we can control. If talent does exist, it is something we were gifted with at birth. It is not something we can go and get for ourselves. We either have it or we don't, and if we do not have it, it is safe to say we will never get it. Therefore, relying on talent does

not give us control over our destiny. As a result, expecting talent to bring us success is a waiting game that will rarely, if ever, generate success.

TALK: Talk about what you want to do. Do not keep it a secret. Telling others about your goals makes you committed to reaching these goals. By talking publicly about the things you want to do, you feel compelled to actually do these things. Say out loud what you want to achieve. Being able to say what you want goes a long way toward being able to make these things happen.

THINKING: Think before you act or make a decision. Do not act on impulse. Do not react. Instead, take time to reflect upon the proper course of action. Delay the decision, if necessary, to give yourself time to consider the options available to you.

Changing your thinking will change your life. You are where you are because you thought a certain way. If you change the way you think these are some of the things that will follow:

- ❯ You will change your goals and aspirations
- ❯ You will change who you are as a person
- ❯ You will see the world differently
- ❯ You will associate with different people
- ❯ You will do things differently
- ❯ You will discover and experience things you never thought existed

TRIAL AND ERROR: Use trial and error only when there are no other options available. Trial and error is inefficient because it is wasteful of time, money, and energy. It is best to seek advice from knowledgeable people rather than make preventable mistakes by trying unproven things yourself.

TIME: Your most valuable asset is time, not money. We can all make more money but none of us can make more time. No matter who we are, we all have 24 hours in a day. Saving time is more important than saving money. There is a fine line between the two, but provided that you are not desperate for money, saving time should be your priority over saving money.

Therefore, value your time and take every precaution toward saving time. Value people who can save you time and do not hesitate to pay them well. Price your own time adequately. Pricing your time cheaply means squandering your most valuable asset and teaching others to do the same. Do not work for free, either. Instead, make sure you count your time as a cost of production.

VALIDATION: Business success is not a validation of you as an artist. Selling your work does not make you a better artist. Knowing that people are buying your work does not validate your artistic skills. There are some very bad artists out there selling tons of work. And there are some superb artists out there

selling nothing at all. What people buy and why they buy it is directly related to how a specific product is marketed. It is not necessarily related to how good this product is. An inferior product well marketed will always outsell a superior product poorly marketed.

WINNING: There is no better recipe for success than winning. Being successful is being a winner. It is knowing how to win. The best remedy for depression is winning. Winning will help you defeat depression more effectively than all the therapy and drugs in the world.

The thrill of winning is found in the act of winning. It is not found in the *memory* of winning. To experience this thrill again you have to win again. You cannot live in the past and be a winner. You have to continue to go out there and fight for the win.

When you can no longer compete in person, it is the time to train people to compete for you, so to speak, people that you compete through in a sense. This also means having a support team who believes in you. There has to be mutual respect between you and your team. Alone, you cannot be successful regularly. To experience regular success you need to have a group of people who gain something by supporting you.

The problem with winning is that it is temporary. Eventually, someone will come and take what you have won. It may take a day, or a year, or longer, but it will happen. Success is therefore knowing how to overcome defeat because you will not win each and every time. You will lose some of the time and you will know defeat. How you come back from defeat, how you learn to pull yourself back together, is what being a winner is all about. It is something you carry within you, something you can go back to. It is a resource you can tap into when you lose, a safe haven.

WHY: Define *why* you do what you do. I will share here my own answer to this question. To me the justification for creating art is that it is what I love to do. I am blessed in that I can derive a good income from it, but income is not why I decided to do this as a career. What made me make this decision was the realization that anything one wants to do at the highest level is difficult, competitive, and requires dedication. This being the case, I decided I might as well do what I love. If I failed I would still be doing what I love. If I succeeded I would be doing what I love and be financially secure. In either situation I would be able to put all my energy and resources into this endeavor since there is nothing else that I would rather be doing.

My thinking in that regard followed the thinking of Jean Jacques Rousseau and Blaise Pascal, although I realized this after I made my decision, not before. This process would have been easier for me if I had been more familiar with their writings beforehand.

I was fortunate that when I made this decision my income was virtually nil. I was enrolled in a PhD program and made $500 a month as a graduate

teaching assistant. If I had been earning a six-figure income in a corporation, this decision would have been more challenging.

YOU: Care for yourself. You are the one who cares the most about yourself. Certainly your family, friends, significant other, spouse, etc. care about you and your well-being. However, you are the one who has the greatest interest in yourself.

Be yourself in all that you do. Real success is being yourself. Remember that your art has to be "you." Art is profoundly personal and your success as an artist depends on expressing your personality through your art.

Skill Enhancement Exercises

Exercise 1: Important skills. Which of the sections on personal skills do you find the most important? List them all, then reflect on why these are particularly meaningful to you.

Exercise 2: Believing in yourself. Success in doing what you really want to do is believing you can do it. Often, we do not believe that we can do something because we cannot see ourselves doing this thing.

In order to change the image you have of yourself, write a description of who you would like to be. In doing so, describe how you would be if you were doing what you really want to do. Describe how you would act, talk, dress, and any other detail that comes to you as you think about this future version of yourself.

Let others lead small lives, but not you.
Let others argue over small things, but not you.
Let others cry over small hurts, but not you.
Let others leave their future in someone else's hands, but not you.
 JIM ROHN

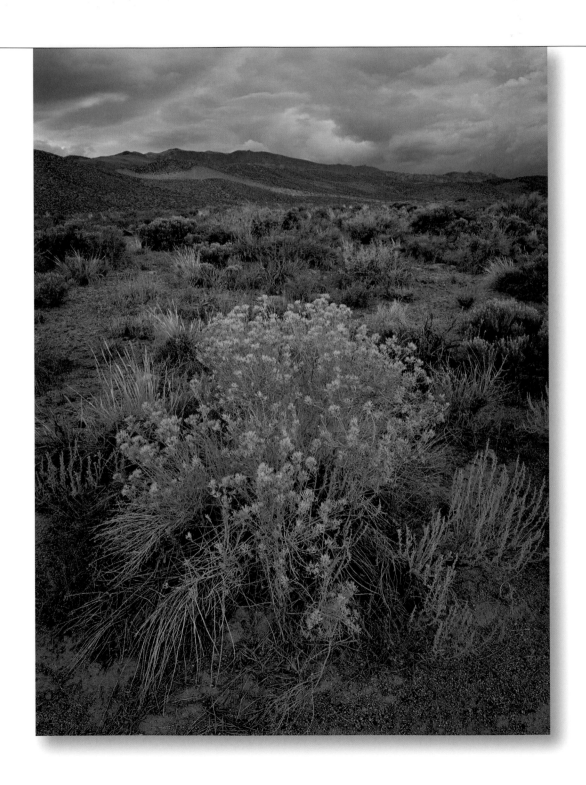

The 25 Most Common Marketing Errors

The purpose of this chapter is to describe the most common marketing errors made by artists and photographers when they are selling their work. I have made most of these mistakes myself and doing so cost me both money and time. My goal is to help you avoid making the mistakes I made and the mistakes I saw other artists and photographers make.

I cover each marketing error in two steps: first by describing the problem and second by offering a solution.

1 ## Not charging for your time

Problem: Some artists think that their time does not cost them anything. However, your time does carry a cost and this cost must be accounted for by you and charged to your customers.

Why is there a cost for your time? First, because you have a finite supply of time; you have 24 hours in a day, not a minute more. You cannot make more time. Second, the time you spend working on something for free cannot be spent working on something for which you are being paid. When you are in business, you need to focus on the things you are being paid to do in order to maximize your income. If you continuously work for free, you will not only lose money, you will soon be out of business.

Solution: Decide how much you want to charge for your time. The best approach is to determine an hourly rate for your time and then charge this rate times the number of hours you spend working on a specific job for each job that you do.

2 ## Not counting your time as a cost

Problem: This error is related to the above error but it is implemented differently. While the previous error occurs when artists do something entirely for free, this error occurs when artists charge only for the supplies they use when calculating the total cost of their product.

Solution: When calculating the total cost of your product, do not count only your supplies (paper, ink, mat board, frame, hanging wire, screws, tape, etc.). Also count the time you spent creating the piece in your total cost. Use the cost per hour you calculated for error #1 and multiply this cost by the number of hours you spent working on a piece. Finally, add the cost of your time to the cost of your supplies. This is your total cost for this specific piece. To this cost you then apply a multiplying factor as described in Chapter 7: *How to Price Fine Art Photography*.

3 Expecting your work to sell itself

Problem: Many artists believe that their work will sell itself because it is beautiful, therefore, they believe that they do not need to market it. Supposedly, the beauty of their artwork is enough to make people want to buy it. I certainly wish that this situation were true because it would save us a lot of time. Unfortunately, artwork is no different from other products and needs to be marketed in order to be sold. If you do not market your work one thing will happen: nothing.

Solution: You must market your work in order to sell it. Teaching you how to do this is the purpose of this book. On average, you need to spend 50 % of the time you devote to your business marketing your work. If you spend less time than that, or if you do not market at all, you cannot expect to be successful.

4 Selling postcards

Problem: Many artists believe that selling postcards will help their business because they will have a low introductory-price item that will attract people who would not otherwise be interested in their products. They also believe that after people buy a postcard they will move up to buying more expensive artwork. Finally, they believe that while the profit per postcard is low, they will make up for this low profit through a high volume of sales.

The problem is that selling postcards is not profitable in a fine art environment. First, you will not make up the low per-item profit through volume because in fine art volume is by definition low. Your clientele is small and the number of sales you can reasonably expect to make is also small. Second, it is unrealistic to expect someone to buy a postcard for a few cents and later move up to buying artwork for hundreds or thousands of dollars. There is simply nothing in common between these two products. Postcards are sold on the basis of price while artwork is sold on the basis of emotion and artistic reputation. By offering postcards you are attracting a price-oriented audience while what you need to attract is an emotion- and artist-oriented audience.

Solution: Just say no to selling postcards. No matter how attractive they might seem, postcards will hurt your business more than they will help it. Instead, focus on selling high-priced items and use the marketing techniques described in this book to attract an audience that is interested in buying art. Let souvenir stores sell postcards. To make a solid income selling your artwork you need to sell high-price items, not low-price items.

5 Expecting sales volume to make up for low prices

Problem: A number of artists charge low prices for their artwork, expecting to make up the loss of per-sale profit through volume. This problem is described above in error #4. However, here it goes beyond just offering postcards and extends to offering many other products at low prices, including artwork.

If you slash your prices to the point where you need a huge number of sales to generate the profit that you need, you will end up sacrificing quality for the sake of quantity. You simply cannot produce a quality product in huge quantity by yourself or with the help of one other person. You would need a factory to do this, with many employees, each assigned to a specific task, working in a high-efficiency manufacturing environment focused on maximizing productivity. While there is no doubt that such a factory can be created, if you were to take that approach, you would no longer be creating fine art. You would be creating mass-produced products that you would try to pass off as art.

Solution: You need to set your prices high enough to generate a significant per-piece profit. This will ensure that you do not have to mass-produce your work and that instead you can create a small number of high-quality pieces by yourself. In turn, you can market these pieces as having been created entirely by you in small numbers. By doing so, you will present your business as being committed to the creation of fine art and you will attract an audience who is looking for artwork that is not mass-produced and that is made entirely by the artist. This audience expects to pay higher prices for such a product because they understand that you have to make your income from the sale of a small quantity of artwork. This audience values quality and understands that quality and quantity are not compatible in a 1- or 2-person business environment.

6 Pricing your work on an emotional basis

Problem: Artists often price their work based on how much they like each piece. This is because as artists we are emotionally involved with our work. When it comes to pricing, this emotional involvement influences our decisions and sometimes causes us to put a higher price on pieces to which we

are emotionally attached. The problem is that our audience does not necessarily share our opinion about which piece is the best and they often prefer different pieces than we do. Therefore, to price a piece on an emotional basis often results in our audience not understanding why one piece is significantly higher priced than another one, even though the print sizes may be similar.

Solution: Price your work on the basis of size and not on the basis of emotional attachment. That way all pieces of a given size have the same price, regardless of which ones you like the best. Such a pricing structure is easy to explain to your audience. Plus, if your audience prefers different pieces than you do, this difference in preferences is not reflected in the price. This prevents problems and conflicts that otherwise may ruin the sale.

 Pricing your work low to make a name for yourself

Problem: Some artists offer their work at low prices in the hope that doing so will get their name "out there." The assumption is that their low prices will increase the size of their audience and therefore generate more awareness of their work.

This is a misdirected marketing approach. First, making more sales does not guarantee that your name is going to be better known. There are many unknown artists selling large amounts of work at low prices. If you want proof of this, just go to a large retailer and look at the "artwork" sold there. Clearly, these artists are selling huge volumes of work. However, their names are virtually unknown.

Second, the implication is that once the artist has generated enough awareness of their name they will raise their prices. The problem is that by then you will have attracted an audience who is buying your work on the basis of price. When you raise your prices this audience will no longer find your work affordable and will stop buying from you.

The marketing rule at work here is that if people come to you because of price, they will also leave you because of price. If you start with low prices and then raise your prices dramatically, you will lose all your customers. Your efforts will be wasted and you will have to either start a new marketing approach or lower your prices back to what they were initially.

Solution: First, price your work according to the advice in Chapter 7: *How to Price Fine Art Photography*. Second, do not attempt to make a name for yourself by offering low prices. All you will achieve is making yourself known for offering cheap artwork. Instead, use sound marketing techniques and focus on making a name for yourself as an artist who offers quality work in small quantities. Focus your efforts on marketing your name, not your prices.

8 **Trying to have something for everyone**

Problem: Some artists are tempted to offer something for everyone, price-wise. This leads to a wide variety of prices, from very inexpensive to very expensive with every price-point in between. The problem is that when you try to have something for everyone you often end up having nothing for anyone. A business needs to make a choice about which audience they want to address. You cannot be both WalMart and Ferrari. You cannot successfully address both an audience who wants something affordable and an audience who wants something exclusive.

Solution: You need to make a decision regarding the buying audience you want to target. In fine art, this audience is small and your prices need to be adequate (meaning high) for your business to be profitable. Do not try to reach everyone. No matter how tempting this might be, it will not make you more successful because your audience will be confused about whom your product is for.

9 **Doing everything people ask you to do**

Problem: Some artists are willing to do everything that customers ask them because they believe that doing so will bring them success. By being all things to all people, they believe they will let no sale pass through the net, metaphorically speaking. The problem is that if you do this you will run yourself into the ground. You do not have an endless supply of energy and by spending your energy blindly you will end up being exhausted and unable to operate your business efficiently.

Solution: You do not have to be all things to all people in order to be successful. To find proof of this, just take a look at successful businesses. You will see that there are many successful businesses that do not offer products you are interested in. These businesses are limiting their audience purposefully and doing so makes them successful.

As a visual artist you limit your product by setting a certain range of prices and by limiting the subjects you depict. If you are offering landscape photographs at high prices, you will not be able to target customers who want low priced animal photographs. That is perfectly fine because by doing so you are being very clear in regards to the artwork and the prices that you are offering. Successful fine art artists are recognizable by their style, their subject matter, and their pricing.

For example, Henri Cartier Bresson is known for his Paris street scenes and for his reportage-style photographs. Ansel Adams is known for his grand landscape and for the quality of his printing. Few people collect both Cartier

Bresson and Ansel Adams because each artist addresses a different audience. They did not try to be all things to all people and that is one of the reasons why they have both been successful. This sucess is reflected in the high prices that the work of both artists command today.

 Expecting to make a profit by doubling costs

Problem: Some artists believe all that is required to make a profit is to set prices by multiplying their costs of production by two. This error is usually compounded by not including one's time in the cost of production and only counting the cost of supplies.

The problem is that even if you sell wholesale, and assuming you added your time to your costs, doubling the cost of production is far from being enough to generate a profit in a low volume environment. Even in a high volume environment, doubling your costs would only get you to the wholesale price. To calculate the retail price you would have to multiply the wholesale price again by two at the very least.

Solution: You cannot price fine art on the basis of what it costs you to produce it. You must price fine art on the basis of your leverage, your name recognition, and your experience. This means having relatively low prices when you are just starting, then increasing your prices 10% to 20% every year. As you increase your prices, your costs of production become less relevant because they become a smaller percentage of your selling price.

Fine art has never been priced according to the cost of the supplies used in its production. We do not price a painting by Van Gogh, or a print by Ansel Adams, on the basis of the cost of canvas, paint, paper, developer, or other supplies. If we did, we would get ridiculously low prices that would not reflect the actual value of the work. While you may not be in the same price category as these two artists, your work does follow the same pricing approach. You just need to adjust it for your leverage, reputation, and experience.

11 **Confusing activity and productivity**

Problem: Some artists believe that being constantly busy means that they have a productive business. This is similar to thinking that because you drive fast you will get to your destination sooner. This is only true if you are going in the right direction.

Solution: The road to success begins by setting specific goals and designing a plan of action to reach these goals. It continues by working on this plan every

day. What matters most is not how much you achieve at once, but that you work on things regularly without stopping unnecessarily.

Productivity means working diligently towards reaching the goals that you have set. To be productive your activity must be placed at the service of reaching these goals. Activity alone, without the desire to reach specific goals, is wasted energy.

12 Offering too many choices

Problem: Some artists believe that offering a huge number of choices to their customers will make them more successful when selling their work. An example would be artists offering 20 different frame moldings and 15 different mat colors in 12 different sizes.

This approach does not work for two reasons. First, as a small business owner it forces you to stock an enormous inventory of mat colors, frame types, and print sizes, which will tie up valuable cash that should be kept available to pay for other expenses.

Second, the more choices you offer to your customers the more difficult it is for them to make a decision. If you were to offer only one mat color, one frame type, and one print size, your customers would only need to decide whether they want to buy your work or not. For each new option that you offer, you make this decision slightly harder until the number of options is so overwhelming that it becomes impossible for customers to decide what they want.

This approach is often carried into the artist's price list when selling over the Internet or by mail order. Their endless lists of options make it difficult for customers to make a decision, which discourages sales.

Solution: Keep it simple. Although having only one mat, one frame, and one print size available may be too limiting, you do not want to go too far in the other direction. I recommend having one or two matting options, two or three framing options, and three or four print sizes.

The number of choices you offer is not what will make you successful as a fine art artist. Picasso did not offer his paintings in 12 sizes, on 5 different types of canvas, with 7 different framing options. He offered each painting in only one size and without a frame. Always remember that you are selling the artwork first and the matting, framing, and print size second. Don't turn things around by making framing options the main purchasing decision. The customer's emotional response to the work must be the main reason for investing in your work.

 Charging different prices for cash and credit card purchases

Problem: Some artists charge a different price for cash and credit card purchases. The reasoning behind this approach is two-fold. First, credit card purchases are subject to a 3% to 5% processing fee, therefore purchases paid by credit card are priced higher to reflect this. Since cash purchase are not subject to a processing fee, cash purchases are priced lower.

Second, some artists do not declare cash income when they file their taxes. For these artists, offering a discount for cash purchases is a way to motivate more people to pay with cash so that they can report less of their income.

Solution: You must charge the same price regardless of the form of payment used by your customers, be it cash, checks, credit cards, gold coins, beaver pelts, whatever. To charge different prices for different forms of payment favors some customers over others. In the end, while you may make a few people happy, you will upset many customers. Plus, you will expose yourself to legal penalties if you do not declare your income. All in all, this is simply bad business.

14 **Charging different prices at different venues**

Problem: Some artists charge different prices for the same items sold in different venues, such as retail sales, gallery sales, store sales, etc. Usually the lowest price is for retail sales made directly from the artist to customers. If the artist sells through a gallery or store, the price is higher.

The reasoning behind this pricing is that since the artist receives only 50% (on average) of the retail price from galleries and stores, they can afford to price items sold directly to customers lower. This makes buying directly from the artist more attractive, leading some artists to think that they will make more money that way.

This is a bad practice for a number of reasons. First, if you sell your work in different venues, eventually some of your customers will see the same items offered at different prices. While this may cause some customers to buy directly from you to get the lowest price, this will cause most customers to lose trust in your pricing. When you offer the same item at different prices, customers have no way of knowing what the lowest price is. As a result they wonder if you will lower your prices further later on, or if you offer "secret deals" to favored customers. This instigates a feeling of distrust toward you and results in lost sales.

Second, this practice causes customers to make price the most important aspect of their purchase. In fine art the most important aspect of a purchase must be emotion. Only by making the purchase an emotional decision will you be financially successful selling fine art.

Third, you will lose the business you are getting from stores and galleries as soon as they find out that you are charging less for sales made directly to customers. This is because you are in effect under-pricing stores and galleries on sales of similar items. This is a no-no in business and it is usually part of the contract you sign when you agree to have a gallery or a store sell your work.

Solution: You must charge the same price for sales made by yourself, made through galleries, and made through stores. If you charge different prices in different venues you will build a negative reputation and you will soon be out of business. You need to consider the percentage taken by stores and galleries as the cost of having someone else sell your work for you. If this is not OK with you, the solution is to sell all your work only by yourself, not through stores and galleries.

15 Not charging tax on cash purchases

Problem: Some artists do not charge sales tax on cash purchases. In the United States sales tax is charged on all purchases, except when purchases are shipped out of state, regardless of what type of payment is used. Artists who do not charge tax on cash sales usually do so because they do not report these sales as income.

Solution: You must charge sales tax on all purchases. If a customer complains that they have to pay sales tax, simply explain that by law we all have to pay sales tax on products. Also explain that you do not keep this tax because you pay it back to the state. In effect you are a sales tax collector and you do not make a profit by collecting sales tax.

16 Not writing a receipt for each sale

Problem: Some artists do not write a receipt for each sale. This is often because sales made without receipts are not declared as income. This is also because some artists forget to write receipts, often when sales are brisk and they are busy helping several customers at the same time.

Solution: You must write a receipt for each sale. This will make your accounting much easier when it comes to totaling your income for the month or for the year. If writing receipts is not possible because of the volume of sales, you may want to start using a cash register to prevent having to write receipts. This will make the process faster and more efficient. Whatever solution you use, you must have a record of each sale.

 Not declaring cash income

Problem: Some artists do not declare their cash income. The logic behind this approach is that if there is no written record for cash sales (or no receipts), then there is no evidence that cash sales were made. The problem is two-fold. First, this is an illegal approach since by law you are required to report all sales as income for tax purposes. Second, not reporting cash income makes your business appear to generate a smaller income. This is a serious problem when applying for a loan. The bank may deny you a loan based on the income declared on your tax return, while you might have actually qualified for this loan based on your undeclared income.

Solution: You need to declare all income, whether it is paid by cash, check, credit card, or whatever. Not doing so is not only illegal, it is also poor business practice. Your business must be based on honesty and integrity, and declaring all your income is part of this.

When you declare all your income you not only sleep better at night, you also do not have to worry about how you are going to hide all that cash that you are not supposed to have. I believe that you make more money by being honest; instead of worrying about being audited you can put all your energy into creating new products, marketing your work, and running your business in the most efficient manner possible. I have followed this approach since I started my business and I believe that it is one of the reasons I have been successful.

Finally, we demonstrate who we are through our actions. By acting with honesty and integrity we attract people who also act with honesty and integrity. Dishonest clients and businesses will stay away from you and honest clients and businesses will be attracted to you. You will create a business environment that is positive and beneficial for all the parties involved in it.

 Selling retail at wholesale price

Problem: Some artists sell their work in retail outlets at wholesale prices. This takes place primarily at art shows and at other venues where artists sell their work directly to customers.

In doing so the artist's intent is to offer their work at an affordable price. However, what they do not realize is that they have lowered their prices so much that their prices are literally half of what they should be. Should a wholesale vendor come by and want to buy their work for resale they would either be unable to lower their prices any further, or they would be selling their work at a loss.

Solution: You need to have a price for both retail and wholesale, even if you do not do wholesale. The reason for this is because your prices must be high enough to generate a satisfactory profit. Because wholesale pricing is half of retail pricing, if you are in the situation described above (i.e., selling retail at wholesale prices), you need to double your retail prices so that you bring your prices to the level at which they should be.

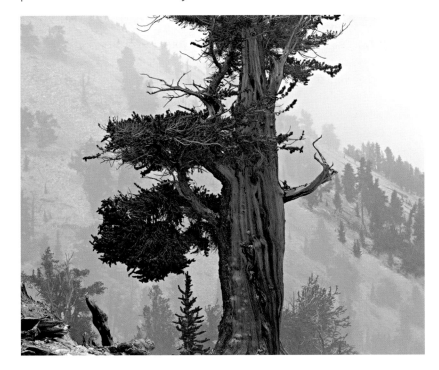

Bristlecone Pine

 Confusing net income and profit

Problem: Some artists, especially those who are just starting in business, consider their net income to be pure profit. Net income is all the money you take in when you sell your work. It includes the price you charge for your work, the sales tax you collect if you sell in a retail location, and the shipping charged if you ship orders. Profit is what is left when you have paid all your suppliers, your fees and other expenses, your shipping costs, and your sales and income taxes. Some artists go as far as spending the sales tax money they collected and end up being in financial difficulties when the time comes to repay the sales tax to the state. Others spend their net income so freely that they have no money left to buy new supplies when their stock is exhausted, or even pay their income tax.

Solution: Not all the money you make selling your work is profit. In fact, most of it is not profit. To know what is profit and what is not profit you need to

keep careful records of what you have to pay for so that you can plan ahead and save enough money to cover all your expenses. It is also very important that you know the profit you make for each piece so that you can save enough money to buy the supplies you need to create more artwork.

In addition, you must separate sales tax from business income so you do not spend the sales tax money you collected. Besides sales tax, you also need to save enough money to pay state and federal income tax. If you do well, in the United States this will be about 30 % of your profit.

Finally, you need to save enough money to place in a retirement account for when that time comes.

Saving money is the key to staying out of financial trouble when you are in business. I recommend that you open a separate bank account in which you deposit all the money you save, money that will go towards paying upcoming expenses such as supplies, fees, income tax, sales tax, and other business expenses.

 20 **Not knowing the costs of production for your work**

Problem: Some artists do not know how much it costs them to produce their work. As a result they are at a loss when it comes to pricing their work, when they need to negotiate with customers, or when they need to calculate their profit versus their net income as we have seen.

Solution: You need to calculate your cost of production precisely, as described in Chapter 7: *How to Price Fine Art Photography*. This is a vital aspect of doing business. Only then will you know precisely not only how much to charge for your work but also how much pricing flexibility you have to work with when a customer wants to negotiate a lower price.

 21 **Acting inappropriately with customers**

Problem: Some artists have improper behavior when dealing with customers. This behavior ranges from being short tempered to being rude. The outcome is lost sales and being known for being unfriendly and difficult to deal with.

Solution: Working directly with the public can be challenging at times. We all have limits and sometimes we do reach these limits. However, when this happens the solution is not to act inappropriately with customers, but rather to remove yourself from the situation.

The golden rule in customer relations is to be helpful, not to be right. Your customers need and want your help, even if their assumptions are incorrect. Proving them wrong will not be satisfying to them, even though you may be

correct. Instead, point to alternate options or offer solutions to their problem. Be helpful and be patient. Remember that not everything can be resolved on the spot. If you cannot solve the problem immediately, get the customer's phone number or email address and let them know that you are looking for a solution and that you will contact them shortly. Then contact them after you have found a satisfying answer or solution to the matter at hand.

In business, diplomacy goes a long way toward making things right. No one wants to spend money with someone who is unpleasant, rude, or forceful. Being helpful is the best attitude. In the long run it will make you successful even with people that you thought would never buy from you.

22 Waiting until everything is perfect to get started

Problem: Some artists will wait until all the conditions are ideal to start selling a new product. This affects both artists who are just starting their business and artists who are already in business. Perfection is an elusive and subjective goal. Instead of looking for perfection, do the very best you can to get your product the way you want it, then offer it to your audience. As artists we see flaws that nobody else sees. This is because we are perfectionists and because we have an emotional connection with our work. This emotional connection can cause us to procrastinate indefinitely.

Solution: The best time to get started is now. There will never be a better time. Any time spent waiting is time that is being wasted. Procrastination in business is costly and if taken too far it will cause you to lose your business. Having the right timing is very important because a product that is exciting today may not be of interest to customers tomorrow.

Your ideas are only as good as your implementation of these ideas. Most importantly, you cannot do business unless you put yourself, and your work, out there. It may be scary at times but it is the only way to do business.

23 Paralysis by analysis

Problem: Some artists over-analyze everything they do. This excessive analysis makes them incapable of doing anything, be it creating artwork or making business decisions.

Solution: Stop analyzing everything and make the decisions you need to make now. As we saw above, there will never be a better time to do so. Thinking about what you are going to do and about the decisions you are going to make is important. However, at some point thinking must stop and action must take place.

24 **Confusing media exposure and business success**

Problem: Some photographers confuse receiving exposure for their work in the media (print, web, TV, radio, etc.) with being successful in business. Unfortunately, exposure does not mean income. For income to occur you have to sell something, and while media exposure may lead to sales, there is no direct connection between the two unless you make that connection through your marketing.

Solution: Receiving exposure is great. However, for this exposure to result in sales it has to be part of a marketing campaign. If the media contacts you for an interview, explain to the reporter that you want your products mentioned in the interview. This does not have to be the main focus of the interview, but it should be in there. I also recommend having a special offer for people who watch your interview.

For example, you can say that your goal is to have your photographs used in the design of book jackets and then point out why your photographs are particularly well adapted for this purpose. This will raise the interest of people watching your interview who are looking for book jacket designs. Of course, the probability of a book jacket designer reading or listening to your interview is small. Hence, it is much more effective to write directly to book jacket designers and to send them a portfolio of book jacket designs.

Through this example you can see how targeted marketing is much more effective than relying on media exposure to find customers. What is needed for media exposure to lead to solid sales is making the media event part of your marketing approach. In that instance media exposure becomes one of the vehicles of your marketing campaign instead of being an end in itself.

25 **Confusing publication with business success**

Problem: Some artists believe that being published will lead to business success. The problem is that there is no direct relation between the two. Being published in a magazine, on the web, or in other venues is not an entrepreneurial activity per se. While it may lead to sales, or to interest on the part of galleries, museums, or other parties interested in offering you opportunities, more often than not it does not lead to anything further.

This error leads some photographers to accept having their work used for free by publications in exchange for a caption with their name or to a link to their website. While the possibility that someone contacts you because they saw your name under your photograph does exist, in practice the chance this will happen is very slim. It is therefore foolish to consider free publishing to be an effective marketing approach. It is simply not effective at all. In fact, it benefits the publisher far more than it benefits the artist.

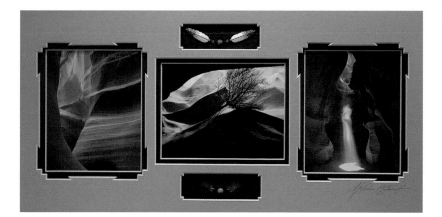

Decorated mat

Solution: I recommend that you charge for the use of your work by commercial publications. By doing so you make it clear to the publisher that you expect payment in exchange for the right to use your work in their publication. Most importantly, you are also making an income now instead of expecting a possible windfall later. As the saying goes, one bird in the hand is better than two in the bush.

Skill Enhancement Exercises

Exercise 1: Mistakes you made in the past. Looking at the list in this chapter, ask yourself which marketing errors you have made in the past and make a list of them. Once this list is complete, decide what you will do from now on to prevent making these errors again. List all the things that you are going to change.

Exercise 2: Mistakes you might make in the future. Make a list of the errors that you believe you are most likely to make. Then list the steps you need to take to prevent making these mistakes.

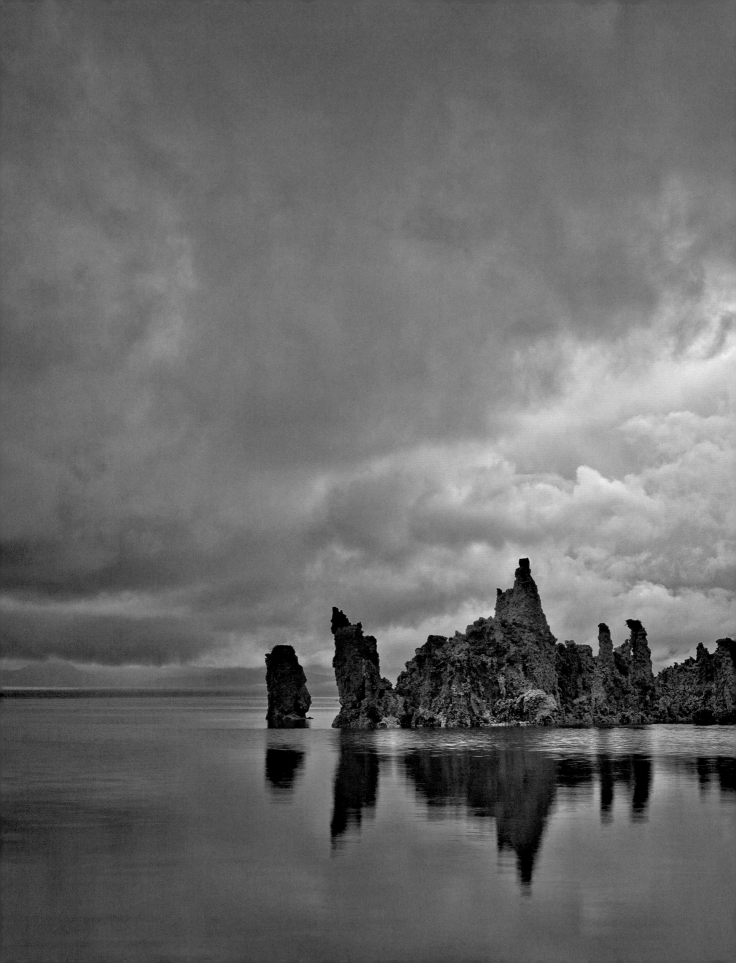

The achievement of your goal is assured
the moment you commit yourself to it.
 MACK R. DOUGLAS

Chapter 17
Business Tools

In this section we are going to look at the tools you need to operate a fine art photography business successfully. Clearly, the tools I am referring to here are not screwdrivers, wrenches, or hammers. Instead, they are business and marketing tools, more likely to be found in a desk drawer or on a computer than in a toolbox.

Some of these tools consist of supplies such as business cards, brochures, and flyers that you can order from suppliers. Other tools are documents that are unique to your business, such as artist statements, a list of unique points, or warranties, which you will need to design yourself.

I will feature specific examples for each type of tool. You can use examples from my own business as a source of inspiration when designing your own version of these tools.

What You Need to Conduct Business

A Place to Work

The first thing you need to conduct business is a place to work. When getting started, many artists use temporary work areas, such as their living room, a guest bedroom, etc. This requires them to set up their work and tools for the day, and then pack everything up after they are done working. This is impractical, time consuming and ineffective.

You need a permanent place where you can leave your work out while it is in progress without having to worry that it gets in the way of someone else. This is true both for your creative work, such as making new photographs, and for your business work, such as marketing, record keeping, and other business activities. This permanent work area does not have to be large. It only needs to be sufficient for your needs. It can be expanded as your business grows.

A Product that People Want to Buy

You need to understand your audience. This is something that we have looked at previously, in Chapter 5: *What to Sell,* and in Chapter 8: *Best Sellers.* However, in this section I want to make a number of important points in regard to selling your work to a specific audience.

The customers you offer your work to must be able to relate to your product. You therefore have to know your customers' tastes. You also need to know what your customers want. For example, offering photographs of Paris at the Grand Canyon makes no sense and will not generate sales. This is because what customers want when visiting Grand Canyon National Park is a souvenir of their visit, something that will help them remember the Grand Canyon when they return home.

Some artists feel that considering what the audience wants and catering to their needs is synonymous with "selling your soul." This is certainly not the case. If you do not want to cater to the needs of a specific audience, simply do not sell your work to this audience. For example, if I want to sell photographs of Paris and not of the Grand Canyon, all I need to do is look for venues where Paris photographs are in demand. This venue might be art shows where the buying audience is looking for European photographs, for example.

Having a product that people want to buy simply means understanding who your audience is and placing your work in front of this audience. As the Grand Canyon versus Paris example shows, there has to be a match between audience and product. You therefore need to understand who your audience is and market your product to them.

You need to build a client database. As you start to sell your work, you need to keep your customers' contact information on record. This is necessary for invoicing, record keeping, and marketing. The simplest way to do this is to use a database. We use FileMaker Pro with custom-made forms. The forms we use include invoice, letterhead, contact information, email address, and more. The customization is necessary in order to include a header and footer with our business name, contact information, and logo. Examples of our letterhead and invoices are provided below.

Use a PO Box for Your Business Address

I strongly recommend using a PO box on all your business stationery as well as on your website, in emails, and on any document that you make public. This is especially important if you operate your business out of your home, in which case it is best not to make your physical address public. The reason for this is to protect your privacy and guarantee your personal security. The examples of various business forms in this book show that I use only a PO box on all my business forms. I do the same on my website. No one needs to know your physical address unless they are coming to visit or if they are shipping you something by a delivery service that cannot ship to the post office box.

Renting a PO box costs about $40 a year, depending on your location. It is well worth the expense. Make sure that you rent a PO Box in the post office nearest to you to save you unnecessary driving. In the US you can also rent a PO box in UPS Stores and in businesses that specialize in offering mailing

services. If you rent a PO Box from the U.S. Postal Service, your address will say "PO Box xxxx." If you rent a box from a mailing service type of business your address may say "Suite xxxx." I personally prefer to rent my PO Box from the post office. Doing so saves me time because I can check my business mail and ship my packages and letters at the same time.

Phone, Fax, and Internet Access

Everyone you will be doing business with has different preferences when it comes to contacting you and sending you information. This is true whether you are working with customers or with suppliers. To facilitate doing business with everyone you need to have the different forms of contact available to you, which means having phone, fax, and Internet access. This also means having both a regular phone number and a toll free phone number.

Your phone number can be either a landline or a cell phone number, or both, depending on your preferences. I personally recommend having a landline in addition to a cell phone number if you have a cell phone. I also recommend having a toll free number so that people can call you at no expense to themselves. With a toll free number you will pay for the calls you receive but you will get more calls and more business. A toll free number is a significant incentive for people to call you. It makes the difference between someone picking up the phone and calling you and someone not picking up the phone because they do not want to pay for the call when placing an order. A toll free number can be set to ring to your existing phone line number. It simply becomes a second number on the same line. The company I use to transfer my toll free number to my regular phone line is Comlinq. You can check their rates and their services at www.comlinq.com.

You also need to have the capability to send and receive faxes. Faxing is still an important way of sharing business information and receiving orders. I personally receive several faxes each day, even though I also get information and orders via email and phone.

The simplest way to have faxing capabilities is to use a web-based fax service. I personally use efax.com, but other companies such as GoDaddy.com offer similar services. When using a web-based fax service, the company you work with receives your faxes and forwards them to you over email. In short, you receive your faxes in your email. However, your faxes are also stored on the web-fax company website and you can read them and download them from there as well.

To send faxes you simply log onto your web-fax account and send your faxes from there. You can fax a variety of documents, including PDFs, Microsoft Word documents, and more.

This approach makes receiving and sending faxes simple. It does not interfere with your regular phone line the way a phone-based fax would, and you

do not need to purchase a fax machine. The fact that I do not need a fax machine is one of the things that I like the most because that saves a lot of desktop real estate. It is also one less machine to maintain and worry about. Plus, with a web-based fax service you can receive your faxes anywhere you have web access.

To print your faxes you simply use your inkjet or LaserJet printer. I personally use a dedicated inkjet printer for all business printing such as letters, invoices, orders, faxes, etc. No need to use one of my fine art photography printers for that!

Having high-speed Internet access is indispensable, whether it is cable, ISDN, or something else. Not only is it just as important as phone and fax access, it is one of the main ways you will be doing business.

I recommend having separate email accounts for personal emails and for business emails. However, I do not recommend having several business email accounts with names such as customer-service@yourwebsite.com, orders@yourwebsite.com, questions@yourwebsite.com, and so on. It is just too obvious to customers that all these different email addresses are being directed to the same person—you—and it does not make your business look good. Instead, it gives the impression that you are trying to look bigger and busier than you really are. This is definitely not a good thing.

I also recommend installing a variety of different web browsers because not all sites load well on all browsers. This way, you can easily switch to a different one should you experience problems logging on to a specific site.

Finally, if you have a website (which you should), I recommend testing it by logging onto your site from both a Macintosh and a Windows computer, using a variety of different web browsers to make sure your site is loading well on both platforms and with all browsers.

The eFax Logo

Accept Credit Cards

Accepting credit cards carries a cost because banks charge a fee to process credit card purchases. This fee varies from 2% to 5% on average. However, in today's world, businesses must accept credit cards because the majority of customers prefer to pay by credit card. The processing fees that come with accepting cards must therefore be considered one of the costs associated with doing business.

If you do business on the web you do not have a choice. Accepting cards is the only way to get paid immediately on the web. The same thing is true if you sell over the phone. The only instances you are not obliged to accept credit cards is when you do business in person with customers. Shows are the best example or any situation in which you are face to face with your customers. In these instances you can ask customers to pay cash or write a check.

However, regardless of the selling situation you are in, accepting credit

cards carries many benefits. For one, most people today do not carry much cash, if they carry any at all, and this holds true with checks as well. And even if they have cash or checks, they may not have enough cash or enough money in their account to cover an expensive purchase. With credit cards there is no such problem. You can make a large purchase even if you did not plan to, as long as your credit line covers it. Many cards have a high credit limit and some cards do not have a limit.

Customers are likely to spend more, or make larger purchases, when they can pay by credit card. For one thing, they are not limited by the amount of cash in their pocket or in their bank account. Also, the feeling of spending money is not as real with credit card purchases as it is with cash or check purchases. As a result, the credit card fees you pay in order to offer credit card purchases are offset by higher dollar sales and by larger sales.

Accepting credit cards also guarantees good cash flow as you do not have to wait for the proverbial check to be "in the mail." You get paid right away and you only need to wait for the charge to clear to get the money deposited in your account. This takes a couple of days with most card processors. With some credit card processing companies, such as PayPal, this is immediate.

If you choose, you can bill customers in several monthly installments instead of all at once. All you need to do is make this arrangement with your customers, get their card number and all relevant information, and then charge their card in equally spaced installments. You also have other forms of recurring billing available to you with credit cards, such as self-renewing subscriptions.

Most credit card companies provide benefits to their cardholders, such as free airline miles, cash back, gifts, or other bonuses. As a result, customers prefer to use their cards rather than pay by cash or check, especially when making large purchases, because they get rewards when they use their cards. Being able to get these bonuses plays an important role when customers decide to purchase from you. Customers are more likely to make a purchase if they can use their card because they see these bonuses as a form of "discount" or "money back" on their purchase.

Finally, many credit card companies insure purchases made with their cards and this gives the consumer an added level of protection.

As a result of all these benefits, being able to pay by credit card facilitates the decision-making process for customers. Therefore, as a business you must be able to accept credit cards.

The three most popular credit cards are Visa, MasterCard and American Express. In my business I hardly ever get other cards; however, I do have the capability of processing any card, including Discover, Novus, etc. If the card processing company you work with does not charge more for accepting all credit cards, I recommend accepting all the cards. If you have to pay extra for accepting certain cards, you will do very well by accepting only the 3 main ones.

Whether you sell your work at shows, in your gallery, on your website, by mail, or in other venues you need to display signs showing which cards you accept. There is no cost for doing so and it lets everyone know that you accept credit cards.

Shown here are some of the signs we use during art shows and on my website.

Business Insurance

Business insurance is a necessity. It covers two things: 1) the cost of your business equipment such as cameras, show displays, and any other equipment used in your business, and 2) your liability if someone gets hurt or someone's property gets damaged during the course of operating your business.

Most art shows require that you carry business insurance, and organizers ask to see a copy of your insurance policy before you can register for these shows.

If you sell through a home gallery, or have customers at your home, you also need to have business insurance in case a client gets hurt or something gets damaged or stolen.

There are many insurance companies that provide business insurance. Your current insurer may be able to include business insurance on your current (homeowner's) policy, or you may need to find a separate insurer and start a new policy. Personally, we have used The Hartford for our business insurance for years and we have been very pleased with their services. They will fax a proof of insurance on request to shows and other businesses that require it literally within hours. This is very convenient and their policies are affordable.

A Trade Name in Your State

You need a trade name before you can apply for a business tax license, unless your tax license is under your name. Even then, the state will do a search to see if there is another person with the same or similar name as you. If there is, you will need to apply for a trade name also. Once your application has been successfully processed you will receive a trade name certificate. This certificate guarantees that only you can use this trade name in your state. The trade name certificate needs to be renewed every few years. You will receive a notice by mail when the renewal date comes around.

Applying for a trade name therefore needs to be the first step you take, before applying for a city and state tax license. You will also need your trade name when you open a business account with your bank. The bank will not issue business checks if you do not have a trade name certificate.

City and State Sales Tax Licenses

Depending on where you live in the United States, or in the world, you will need different types of city and state tax licenses.

In Arizona, where I live, what is needed to operate a business such as mine is a sales tax license from the State of Arizona and from the city where I am physically located. Obtaining a tax license is simple. All you need to do is file a separate application with the sales tax division of your state's Department of Revenue and with the city where you live. You have to pay a small fee to both departments and once your application is processed you receive your sales tax licenses in the mail. The state sales tax license is valid for as long as you do business in the same location. The city tax license is good for one year and has to be renewed each year.

These licenses allow you to charge state and city sales tax and return this tax to the state and to the city. You file a form for both the state and the city to report how much tax you collected and you include a check in that amount. Depending on your volume of sales, you need to file these forms on a monthly, quarterly, or yearly basis.

Depending on where you live in your state, you may or may not need to collect city tax because not all cities charge sales tax. On the other hand, if you do business in several cities, for example by selling at art shows organized in different cities, you may need several city tax licenses if the various cities where you sell your work charge city sales tax.

If you do business outside of your state regularly you may also need to have several state sales tax licenses, one for each state where you sell your work physically. This only applies to states where you sell your work in person. If you sell your work over the web or over the phone then you only need a sales tax license for your state because purchases shipped out of state are not subject to sales tax.

In some states, having a sales tax license allows you to not pay sales tax on products bought for resale in the normal course of business. To not pay sales tax you have to file a form stating that you are purchasing these items for resale. In Arizona (where I live) this form is called the transaction privilege tax exemption certificate.

You only collect tax when you sell retail, meaning when you sell directly to retail customers. If you sell wholesale to stores that sell your work to customers, you do not need to charge sales tax. However, both wholesale and retail sales must be reported on the sales tax form. The only difference is that if all you do is wholesale you do not send a check along with the form.

The sales tax you collect is not income. It is a collection that you make for the state. In that sense you are a tax collector and you only keep the tax until you return it to the state. As emphasized before, you have to make sure not to spend the tax you collect! This money is not yours and if you count it as income you may be short of cash when the time comes to pay the tax to the state.

Because sales tax laws are complex and subject to change, the information in this section is provided only as an example. Before you start doing business you need to check with your city and state to find out the exact regulations for your location.

It is best to contact your State and City Department of Revenue and ask that they send you a brochure outlining the sales tax laws for your state. You can also visit their website and download the forms you need if they are available. You can also take workshops with your state to help you with this aspect of your business.

In the U.S., the following resources can help you learn how sales tax laws operate in your state:

- Your city and state sales tax department
- The Small Business Bureau (SBB)
- The Better Business Bureau (BBB)
- Your local Chamber of Commerce
- Websites for all of the above

Copyright Protection

Having to deal with copyright issues is part of being an artist in business. Copyright infringements are commonplace and with the advent of the Internet they are more numerous than ever before. Copyright infringement in photography takes place when someone uses your photographs without your permission. The question is not *if* you will need to enforce your rights, the question is *when* you will need to enforce them.

In the United States, copyright laws state that you are automatically the copyright owner of any work you created. As a photographer you therefore hold the copyright to all the photographs you take. This copyright ownership is automatic. You do not have to do anything. However, you can also register your work with the U.S. Copyright Office. If you do so, you benefit from a greater level of protection should you need to defend yourself against unauthorized use of your photographs.

If someone uses your work without your knowledge or permission, you can take action against them. My recommendation is to first find out if your photographs are being used in the context of an income-producing situation or if they are used just for illustrative purposes. For example, I find a lot of my images used on MySpace as illustrations on personal pages. Clearly, no money is being made from the use of my work. In such instances all I ask is that the person stops displaying my work. If they comply, and they almost always do, that is the end of it.

However, if your work is being used in a commercial activity, for example to sell or advertise a product or service, then you may be in a position to ask

not only that this use be stopped but that you are paid a financial compensation for prior use. You may also be able to receive payment for future use should you be able to negotiate a contract. This is a legal situation and in that case it is best to seek help from an attorney who specializes in copyright law.

The best resource in regards to U.S. copyright law is the copyright office in Washington, D.C. Its website is www.copyright.gov. You will not only find information about copyright law but also copyright forms that you can download, fill in, and return to register your work.

Another important resource is lawyers specializing in copyright law. I have no particular recommendations in that regard.

Invoices and Stationery

Different approaches call for different needs in regard to invoice and stationery forms. For some time, until around 2001, I used the same form for orders and for invoices. I received relatively few mail orders at that time because I made over 90 % of my sales in person. Therefore I only needed to write a few invoices per year. But I now make many more sales for which the customer is not physically present and I write hundreds of invoices per year. This has made having separate invoice and order forms a necessity.

Natalie uses a database software package, FileMaker Pro, for all our invoicing and stationery needs. This database is designed to meet our needs for invoicing, record keeping, customer data, etc. I designed the forms myself with the tools provided in FileMaker Pro.

If you are serious about record keeping consider creating and using a similar database. I believe that FileMaker Pro is one of the best database packages for this purpose. If you implement such a system early on in your career, when your business starts growing you will be thankful that you did because you will be able to expand your invoicing and record keeping capabilities without having to change your database.

Both stationery and invoices need to have your contact information and your business name on them. Before using FileMaker Pro I used the header and footer feature in Microsoft Word for this purpose. That way, this information was always there; separate from the body of the letter or invoice. I kept a locked file saved under the name "stationery," so that I would not accidentally make any changes. I would then open this stationery file and save each letter and invoice under a different name.

Alain Briot
Beaux Arts Photography

INVOICE

Date:_____

Sold To: _____

Product Description	Qty.	Unit Price	Extended Amount
Sub-total			
7.8% tax			
Shipping and handling			
Total			

Thank you for your order.

PO Box 12343 • Glendale, AZ 85318 • 800-949-7983 or (623) 561-1641
alain@beautiful-landscape.com

www.beautiful-landscape.com

BEAUX ARTS PHOTOGRAPHY

Date

Sold To _____

BEAUX
ARTS
PHOTO
GRAPHY

Description	Unit Price	Qty.	Total
		Sub-total:	
		Shipping and Handling:	
		sales tax (7.85%)	
		Grand Total:	

Thank you

PO Box 12343 • Glendale, AZ 85318
800-949-7983 or (623) 561-1641 • alain@beautiful-landscape.com

Invoices and general stationary.

Alain Briot
Beaux Arts Photography

PO Box 12343 • Glendale, AZ 85318 • 800-949-7983 or (928) 252-2466
alain@beautiful-landscape.com

www.beautiful-landscape.com

Full-sized downloadable forms and documents may be found at www.beautiful-landscape.com/Briot_Marketing.html

Order Forms

Order forms are important. If you sell your work by mail order, your order form is what your customers will fill in and return to place their orders. In effect, your order forms will be the mode of communication between you and your customers.

There is a widespread belief that marketing materials, including order forms, have to be attractive. This belief is inaccurate. Marketing forms do not have to be attractive, colorful, or even impressive. If your order forms look great, fine; however, this is not a requirement. The only requirement for a marketing form is that it does the job it is intended to do. In fact, more often than not, colors, fancy fonts, nice formatting, etc. distract customers from the purpose of the form, which is to place an order.

The example forms shown in this chapter have generated many sales over the years. Yet, none of them has color, fancy fonts, or sophisticated formatting. In fact, my most recent order form is actually one of the simplest. Why? Because I have learned over the years that the simplest order forms actually work the best. Most customers do not want to spend hours completing a form. Keep the amount of information your customers need to fill in to a minimum and keep your forms as simple as possible.

ALAIN BRIOT FINE ART PHOTOGRAPHS ORDER FORM

Yes! I want to order your beautiful artwork. I have found my favorites among your collection! I understand my purchase comes with a one-year, "no questions asked", money back guarantee. If I decide not to keep this artwork after I receive it I can return it for a full year and you will refund all my money.

Here is my selection:

Photograph title	Size	Frame style	Qty.	Price
	Arizona orders add 7.85% sales tax:			
			Shipping:	
			Total:	

Please process my order right away: VISA MasterCard AMERICAN EXPRESS

Name_____

Address_____

City_____

State_____ZIP_____

Phone Number (_____)_____ Email_____
Payment by:
__Mastercard __Visa __American Express __Personal Check

Credit Card Number_____ Exp._____

Mail to: or **Fax (24hrs a day) to:**
 801-340-9850
Alain Briot
PO Box 12343
Glendale, AZ 85318

FOR FASTER SERVICE, CALL THE TOLL FREE,
"ALAIN BRIOT FINE ART" HOTLINE:
1-800-949-7983

My general order form

NAVAJOLAND MUSEUM PORTFOLIO ORDER FORM

Order form

Photograph title	Price	Quantity
Navajoland Museum Portfolio	$4000	
Orders shipped to Arizona add 7.85% sales tax		
Shipping:	included	0
Total:		

Please process my order right away:

Name_____

Address_____

City_____

State_____ZIP_____

Phone Number (_____)_____ Email_____

Credit Card: ___Mastercard ___Visa ___American Express

Credit Card Number_____ Exp._____

You can also use a personal check if you prefer

Mail this form to: or **Fax this Form 24hrs a day to**
Alain Briot **207-226-6168**
PO Box 12343,
Glendale, AZ 85318

FOR FASTER SERVICE, CALL THE TOLL FREE,
"ALAIN BRIOT PORTFOLIO HOTLINE" AT:
1-800-949-7983

Navajoland Portfolio order form

Address label used when I lived in Chinle, Arizona, on the Navajo Reservation.

Fragile, Glass, and Do Not Drop labels.

US shipping and handling costs
Insurance and tracking label included

Framed photographs
One 11x14 .. $35
Two 11x14 .. $45
One 16x20 .. $40
Two 16x20 .. $50
One 18x24 .. $45
Two 18x24 .. $55
One 22x28 .. $55
Two 22x28 .. $65
One 16x38 panorama $45
One 10x20 .. $40
One 20x54 .. $170
One 36x44 .. $215

Matted photographs
Up to five 8x10 $15
Five to fifteen $20
Fifteen to thirty $25
One or two 11x14 (not decorated) $15
One or two 16x20 (not decorated) $20
One 18x24 .. $25
Decorated Mats Add $5
Rolled photographs shipped in tube $10

Canada addresses: add $15(air mail)
England and overseas addresses: add $20

-- We ship with the US Postal Service except for
20x54 and 36x44 which are shipped via FedEx--

Shipping chart

Shipping Labels

You wouldn't think that shipping labels and notices are an important part of marketing your work, but they are. A sale is not complete until your product is safely in the hands of your customers. If you sell your work at shows or in a gallery, you will need to ship items too large to be carried by your customers. In the case of orders placed over the phone, by mail, or on the web, the only way to get your product to your customers is to ship them. How to get your product safely through the shipping phase is where good labeling comes in.

Something as simple as having the wrong address can cause major problems. A package without a "Fragile," "Do Not Drop," "Do Not Bend," or "Glass" label on it can be the cause of a broken frame, a damaged mat, or a bent photograph. Labels go a long way toward informing shipping and post office employees about what is in the box and how carefully they need to handle the package. Of course, a lot more than just labels goes into good packing, as we saw in Chapter 14: *Packing and Shipping Artwork*.

Shown here are some examples of the labels we use on a daily basis. At first I designed and printed my own labels. Today we use ready-made, commercial labels because we need many of them and no longer have time to print them.

Shipping Costs Chart

A shipping costs chart is necessary. Its purpose is to list the shipping costs for the various sizes and types of photographs you are selling. It is important to have one because it answers customers' questions regarding the cost of shipping specific items. It also allows you to quote an exact amount to your customers instead of guessing what the shipping costs might be. That way you can calculate the exact total for the photographs and the shipping.

We always carry a shipping chart at shows, which allows us to quickly answer the many questions we inevitably get. Being able to answer these questions quickly is key to selling our work successfully.

Name Tags

You need a name tag if you are selling your work at art shows. A name tag identifies you as the artist, the owner of the booth, and the person to whom prospective customers can ask questions. Without a name tag, people do not know who you are. Because of that you may lose sales that you would otherwise have made if people had known you were the artist and had talked to you.

Most sales in art start by people asking you a question and you answering it. That question can be about anything. What is important is that people

talk to you. You can also ask questions to customers. In fact, very often this is exactly what you need to do if someone is looking at your work and saying nothing. When you sell art, people will very rarely come to you and say, "Give me two of this model," or pick up a piece and say, "That's the one for me."

Don't get me wrong. Immediate sales do happen. In fact, the two situations I just mentioned have happened to me. However, they each happened only once in 12 years of selling my work. These kinds of sales are great when they happen but you cannot build a business upon them. Instead, nearly all your sales will be made as the result of a conversation between you and your customers. And since wearing a name tag does help get a conversation started this is an excellent reason to have one.

Shown here are examples of the name tags we use when doing art shows.

Skill Enhancement Exercise

Looking at the entire list of necessary business tools in this chapter, first make a list of what you already have and then make a list of what you need to get.

Do you have a sales tax license? If not, set a date by which you will have one.

Do you have a business license? If not, set a date by which you will have one.

Do you have a trade name certificate? You cannot apply for a business license without a trade name certificate. You also cannot open a business checking account without having a trade name certificate. However, if you open a business checking account your bank can apply for a trade name certificate for you.

Do you have liability insurance? If not, find a liability business insurance provider.

Do you have a credit card processing account? If not, find a credit card processor so that you can accept credit cards.

Follow the same process for all the items listed in this chapter.

Set a deadline for getting what you need. I recommend setting a one-week deadline. Deadlines that are too far in the future do not work because they allow us to "slack off" and procrastinate until the deadline is almost there. A one-week timeframe to complete these tasks should be plenty of time.

Name tags.

Without promotion something terrible happens...
Nothing!
 P.T. BARNUM

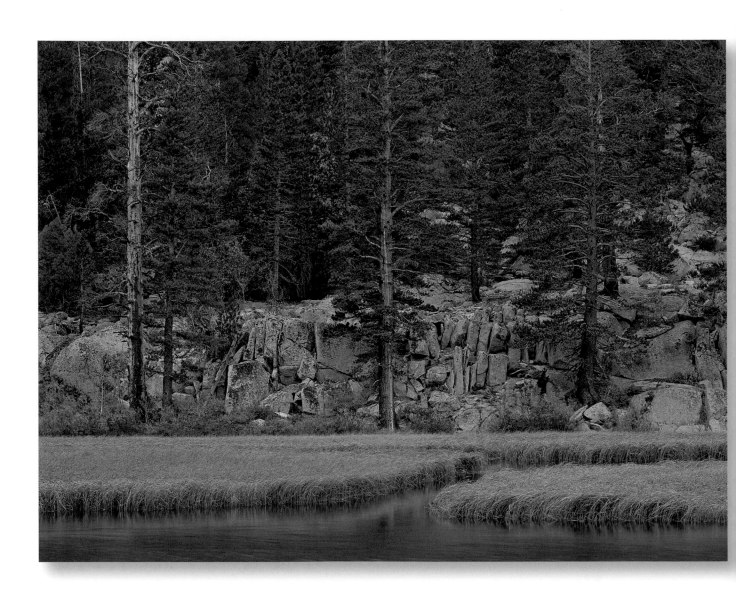

Chapter 18
Marketing Tools

Marketing tools are essentially elements and documents of promotion. They are used in promoting your business and marketing your products. You will need to create most of these documents yourself. When doing so, keep in mind that your best promotional elements are your photographs. If you give too much prominence to marketing documents, they become more important than your artwork. You do not want to do this because you want your customers to remember your artwork, not your promotional documents.

The best approach is to keep your promotional documents simple so that they do not compete with your artwork. As I mentioned before, there is no need for marketing documents to be beautiful. They just need to be effective. In other words, they need to generate sales.

Special Offers

In this section you will find several special offers that I have personally designed and used. Some of these offers were used at the El Tovar Hotel when I sold my work at Grand Canyon National Park. Others were used in other locations where I did shows.

These offers will work with first-time buyers; however, they will work even better with previous customers. The best people to send a special offer to are those who have bought from you before because they are already sold on you and on your products. They know you, they like you, and they like your work; otherwise they would not have bought from you in the first place. If you make them a special offer they will perceive it as a "thank you" on your part and they will take advantage of your offer.

In fact, if you are wondering who you should be marketing to first, the answer is that you need to market first to your past customers. The success rate when marketing to past customers is many times superior to the success rate of marketing to new customers. This is because when you market to people you have never met before you have to do everything from scratch. You have to convince them that your product is a quality product, you have to convince them that your prices are fair, and you have to educate them about who you are, where you are coming from, what your work is about, and so on. With past customers all this has already been done. All you have to do is extend an invitation for a special offer.

A special offer needs to feature a number of specific things. To help you in writing your own special offers, here is a checklist of what a special offer needs to have:

(1) A letter: It doesn't have to be necessarily a personal letter written to individual customers, although that works very well if you have the time for it. However, it has to be a letter written by yourself to your customers. This letter is the part in which you describe your product. You need to show enthusiasm, enthusiasm, and more enthusiasm! Remember that enthusiasm is contagious. If you are enthusiastic about your work, your customers will be enthusiastic about it as well.

(2) An emotional component in your letter: Your letter needs to focus on the emotional aspects of your work—on how your work creates emotions and feelings for your audience. In my special offers my goal is to place my customers in an emotional state of mind. I want them to see the beauty and the emotional aspect of my work. I do not want them to look at my work from an analytical perspective. Study how I achieve this in the letters featured in the examples shown in this section (especially in the ISCAS offer).

Always remember that people buy photographs for emotional reasons, not for technical reasons. Therefore, if you do not create an emotional response you will not sell many photographs.

(3) An expiration date: No offer should last forever. All offers need to be for a limited time only. Your special offer needs to say, in big red letters for maximum visibility, "this offer expires on *such date.*" For maximum effect you can add: "at midnight, no exceptions, no extensions, no excuses," for example. You can purchase a date stamp and use it to stamp the date, in red, on each letter. You can also create red type in InDesign, or another program, that looks like a date-stamp. I have used both approaches: I use the stamp approach when I distribute forms at shows because this allows me to change the expiration date without having to reprint the form. I use the printed approach when I use a form only once.

Keep in mind that a shorter length of time for the offer will result in people making a quicker decision. This is important because the longer people wait to take advantage of your offer the less likely they are to buy. Ideally, you want customers to make a decision immediately. If this is not possible, then you want them to make a decision as soon as possible after they read your offer.

(4) A special deal: This can be a package price, a certain percentage off, etc. Ten to 20 percent off is standard. Less than that is not enough to be convincing.

(5) Several testimonials: This is very important. See the testimonials section in this chapter for details.

6 **An order form reiterating the expiration date:** The order form should also have a short version of your offer. As we just saw, all offers must be good only for a limited time.

7 **A secondary benefit added to the Special Offer:** For example, "Get X for free if you order today." Or, "Buy two and get the third one for free." Or, "Get a free gift in addition to the special offer price."

8 **An itemized list of all the advantages that your offer includes:** The longer the list, the better. This list should include the regular price and the special offer price so that your customers know exactly how much money they are saving by placing their order during your special offer period.

Alain Briot
Beautiful Landscape Photographs

May 2nd, 2003

20% off all unframed photographs
10% off all framed photographs

Today only

Mother's Day Special

Mother's Day Special Offer

"I feel this unique emotion each time I watch the sun set over the Grand Canyon . . ."

Why are we so passionate about the beauty of nature? Why does a sunset trigger such a powerful emotion? And why do we turn to nature when we seek peace, quietness and time to figure out where we are in life and where to go from there?

After all, with all the technological advancements available to us isn't it more exciting to stay home and enjoy the incredible level of sophistication that today's technology affords us? After all, shouldn't we look at nature with raised eyebrows for doing everything with only water, rocks, plants, wind and fire?

Nature's tools are as simple as we will ever find and yet as powerful as tools can ever be. Nature is the great teacher, showing us what can be done and what life is worth. Nature offers us beauty of such magnitude that we can only begin to ponder its complexity. That some of the mysteries of nature be revealed to us in our lifetime maybe all we can ask after all because such knowledge opens the doors to understanding beyond belief.

The Grand Canyon is perhaps the most famous natural wonder in the world. It is a place of solace and peace, a place where one can finally find time to sit down and reflect freed for a moment from a hurried schedule.

But why the Grand Canyon, why not another and just as remarkable natural wonder? After all there are sites just as grand although far less well known?

Because here better than anywhere the earth opens up to reveal its most intricate wonders and its most secret places. Because immensity can be so vast as to challenge understanding. Because such vastness forces us to acknowledge how small we really are. And because the Grand Canyon exists in an entire different reality than we do: what is to us a lifetime is nothing but an instant in the timescale of the giant chasm.

I have made it my life's work to represent the beauty of nature. It is my hope that, through these images, I can share some of this beauty with you.

Alain Briot
Canyon de Chelly, Arizona
Febuary 2002

www.beautiful-landscape.com
alainbriot@excite.com

ISCAS Special Offer – Letter

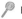
Full-sized downloadable forms and documents may be found at www.beautiful-landscape.com/Briot_Marketing.html

— ISCAS Conference Special Offer —
Beautiful photographs of the Grand Canyon and the Southwest
by artist photographer Alain Briot!

Hello to all the ISCAS conference attendees! You have seen my work on all the ISCAS materials —poster, proceedings books and CD, and web site. Now, how would you like to own your very own, limited edition artwork of your favorite image, beautifully hand-printed and matted? Well, it's not only possible and easy but very affordable as well. Just fill in the order form on this other side of this page and mail it back to me. And, you will benefit from a special, not to be repeated, 20% discount from my already affordable regular prices. This offer is valid for two weeks after the end of the conference, or until June 15th!

Visit my web site at www.beautiful-landscape.com
All my prices are on my web site at www.beautiful-landscape.com There you can find the title of each photograph and learn about sizes and prices. Just take 20% off any price and that is what you pay as an ISCAS attendee.

But you don't even have to visit my site (although you really will enjoy the experience if you do). All you have to do is use the order form provided here. If you don't know the title of the photograph you like just describe it as best as you can. I will be able to tell what it is. If you don't mind including your phone number I can call you in case I need to make sure I am shipping you the right photograph.

Two great sizes, matted or framed, at a 20% discount only for ISCAS attendees!
There are two very convenient sizes which I want to present to you here. First, 11"x14", mat size, which is a great size for a limited space area or as an accent in a larger room. Matted, this size is normally $45, but for the ISCAS conference it is only $36. If you would prefer to invest in it framed, in a stunning hand made, southwest design inlay frame, so that all you have to do when you receive it is proudly hang it in your home or office, then it is only $105, minus the IS-CAS 20% discount, which brings it to only $84. That's all, for a beautifully framed photograph will for years to come will bring back wonderful memories of your visit to Arizona and of the 2002 ISCAS conference!

The other size I would like to tell you about is 16"x20", mat size, which again is regularly priced at $95, but which for the ISCAS conference is only $76, and if you would prefer it framed, in the same beautiful hand made, southwest design inlay frame, it would cost you only $195 normally, but because of my special IS-CAS offer you can own this stunning piece, which by the way is a limited edition print of only 100 copies of each photograph, for just $156!

Have your photographs shipped to you 100% insured and traceable!
Shipping is a flat $15 for matted photographs and $25 for framed photograph in the continental US. For overseas orders just add $10 to these prices. Shipping includes insurance and tracking number so that if anything happened to your package you are covered- just contact me and I will ship you a replacement right away. I can also provide you with the tracking number over phone or email so you know exactly when to expect your package.

Invest in beautifl original artwork which will remind you of your visit for years to come!
The photographs selected for this conference were all created in the most breathtaking natural locations in Arizona! Each of them took many, many hours of planning and often involved going back to a specific location over and over again until everything -the sun, the clouds, the shadows, the composition - was "just right," just the way I wanted it to be. I am a perfectionist, and I don't want to think about how much film I used in the creation of each of these unique pieces of artwork! To me they are like paintings and what matters is the final result, as I am proud to present it to you today.

Which one of these beutiful images is your favorite?

--Please turn the page over --
thank you

Grand Canyon Special Offer – Page 1

Order form:
Please mail to Alain Briot, PO Box 520, Chinle, AZ 86503

Name: ..Phone number: ...
Shipping Address...

Email:...
Title of photograph or description...

I would like my photograph(s) framed - unframed (please circle one)
Cost of photograph (from text above) less 20% until June 15th 2002: $.......................
Cost of shipping (from above as well)-insurance and tracking included: $.......................
Total: $.......................

Credit card number (Visa or Mastercard only):...
Name on card: ...Expiration date (month/year):.......................

You can also pay by personal check or money order made to Alain Briot
If you prefer to order over the phone or have any questions call my toll free number: 800-949-7983
You can also contact me by email at abstudio@cybertrails.com

100%, no questions asked, money back guarantee! You either love my work or I will refund all your money!
Thank you for your business! And keep in mind that should you not like your photographs when you receive them you are covered by my 100%, no questions asked money back guarantee. I am not just saying this so you would make a purchase, I mean it. My goal is that you are satisfied with your investment so if this is not the case just return the artwork to me and I will refund your money, except for the shipping costs.

Alain Briot

Testimonials	
"Thank you for shipping our photograph so quickly. The packing was incredibly sturdy and our artwork arrived in perfect condition. Although we did not need it we do appreciate the fact you insured it and placed a tracking label on it." Joan Bassler Concord, Massachusetts	"Your artwork has become part of our family heirloom and we look forward to passing it to our children and our grandchildren. Although it has been several years since we purchased it we never tire of admiring it. Every day it reminds us of our visit to Arizona and to the Grand Canyon." Craig and Linda Fox Tampa, Florida
"I shall treasure your artwork as a memento of my experience traveling West and visiting a Grand Place." Lynda Dillon Middletown, Delaware	"Alain Briot is one of the most successful landscape photographers working in the American Southwest today. His work is widely exhibited and collected." Michael Reichmann Publisher, Luminous-Landscape.com

Your limited edition artwork, framed or unframed, comes double matted in a beautiful "Desert Sand" or white mat, bevelled-cut to museum standards! (I almost forgot to mention this!)
Each mat is cut by hand, by myself, and you can choose either a double white mat, for a traditional photographic presentation, or a Desert Sand mat (light beige), for a more Southwestern presentation. Each mat is hand cut by myself, and truly accents the inherent beauty of each photograph. The choice of color is yours, and there is no extra charge for this service, as it is included in the prices mentioned on the other side of this page!

--Please turn the page over --
thank you

Grand Canyon Special Offer – Page 2

Testimonials

A testimonial is something positive that one or several of your customers said about you and your work. They are a very important part of any marketing piece because having your customers say something positive about your work is much more persuasive than you saying something nice about your work. Everyone expects you to say positive things about your own work; therefore, while you may be speaking the truth, you are not credible. However, if one of your customers says something good about your work without being asked to do so, that person has huge credibility. There is no good reason why someone would say they love your work if they don't.

Finally, potential customers relate to other customers. They have something in common with them because they are interested in purchasing your work. So, when a potential customer reads what other customers have said about your work they are learning what kind of response your work generates. This is one of the two best ways to build confidence and trust. The other way is through your warranties, something we will look at in Chapter 21: *Unique Points and Warranties.*

GRAND CANYON, EL TOVAR HOTEL CUSTOMER
SPECIAL OFFER ORDER FORM

Ship me my favorite "Alain Briot" photograph!

THIS SPECIAL OFFER EXPIRES (STAMP DATE HERE IN RED)

Yes, thank you for letting me know about this special offer!

I accept the opportunity to order my favorite photograph by Alain Briot and
take advantage of your unique 20% off Special Offer **because I am a Grand
Canyon, El Tovar customer.** I understand that if I am not satisfied 110% with
your work I can return it for **up to one year** (1) for a complete refund (except
shipping - no questions asked). I also understand that if I am one of the
first 5 customers to take advantage of this special offer I will receive, **at
no extra cost!**, one of your unique, beautifully decorated mats featuring a
shadow box effect with one of a kind Native American Artifacts!

I found my favorite photograph on your website **www.beautiful-landscape.com**
and I wrote the title below. I understand my cost is 20% less than the prices
on your web site. I have deducted 20% and indicated MY PRICE below.

Please rush this package to me immediately. I understand that my order is
fully insured and traceable, and that if it is damaged in any way you will
replace my artwork right away and send me a brand new one.

Name_____

Address_____

City_____

State_____ZIP_____

Phone Number (_____)_____

Title of photograph:_____ Size_____

____Unframed _____ Matted and Framed --> frame style_____

Web site price_____ My price (deduct 20% of the web site price)_____

Shipping_____ Total_____(your artwork is shipped priority mail)

Credit Card Info: ___Mastercard ___Visa ___American Express

Credit Card Number_____ Exp._____

Mail this form to: **Fax (24 Hrs. A Day):**
Alain Briot Fax This Form To: 207-226-6168
PO Box 12343
Glendale, AZ 85318

FOR FASTER SERVICE CALL US TOLL FREE AT
1-800-949-7983

Grand Canyon Special Offer — Order form

You need to include one or several testimonials in all of your marketing pieces. The best is to place a testimonial at the beginning of your marketing materials. If you use several testimonials, use one at the top and others in the body of the text. You can also have a designated testimonials page where all your testimonials are shown together.

When one of your customers gives you positive feedback, ask them if you can quote what they told you. If you do not hear from your customers, contact them and ask them if everything was OK with their order and if they are enjoying their artwork. Most likely your customers will respond and will give you positive feedback that you can then use as testimonial.

Today the best way to get in touch with your customers after a sale is by email. For this reason it is important that you get your customer's email address in addition to their physical address, phone number, and other information. Customers will respond to an email much more readily than they will to a letter.

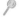 Full-sized downloadable forms and documents may be found at
www.beautiful-landscape.com/Briot_Marketing.html

```
┌ ─ ─ ─ ─ ─ ─ ─ ─ ─ ─ ─ ─ ─ ─ ─ ─ ─ ─ ─ ┬ ─ ─ ─ ─ ─ ─ ─ ─ ─ ─ ─ ─ ─ ─ ─ ─ ─ ─ ─ ┐
```

Testimonials:

"Thank you so much for helping me select a photograph taken from the exact overlook I went to with my family. It means so much to all of us that it has become the most valued memory of our vacation!"
 Jerry Moorman
 Chicago, Ilinois

"Thank you for shipping our photograph so quickly. The packing was incredibly sturdy and our artwork arrived in perfect condition. Although we did not need it we do appreciate the fact you insured it and placed a tracking label on it." Joan Bassler
 Concord, Massachusset

"I shall treasure your artwork as a memento of my experience traveling West and visiting a Grand Place." Lynda Dillon
 Middletown, Deleware

"Your artwork looks just as beautiful in our home as in your Grand Canyon gallery! The colors are so brilliant that it was not even necessary to place a light over it. It is the perfect addition to our home decor!"
 Jerry Feist,
 Hendon, Virginia

"Your artwork has become part of our family heirloom and we look forward to passing it to our children and our grandchildren. Although it has been several years since we purchased it we never tire of admiring it. Every day it reminds us of our vacation and of visiting the Grand Canyon." Craig and Linda Fox
 Tampa, Florida

"Alain Briot is one of the most successful landscape photographers working in the American Southwest today. His work is widely exhibited and collected."
 Michael Reichmann
 Publisher of Luminous-Landscape.com

Testimonials I currently use.

Certificates of Authenticity

In this section you will find examples of my personal Certificate of Authenticity. I have used these for years. I offer them here as a point of departure for you to create your own certificates.

Offering a Certificate of Authenticity is important because it provides an additional level of trust and warranty for your customers. It lets them know that you stand behind your work and that your limited editions are not just a number on the front of a print since the edition is actually recorded on a certificate. This shows that you care about your work and that you follow a professional presentation and work ethic.

I am currently using two different types of Authenticity Certificates: one for limited editions and one for open editions. The open edition label features the name and location of the photograph. The limited edition label features the number of the print in addition to the name and location. I also include technical information about the photograph and the print, plus my contact information, name, and business name on both certificates.

These certificates also work as a warranty. When someone purchases a framed piece from us, if the certificate is affixed to the piece, and the original owner owns the piece, we will repair or replace the artwork if damage is caused by the quality of our framing. This framing warranty is a strong motivation for people to buy framed pieces from us instead of purchasing a matted print and taking it to a framer. If they take it to a framer, we do not insure the piece against any damage caused by the framing or framer.

Finally, these Certificates act as Authenticity Labels since they are only available when affixed to either a matted or a framed piece.

A strong warranty, in fact several strong warranties, are crucial to your business success. Make sure to read my notes on this in Chapter 21: *Unique Points and Warranties*.

Alain Briot

Beautiful Landscape Photographs

Horseshoe Bend Panorama
Page, Arizona

Technical information:
Multiple Phase One P45 captures converted in Lightrom 2 then
stitched and optimized in Photoshop CS4.
Print made on Epson 4800 using ImagePrint with
Phatte Black on Hahnemuhle Photo Rag 308
Open Edition

alain@beautiful-landscape.com -- 800-949-7983 or 928-252-2466

www.beautiful-landscape.com

This label certifies this is an original photograph by Alain Briot

Open edition certificate

Alain Briot

Beautiful Landscape Photographs

Horseshoe Bend Panorama
Page, Arizona

Technical information:
Multiple Phase One P45 captures converted in Lightrom 2 then
stitched and optimized in Photoshop CS4.
Print made on Epson 4800 using ImagePrint with
Phatte Black on Hahnemuhle Photo Rag 308
Limited Edition: 12/100

alain@beautiful-landscape.com -- 800-949-7983 or 928-252-2466

www.beautiful-landscape.com

This label certifies this is an original photograph by Alain Briot

Limited edition certificate

Price Tags

Signs and price tags are part of your business image. As such they need to follow the same design style and the same marketing approach that you use for your other business materials. All these materials work together to create your business identity. They share a set of core values that you want your customers to know and appreciate.

Price tags are very important. Unfortunately, their appearance is too often neglected by artists who use simple stickers with handwritten prices on them. This should not be the case. If you look at the price tags used by luxury stores you will see that a lot of thought goes into creating them. This is because price tags are representative of how you want your customers to feel about your products. When you are selling something expensive—and you are selling something expensive if you price your work on the basis of leverage and reputation—you need to generate respect for the work you are selling in the mind of your customers. If you fail to do so, your customers will not take you seriously and will not buy from you. There is nothing that expresses respect for a price more than a professionally designed price tag.

When I first started in business, I used handwritten price tags. Today I print my price tags. This is important because customers may be suspicious of handwritten price tags that can be changed on a whim, while printed tags take time to retype, reprint, and replace. They may think that the price on a handwritten tag could change from one day to the next depending on how this item sells. In fact, some customers will not buy items marked with handwritten tags.

Longhand, typed price tag on framed piece

Longhand, typed price tag

Numerical, typed price tag

I have used a variety of price tags over the years. The ones I currently use for framed pieces are shown here.

For matted prints sold in a protective bag, I use one of two approaches. The first approach is to use self-sticking Avery labels in a small size of half an inch long or so. Those are available at any office supply store such as Staples, Office Max, and so on. These price tags are affixed to the back of the matted piece, in the top right hand corner. They are discrete and yet easy to read.

The second approach for matted prints is to use a price sign attached to the print bin instead of a price tag. In that instance, the price sign indicates the price of all the prints in a specific bin. This works well if you are organizing your prints per size, with only one size per bin. If you mix and match print sizes in the same bin then you need to use price tags on each print because not all the prints in the bin will have the same price.

The idea for writing prices in longhand came to me while having dinner in an expensive French restaurant in Phoenix. This restaurant had the prices on the menu written in longhand. Not seeing actual numbers, I paid no attention to the prices whatsoever and ended up making choices based on the menu description instead of the menu prices. The bill surprised me and I realized that when you do not consider prices your choices are made on the basis of your taste and emotions, not on the basis of money.

I therefore decided to try the same approach with my own work and for a while wrote all my prices in longhand using a manuscript font (see example). The problem with this approach was that a lot of people did not understand that the price was written in longhand. Therefore, they would ask me what the price was and I had to constantly answer questions about the prices of my work. This caused people to pay more attention to my prices than if I had used numerical price tags. I eventually discontinued this approach because it simply did not work for me.

Why did longhand price tags work at the restaurant and not at art shows? Probably because at the restaurant people were aware that this was an expensive restaurant and therefore were either ready to read the longhand prices carefully or not pay any attention to the prices at all. At art shows people do not know beforehand what to expect and often do not have the time or patience to decipher hard to read signs.

Testing is an important aspect of marketing and testing is what I did in this instance. As it turned out, what I thought would work better did not work at all. However, I would not have found out if I did not test both types of price tags.

Collection Signs

I started using collection signs on my show displays to indicate the general location where a group of photographs were created. Each collection sign is placed on a single show panel, usually at the top. Framed pieces featuring photographs of each location are then displayed under each collection sign. I only feature one location per display panel. I have found that this approach creates an elegant display presentation.

These signs help customers identify where the photographs were taken. During busy times, the signs answer one of the most commonly asked questions, "Where was this photograph taken?" This saves me time because I do not have to answer the same question multiple times.

Take a look at the photographs in Chapter 13: *Show Booths Examples* to see precisely how these signs are used.

Collection signs

Email List Sign-Up Form

One of the most important things to do if you market via email is to create and maintain a customer email list. One way to do this is by having an email list sign-up form available each time you sell directly to customers. For example, you can have this sign-up form available at art shows, in your home gallery, and at any other location where you meet customers in person. This list should be plainly visible so that customers can easily fill in their name and email address. Be sure to ask them to print their email address legibly, because a single missing letter will make the email address useless.

The example here shows the email form we use. As you can see, this form is very simple and has only two columns: one for the email address and one for the customer's name.

At the top of the form is a description of what customers receive when they sign up for our email list. This is very important because customers are more likely to sign up for your email list if they receive something for free. What you offer is entirely up to you. Special offers, news, and announcements are popular choices. So are free essays that customers can download from your website. Regardless of what you give, be sure to make it exciting. The more excitement you can create, the more successful you will be selling your work.

Customers are more likely to sign up for your email list if they receive something for free.

Email list sign-up form

Alain Briot
Beaux Arts Photography

Join our email list

Receive exiting special offers, news about upcoming events, special offers and exclusive announcements.
Be the first to learn about Alain's new photographs.
Sign up now for our email list. A new email is going out in a few days!

Email address (Please block print)	First and last name

Business Cards

The first thing most people do after starting a business is get a box of brand new business cards. While this is not a bad idea, business cards are not all they are touted to be.

When I started selling my work, I designed a beautiful business card that was a work of art In and of itself. I was very proud of my cards; I used them as a creative outlet and I gave them to thousands of potential customers. However, something happened that changed my mind: I hardly ever heard from any of the people who were so excited to get my business card. That is when I started to wonder what was going on.

What was going on is that I was giving the impression that I was doing mail or phone orders rather than direct, in-person sales. Mail order sales are what you are working toward when you give your card to people. You basically say: get my information now then place your order later over the phone, by mail, or on the web.

The problem is that I was not set up for mail orders. I did not have a mail order catalog, I did not have a website people could order from, and I did not send follow up letters. Also, I was not home all the time to answer the phone.

My situation was not unique. Most artists are not set up for mail order, yet nearly all of them distribute business cards generously.

My attitude changed completely and I went through a phase where I only gave my card to people who made a purchase from me. This approach worked better for me. People who did not purchase were told that I did not do mail order and that I wanted my customers to see my work in person prior to making a purchase. I also explained that any piece could be shipped, so that customers knew they were not required to carry it with them. This is important because carrying artwork is a problem for customers who are traveling, especially when they are flying.

Because I now do far fewer shows than I did when I started, I no longer have to give thousands of business cards away each year. Therefore, I now use a slightly different approach, and I realized that giving my card was simpler than not giving my card. I use the letterpress business card that is shown in the examples section below. On this card there is only my phone number and my website. My email address is not on my card either, as it can be found on my website.

The goal of this card is to motivate people to visit my website in order to see my work, read my essays, and find out more about me. The phone number is there in case someone wants to call me directly. There is no address because people do not need it as they can order directly from my website. If someone wants to write me they can do so over email, which today is far more popular than writing a letter. In fact, I want them to do that because they will have to visit my website to find my email address.

Cards with just your website address, or, like mine, with your website and phone number, are becoming increasingly popular as we move toward the web as the center for communication. People visit websites first to get the information they need and then take the next step by emailing or placing orders.

Also note that my card has no photograph on it and no "title" either. I do not like labeling myself because I consider labels limiting. If my card says "artist" then it doesn't say "teacher" or "author" or "publisher," and so on. In my case I am an artist, a photographer, a teacher, an author, a publisher, a marketing consultant, a painter, and more. Therefore I decided to have only my name on my card. Since the main aspect of marketing your art is promoting yourself and your name, this approach reaches this goal more effectively than any title ever could.

This card took me years to design. I know that this is hard to believe when you see how simple it is. However, simplicity can be challenging. There is nothing easier than designing a business card that has everything on it. Designing a card that has the minimum information on it, and that works for you, is much more challenging.

My current business card which is shown here was printed and designed by a professional printing shop using the letterpress process on heavy, textured cover stock. It exhibits class and quality and I get enthusiastic remarks each

Business cards used from 1994 to 1997

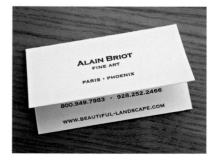

The business card I currently use

time I give my card to someone. From the very moment I exchange cards I make the point that my work is about quality.

The business card I currently use is a folding card that features only my name, phone number, and website address. All other information can be found on my website. No photographs are used. This business card is printed on 100lb cover stock and the type is set in Letterpress, meaning that the type is both inked and pressed into the card stock. The Letterpress process gives a three-dimensional quality to the card and shares the concern for quality that I have for all my work. Printed in quantities of 2000, this card costs over $1.00 per card to produce. It represents the finest quality printing available.

Gift Certificates

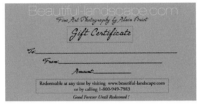

The Gift Certificate I currently use.

I offer gift certificates, both on my website and at shows, and I recommend that you do too. These are popular because it can be difficult to choose a gift for someone else. With a gift certificate, the recipient can purchase an item of their choice. If the item is less expensive than the face value of the certificate, they get a credit toward a second purchase; if the item is more expensive, they just pay the difference.

Notice that my certificate says "Good Forever Until Redeemed!" Why do I do this while most merchants make their certificates expire after a year or two? Because I want my customers to feel free to use their gift certificate whenever they please. Why limit them to one year? After all, they paid me already so why should I be concerned that they use it within a year?

In practice, most people use their certificates soon after receiving them, within a few weeks or months. They are aware that money loses value over time ($50 today buys less than $50 four years ago).

As with the other examples in this chapter you can use this certificate as a model to design your own. Notice how many of my materials use the same fonts and design. This is important in order to create a unique, unified business identity.

Promotional Items

Promotional items are given away for free to potential customers in the hope that these items will help generate sales. Promotional items are widely used by some businesses and not used at all by others.

When selling art, the most important aspect to consider is that you are not giving away your artwork. Giving your work for free devalues it. If you give away your work, there is no reason for customers to purchase it. Some artists believe they can circumvent this fact by giving away small samples of their work in the hope that the people will purchase larger pieces. The problem is

that there is no way for you to know what size pieces the people you give free items to are looking for. What if they are looking for small pieces, and the size of the piece you give them free is exactly what they are looking for?

Photographers are often guilty of giving their work away for free. This is because the cost of printing and matting a photograph is relatively low. Artists who have much higher production costs do not give their work away for free. For example, you do not see jewelers giving away their jewelry to attract customers; the cost of gold, silver, and gemstones make doing so impossible. However, as we saw before, art is not sold on the basis of the costs of production. Instead, art is sold on the basis of your leverage and reputation. The main reason your work has value is because it has your name on it.

Often, the artist's signature is the most valuable aspect of the work. A signed piece is usually worth many times what a similar but unsigned piece is worth. A well-known story about Picasso demonstrates the value of the artist's signature. While having dinner in a Paris restaurant Picasso made a sketch on the paper napkin that covered his table. Seeing the sketch, the owner of the restaurant told Picasso that he would not charge Picasso for dinner if he could have the drawing. Picasso agreed. The restaurant owner then asked Picasso to sign the drawing. Picasso answered that he intended his drawing to pay for dinner, not to buy the restaurant.

This story shows the importance of placing a high value on work that you sign. The autograph you give away to someone on a postcard may come to be worth more than you think in the future. While you cannot know this for a fact, you can protect yourself by not giving away signed work.

So what can you give away, provided that you want to offer promotional items? Personally, I offer very few promotional items and when I do these items are not about my own work. So far the only items I have used are promotional logos, small posters, and postcards. Examples of these promotional items are shown here such as the posters announcing the release of the *Navajoland* and the *Grand Canyon* Music CDs by Travis Terry. These were not about promoting my artwork. Instead, they were about promoting Travis's music CDs. The posters feature my photographs of Travis Terry, but since I do not sell these photographs as prints there is no conflict with my artwork.

The other items are promotional stickers that I use to celebrate the number of years I have been in business. Again, these do not feature my work. I started using these after I had been in business 10 years. I thought that was a significant number of years. Before then I did not think I had been in business long enough to mention the number of years.

Giving your work for free devalues it. If you give away your work, there is no reason for customers to purchase it.

Years in business celebration self-sticking labels.

Navajoland and *Grand Canyon* music CD promotional posters.

Skill Enhancement Exercises

Exercise 1: Marketing materials you already have. Do you currently have marketing materials? If so:

1. Make a list of what these materials consist of.
2. Find copies of all these materials and examine them carefully while taking into consideration what you learned in this chapter.
3. Decide whether these materials are appropriate for your current needs and if using them will allow you to reach the goals you have set for your business.
4. If you have not set precise goals for your business yet, do so before completing this exercise.

Exercise 2: Marketing materials you do not already have. If you do not have marketing materials yet, design a set of marketing materials that fit your needs, your budget, and your audience using the information provided in this chapter.

Many of life's failures are people who did not realize how close they were to success when they gave up.
 THOMAS A. EDISON

There is a wide diversity of marketing venues that you can use to sell your work. In this chapter we are going to look at the most important ones and discuss the pros and the cons for each of them.

When deciding which venues you are going to use to market your work, you need to compare the cost of using a specific venue to the financial return you can reasonably expect when using this venue. Always remember that the goal of marketing your work is to generate sales. The goal is not to generate exposure, or name recognition, or even awareness of your product. While these three goals are worthwhile and important, if this is all your marketing campaign achieves, then it will not be financially successful. You need, first and foremost, to generate sales.

You also need to control your spending. Here too, the most efficient way to achieve this is to consider the cost of each marketing venue and compare this cost to the return you can expect from each venue.

Finally, you need to set specific goals for each marketing campaign. These goals are best set in dollar amounts. These goals also have to be realistic and make financial sense in the situation you are in at the time you start your marketing campaign. For example, if you have never sold your work before, to set $100,000 in sales as the goal for your first marketing campaign is not realistic. However, to set this goal somewhere between $1,000 and $5,000 is very realistic, provided your prices are adequate and you have chosen a viable marketing venue.

I recommend that you start marketing your work using venues that are either free or have a relatively low cost. If these do not work for you, then you may want to move on to more expensive venues. However, before you do so be sure to evaluate *why* your marketing campaign did not reach its goals. Evaluating a marketing campaign objectively does require experience, and you may need to hire a marketing consultant to help you do this.

In this chapter I divide the many types of marketing venues into two basic categories: Traditional non-Internet-based venues and Internet-based marketing venues.

Traditional Marketing Venues (Non-Internet Based)

Direct Mail

Direct mail marketing means sending your marketing materials to customers by mail. Direct mail was widely used in pre-Internet days, but now that we have the Internet the popularity of direct mail is quickly diminishing.

Direct mail was, and continues to be, expensive and labor intensive. This is because you have to pay for the cost of printing your marketing materials, plus the cost of mailing them. To take a simple example, if the cost of printing and mailing your materials comes to $1 per letter, you will need to invest $1,000 to mail 1,000 letters. Because the response rate of direct mail is very low (less than 5% on average), you need to send a lot of letters, often far more than 1,000 just to recoup your investment. You also have to prepare each envelope. This means fold and insert the marketing materials in the envelopes, affix the stamps, seal the letters, and take them to the post office. While doing all this is no big deal when you have only a couple of letters to send, it becomes a significant chore when you must prepare thousands of letters.

Another problem with direct mail is finding addresses to mail your letters to. Certainly, you can purchase a mailing list from a mailing list supplier, but doing so does not offer any guarantees that the people on this mailing list are interested in your product.

The most efficient approach is to build your own mailing list by collecting your customers' information and mailing only to people who have shown interest in your work. Your list will then consist of qualified people who like your product and who want to receive news about your work.

One of the best uses of direct mail in the context of selling fine art is to announce an upcoming show or exhibition of your work. People expect to receive an invitation for such an event, and mailing invitations to upcoming events is a traditional approach in the world of art. If you design and print the invitation yourself, and if you send it only to people on your mailing list, you can keep the cost down to a manageable amount.

When you send this marketing piece I recommend that you ask people to RSVP, to confirm whether or not they will be able to attend your event. This way you can plan the reception knowing how many people will be there. I also recommend having a financial incentive for people to purchase your work the day of the opening, such as a 10% to 20% discount for that day or evening only. Using these marketing techniques will go a long way toward making the event a success.

Telephone

The telephone is a valuable form of marketing. It is often overlooked because when we think of phone marketing we think of telemarketers who call us and pester us to buy things we have no interest in. This is certainly not the type of marketing you want to do over the phone. And, if you have been the victim of telemarketers, which most of us have, you know exactly what not to do: simply avoid doing any of the things that they do!

The best way to use the phone as a marketing tool is to call only people that you know personally and that you have talked to before in person, either at a show, in your home gallery, at an exhibition of your work, or at other venues. Most importantly, do not call people to sell them something over the phone! This is exactly what is upsetting with telemarketers: they call us unexpectedly and they ask us to make a purchase decision on the spot. The outcome is that most of the time we have to hang up the phone to end a conversation that is going nowhere.

One of the most effective forms of telephone marketing is to call people to invite them to a show of your work. Give them information about the show such as the location and the date, and give them an incentive for visiting you at that show, such as a 10% to 20% discount on purchases made at the show on the day of their visit.

We usually go one step further and invite people to visit us on the first day of the show, usually a Friday. The first day of a show is an important day because this is when customers can see all your new pieces before anyone else has a chance to purchase them. We also make the discount higher on Friday than on Saturday and Sunday, in the case of a three-day show. For example, we give 20% off on Friday and only 10% on Saturday and Sunday. Finally, we ask people to confirm their attendance to the show so that we know they will be coming, however, we do not ask people to tell us whether they will visit the show or not over the phone. We ask them to confirm over email, within the next three days after our call.

If you call people you have met previously, if you have good news for them (a show invitation with a special discount is good news), and if you do not pressure people to make a purchase or confirm their attendance on the spot, your call will be well received.

Telephone Directory

Telephone directories such as the Yellow Pages are a traditional form of marketing. They are effective, but only within the local area that the directory covers, which is usually citywide or countywide at most: we are not even talking statewide and certainly not countrywide. For this reason, directory advertising works well if you cater to a local audience. For example, directories

work for wedding and portrait photographers because wedding and portrait clients do not want to travel out of the area where they live to have their photograph taken.

Directories do not work well for fine art photographers who potentially address a worldwide audience. Fine art photography does not require that clients are physically present. We have customers from just about every country in the world. While we have met some of them in person, for most of them we have only communicated over the phone or via email. These customers certainly did not find us in a telephone directory! In fact, we *have* no directory listing because they do not work for our marketing.

However, if you decide to market your work through telephone directories, here are a few pointers:

- You must have a noticeable ad. There are so many ads in these directories that yours must stand out from the rest. This means using color and having a large ad. This also means that your ad may end up costing you more money because large color ads come at a premium price.
- I recommend that you design your ad yourself. Directory salespeople do not necessarily know much about marketing, even though they will tell you that they are marketing experts. Their goal is to sell you an ad and have you use one of their predesigned "canned ad" formats. It is both easier and more profitable for them if you do so, however, it is not necessarily good for you because your ad will end up looking like all the other ads. You will make far better use of your money if you design your ad yourself or if you have it designed by an independent graphic designer.
- Regardless of whether you advertise in a directory, my experience is that for fine art the directory option works better as a reference listing than as your main marketing venue. If you are listed, it won't hurt. However, if are not listed, you will not miss much.

Radio and Television

Radio and television allow you to reach a wide audience quickly. In that sense, marketing on these venues is ideal. Unfortunately, radio and television have a number of shortcomings when it comes to fine art marketing.

The first shortcoming is cost. Both are very expensive in terms of production costs and in terms of airtime cost. A radio or a television advertisement must be professionally produced. You cannot realistically expect to produce it yourself, and companies that specialize in producing radio and television advertising charge a lot of money for their services. The same is true for airtime. You will have to spend a lot of money to have your ad broadcast, especially if you want to have it shown, or heard, at primetime, meaning when the largest audience is watching or listening. While the cost of radio is far less than that of television, it is still substantial.

This means that unless you have a significant budget, purchasing radio or television advertising is not something to consider. You may, however, be able to get free radio or television coverage, for example if you are interviewed by a TV or radio reporter. This sometimes happens during art shows when local TV and radio stations provide coverage for the show. At such time they may interview a few artists and broadcast these interviews during the daily newscast or as part of the show coverage.

Magazine Advertising

Although it is also expensive, magazine advertising is relatively affordable in comparison to radio and television. I have used magazine advertising on several occasions and I was able to make a profit each time.

The cost of magazine advertising is calculated on a per-issue basis. You receive a discounted rate if you publish the same ad in several consecutive issues. In short, the more issues you publish your ad in, the lower the per-issue cost. In advertising, repetition is one of the keys to success; therefore publishing in several issues increases the probability of having readers purchase your product.

As with all marketing endeavors, your ad must stand out among the many other ads featured in the magazine. Magazine ads are priced on the basis of size. Full-page ads are the most expensive, followed by half-page, quarter-page, and smaller. Quarter-page ads make the most sense financially. They are relatively affordable without being too small.

You also have to make sure that your ad is designed professionally and that all the information is accurate. Print magazine publishing is unforgiving. Once the issue has gone to press nothing in it can be changed. This is totally different from publishing on the web where things can be changed at any time.

Magazine advertising for artwork related to Isle Royale National Park.

Press Releases

A press release is the description and the announcement of a new product or an event. A press release can be about a wide variety of things as long as these things are new and current. In fine art this can be the release of a new series of images, a show announcement, the publication of a new book, the description of a specific project, and so on. A press release can be written by you or by a third party. Once the press release has been written, you submit it to magazines, newspapers, and websites that focus on providing news about photography, art, and artists.

You need to include your contact information in the press release. For print media this means phone, email, and website at the very least. For web media this means email and website address. If your press release is about a specific

event, a show opening for example, you also need to include the information necessary to attend the show: date, address, whether reservations are necessary, what to expect at the reception, and even something about the dress code if it is a formal event.

Internet-Based Marketing Venues

Websites

Having a website is indispensable for a 21st-century business. The Internet has simply become one of the main ways that we communicate, exchange information, and do business. Both your clients and your business partners expect you to have a website. You must have a site, even if this means starting with a relatively simple site and adding content and features later on.

A website is a valuable asset to your business because it is at work while you are not working. A website is accessible 24 hours a day and 365 days a year from anywhere in the world. It is a place where anyone interested in your work can find information about you and your work, and can place orders.

As a visual artist, three different kinds of websites are available to you.

- A website that is meant to work as an online gallery. As such this website will showcase a collection of examples of your work (photographs and artwork). It will also feature your biography, artist statement, and contact information.
- The second kind is a website intended to sell your work. Such a website is designed to work as an online store that will feature a selection of your work in different sizes with pricing for matted and framed pieces, as well as testimonials from previous customers. It will also feature a shopping cart so that clients can place orders. Finally, it will have information on printing and framing, on your warranties, and on shipping.
- The third kind is a website which is a combination of the two sites I just described. It is a site that is both an online gallery and online store. My personal website is exactly that. It is a place where I both showcase and sell my work. This third type of website will feature all the things that I described above for an online gallery *and* for an online store.

Designing Your Website

Whether you design your website yourself or have someone design it for you, you need to consider the two most important aspects of a website. The first aspect is its visual appearance. This is the "pretty" aspect of your site. As we saw earlier on, in marketing pretty is nice but pretty is not indispensable.

The second aspect is the functionality of your site. Functionality is how your site works in regard to linking the different areas of your site and making them accessible to visitors. Most importantly, this is also how your website operates as a marketing vehicle. This is the "effectiveness" aspect of your site.

If you are having someone design your website for you, keep in mind that not all website designers are marketing experts. It will therefore be necessary for you to exert control regarding how the marketing aspect of your website will be implemented.

There are many elements to take into consideration when building a website, and listing all these elements is beyond the purpose of this book. However, I want to mention one of them because it is at the top of the "to do" list when it comes to websites: *you need to build a content-oriented website.*

Content is very important on the web. Many websites contain only advertising and marketing materials. This is fine if a potential customer goes there only to buy something. But if they are not ready to buy right away there is nothing for them to do and they will leave immediately. In art, very few sales are made during the first contact between the artist and the client. It is therefore important that you implement this aspect of fine art marketing on your website. The best way to do so is by giving people who are not ready to buy during their first visit something else to do.

This is achieved by having more than a gallery and a shopping cart. For example, you need to have an artist statement on your website (we will see how to write one in the next chapter, Chapter 20). You also need to have essays, photos of yourself, and any other information that can be of interest to your visitors.

Whatever you do, do not make your website only about your work. To do so is a mistake because in fine art marketing you need to sell yourself first and your product second. To reach this goal, you need to feature valuable information about yourself. This will make it worthwhile for visitors to spend time on your site and it will also let them learn more about you.

Finally, add new content regularly to your site. This new content also needs to be about you. For example, it can be about work that you have created recently, or new projects that you are working on. By adding new content you motivate people to return to your site regularly instead of visiting it only once. You make visiting your site a regular activity instead of a one-time thing.

In fine art marketing you need to sell yourself first and your product second.

Websites and Marketing

Having a website does not mean that you no longer have to market your work. On the contrary, having a website means that you now have to do more marketing in order to bring traffic to your site.

If you launch a website and do not market its existence, one thing will happen in regard to traffic coming to your site: nothing. This is because a

website cannot be found by accident the way a brick and mortar gallery can. With a brick and mortar gallery it is possible to walk down the street where your gallery is located, come upon it by accident and walk inside. In other words, it can be found by people who had no idea your gallery existed.

On the web no such thing can happen. No one will ever type the specific web address of your site by accident! The only way people are going to find your site is because they either clicked on a link that took them to your site, or you gave them the link and they typed it in their browser, or they found a link to your site after doing a web search. Either way, visiting your site was the result of marketing: either marketing you did personally, marketing that you paid for, or marketing that was provided to you free by a third party.

Website Stats

Most websites come with a variety of statistical evaluation tools. It is important that you use these tools to study the traffic your website is receiving. With these tools you can find out how many people visit your site, see which pages are the most popular, what keywords people use to search for your site and much more.

Here too, an in-depth discussion of this topic is beyond the purpose of this book. However, it is important that you not only familiarize yourself with statistical web-analysis tools but that you also use them regularly to understand who visits your site and what they do during their visit. This knowledge will help you make future decisions about what content to add to your site, about improving the navigation of your site, and about adding specific keywords to your site (see the section on search engine optimization below to learn more about keywords and keywording).

Web-traffic analysis tools on my website management page

Email

In many ways email has become the Internet version of direct mail. The difference between email and direct mail is that people who sign up for your email list do so expecting to receive information from you, while direct mail is sent to people who do not necessarily expect to receive information.

It is very important that you only send email to people who have requested that you send them information and who expect to receive emails from you. This means having an email subscription form at events where you meet people in person, as well as an email subscription form on your website.

I recommend sending your emails in the form of a newsletter. An email newsletter can be used to send news and information to the members of your list. You can send information about upcoming shows, about new artwork, about new projects, and much more. I also recommend sending your newsletter at regular intervals, such as once a month; this way your subscribers know when to expect your email. It is important that you do not send emails too frequently. If you send too many emails people will either stop reading them or they will unsubscribe from your newsletter.

EmailBrain

When you are just starting and your email list is small you can send emails directly from your email account. This means you manually copy the text and the email addresses, then send the emails one by one. However, as your email list increases in size this approach will become impractical and too time consuming. When this happens the solution is to open an account with an online email marketing company such as EmailBrain.com, ConstantContact.com, or other (a list of email marketing providers is available in Chapter 23: *Resource Materials*). These companies specialize in email marketing and you use their email server to send your newsletter to all the members of your email list automatically. Email companies also give you access to valuable information about your email campaign such as: how many emails were delivered, how

many were read, how many were trapped by spam robots, how many went to invalid email accounts, which links were the most and least popular, and more.

Forums

A forum is a website that consists only of discussions between forum members. A forum can be part of a website or it can be a standalone website. When new members register they get a password and username. Once they have registered, members can post photographs, start a new topic (also called a thread) or post responses to existing threads.

Adding a forum to your existing website, or creating a stand-alone forum, can be both a blessing and a curse. It can be a blessing because it will bring traffic to your site and make people want to return regularly to follow the discussions on subjects that are of interest to them. Unfortunately, forums are also targets for abuse. First, spammers target forums heavily because they know that forum members will read their messages. Even though users have to be registered before they can post messages, there is no way to know if a registered user will be spamming your forum until they do. When this happens you need to delete all spam messages and cancel the account of the spammer. This takes time, especially when you have to do it every day, several times a day.

Second, forum discussions can degenerate into arguments between members. When this happens the discussion becomes unfriendly and results in posters making ad-hominum ("against the person") attacks and insults. The forum moderator (you) has to intervene to stop this behavior. Sometimes banning individuals from the forum is necessary; often, closing the thread is the only solution.

If you are not able to monitor your forum daily, you can run into some serious troubles if a thread degenerates into personal attacks and you are not there to moderate it and solve the problem. If you do art shows, or if you travel a lot, having a forum is probably not a good idea because you will not be able to monitor it regularly.

Even if you are able to monitor your forum regularly you may still not want to have a forum. It can easily require more time than you want to devote to it. Plus, it may not generate the return you expect because forum members may be more interested in forum discussions than in purchasing your products. I have personally considered all of this and I decided to not have a forum on my site. If you are thinking of having a forum, I recommend seriously contemplating the pros and the cons.

Blogs

A blog is a website on which the owner regularly posts short entries. Compared to a regular website, a blog has one major advantage: it allows readers to type responses to each blog entry. This creates a dynamic relationship between the blog owner and the blog readers. Instead of being passive readers, visitors have the opportunity to become involved in adding content to the blog by posting their comments and opinions.

In that sense a blog is halfway between a website and a forum. However, unlike a forum where hundreds of threads may be active at the same time, a blog usually sees comments posted only on the most recent entries. Plus, a blog gives the owner the possibility of approving or editing comments before

Screenshot of my Reflections blog

they are posted. This prevents the automatic posting of inappropriate, rude, and improper comments.

A blog is more informal than a website. On a website you are expected to post entire essays. On a blog short entries written quickly are appropriate because readers do not expect you to publish perfectly polished essays. Instead, the value of a blog is to read someone's thoughts, reflections, and opinions as they are formed and to comment on them in a similar manner. In many ways a blog is an exchange of views between blog writer and blog readers.

A blog can work very well as a marketing tool by providing you with a place to post news about your work, upcoming shows, and exhibitions, and let readers ask questions and post comments on your entries.

Google AdWords

Google AdWords represents a unique form of marketing. Basically, AdWords displays ads about your product based on keywords that you select when you design your ad. When your Google AdWords campaign goes live, the keywords you selected are indexed by search engines. When someone searches for one of your keywords, your ad is displayed as a link in the browser's search results window together with other search results. Users can then click on the links in the search results, including on your ad.

The cost of running your ads is based on the monetary value that Google attaches to specific keywords. The more popular a keyword is with search engines, the more expensive this word will be. When you start your Google AdWords campaign you determine how much you want to spend on each keyword. When someone searches for one of the keywords you selected, whether your ad is displayed or not depends on how much money you decided to spend for this specific keyword.

In other words, the ad that gets displayed is based on how much money each advertiser is willing to spend when one of their keywords is searched for. Basically, the user who is willing to spend the most money wins. You decide the upper limit you are willing to spend to have your ad displayed, for each keyword you selected, when you create your ad.

You are charged a small fee only when someone clicks on your ad in the search engine results window. Google calls each click an "impression." To control your budget you need to determine how much money you want to spend each month on impressions, and once that amount has been reached your ad stops being displayed. Your ad starts being displayed again at the beginning of the following month.

You can decide to start or stop your AdWords campaign at any time. You do not have to let your campaign run for a predetermined length of time. This places you in full control of both your campaign and your budget.

You can sign up for Google AdWords on Google.com. You first have to open a Google account and then you can participate in the various programs that Google offers, including AdWords. The cost of your ads is charged monthly to your credit card.

Google AdWords

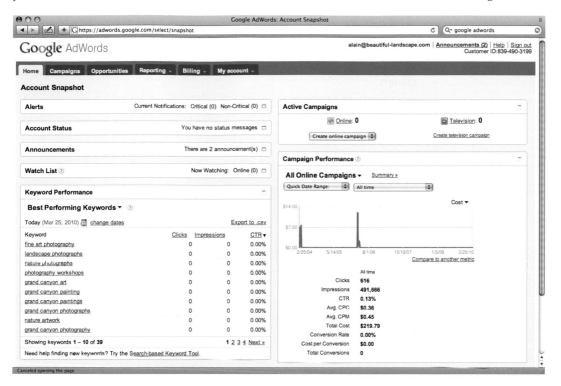

Affiliate Programs

Affiliate programs work by having an ad for your products displayed on an affiliate's website. Each time someone places an order by clicking on your ad, the website owner—the *affiliate*—who displays your ad receives a percentage of the sale as payment. Each ad has the affiliate information encoded in it. This makes it possible to track not only sales but also number of clicks, frequency, and other information about each affiliate.

You control the percentage you give to your affiliates. For example, my affiliates receive 10% of the selling price initially. This percentage increases to 20% and more depending on the affiliate's sales volume. The more products an affiliate sells, the more money they receive. This gives affiliates an incentive to drive customers to my site.

I use iDevAffiliate.com for my affiliate program. Its software is straightforward and easy to install. Most importantly, the software is sold on a one-time fee basis. Other companies may charge a monthly or a yearly fee. This approach is far more expensive over time and to my knowledge does not offer

any advantage over the one-time-fee approach used by iDevAffiliate. With iDevAffiliate, once you have purchased the software you only need to pay for updates, however, updates are rare with this type of software. I installed mine in 2005 and I have not had to update it so far.

This is the page on my website where affiliates can both sign up for my affiliate program and log onto their account.

Social Networking Sites

Social sites, such as Facebook, Twitter, Linkedin, etc. can be helpful when marketing your work. I announce news about my work and products on both Facebook and Twitter. At the time this book is being written I find Facebook and Twitter to be the most useful of all the social networks when it comes to marketing.

Facebook and twitter logos

There are noticeable differences between the two. Facebook is great because you can post news and initiate an online conversation with readers. Visitors can post comments and questions about your news items and you can answer these comments and questions easily. This allows the implementation of informal online conversations. There are many different applications to help you post interesting items on Facebook, such as audio and video files, games, questionnaires, and much more. Facebook also provides an applet that lets you post a new item in one click from any page on the web. Using this applet, you can go to a page on your site, and use the applet link to post a link to that page on your Facebook page.

Twitter is more limited but is highly valued by people who access social networks from their cell phone. Twitter lets you post messages with a maximum of 140 characters. This limitation seriously reduces what you can post, but, it opens the door to specific types of posts such as quotes, short statements, recommendations, insights, and basically anything that can be said quickly. Twitter forces you to get to the point. There is no limit regarding how many

"tweets" you can make (a tweet is a Twitter post). Therefore you can actually say quite a bit on Twitter, you just need to say it 140 characters at a time!

My Facebook page

I do recommend that you use social networking to market your work. These venues are free, they are becoming increasingly popular, and their potential as marketing vehicles cannot be ignored. However, keep in mind that there is no substitute for implementing a true and proven marketing system. In other words, Facebook, Twitter, and other networking sites alone are not enough to market your work and generate a solid income. Having access to social sites does not mean that we no longer need to study the fundamental aspects of marketing. These fundamental aspects are immune to technological changes and you need to study them and implement them to be successful selling your work. (The fundamental aspects of marketing, business, and salesmanship are found in Section C.)

Search Engine Optimization

Search engine optimization comes into play when people do a search on the Internet for specific words or names. People type keywords in the search engine search window and the search engine looks for websites in its database on which these keywords are found. The criteria used by search engines are complex and using specific words on your site is no guarantee that your website will be found when a search for these words is made. This is because search engines look at many things besides the presence of a specific word including context, relevance, repetition, and much more.

In my case, and in your case if you follow the marketing approach that I recommend, the two most common words used in search engines by people who visit my site are my first and last name: Alain Briot. This is just as it should be since my approach is to market myself. The basis for this approach is that people purchase the artist first and the work second. People say "I own an Alain Briot" not "I own *Antelope Light Dance*" or "*Yavapai Dusk*." I strongly recommend that you follow the same approach. If you do, you will not have much to worry about in regard to search engines because your first and last name are specific to you and to no one else.

Optimizing your site for search engines is a tricky business. First, this requires specialized knowledge and it is best left to people who do this for a living. Second, the criteria used by search engines to reference and index your site are constantly changing. Finally, search engines are becoming smarter and smarter to the point of being able to detect websites that have been optimized to get a higher ranking in search engines, and some search engines will list your site lower if such an intent is detected.

Yet, it is possible to optimize your site for search engines. To do so make sure that you use words that describe location, subject matter, and other relevant information about your photographs as precisely as possible.

Sharing and Exchanging Links

Exchanging links with other websites can be a good marketing approach if used in addition to your other Internet-marketing endeavors. It is an excellent way to get your ranking higher, provided you exchange links with websites that are ranked high and that have content and focus similar to your site.

Google relies on the frequency with which your website is found on the web to determine its ranking. Google also looks at which websites have links to your site. Therefore, having your site linked to a large number of high-traffic, reputable sites will increase the ranking of your site.

Polls and Surveys

You may want to conduct polls and surveys to learn more about your customers' needs. Doing so can help you find out what your customers want and how you can better serve their needs. I have conducted several online surveys over the years using web services such as Bravenet.com to create and maintain these surveys.

When designing a survey keep in mind that people will answer your questions because of good will and that most people do not want to spend much time doing this. Therefore, keep your survey short and to the point.

Personally, I have always kept my surveys to a single question. I found that I received more answers to single questions than to lists of questions. By asking a different question each week I was able to get all my questions answered. Plus, my visitors only had to spend a few seconds answering my polls.

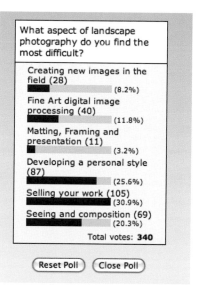

Bravenet website

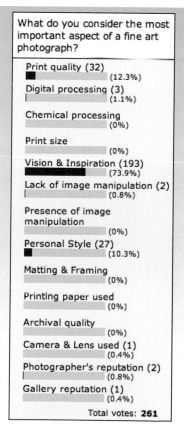

Survey results

Online Calendars

Having an online calendar on your website is a nice feature when you do shows, exhibitions, or other events that are scheduled ahead of time. Indicating the event name, location, and dates on your online calendar allows your audience to keep track of each event and make plans to attend a particular event ahead of time.

I also use Bravenet.com to create and maintain my online calendar. Similar services are provided by other online companies, however, using the same web service for both my surveys and my calendar keeps things simple and saves me time.

Bravenet calendar

Skill Enhancement Exercise

- ❯ Based on the information provided in this chapter, list five venues where you want to market your work.
- ❯ Organize your list on the basis of cost starting with the least expensive venue and moving up to the more expensive venues.
- ❯ For each of these five venues set up financial goals you want to reach. To do so, simply indicate the amount you want to make through each venue. Be realistic in your income forecast.
- ❯ Compare this dollar amount to the cost of each venue. Deduct cost from expected income and see if there is enough potential profit for this venue to make sense at this time. After completing this step you may have to revise your list of marketing venues because some of them may be too expensive.
- ❯ Prepare an ad or a marketing campaign for each venue you selected.
- ❯ Finally, take the necessary steps to contact each venue and get your ads up and running.

You can have brilliant ideas,
but if you cannot get them across,
your ideas will not get you anywhere.
 LEE IACOCCA

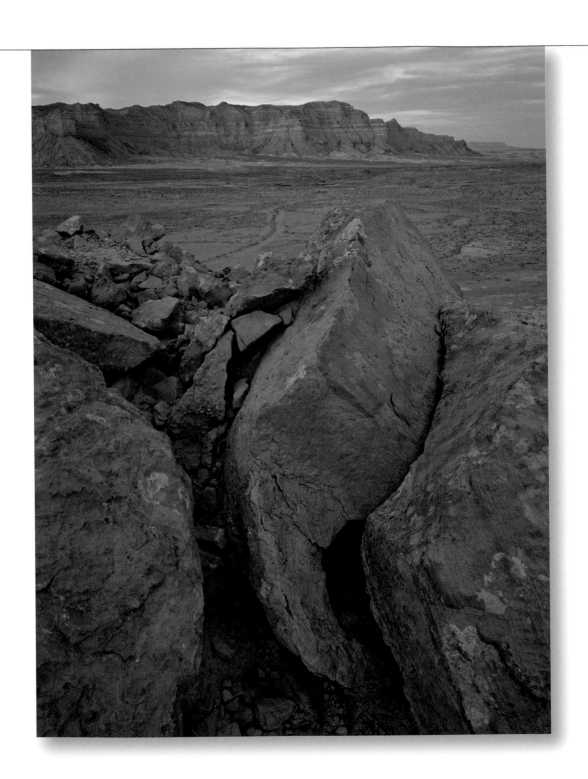

Chapter 20
Vitae, Biography, and Artist Statement

In order to be successful selling your fine art photography, as an artist you need to personally present yourself to your audience. This is necessary so that there is no conflict between the public's perception of you and of your work.

The most effective way of presenting yourself as an artist is to write a vitae, a biography, and an artist statement. Your curriculum vitae (also known as a resumé) lists your artistic accomplishments, your biography details your life as an artist, and your artist statement describes your artistic goals. Each of these documents has a specific purpose, each is used in specific instances, and each is focused on your artistic background. In this chapter we are going to see how to write these three important documents.

Your Curriculum Vitae

A curriculum vitae (Latin for "the course of your life") is an overview of your life, training, and qualifications. Often referred to as just a "vitae" or "CV," it is a rather formal document that lists all the work you have done so far in regard to your career. A vitae is necessary when you formally present your work for professional consideration to people in the industry. For example, when you apply for a job in a gallery, or when you seek gallery representation, you should expect the gallery owner to ask for a copy of your curriculum vitae.

I make my vitae available in PDF format on my website. That way anyone who wants to see my training, schooling, publication and exhibition record, and other information relevant to my professional career can download and read it. I do not consider it a private document but rather a public source of information about my career.

Keep in mind that for the purpose of marketing your work, your vitae is about art and photography, not necessarily about your whole life. My vitae does not mention jobs that are totally unrelated to photography, or occupations and achievements that have nothing to do with art. In other words my vitae is not about my entire life. It is about my life as it relates, informs, and addresses my artistic and photographic career.

Your Biography

A biography is basically an account of your life with the main focus being your experiences as an artist and a photographer.

Your life, just like everyone's life, is complex and filled with thousands of events. Because this biography is about your experience creating art, it only needs to be an account of your life as an artist and a photographer. The 20th century American rhetorician Kenneth Burke said that a biography is a collection of specific facts about a specific aspect of your life. If your life consists, for example, of 1,000 events, you only need to pick the 20 or so events that relate to the part of your life concerning fine art.

Whereas a vitae is essentially a list of facts, a biography is a story about your life as a photographer. Biographies are more interesting to customers than vitaes because stories are more enjoyable to read than lists of facts. Finally, writing your biography is the first step toward writing your artist statement.

Your Artist Statement

Your artist statement can be either an extension of your biography or a separate statement about your goals and purpose as an artist. Personally, I chose to combine my biography and my artist statement because there is a direct relationship between my life and my artistic work, and because I can do a better job explaining my artistic purpose by describing my life. Clearly, this is a personal choice and in a way I may be lucky that my life makes sense in regard to my creative endeavors. Understandably, your choice may be different.

What I like about having my biography and artist statement in the same document is that it allows me to explain who I am to potential customers. It also allows me to give them important information about myself in a casual and, at times, humorous manner. This allows people to get to know me and to start a relationship with me. All I have to do is give them a copy of my biography. By doing so, my biographical information becomes a common ground between potential customers and me. As it turned out, my biography is an effective sales document. Customers enjoy reading it and regularly make comments or ask me questions after reading it.

The main idea behind my biography/artist statement is to avoid doing what most other photographers do in their biographies, and that is: list all the galleries that represent them, list all the awards they received, say that their work is in private and corporate collections, and list all the famous people who own their work. I wanted to present myself as a successful artist who finds it more important to talk about my experience and my approach to art than to talk about how many people bought my work, how many galleries I am in,

or how many awards I received. I wanted to make my biography emotionally based rather than analytically based. I wanted to make it a collection of interesting events that occurred in my life rather than an accounting of my achievements.

In short, what I am doing is what most people do when they first meet a stranger and ask, "Where are you from?" Asking someone where they are from is a polite and discrete way of asking that person to tell you a little bit about themselves.

In my biography I tell customers not only where I am from (it does come first in the text because it is important) but also what I have been up to in my career as an artist, where I have lived, what the inspiration for my work is, and so on. I am, in a sense, chatting with them and answering their questions. Because there are thousands of customers, I cannot do this individually with each of them, therefore, I do it with my biography.

The implied belief here is that people buy from people they like. If I do my job well, by the time they finish reading my biography they have already decided if they want to talk to me personally and look at my work. I want customers to be interested in learning more about my work and myself after reading my biography. At that point I can talk to them personally.

Guidelines for Writing an Artist Statement

Your artist statement must fulfill several goals. To make sure you address them all it is best to have guidelines.

Below is a list for you to follow when writing your artist statement. This list is divided in two categories. The first category focuses on the goals of your artist statement.

The second category in your artist statement is a description of the elements that define your artistic positioning. Defining your artistic positioning means describing the artistic and technical choices you have made and providing reasons to support these choices. Here is a short list of the different elements that are part of your artistic positioning:

Artist Statement Goals

❯ The first goal of your artist statement is to define your *artistic positioning*. This means where you fit in the world of art, in relationship to other artists and works of art—regardless of your medium. Do not limit your comparisons to photography and photographers. Instead, extend your comparison to painters, musicians, and other artists working in a variety of mediums.

❯ The second goal of your artist statement is to present your *artistic approach*. This means describing the work that you do both in the field and

in the studio. It also means describing the work you did in the past, as well as the artists and the teachers you studied with or who influenced you.

❯ The third goal of your artist statement is to define the *main lines of communication with your audience*. Are you organizing shows, do you have a website or a blog, do you write a newsletter, do you publish essays or portfolios in magazines, do you write books? All these are venues through which you can communicate with your audience. Which of these do you use? Your audience needs to know so that they can continue learning about you and your work. This is important because selling art happens through regular communication with your audience. Of course, this implies defining your audience as well, something that you need to do now if you have not done it yet.

Artistic Positioning

❯ Technique and approach
- List the techniques you use
- Describe why you use these specific techniques
- Describe how you use specific techniques

❯ Sources of inspiration
- List your sources of inspiration and creativity
- Explain why these inspire you

❯ Personal expertise
- Describe your personal expertise
- Explain which subject matter, technique, artistic approach, etc. you are expert in

❯ Artistic training and career path
- Describe your artistic background (upbringing, training, practice, etc.)
- Describe your artistic formation (schools, etc.)
- List the teachers and artists with whom you studied and worked

❯ Artistic community participation
- Describe your level of participation in the artistic community
- This can consist of participation in art shows, attendance at artistic events, and so on
- These art events do not have to be all photography related; they can feature other mediums

❯ Goals and projects
- Describe your current goals
- Describe the projects you are currently working on

- ❯❯ Describe your motivation for working on these specific projects
- ❯❯ Describe the evolution of your work
- ❯❯ Provide a short historical account of the projects you are working on
- ❯❯ Describe the techniques used in these projects
- ❯❯ Explain what your projects will look like when they are completed
- ❯❯ Will they consist of a show, a portfolio, a book, or something else?

Displaying Your Artist Statement

When selling my work at art shows I display a framed version of my artist statement. My framed artist statement features more information than the printed version I give to customers. In addition to the text, which is basically the same, the framed version features a photograph of me at work, plus several testimonials. The combination of these three elements creates a package that is very effective in showing who I am and what I do, and that only takes a short amount of time to read.

My artist statement is also published on my website, on a page dedicated to it and titled "Artist Statement." I also feature my artist statement in my portfolios, folios, books, and other projects.

Framed artist statement used at shows

2010 Artistic Positioning

Alain Briot
Beaux Arts Photography

Artist Statement
&
Artistic positioning

1- Technique and approach

Alain's work continues and expands the tenets of modern landscape photography. Like the classical masters that preceded him, who include Ansel Adams, Phillip Hyde, David Muench and many others, Alain seeks unique natural lighting conditions. Because good photographs are often created in bad weather, and seeks active weather conditions to photograph in. The light is his first and foremost concern because it is light that is the most important element of photography.

Similarly, and again like the classical masters that preceded him, Alain is constantly searching for those natural locations that will afford him the means of creating exciting compositions. To this end, the vantage point, the location itself is very important. However, the small details found at a specific location are just as important: patterns in rock formations, the visual rhythm formed by plants and rocks effectively visually organized and the repetition of similarly-shaped elements for example.

Combining the large landscape in front of him with the intimate landscape at his feet, enables Alain to create dynamic compositions. Often called near far composition, this approach allows his to show a scope of view larger than our eye can see in a single glance. While his images may appear "natural", many of them cannot be seen as such because the field of view they encompass far exceeds what our eyes can see at once.

Again, like the classical masters before him, in what was for them the darkroom which for Alain is the digital studio, Alain uses the tools available to him to refine the color, contrast and density of his photographs. His aim, as theirs was, is to create a final print that expresses, in the words of Ansel Adams, what Alain saw and felt or, in the words of Edward Weston, to turn things seen into things known. Alain's goal is to create images that are emotional renderings of the scenes Alain experienced.

However, while the classical masters sought to do little to their work in regards to composition after the photograph had been taken, Alain expands his work in this domain as well. Still using the digital tools available to him, Alain combines, reformats and warps images as he sees necessary to express his vision. Combination of images, from 2 to 8 or more, is necessary when the camera cannot capture the field of view Alain wants to show in a single frame. Adjusting the format of an image is necessary when an image does not offer the format, or the dynamic that Alain is looking for. And warping of the image is often required after images have been combined in order to turn the technical output of the computer into an image whose composition is artistically structured.

Digital processing gives the artist many tools that were not available in a darkroom environment. However, many photographers working with digital processing today apply the traditional darkroom approach to their digital processing work in a literal fashion. In doing so they forfeit many of the

PO Box 12343 • Glendale, AZ 85318 • 800-949-7983 or (928) 252-2466
alain@beautiful-landscape.com

www.beautiful-landscape.com

Alain Briot
Beaux Arts Photography

possibilities provided to them by digital processing. Many of the tools and possibilities offered by digital processing are not used when the traditional approach is applied as-is to digital processing.

Alain feels that the traditional approach to landscape photography is unnecessarily limiting when applied to digital image processing. Giving himself the freedom to expand beyond the boundaries of the traditional approach allows Alain to create images that go beyond what can be achieved through a literal reproduction of the traditional approach in a digital context. It is this freedom that allows him to explore the numerous creative possibilities provided by digital processing. In turn, this freedom of exploration is what allows him to create new and never-before-seen images. Both his approach and his creative work demonstrate a daringness to explore territory uncharted by landscape photographers so far.

This methodology allows Alain to continue working within the traditional approach to landscape photography while expanding his style beyond this traditional approach. In doing so Alain gives a large freedom to his artistic approach, a freedom that allows him to create images that go beyond what can be done within the limitations of traditional landscape photography.

2-Personal expertise, artistic training, career path and personal life

My artistic inclinations go back to my childhood during which I engaged in many artistic endeavors using a wide variety of mediums. Encouraged by my parents, I pursued my artistic interests intensely, a pursuit that culminated by enrolling in a private art school in Paris to prepare for the entrance examination to the Academie des Beaux Arts. After successfully passing this entrance examination, I enrolled full time at the Beaux Arts from which I graduated with a degree in painting and drawing.

During these studies, and shortly afterwards, I also engaged in studying photography. For some time these two courses of studies ran concurrently, and I was effectively doing painting and drawing on some days and photography on other days.

My interest in photography stemmed from a certain boredom that I experienced doing solely painting and drawing, all day long, day after day after day. While at first such a regimen was a dream come true, it eventually revealed itself sorely lacking variety. Photography offered a remedy to this situation by allowing me to take my mind to places that my painting studies did not take me. Furthermore, it also brought me in contact with a contemporary medium, a medium in which both technique and technology were in continuous change and development, while painting was for the most part static, having changed little in terms of technique and technology for decades, if not centuries.

My photography studies were conducted at the American Center in Paris, under the guidance of Scott McLeay and occasionally of other instructors whose name I cannot recall at the moment. The American Center was one of only a few places where photography was taught as a fine art in Paris at the time. The other was Parson's School of Design, where darkroom sessions for American Center Photography classes were conducted.

Following these studies I continued to practice and explore photography on my own. I continued to practice painting and drawing, but I decided not to exhibit my paintings or drawings, only my photographs.

PO Box 12343 • Glendale, AZ 85318 • 800-949-7983 or (928) 252-2466
alain@beautiful-landscape.com

www.beautiful-landscape.com

Alain Briot
Beaux Arts Photography

While my photography started by focusing on street scenes in Paris, France and Europe, I rapidly moved to photographing landscapes, for which I had been influenced early on by the work of Ansel Adams. My first interest in photography coincided with the publication of Adams' seminal work, *Yosemite and the Range of Light*, a book that I first saw in a photography bookstore in Paris, and which impressed me so much that after browsing through it quickly, I put it back on the shelf, walked out of the bookstore, and spent the next several hours recovering from the realization that photography could be much more than what I had seen so far or was able to accomplish by myself up to that point.

The discovery of Adams' work let to an attempt to duplicate his approach during a six-month trip throughout the Western United States in 1983 during which I worked solely with black and white Polaroid film (with a few packs of Color Polaroid thrown in) and an Arca Swiss 4x5 camera with a 90mm and a 210mm Rodenstock lenses.

This trip revealed to me the beauty of the American West, the extensive photographic opportunities it offered, and the impossibility of capturing all of this in six month with the equipment and budget I had to work with. Motivated by what I had seen and experienced, I returned to the US Southwest in 1986 as a foreign student enrolled in a Bachelor Degree program at Northern Arizona University in Flagstaff, Arizona. The choice of NAU as a university was based on Flagstaff being located on the Colorado Plateau, within a day or less drive to countless fantastic photography locations.

I received my Bachelor Degree from NAU in 1990 and two years later I received my Master's Degree, also from NAU. In 1992 I moved to the Upper Peninsula of Michigan to work on my PhD. The Upper Peninsula offered photographic opportunities almost equal to those offered by Arizona, except that the cold and the snow lasted half a year instead of a couple of weeks. Eventually, the combination of cold weather and grad-student-status, with which came extreme workload, low pay and the challenge of doing photography semi-professionally while completing a PhD degree, proved too much for me. As a result, in 1995 I returned to Arizona where I started Beaux Arts Photography. I never turned back, and I have enjoyed a very high level of success ever since, proving to myself and to others who are curious about making such a change in their lives, that following your heart instead of plowing along in an unfulfilling activity can be the best decision you'll ever make.

Alain Briot
Beaux Arts Photography

3-Sources of inspiration and artistic process

For me a work of art is primarily the product of a person, not of a machine. For this reason, a photograph printed straight from the original capture, either film or digital is unsatisfying. Such an image represents the output of my camera rather than the expression of my emotions.

While, as a photographer, I can to some extent choose the type of light, composition, lens, equipment and other technical aspects of the image, I have very little control over the artistic aspects of my work during image capture.

To satisfy my creativity I need to work on my photographs after I complete the image capture. For me, the creative aspect of photography starts after the image has been recorded by the camera. It is then that I am able to infuse the image with the emotional content that I experienced while being at the location where I took the photograph.

To this end I do to the image everything that I deem necessary. On the level of image adjustments, I first adjust the global color balance and the global contrast of the image to my taste. I then focus on individual colors and work towards making them the exact tonalities that I desire. Similarly, I adjust contrast so that it reflects the feeling of open, glowing light or of deep, mysterious shadows, according to my memories of the original scene.

On the level of image composition, I routinely collage multiple captures into a single image. The goal of these collages is to expand the field of view represented in the image far beyond what a single capture can show, even when the photograph is created with the widest lens available. These collages have the added benefit of representing time as well as space. Because the different images that compose the final work are taken over a span of time, which can vary from a few seconds to 25 minutes or more, the resulting collage shows the variation of light, the movement of clouds, and the changes in other moving elements that took place during the time required to complete the image captures.

I also clone elements that I deem unnecessary or unaesthetic. These elements are rarely "trash" (empty cans and other litter) because I can easily remove these prior to taking the photographs. Rather, these elements are either natural features that I could modify in the original scene, or elements that I did not "see" as troublesome when I took the original captures. The _____ or twigs intruding into the borders of the image, texture _____ _____ unwanted element

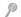 Full-sized downloadable forms and documents may be found at www.beautiful-landscape.com/Briot_Marketing.html

2010 Artist Statement

Alain Briot
Beaux Arts Photography

Artist statement

My goal is to create Fine Art Photographs. A Fine Art Photograph, is an image that is both artistically inspired and technically excellent. Just one or the other is not enough. Technique without art is cold and uninviting, while art without good technique prevents the viewer from truly enjoying the work.

For me a work of art is primarily the product of a person, not of a machine. For this reason, a photograph printed straight from the original capture, either film or digital is unsatisfying. Such an image represents the output of my camera rather than the expression of my emotions.

While, as a photographer, I can to some extent choose the type of light, composition, lens, equipment and other technical aspects of the image, I have very little control over the artistic aspects of my work during image capture.

To satisfy my creativity I need to work on my photographs after I complete the image capture. For me, the creative aspect of photography starts after the image has been recorded by the camera. It is then that I am able to infuse the image with the emotional content that I experienced while being at the location where I took the photograph.

To this end I do to the image everything that I deem necessary. On the level of image adjustments, I first adjust the global color balance and the global contrast of the image to my taste. I then focus on individual colors and work towards making them the exact tonalities that I desire. Similarly, I adjust contrast so that it reflects the feeling of open, glowing light or of deep, mysterious shadows, according to my memories of the original scene.

On the level of image composition, I routinely collage multiple captures into a single image. The goal of these collages is to expand the field of view represented in the image far beyond what a single capture can show, even when the photograph is created with the widest lens available. These collages have the added benefit of representing time as well as space. Because the different images that compose the final work are taken over a span of time, which can vary from a few seconds to 25 minutes or more, the resulting collage shows the variation of light, the movement of clouds, and the changes in other moving elements that took place during the time required to complete the image captures.

I also clone elements that I deem unnecessary or unaesthetic. These elements are rarely "trash" (empty cans and other litter) because I can easily remove these prior to taking the photographs. Rather, these elements are either natural features that I could modify in the original scene, or elements that I did not "see" as troublesome when I took the original captures. These include, for example, branches or twigs intruding into the borders of the image, textures whose patterns are incomplete or visually unsatisfying and any other unwanted element.

PO Box 12343 • Glendale, AZ 85318 • 800-949-7983 or (928) 252-2466
alain@beautiful-landscape.com

www.beautiful-landscape.com

Alain Briot
Beaux Arts Photography

The collage process often results in areas of the image being left blank. This is because as the collage process unfolds, the image is warped, stretched and "kneaded", so to speak, into a specific visual projection. Sometimes the goal is to project the image without any distortion. Sometimes the goal is to induce distortion purposefully to reinforce a specific pattern in the image, such as a sweeping curve, or a specific visual rhythm.

This process results in an image that rarely, if ever, fits into a rectangular format. Rather, the image ends up having rounded corners, and areas are routinely left empty, being simply "blank canvas" space. While I could choose to leave the image as it comes out of the collage process, I currently fill these blank image areas with details and patterns cloned from other areas of the image. This process is very similar to painting, in the sense that I add, ad lib, color and patterns that are the product of me imagining what could have existed in locations where there is currently nothing. In other words, I invent photographic information. I create part of the image from my own inspiration with the goal of expressing the emotions and the vision that I had while I took the original captures.

Because of this cloning and "image painting" process, cropping of the image is frequently necessary in order to eliminate unwanted areas and give straight borders to the image. This cropping, and of course the collage process, mean that the final image format is quite different from the original capture format. This final image format is arrived upon because of the image's needs not because of the desire to use a specific, or a "standard," format.

On occasion, the image format that I arrive at through the process I just described is unsatisfactory. In those situations I stretch the image digitally, either in the width or in the height, to give it proportions that represent my vision rather than the technical output provided by the computer and camera combination. This stretching may be rather moderate or quite extensive, depending on the needs of each individual image. When performing this important step, my concern is to not distort natural element beyond believability.

Here, as well as in the other aspects of my work, my concern is believability rather than reality. In other words my goal is not to create an image that represents something that exists, as is, in reality, in the "real" landscape. Rather, my goal is to create an image that is believable, an image of something that one can consider to be possible, even though one could not quite find this exact same image in nature.

Alain Briot
Vistancia, Arizona
2010

PO Box 12343 • Glendale, AZ 85318 • 800-949-7983 or (928) 252-2466
alain@beautiful-landscape.com

www.beautiful-landscape.com

Skill Enhancement Exercises

Exercise 1: Your Artist Statement. Write your Artist Statement now.

Include your story, relevant anecdotes, plus your USP (Unique Selling Points; see Chapter 21) and your guarantees.

Avoid using technical items unless they are unique to you. Remember that people buy photographs for emotional reasons; therefore, you want people to look at your work on an emotional level, not a technical level.

Exercise 2: Who is your audience? Define your target audience. Be as specific as possible.

Keep in mind that your audience is not everyone who looks at your work. Your audience consists of people who like you and what you do and who want to purchase your work for emotional reasons.

If you do build a great experience, customers tell each other about that.
Word of mouth is very powerful.
 JEFF BEZOS

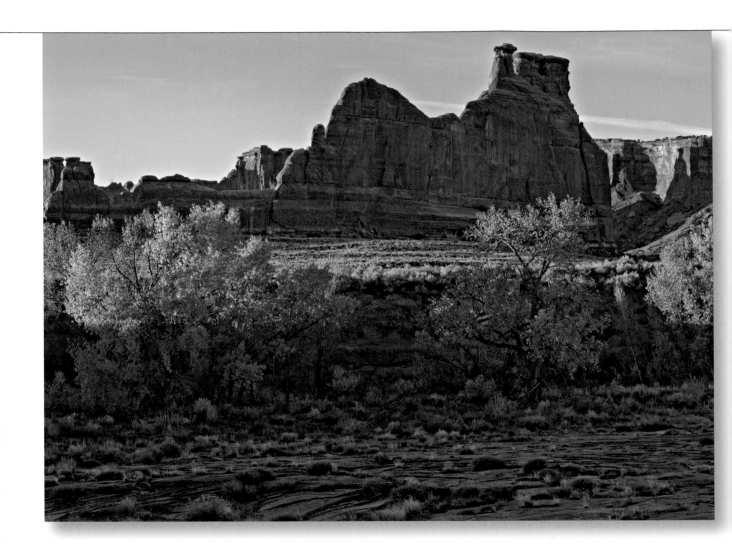

Warranties and Unique Selling Points

This chapter describes two of the most important marketing documents in this entire book: your warranties and your unique selling points (USP). We are going to see why both are important in your marketing.

The Importance of a Warranty

An asset is something that you own and which gives you a business advantage. Assets are often thought of as being solely material items. In the case of photography, assets are often considered to be cameras, printers, computers, tripods, and other equipment. Warranties are rarely thought of as assets. However, they are what are called *intangible assets,* meaning that a precise monetary value cannot be applied to them and they have no physical presence (you cannot put them on a shelf the way you can a camera). Yet your warranty is one of the most important assets of your business because it gives you a business advantage—if it is a good warranty, that is.

So what is a good warranty? A good warranty is one that truly benefits your customers. In my case my warranty is simple: "If you are not satisfied with your purchase you can return it for a credit, refund, or exchange for up to one year." A few disclaimers apply to prevent abuse; for example, the work has to be in like-new condition, which is logical since someone else will purchase it later on.

This warranty does wonders in terms of generating trust on the part of new customers. Previous customers like it too, because anyone can make a choice they may regret later on. Either way, customers know they will not be "stuck" with artwork that they do not like.

Your warranty doesn't have to be the same as mine. You may, for example, decide to give your customers only one or two months to return their artwork. What is important is that you have a warranty. This is particularly important for artwork sold over the Internet. You need to have an excellent return warranty when selling on the web because assessing the exact quality of a work of art is not possible by looking at images on a computer monitor.

A 15 days money-back warranty is commonplace, however I know from experience that such a warranty is not long enough for most customers. Many of my customers take months, if not longer, to frame, display, and enjoy the artwork in their home. It is for this reason that I offer a one-year money-back warranty.

I have used the same warranty for 13 years now and I have had very few returns. In fact, most years I have no returns at all. When I do, customers often ask for an exchange instead of a return, and most of the time that exchange is for a larger version of the same photograph because, as most customers explain, "It doesn't look as large as I thought it would."

I truly believe, based on my experience, that this warranty helps my business tremendously by giving confidence to customers and by creating a win-win situation. I would not change it for anything. As they say, if it works, don't fix it!

One of the warranty signs I use at art shows

Alain Briot

Beautiful Landscape Photographs

I absolutely guarantee that you will be THRILLED (not just "satisfied") with your Grand Canyon photographs!

If for any reason you are not I will cheerfully exchange them, or refund 100% of your investment. No hassles, and no hard feelings, either.
Take up to 12 months to decide.

Unique Selling Points (USP)

Now let's look at your list of unique selling points, USPs for short. USPs are things that are unique to you, to your approach to art, and to your approach to business. It doesn't mean that no one else does any of these things. Most likely, others do. However, you chose to do these things for personal reasons and this is your opportunity to state what those reasons are, together with what you consider to be unique to your work.

Communicating these points to your customers is important because very often customers will buy from you instead of another business because what you do is unlike what anyone else does. Although some of the things you do will most likely be done by other people as well, we are looking at the total "package," at the sum of your efforts, at who you are and what you do.

For example, one of the things unique to me is that I studied at the Academie des Beaux Arts in Paris. Obviously, I was not the only student there. However, I was certainly one of the few to have pursued photography in addition to painting and drawing, since photography is not taught at the Beaux Arts. I was also one of the few to move to the United States, and I may be the only one to have decided to focus on landscape photography while using the education I received at the Beaux Arts as a source of inspiration and direction for my work. Any one of these decisions can be made by a multitude of people. However, when considered as a whole they are unique to me.

Your unique selling points are, well... unique to you! It is for you to find them out and list them. I strongly encourage you to do so. It will not only help improve your marketing, it will also help you develop your personal style.

Your warranties and your unique selling points are designed to work together. For this reason I recommend that you present them on the same document. This is because a good warranty is definitely a selling point for your customers.

Finally, I also want to mention that some marketers refer to USP as being a "unique selling proposition" instead of a list of "unique selling points." The difference is semantic rather than practical. Regardless of which expression you use, the purpose is the same: to market your work effectively.

How to Write Your Own List of Unique Selling Points

- Always start with your warranty
- You can have more than one warranty
- Have at least ten unique selling points on your list
- Make sure that each unique point on your list benefits your customers. This is not about you, this is about them!
- Call your list *Warranties*. Do not call it *Selling Points*.

When you look at my examples, note how most of what is on my lists are things I would do anyway. I am simply presenting them as advantages to my customers by describing what I do in a benefit-oriented manner.

Fourteen Unique Selling Points
(taken from a document that I used at my Grand Canyon Show)

You receive these 14 warranties with your artwork:

1. A percentage of your purchase will be returned to Grand Canyon National Park.
2. You have the choice of selecting your favorite photograph framed or unframed.
3. You can ask to have your photographs framed right here at Grand Canyon. This only takes a few minutes and there is no obligation to buy. If you do not like the framing, no problem. I certainly do not want you to go home with artwork that you do not like!
4. You can choose among a large selection of handmade Maple Burl Frames featuring stunning Southwest inlay designs. I also offer Red Oak Wood frames and Walnut Wood Frames. My framing and matting are designed to complement your artwork and enhance your home decor.

>

5. Each photograph is mounted and matted to archival museum standards. The mats are 4-ply window mats, bevel-cut by hand. Each mat is precisely cut to standard frame sizes so you can insert the print directly into the frame of your choice. You do not need to get custom framing.

6. I print each image myself, to my specifications, so that you can get the most enjoyment from its exceptional qualities of light, shadow, and color.

7. Each photograph is personally signed by me. Limited editions are signed and numbered, and come with a certificate that guarantees the value of your investment.

8. I can personalize your photograph so that it is a unique keepsake of your visit and reminds you of meeting me in person each time you see it.

9. I will personally explain to you where your photograph was taken, at what time of the year it was created, as well as discuss many other unique aspects of your selection. This "Story Behind the Scenery" is something that I can offer because I am here in person to explain to you how I created each of my photographs. It will make your artwork much more enjoyable when you share this knowledge with your friends and family.

10. I will give you a copy of my biography and artist statement.

11. I will give you my toll free number and my email address. You can call or email me any time you have a question about your artwork or about your order. I look forward to helping you.

12. Your artwork can be shipped to you and your package will be insured and traceable. Just call my toll free number or email me and I will give you the tracking number. If something should break despite all the care we take while packing and shipping your order, we will ship you a replacement at no additional cost.

13. If you asked to have it shipped to you, your artwork will be delivered in a timely manner. Most packages are shipped within a week and arrive an average of three days after being shipped.

14. When you purchase one of my photographs you not only purchase an exquisite piece of artwork to decorate your home, you also purchase a lifetime of knowledge.

About Alain Briot

I have been an artist my entire life and I have photographed the Grand Canyon and the Southwest for nearly 20 years. I offer you my knowledge of the Grand Canyon by presenting you with artwork that will complement and enhance your home décor by bringing you the beauty of the Southwest as expressed by a French artist.

My goal is to make sure you receive these 14 warranties in writing!

Turn the page over to read my biography and artist statement.

(See Chapter 20: *Vitae, Biography, and Artist Statement*.)

My warranties on my website

2 - Three unique warranties
We offer three unique warranties to protect your investment:

- One year, 100% money back guarantee: all artwork purchases are covered under our 100%, *"take one year to decide"* money back guarantee. If you are not satisfied with your purchase you can return it for a credit, refund or exchange for up to one year. Some limitations apply, essentially to prevent internet fraud which, unfortunately, does happen. See the section on *Returns* below for details.

- Lifetime Fade-free warrantee: Alain's work is exclusively printed using fade-free fine art archival papers and inks. All artwork comes with our exclusive *Fade Free Warranty* designed to protect your investment: if your artwork was to fade we will replace it at no charge for as long as you own it. No questions asked, just return the artwork to us me and we will ship you a new piece right away.

- Lifetime Framing Warranty: if you purchased your artwork framed from us, and if your framed artwork was to get damaged because of our framing, we will reframe it or replace it at no charge. Sometimes the materials used by framers –such as tape, matboard, backing board, etc, can damage your artwork. To prevent this we use only use the finest archival materials, and we guarantee that our framing will not damage your artwork in any way. However, if for some reason something was ever to happen, you are 100% covered. This warranty applies to each and every piece we frame and mat for you. Our unique *Beaux Arts Photography Seal of Authenticity*, which is placed on the back of every piece framed by us, must be present on your piece for this warranty to be honored. This warranty does not apply to pieces which are not framed by us.

- You select the type of framing that you want, at no extra cost: We offer several presentation options for framed pieces:
A-Wood or metal frame
B-Wood-Mounting
C-Stretched canvas
You can select either of these 3 options at no extra cost. What matters, is that you choose the presentation that you like the most. Our prices are the same regardless of which presentation you choose.

3 - The four following characteristics apply to each photograph:
- Each photograph carries the unique *Alain Briot Seal of Authenticity*
Each photograph comes with our unique *Alain Briot Seal of authenticity* label on the back of your artwork. The presence of this label guarantees that you own an original Alain Briot Fine Art photograph. Our **Lifetime fade free warranty** is honored on all artwork printed by Alain. **Our lifetime Framing Warranty** is honored on all artwork framed by us and which carry Alain's label.

- Each photograph is individually hand-signed by Alain Briot
All of Alain's photographs offered on this page are signed on the print *and* on the mat . This way, if you decide to remat your artwork, you will still have Alain's signature on the print. Alain signs his prints using an archival pen which does not fade nor damage the print.

- Each image is printed using the latest equipment and supplies
Digital photography is a quickly changing medium. As technology and supplies changes, so do my workflow and approach. To guarantee that you always receive the latest and highest print quality, each print is made when you order it.

- Our prices increase regularly
This pricing structure guarantees that your investment increases in value proportionally. All orders placed after a price increase are billed at the new prices. We do reserve the right to change our prices at any time without notice.

Skill Enhancement Exercises

Exercise 1: Your warranties. List all your warranties now.

Exercise 2: Your USP. Describe your USP now. Remember: USP means "UNIQUE selling points" not just "selling points." Is your USP unique? If it is not unique, it is not a USP. Your USP must be unique to you.

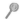 Full-sized downloadable forms and documents may be found at
www.beautiful-landscape.com/prices.html

Without ambition one starts nothing. Without work one finishes nothing.
The prize will not be sent to you. You have to win it. The man who knows how
will always have a job. The man who also knows why will always be his boss.
 RALPH WALDO EMERSON

Less is More

When you want to do your very best, when your focus is on quality instead of quantity, less is more. This is because creating fewer images will result in creating higher quality images. Instead of spending your energy, time, and money on creating a huge quantity of average or below average images, you can spend the same resources toward the creation of a small number of superb images with impressive quality.

Keep in mind that shooting, optimizing, and printing the image is only the beginning when it comes to selling your work. While the amateur may stop there, the professional must continue by mounting, matting, framing, presenting, and marketing his work. This aspect of your profession takes a huge amount of time and has to be completed to the same high quality standards used to create the photograph and the print.

Do not be cheap with quality. You can never have quality that is too high. You can only impress your customers once because there is no second chance for first impressions. Therefore, make sure that the first impression you make on your customers is one of quality in every aspect of your work and business, including customer service.

Art is Not a Commodity

Art is not a commodity like food, clothing, and other items that we need to buy regularly.

Commodity items get used up and need to be replaced. Food is eaten and more food needs to be purchased. Clothing wears out and has to be retired.

Art, on the other hand, does not get used up or worn out. Neither is art a machine. It has no moving parts. Therefore nothing will wear out over time in a work of art. The only reason a work of art may need to be replaced is because we get tired of it. However, if we purchase art that we really enjoy, there is no reason we should tire of it.

Art purchases are not regular purchases. Art is not a requirement for living. While we need food, clothing, and other essentials, we do not *need* art in order to survive on a physical level.

Art is therefore a want rather than a need. It is something we want to have, not something we need to have. We want art to make our lives more

enjoyable. We want art to decorate our home and make it more pleasant to live in. We want art to enrich our lives and our appreciation of life. We want art because it provides an opening into how other human beings perceive the world. We want art because it gives us access to a world that goes beyond the tangible reality that is around us. We want art for the same reason we want philosophy, or religion, or poetry. We want art because it makes us forget our earthly reality and opens a window into another dimension that we cannot access any other way.

We want art when fulfilling our basic needs is no longer enough. We want art to elevate the fulfillment of these needs to another level, beyond the mere satisfaction of physical necessity. We want art because we want to satisfy our souls and not just our bodies.

Art and Business

Artists often have a natural aversion to selling. They much prefer creating art to selling it. However, to be successful as an artist in business you need to overcome your aversion to selling. In order to do this you need to study how to operate a profitable business and you need to practice marketing and salesmanship.

For many artists this aversion to marketing causes them to ask low prices for their work. Unfortunately, low prices in art get you nowhere. This is because art purchases are few and far between. Therefore, as an artist in business you can only expect a low volume of sales. Even if you sell hundreds or thousands of pieces, you are far from doing high-volume sales, which are counted in the millions. Art simply does not generate such volume. In order to make up for the lack of volume you need to set your prices high enough to support your financial needs.

Start Slow

When starting your fine art photography business I recommend that you start slow and go from there. You do not have to quit your day job right here, right now. Instead, you can start running your business part-time and increasing your business involvement and investment over time.

When operating your business, keep in mind that the 80/20 law applies not only to what you do, but also to how many artists succeed financially. Among artists selling their work, 20% of artists make 80% of the sales. This means that the majority of artists (80%) make little or no money from the sale of their work, while a minority (20%) make most of the money.

Why is this minority of artists making most of the sales? Because they studied marketing and are marketing their work regularly. This minority

spends 50 % or more of their time marketing their work and they use their time efficiently. The key word here is *efficiency*. You have to become efficient at marketing your work and this is only possible through careful management of your time. In short, you must learn to use your time wisely.

Using your time wisely means that you have to be selective about the projects you get involved in. Otherwise you will end up wasting precious time and will have nothing to show for your efforts.

The best way to manage your time efficiently is to define specific goals at the start of your career and work diligently toward reaching these goals. Make these goals your personal obsession. Let little, or nothing, get between you and the concretization of these goals. However, do keep your eyes open for opportunities that may show up along the way, provided these opportunities fit in with your goals.

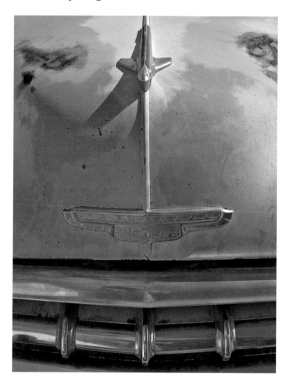

Rusted and faded
Chevrolet hood detail

Multitude and Quality

A multitude of photographers are starting to market their work right now. These numbers will get even higher because the trend is for a drastic increase in the number of artists trying to make an income from their work.

In these conditions you must find a way to stand out from the crowd. In art, the solution has been found long ago and it has not changed to this day:

to develop a unique personal style. Developing your style must be one of the goals you define at the start of your career.

Having a personal style will allow you to obtain higher prices for your work because in art you increase your income by increasing your prices. Your style, and most importantly how you market your style, is the key to your financial wealth. However, this is only true if you market yourself efficiently. Remember that no one will know what your style looks like if no one knows that your work exists!

Finally, in your efforts to sell your work and make an income from it, never undermine the quality of your work. No matter what you have to do, maintain a high level of quality. Never cut corners. Doing so cheapens your work. Remember that you cannot redo poor quality work after it has been sold and is in the hands of your customers. The only time you have control over the quality of your work is when you are making it.

Quality should be your number one concern because quality will make you stand out. Among the multitude of artists competing on the market today, only a minority offers high quality work. The vast majority offers low quality work because selling inexpensive items is easier than selling expensive artwork. Low quality work also requires a smaller investment and thus a smaller risk if one's endeavors do not pan out.

However, thinking that way means thinking in terms of potential failure, not in terms of potential success. Plus, creating quality fine art in a digital medium is not very expensive. If you are concerned with costs, and understandably you most likely are, remember that if you focus on quality and not quantity, you do not need to create many pieces. In fact, you can go as far as only making a single print from each photograph that you take. Since doing volume is not your goal, this approach can serve you very well.

What Comes Next?

This book was intended to teach you how to sell your work and how to start a successful photography business. However, it was not intended to cover everything about marketing. This is because there are countless aspects to marketing. Eventually, each marketing situation has its own unique characteristics and calls for unique decisions. Covering all of these characteristics and all of the decisions that they potentially entail is unfeasible. It would also be pointless because these situations apply only to very specific individuals, businesses, and circumstances.

Therefore, this book was designed as a starting point. I organized the information to cover the most important aspects of marketing fine art photography. Because of the complexity of the subject, I organized this information in a logical and progressive manner, grouping chapters in sections organized around specific themes.

I also focused on shows as the best way to learn how to market and sell your work. Shows work well for many people; but they do not work for everyone. Therefore, you may find that shows are not your cup of tea. You may, instead, prefer to use a different marketing venue such as galleries, wholesale stores, etc.

Alain Briot Workshops, Tutorials, and Mentoring

For all the aforesaid reasons, if you need information that is not in this book, or need help with a personal situation, I offer additional teaching through my seminars, my mentoring program, my workshops, and my DVD tutorials. Information on all these is available on my site at www.beautiful-landscape. com. I also offer a free newsletter. When you subscribe to the newsletter, you receive over 40 free essays that are not in this book.

Alain teaching a field workshop

Finally, as the owner of this book you qualify for free updates to the book. These updates are also available through subscription to my free newsletter. Just let me know when you subscribe that you also own *Marketing Fine Art Photography*. When you do, I will email you a special link to the book updates area. This update area is only accessible to book owners.

You may also find that attending one of my seminars or field workshops is the next step in your photographic journey. Our workshops and seminars are designed around the concepts outlined in this book and my two other books: *Mastering Landscape Photography* and *Mastering Photographic Composition, Creativity and Personal Style*. In other words, if you enjoyed reading this book, you will enjoy attending our workshops and seminars, taught by me and my wife, Natalie. Natalie is an art teacher and offers her own perspective and approach in our curriculum.

Our seminars and field workshops go beyond this book by providing you with personal feedback on your marketing efforts and your photographs. Often, there comes a time when it is necessary to know exactly where we stand in regard to our work—to ask someone who has the knowledge we want to acquire how we are doing and what we need to do to reach the next step. This is something that we offer in each of our workshops. If this is what you are looking for, please contact us directly by phone or email. My email is alain@beautiful-landscape.com. My phone number can be found on my website at www.beautiful-landscape.com.

It is my hope that this book will help you start a profitable photography business. Starting my photography business changed my life. I certainly hope that it changes your life as well. Just keep in mind that the best time to get started is now—not tomorrow, not a month or a year from now, but right now. It is already later than you think.

There will never be a better time.

No one knows what he can do till he tries.
 PUBLIUS SYRUS

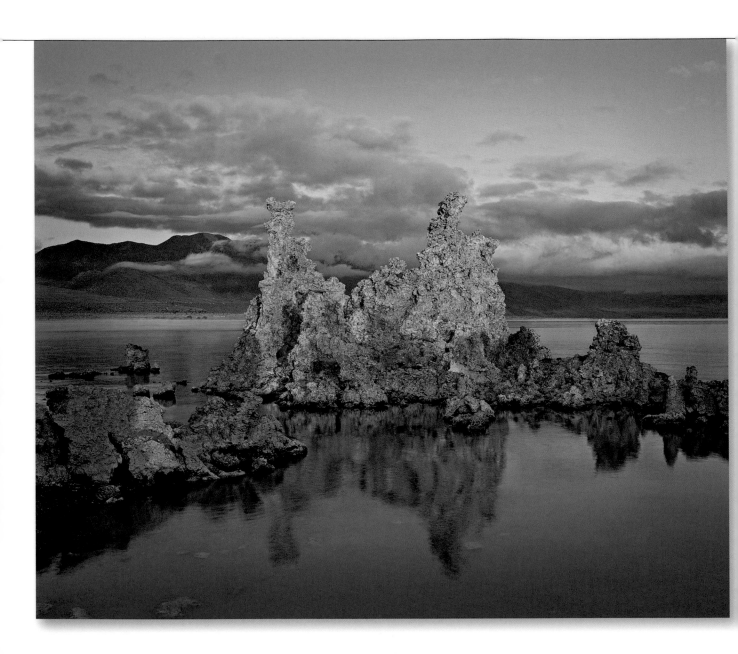

Appendix A – Art Questionnaire

This art questionnaire is designed to help you find out where you stand in regard to marketing your work. It will help you find out which areas you are strong in and which areas you need to work on. Think of it as an assessment tool that can help you grow and reach the next step in your marketing efforts.

How to calculate your score is explained at the end of the questionnaire— but do not look at it now! That would influence how you complete this questionnaire. Therefore, you need to complete the questionnaire first.

The Questionnaire

Answer each question by circling the letter in front of the answer that best describes your situation or experience:

What do you focus your business on?

Quality Quantity
 A – Yes A – Yes
 B – No B – No

How enthusiastic are you about your art?
A – I am not very enthusiastic about my art
B – My enthusiasm fluctuates from day to day; some days it is high, other days it is low
C – I am fairly enthusiastic
D – I am super enthusiastic about my art and can't wait to show my new work!

Do you have a contact list of people interested in your work?
A – Yes
B – No

How many people are on your contacts list?
A – 10 to 100
B – 101 to 1,000
C – 1,001 to 10,000
D – 10,001 or more

How often do you contact the members of this list by mail or email?
A – Once a year
B – Twice a year
C – Quarterly
D – Monthly

How often do you offer a special offer to your mailing / emailing list?
A – Never
B – Once or twice a year
C – Four times a year
D – Every month

Do you personally call on the phone the people on your contacts list?

A – Yes

B – No

Do you have a price list?

A – Yes

B – No

How do you try to set your prices?

Adequately (high) Low

 A – Yes A – Yes

 B – No B – No

How many of your contacts have seen your price list?

A – None

B – One third

C – Two thirds

D – All of them

Do you have a specific business card for your different photographic activities?

A – Yes

B – No

If yes, what is the quality of your business card?

A – Low. I did not want to spend much money on it

B – OK, but it could be better

C – Good, but not the best possible quality

D – I went all out and my cards are the finest quality possible

How much time do you spend marketing your work?

A – None, I wait for customers to contact me

B – I spend 10 % of my time marketing my work

C – I spend 25 % of my time marketing my work

D – I spend 50 % or more of my time marketing my work

How do you rank your salesmanship skills?

A – I don't have any salesmanship skills

B – I am learning but I have a long way to go

C – I have good salesmanship skills but I am not at the top yet

D – I have superb salesmanship skills

How many sales do you successfully close after contact with a potential buyer?

A – Less than 10 %

B – 10 % to 25 %

C – 25 % to 50 %

D – More than 50 %

How specific are your goals and deadlines in regards to your photographic career?

A – I have not started to define my goals or deadlines

B – I am in the process of defining my goals and deadlines

C – I have set specific goals but I do not have a deadline for them

D – I have set specific goals and specific deadlines

How specific are your deadlines for these goals?

A – I am still trying to define my goals

B – I have defined some goals but I have not started working towards reaching them

C – I have some specific goals and I have started working towards reaching them

D – I have set specific goals that I am committed to reach in a timely manner

What is your marketing budget in relationship to your profits?

A – I don't have a marketing budget. I don't spend any money on marketing

B – 5 % or less of my profits

C – 10 % or less of my profits

D – 25 % or less of my profits

Do you have an artist statement?

A – No

B – Yes, but I need to re-write it as I am not happy with it

C – Yes, it is nearly complete

D – Yes, it is ready to go. I already published it on my website and made copies to give at shows

Do you have a website?

A – Yes

B – No

Do you offer warranties to your clients?

A – Yes

B – No

If yes, how many warranties do you offer?

A – 1

B – 2

C – 3 to 5

D – 5 or more

Do you offer a money-back guarantee?

A – Yes

B – No

If yes, how long is your money-back guarantee?

A – One week

B – One month

C – Six months

D – One year or longer

How many Skills Enhancement Exercises in this book have you completed?

A – None of them

B – ¼ of them

C – ½ of them

D – Nearly all of them

Refer to page 313 to calculate your score. >>

Knowledge is of no value unless you put it into practice.
 ANTON CHEKHOV

Appendix B – Resources and Materials

This appendix features web addresses that will link you to just about everything you will need to run your business: show listings, tools, supplies, frames, shipping materials, etc.

I decided to feature only the web address here because you can order most of these supplies and items over the Internet. In the few instances that you need to order by phone or mail you can find the phone number and physical address for the store on the company's website.

Show Listing Resources:
- Sunshine Artist: www.sunshineartist.com
- Art Fair SourceBook: www.artfairsourcebook.com

Credit Card Processing:
- Card Service International: www.firstdata.com
- PayPal Virtual Terminal: www.paypal.com

Show Supplies:
- Banners & banner stands: www.bannerstandstogo.com
- Show booths—E-Z Up: www.ezup.com
- Displays—Pro Panels: www.propanels.com
- Director chairs—Dick Blick: www.dickblick.com
- Print bins—Dick Blick: www.dickblick.com

Frames, Matboard, and Miscellaneous Supplies:
- M&M Distributors: www.mmdistributors.com
- Light Impressions (presentation and preservation supplies): www.lightimpressionsdirect.com
- United Manufacturers (framing supplies): www.unitedmfrs.com
- Documounts (precut mats): www.documounts.com

Mounting Supplies:
- Coda (cold mounting adhesive and presses): www.codamount.com
- Seal Optimount (2-sided, optically clear adhesive for face-mounting prints on plexiglas): www.sealgraphics.nl

- Photo labs offering mounting on plexiglass and other supports:
 - PC Colour: www.pccolour.com
 - Finishing Concepts: www.finishingconceptsinc.com
 - Plexi Photo: www.plexiphoto.com
 - Colourgenics: www.colourgenics.com

Transparent Bags:
- Impact Images (package your photographs for display or shipping): www.clearbags.com

Shipping Materials:
- U-line (shipping boxes, tubes, tape, tools, etc.): www.uline.com
- United Manufacturers: www.unitedmfrs.com
- Reliable: www.reliable.com

Online Shipping:
- US Postal Service: www.usps.com
- UPS: www.ups.com
- Federal Express: www.fedex.com

Email Marketing:
- Constant Contact: www.constantcontact.com
- Email Brain: www.emailbrain.com
- Exact Target: www.exacttarget.com
- Email ROI: www.emailroi.com

Web Marketing:
- Google Adwords: www.Google.com
- Clustermaps: www.clustermaps.com/getone.php

Shopping Cart / eCommerce Software:
- ApsDotNetStorefront: www.aspdotnetstorefront.com
- Volusion: www.volusion.com

Blog Software:
1 – Software: www.WordPress.com
2 – Wordpress themes:
- www.wprocks.com/free-themes
- www.wpthemes.info
- www.pagelines.com
- www.studiopress.com

Affiliate Programs:
- Idevaffiliates: www.idevaffiliates.com

Surveys:
- Bravenet: www.bravenet.com
- SurveyMonkey: www.surveymonkey.com
- Polldaddy: www.polldaddy.com

Website Providers:
- GoDaddy: www.godaddy.com
- HostForweb: www.hostforweb.com

Sales Tax Information:
- Google "[your state] sales tax" to find the sales tax site for your state.

Business Insurance:
- The Hartford: www.thehartford.com

Printing Trade Magazine
- Horsetrader Magazine (lots of advertising by all types of print shops): www.printrade.com

Commercial Printers

A – Postcards
- Modern Postcards: www.modernpostcard.com
- Postcard Press: www.postcardpress.com
- Photographer's Edge: www.photographersedge.com

B – Brochures and Posters
All these companies will print your cards and posters. You provide them with your ready-to-print materials over the web by uploading them to their FTP server. You usually get a free PDF proof and you can request a physical proof for an extra fee.
- LithoTech: 888-332-8791 and 626-433-1333
- 4Over: www.4over.com
- Metro Digital Printers: www.metro-digital.com

Stock Pricing Software
- FotoQuote: www.fotoquote.com
- Agave SPS: www.prenticephoto.com/agaveweb.htm

Online Stock Pricing Sites:
- www.ozimages.com.au/stockpricing/calculator.asp
- www.photographersindex.com/stockprice.htm

Invoicing Software

- Blinkbid.com: www.blinkbid.com
- iBiz: www.iggsoftware.com/ibiz/index.php
- FotoBiz and FotoQuote: www.fotoquote.com/fb-overview.html
- Billable: www.clickablebliss.com/billable

Custom promotional items (Anniversary / Commemoration resource):

- Stephen Fossler Company: www.fossler.com

Long Distance and Toll Free Phone Service:

- ComLinQ: www.comlinq.com

Appendix A – Art Questionnaire Scoring

1. Count how many D answers you have.
2. Count how many Yes answers you have.
3. Add the number of D answers to the number of Yes answers. This is your total score.
4. Refer to the table below to find your score:

20 to 25	A (Excellent)
15 to 20	B (Good)
10 to 15	C (Average)
5 to 10	D (Barely Passing)
0 to 5	F (Failing)

Get in the Picture!

c't Digital Photography gives you exclusive access to the techniques of the pros.

Keep on top of the latest trends and get your own regular dose of inside knowledge from our specialist authors. Every issue includes tips and tricks from experienced pro photographers as well as independent hardware and software tests. There are also regular high-end image processing and image management workshops to help you create your own perfect portfolio.

Each issue includes a free DVD with full and c't special version software, practical photo tools, eBooks, and comprehensive video tutorials.

Don't miss out – place your order now!

Get your copy:
ct-digiphoto.com